PORTRAITS IN
STEEL

An Illustrated History

of Jones & Laughlin

Steel Corporation

The Kent State University Press

Kent, Ohio, & London

PORTRAITS IN
STEEL

David H. Wollman

& Donald R. Inman

Library of Congress Catalog Card Number 98-44778

ISBN 0-87338-624-8

Manufactured in China

07 06 05 04 5 4 3 2

Library of Congress Cataloging-in-Publication Data

Wollman, David H., 1936–

Portraits in steel : an illustrated history of the Jones & Laughlin Steel Corporation /
David H. Wollman and Donald R. Inman.

p. cm.

Includes bibliographical references and index.

ISBN 0-87338-624-8

1. Jones & Laughlin Steel Corporation—History. 2. Steel industry and trade—
United States—History. 3. Iron industry and trade—United States—History.
I. Inman, Donald R., 1940– . II. Title.

HD9519.J64W65 1999

338.7'669142'0973—dc21 98-44778

British Library Cataloging-in-Publication data are available.

To our wives,
Ann and Carol,
for their support,
understanding,
patience,
encouragement,
and readiness
to assist.

Contents

This work was a labor of love and respect for the many men and women who worked in all capacities at Jones & Laughlin Steel Corporation over the years. It began with Don Inman's commitment to save something of the heritage of the company to which he had devoted his professional career, and it continued with Dave Wollman's desire to help explain that heritage to the local and national community. In the process of collecting and analyzing the documents, artifacts, and photography that make up the Inman Collection in the Beaver County Industrial Museum, we have enjoyed the expertise and assistance of numerous people, to whom we are grateful. Most notably, the workers and management of Jones & Laughlin Steel and LTV Steel have been tremendously supportive and helpful. Frank Zabrosky, formerly the director of the Archives for Industrial Society at the Hillman Library, University of Pittsburgh, provided much-needed direction for arranging the collection, and many students at Geneva College did yeomen's duty in working with the collection and constructing the first public exhibit. The staff of McCartney Library, Geneva College, has been very helpful as well, as were our editors at The Kent State University Press. We also wish to thank the advisory council for the museum, the development staff of Geneva College and the Beaver County Foundation, the P. M. Moore Foundation, the LTV Foundation, the Pennsylvania Historical and Museum Commission, the Beeghly Foundation, and many others for their assistance, both financial and otherwise.

As always in these cases, we have made every effort to be accurate, and we have sought assistance from a variety of sources to ensure accuracy. No one is perfect, however, and we regret any inaccuracies that might have crept in, despite our valiant efforts to combat them. We hope you will be as gracious as the Lord is in dealing with our failures.

Preface

PORTRAITS IN
STEEL

Most of us can give the date of our birth. If we have no memory of the event ourselves, there are relatives who will tell us when it occurred; ultimately there are official documents that will give us more conclusive information. But the birth of Jones & Laughlin Steel is shrouded in uncertainty, or at least ambiguity. Much depends on how J&L is defined as an organization, separate from the companies that preceded it.

When the company management was considering how it should celebrate its centennial, various officers compiled accounts and consulted records to determine exactly what year to choose as its beginning. A history put out in 1931, based on an address the previous year by Willis L. King (a nephew of the founder, B. F. Jones), gave the birth year as 1850. This was also the date used by B. F. Jones Jr. in a brief historical sketch he wrote a year or so before his death.[1] However, when William T. Mossman, W. C. Moreland, and others looked into the matter in the late 1940s, they found reason to question this date, and eventually they settled on 1853 as the official year for the birth of Jones & Laughlin Steel.[2] This then was the date used by Ben Moreell and H. W. Graham in their addresses during the official celebrations.[3]

One reason for the uncertainty goes back to the problem of defining what exactly J&L is as an organization. It is possible to speak of Jones & Laughlin Steel as a separate, distinct, and independent entity only from 1900 to 1968. During the nineteenth century what became the Jones & Laughlin Steel Corporation was actually a series of interlocking partnerships among various members of the Jones and Laughlin (and for a time Lauth) families. Only on April 1, 1900, were the two primary partnerships of Jones & Laughlin, Ltd., and Laughlin and Company, Ltd., consolidated. Two years later, on June 2, 1902, the single limited partnership was reorganized as Jones & Laughlin Steel Company, a corporation under Pennsylvania law. A further reorganization on January 1, 1923, resulted in the Jones & Laughlin Steel Corporation, when for the first time company shares were traded on the stock exchange. After 1968 it was owned by another corporation, The LTV Corporation. In 1984 the J&L name itself was abolished; LTV merged the company with the newly acquired Republic Steel and named it LTV Steel.

The 131 years (1853–1984) of Jones & Laughlin as an independent entity divide naturally into a number of distinct parts. In its first fifty years it took on the character of its dominant entrepreneurial founder, B. F. Jones. The next twenty-five constituted a transitional period under the leadership of B. F. Jones Jr. as the company came to terms with its role in modern American industry. Managers both inside and outside saw the corporation through its heyday as a major "independent" steel producer during the

Introduction

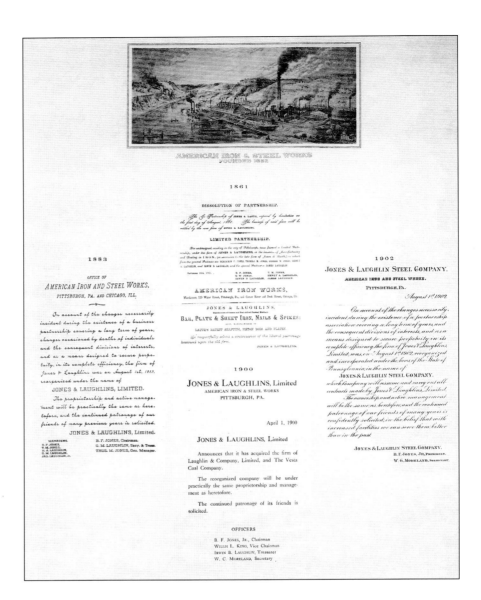

Company commemorative picture showing the first four reorganizations of J&L, in 1861, 1883, 1900, and 1902.

next thirty-five years. The final decades witnessed the failure of J&L to surmount the challenges of surviving in a global economy.

Jones & Laughlin was more than just management, however, for its workers from the beginning were intensely loyal and creative. So the story of J&L involves the workers in iron and steel and their relationships with management over the decades. The skilled workers in iron—the puddlers, heaters, and rollers—sought strength and comradeship in combination. By 1862 there were "forges" (as the local units were called) of the Sons of Vulcan at J&L, and B. F. Jones reluctantly worked with them to promote industrial harmony, conceiving the "sliding scale" for establishing wages that the union would later champion. So long as labor involved primarily

skilled workers in iron, labor-management relations were marked by civility despite the abuses of the contracting system and the occasional strikes and lockouts. The transition to steel, however, changed the dynamics of the relationship by introducing more semiskilled and unskilled workers, as technology, initially at least, made workers more adjuncts of machines than skilled craftsmen controlling the processes. Although the older skilled craftsmen remained, their proportion among total workers declined. At the same time, immigration from eastern and southern Europe brought a new component to the workforce, one with different traditions and assumptions about relationships between capital and labor. By the end of the nineteenth century, B. F. Jones joined with other manufacturers in driving organized labor out of J&L's mills, and a new generation of industrial managers brought a very different approach to labor-management relationships.

It would take considerable hardship, conflict, and perseverance throughout the American industrial workforce to create a new type of union in the face of management hostility. The industrial union, with its broad range of skilled, semiskilled, and unskilled laborers, reasserted the comradeship of the working class in the first half of the twentieth century, sometimes in opposition to the old craft unions and sometimes in cooperation with them. J&L, as the second largest steel producer at the start of the century and the fourth largest after horizontal integration had produced the United States Steel Corporation, Bethlehem Steel, and Republic Steel, was one of the independent steel producers who held out vehemently against the Steel Workers Organizing Committee (SWOC) both in the courts and in the workplace. It was J&L that challenged the constitutionality of the Wagner Act, and even when it lost that landmark case in the Supreme Court, management still resisted the inevitable, giving in only after a brief strike in May 1937. Thereafter, J&L in common with the other steel producers negotiated with the United Steel Workers of America and shared the ups and downs of industrial relationships in the 1940s, 1950s, and early 1960s. A more cooperative era of labor-management relationships followed thereafter with, among other things, the development of joint labor-management participation teams.

Iron- and steelmaking are industries driven by technology, and J&L was a leader in developing and adopting the fruit of scientific and metallurgical research. From the early puddling and heating furnaces and primitive rolling mills for transforming pig iron into usable forms of iron to the later Bessemer, open-hearth, and eventually the basic oxygen furnace for making steel; from small blast furnaces capable of twenty-five tons per heat to the massive blast furnaces able to produce three hundred tons per

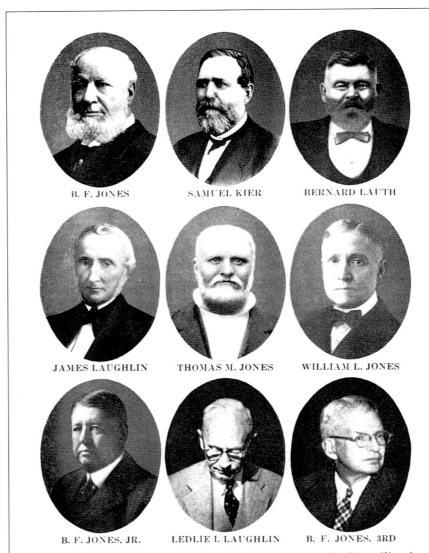

J&L STEELMEN!—Presenting some of the men who pioneered iron- and steel-making at J&L, and some of their descendants. It was in 1853 that B. F. JONES entered into an agreement with SAMUEL KIER, BERNARD LAUTH, and John F. Lauth, his brother, to establish the firm Jones, Lauth & Company. In 1861, JAMES LAUGHLIN, together with his sons, Henry A. and Irwin B. Laughlin, and B. F. Jones and his brothers George W. and THOMAS M. JONES, formed the firm of Jones & Laughlins. WILLIAM L. JONES, son of Thomas, was elected to the Board of Managers of Jones & Laughlins, Limited, in 1899, and was named President when J&L Steel Corporation was formed in 1923. B. F. JONES, JR., was elected to the Board of Jones & Laughlins, Limited, in 1891, and was named Board Chairman in 1923. The photographs of LEDLIE I. LAUGHLIN and B. F. JONES, 3RD, were snapped on April 28, 1955, at the 33rd Annual Meeting of J&L Shareholders. Mr. Jones, grandson of B. F. Jones, is J&L's Vice President and Secretary; Mr. Laughlin, great-grandson of James Laughlin, is a J&L Director. William Larimer Jones, Jr., grandson of J&L pioneer Thomas M. Jones, served 24 years with the Corporation; from 1925 to 1936 as a Director, and from that time to 1949 as a Director and Vice President.

Portraits of J&L steelmen, 1853–1957

heat; from the primitive plate mills to the computer-controlled and specialized variety of rolling mills that produce finished products of amazingly precise composition and size—in all of this J&L was a proud pioneer in research and development. Not all efforts were completely successful;

the Talbot open-hearth process employed early in the twentieth century, for example, turned out to be more difficult and dangerous than other open-hearth processes and was eventually abandoned. But at least J&L was willing to innovate, despite the risks.

That sometime willingness to take risks, however, could not in the long run save J&L from the fate of many other basic steel producers in America in the face of foreign competition, compounded by management and union mistakes. J&L, which had prided itself on a long history of internal expansion rather than the acquisition of other steel producers, broken only by the wartime purchase of Otis Steel, itself became an acquisition in 1968. Its long existence as an independent company had ended with unfortunate consequences both for itself and for its purchaser, The LTV Corporation. At first the U.S. government challenged the action and permitted it only under stringent controls, and then the financial markets buffeted the fiscal stability of the parent company. In the long run, J&L/LTV, no more than U.S. Steel, could withstand unchanged the challenges of a global economy that provided basic steel products in Japan, Korea, and Europe at a lower cost than in the United States. The future of American steel would be with minimills and specialty steel products.

In the pages that follow we will explore the themes of organization, labor, technology, and markets as we look at the story of Jones & Laughlin, "an American Business" that mirrored the remarkable growth and creative accomplishment as well as the unfortunate decline and collapse of the American iron and steel industry.

one "Present at the Creation"

The story of Jones & Laughlin begins with those who were present at its creation, and that means that it begins first and foremost with Benjamin Franklin Jones. Considered by some commentators as second only to Andrew Carnegie as a dynamic and innovative ironmaster,[1] Jones was the ninth child of Jacob and Elizabeth Jones. His Jones forebears had come to Pennsylvania from Wales in the year of the founding of the Commonwealth, and the family joined the westward movement within Pennsylvania during the early years of the Republic. Jacob Jones, born near Chambersburg, Franklin County, in 1779, married Elizabeth Goshorn of Mifflin County, twelve years his junior, on January 15, 1810. Their first two children, Eliza (1810) and Goshorn Alexander (1811), were born in Elizabeth's hometown of Tuscarora Valley, but thereafter the family moved to Franklin County (Fort Loudon), where the next two children, Sarah (1813) and Rebecca (1815), were born. Maria, their fifth child, arrived in 1817 while they were briefly living in Newry, Huntingdon County, while the next two children, Margarett (1819) and Susan (1820), were born in Ligonier, Westmoreland County. Thus, in one decade they had lived in four places, the last move taking them from central to western Pennsylvania.

The 1820s were spent largely in Claysville, Washington County, where four sons—William (1822), Benjamin (1824), Randolph (1826), and Thomas (1828)—were born. The last two children, James (1830) and George (1833), were born in West Alexandria, only a short distance away from

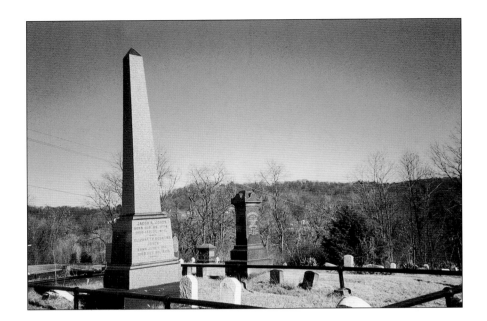

The Rochester, Pennsylvania, cemetery monument for Jacob A. Jones (1776–1870) and Elizabeth Goshorn Jones (1781–1863).

Claysville and also in Washington County, at the western extreme of Pennsylvania. This suggests that the Jones family had pretty much settled into a stable routine. Within a year this stability was broken, first when Randolph, known as Dolphus, died in March 1834, and then in the following May when the eldest daughter, Eliza, married Horatio Nelson Frazier, from Connecticut. The newlyweds must have continued to be part of the family, however, for they apparently moved with the rest of the Jones family to New Brighton, Beaver County, about 1838. The family stayed in Beaver County for some time, first in New Brighton and then in Rochester, where Jacob operated a hotel. Sarah, Rebecca, Maria, Margarett, and Susan were all married in Beaver County between 1839 and 1847, and three family members died there: Elizabeth in 1863, son-in-law Frazier in 1867, and Jacob in 1870. Beginning in 1842 the younger boys had gone off to seek their fortunes in Pittsburgh. Benjamin led the way, but before long he was joined by Thomas and George.[2]

The third son, Benjamin Franklin Jones, was born on August 8, 1824. Since he had numerous older sisters and a number of brothers about his own age, he did not lack for companionship. When he was fourteen the family moved to New Brighton, Beaver County, where he attended the New Brighton Academy. At age eighteen he went to Pittsburgh to make his own way in the world.[3] His first significant employment was as a clerk for entrepreneur Samuel M. Kier, whose interests included firebrick, pottery works, and canal boats. Young Jones must have impressed his employer with his skill and his ambition, for within three years Kier made Jones manager of

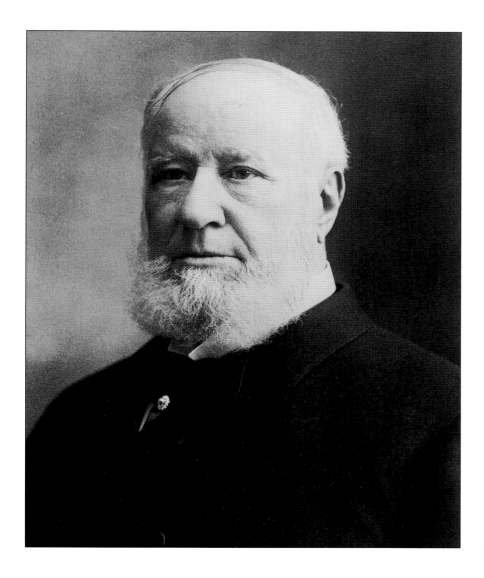

Portrait of Benjamin Franklin Jones,
ca. 1890.

his Mechanics Line of canal boats, and together they started an additional Independent Line in 1846. Before long the two were also partners in an iron furnace and forge near Armagh, Indiana County. Unfortunately, the business climate turned bad with a change in tariff policy, and the small ironworks never did get off the ground. Throughout his life Jones supported a protectionist tariff policy, perhaps as a result of this experience.

In any case, by 1850 both Kier and Jones realized that the expansion of the railroads, especially the Pennsylvania Railroad, into Western Pennsylvania would end the canal boat business, so they shifted their focus. Kier concentrated on developing "Kier's Rock Oil" as a light source and would be a significant figure in the development of the Pennsylvania oil industry, while young Jones chose to pursue iron making more aggressively, initially at least with financial support from his older partner. His

New Brighton, Pennsylvania, ca. 1904. The house where the New Brighton Academy had been is to the right of the church at the far right of the photograph.

marriage in 1850 to Mary McMasters, later called an heiress by one of the millworkers, may have helped provide financial support as well as gain him social status. Thus, by 1854, when the Mechanics and Independent Lines officially went out of business, both entrepreneurs had new interests to pursue.[4]

The actual sequence of events for the creation of the initial Jones & Laughlin ironworks lacks clear chronological benchmarks. The basic outline of the story, however, is fairly certain. In 1850 two German ironmasters, Bernard and John Lauth, formed the common partnership of B. Lauth and Brother to establish puddling and heating furnaces in Brownstown (now part of the South Side in Pittsburgh). Sometime early in 1853 they planned to erect a rolling mill in the same location, but the death on September 5, 1853, of their father, a tavernkeeper who was perhaps providing at least some of the capital for the mill, forced a postponement of its opening until October. By December 3, 1853, the Lauth brothers had been joined by B. F. Jones and Samuel Kier in another common partnership—Jones, Lauth, and Company. Jones would manage the business, the Lauth brothers would provide the expertise, and Kier would provide capital for the American Iron Works, as the mills were called. B. F. Jones, Bernard Lauth, and John Lauth each were salaried at $1,500 per year, with Jones in charge of finances, Ben (as Bernard seems to have been called) in charge of the rolling mills, and John in charge of the small mills and turning department. Kier was a silent partner with neither duties nor salary.[5] Some time before the spring of 1854, Jones, with Kier's help, purchased an interest in a rolling mill in Brownsville on the Monongahela River in Fayette County; he then arranged to have it dismantled and parts of it brought to Brownstown for use in the American Iron Works.[6]

Shortly afterward James Laughlin became a part of the story. Laughlin had been born in County Down, Ireland, in 1806 and, following the death of his mother, had emigrated to the United States in 1829 with his father and sisters to join his brother, Alexander, in Pittsburgh. The Laughlin brothers were successful in the provisioning trade, and after a while James branched out into banking. In 1852 he became the president of the Fifth Avenue Savings Bank (later called the Pittsburgh Trust Company), which he had helped to found and which became the basis for the First National Bank of Pittsburgh. When in 1863 this bank became the first national bank established in Allegheny County under the terms of the new Banking Act of the United States, James Laughlin was still its president. By then, however, he had already taken a strong interest in the iron business, loaning

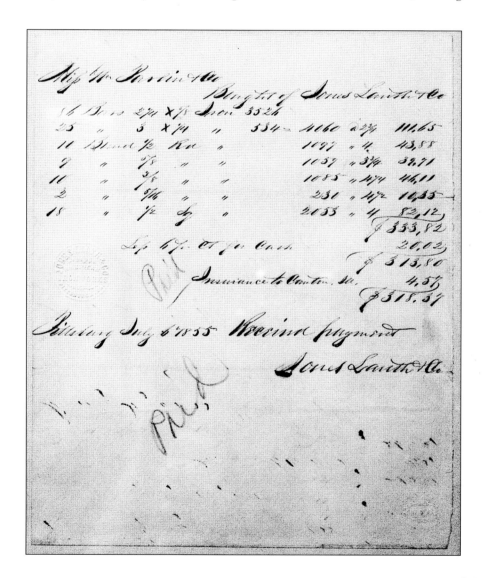

Bill of sale dated July 6, 1855. The payment was received by Jones, Lauth & Company.

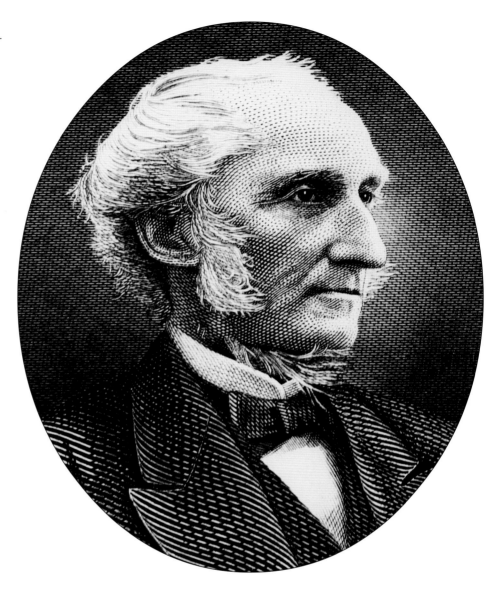

Portrait of James Laughlin, ca. 1870.

Jones, Lauth, and Company money and becoming a special partner with them on August 21, 1856, replacing both Kier and John Lauth in the new limited partnership, now called simply Jones and Lauth. The limited partnership made it possible to quantify the respective shares of the three partners, with B. F. Jones and James Laughlin each receiving $^{13}\!/_{32}$ds while Bernard Lauth received $^{6}\!/_{32}$ds.[7] It was a melding of entrepreneurial vision, managerial skill, technical expertise, and financial capital that would help make J&L the leader in iron making in Pittsburgh and Pittsburgh the leading iron-producing region in the country, giving it the nickname "Iron City."

Theirs was an interesting mixture of personalities and backgrounds. Jones, of Welsh–Pennsylvania Dutch stock, was still young at thirty-two and ambitious enough to make a name for himself. He was recognized as

being an able manager, the epitome of the entrepreneurial American, and a member of the prosperous Presbyterian elite of Allegheny County. The Scotch-Irish Laughlin came from a dour Presbyterian background and, at fifty, was already well along in years and accomplishments and thus was willing to let his younger partner Jones run the business to which he was so financially committed. The German-Catholic Lauth contrasted strongly with both of them; certainly older than Jones, perhaps in his late forties, he was of lower-class origins, a craftsman in iron making. It was he, for example, who developed cold rolling for a more polished surface and who rediscovered the principle of putting a third roller in a plate mill.[8]

Both Jones and Laughlin became well-established members of the Pittsburgh elite community.[9] Lauth, however, perhaps because of his Catholic, lower-class background, never gained such acceptance. In 1861, when the partnership came up for renewal, he decided to sell his interests to the other two, both of whom then brought relatives into the new limited partnership, now called Jones & Laughlins. Jones brought in his younger brothers Thomas and George, while Laughlin brought in his two oldest sons Henry and Irwin. By that time the same six people, plus James Laughlin's other two sons and Richard Hays, had become engaged in Laughlin and Company, a partnership begun in 1859 to produce pig iron just across the Monongahela River from the American Iron Works of Jones & Laughlins.[10] Both partnerships carried on the tradition established by the original agreement in 1853 to reinvest all profits in the company: "Neither of said

J&L's American Iron Works in the 1880s. In this etching, puddling furnaces flank the right side of the Monongahela River and Eliza blast furnaces the left. The Pittsburgh–New Orleans packet boat is heading downriver.

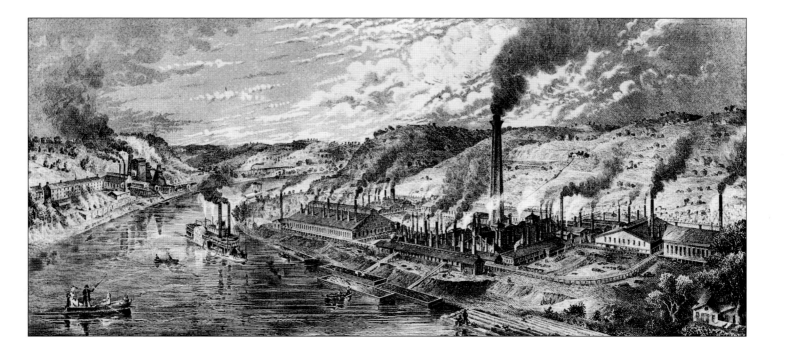

partners shall during said term draw out any moneys from said firm; but the profits thereof shall be added to and become part of its capital stock; nor shall either of said partners use the name or credit of said firm, by endorsement or otherwise, except in the legitimate business of said firm."[11]

The Lauth Brothers, B. F. Jones, and James Laughlin were not the only people involved with the founding of the American Iron Works in Brownstown. There were also the workers and the townspeople, a colorful lot by any standard. According to Thomas Boyle, one of the many Irishmen who worked in the mill in the early days, and Albert Daschbach, the workers included Germans, Irish, Welsh, Scots, and even an odd Englishman. They were mostly Catholic, worshiping at the German Catholic church, St. Michael's, until the Irish Father Reynolds organized an English-speaking church, St. John's, in 1845. They liked to congregate at Grierson's Grocery Store to discuss politics and drama. Their politics were based on the speeches of Webster, Haynes, Lincoln, and Douglas and tended to be strongly abolitionist and pro-Union, while their discussion of drama centered on the previous night's performance by the elder Booth, or the younger Kean, or some other of the theatrical stars of the age, at Pittsburgh's Old Drury. If they wanted liquid refreshment to accompany their conversation, they frequented Dominick Maguire's tavern on Carson Street. The men exchanged stories about such legendary gamblers as Pat Hughes, who won a hand with four kings and an axe-handle to overawe the card shark who had palmed two aces, or the Southern gentleman who used his black valet as collateral in a losing game on an Ohio packet boat.[12]

J&L's first office and warehouse, Pittsburgh South Side.

The Daschbach family, 1887. Five generations of Daschbach men worked in J&L mills from 1853 to 1960. Courtesy of the Historical Society of Western Pennsylvania.

In 1850 Brownstown was already home to Cunningham and Ihmsen's window-glass works, Saeger and McClurg's flint glass factory, and George Bennett's soda and chemical works when the Lauth brothers purchased land from John Brown, for whom the town was named, between Bennett's Chemical Works and Grierson's Orchard to build their new American Iron Works. B. F. Jones was also active in Brownstown, where the headquarters for the Mechanics Line of canal boats was located. When Louis Kossuth, the Hungarian patriot, visited the Bennett works in 1852, Jones was on the committee to welcome him. Employees at the soda works, we are told, gave Kossuth a "liberal contribution for the freedom of Hungary."[12]

The fact that the Lauths called their works the *American* Iron Works indicated something of their patriotic sentiments. This showed up as well in an incident, probably about 1855 and certainly before the Civil War, when a supposedly liberal Jack Heakly, an English mason, let his artistic license get the better of him in finishing off the top of the "finest eight fluted stack that this end of the state has seen." With his trowel and bricks he fashioned a man's head with "an artistic kings crown shaped out of brick as a finish to the top of the stack. B. F. Jones, who used to come over every day, rain or shine, saw the kings crown from his buggy. Heakly was called in and told that this was the American Iron Works." So the next day he filled in the crown to make it look like a man's hat, "and many no doubt thought that the hat was the stacks first finish."[13]

The contract for building the four puddling furnaces, two heating furnaces, guide mill, muck rolls, and crocodile squeezer that constituted the

original works was given to John Brown's brother-in-law, Mr. Wareham. Thomas Boyle remembered the building process well since it was right beside the path he used to take to the swimming hole. He also remembered the names of many of the workers. In the spring of 1853 he was working in Cunningham's Glass Factory when word came that the Lauths were planning to add a rolling mill, and he was one of those who moved over to the new mill. The workers' names were largely German, Irish, and Welsh: Joe Myers was the first guide roller and the one who rolled the first piece of finished iron; Bill Duval served as "rougher up" and Hesac Foley as "rougher down"; Sam Collins as scraper; Dennis Heaphy and Jess Boyle as straighteners; Joe Manky as first muck roller; Johny Sites as catcher (and champion skater of Pittsburgh); Pat Boyle as "hook-up" (or "heave-up" as then called); Tony "Holy" Heilig as "drag-out"; his brother, Frank Holy, better known as "Blood Pudding," as catcher on the 12-inch mill; Hen and Hon Diebold, Evan Jones, and Davy Morgan as puddlers, assisted by Evan's two sons, Evan and Davy, and Mike Scheidemantle. Those who came from Brownsville to Brownstown included Ben Warman as heater and George Downs, Bill Walker, Johnny Walker, Ed Ganby, and Davy Lloyd as puddlers.[14] Joe Myers was only about twenty-three when the new rolling mill opened, and he would continue to work there until an accident in about 1898 cost him a limb.[15]

One of the workers may have been George Jones, the younger brother of B. F. Jones himself. Thomas Boyle described him thus:

> Among those who came down from Brownsville was a youth of perhaps nineteen years. He was well built, a good dresser, bright, quick and energetic; a crisp talker, who never seemed lost for the proper word, or to stumble over it. His hair which curled close to his head was the [color of a] ravens wing. He became a general favorite with all classes. Having a good memory, he could with ease call the name of every man and boy in the town, a feat attributed by Plutarch to Themistocoles [sic] in regard to Athens. This was G. W. Jones, as he wrote it frequently, sometimes perhaps on his shirt cuff when he would dot [sic] down items as he passed through the mill, but G. W. Jones running into one became simply "George" as he passed through the streets. He was good and kind, but no means pamby, indeed, virility was one of his acknowledged traits.[16]

The description of his black curly hair matches that given by the son of Jacob Shook when he visited the mill and met George Jones in 1867.[17] In

A sample of advertising in the iron industry as it appeared on an 1880 blotter.

later years it was fashionable for younger sons of management to spend summers learning the iron and steel business by working in the mills.

Iron puddling was not for the faint of heart or the inexperienced. It required much skill and a knowledge of the metal. A cooking analogy was often used, and the process itself was called "boiling iron." Early puddlers in America were Welshmen who had learned the trade in Wales and were loath to impart knowledge of the craft to any but their sons. A puddler's helper who was not the puddler's son would have a hard time learning all the fine points thanks to the tricks of his master. The crucial skill involved "balling a heat," in which the puddler determined that the metal had boiled sufficiently and was now suitable for working. After having helped stir the iron that had risen to the top of the molten brew to bring it into a ball, the now-unwanted helper would be sent on some superfluous errand so that he could not gain by observation what his master refused to teach him by lesson. Before he could return from dealing unnecessarily with cinders, water, or slate to figure weights on, "the puddler had thrown a 'ball in the jamb' and was ready with his familiar cry of 'Wedge out.'" All the hapless helper could do was carry the ball to the "squeezers" and resume his tedious role of watching the brew after a new heat had been charged. The puddler, highly paid for his skill, would head for the nearest tavern in his "skull cap, sleaveless [*sic*] flannel shirt and the inevitable towel about his neck" for a mug of ale to quench his heat-inflamed thirst.[18]

The puddling furnace was a rectangular box with a hearth shaped like a roasting pan, made of firebrick or stone and lined with iron and slag cinder. At one end was a firebox; at the other was an opening to a tall stack for escaping gases. The end result of boiling iron in a hot furnace was a ball of iron and various impurities, from which the squeezers would remove most

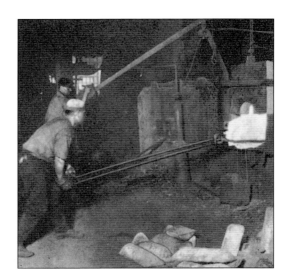

An iron puddling furnace with puddlers at work removing a "ball."

of the slag to form a square or flat bar called muck iron. This was then sent on to the rollers and others who worked the wrought iron into various shapes by rolling or further hammering, depending on the product desired. Early products were listed in 1858 as iron shapes, nails, and cut and pressed spikes.[19]

The new rolling mill built at Brownstown in 1853 was a standard two-high mill, which squeezed the red-hot muck iron as it passed through. Catchers would then pass it back over the rollers for other passes until the desired thickness and finish had been obtained. A polished finish was especially appreciated, and Ben Lauth made a major technological breakthrough in that regard in 1860. The stories vary somewhat about whether it was a tong or a bar that accidentally passed through the press and presented a more polished finish. The tong is more probable since tongs were usually set to cool in the bosh (the vessel of water kept alongside the rolls for that purpose), and it was the cooler temperature of the rolled metal that contributed to the eye-catching finish. The accident itself was insufficient, however, and the Lauth brothers experimented with different shapes (rounds turned out, initially at least, to be easier to work than squares) and different acid baths to remove the scale, sometimes working late at night on Saturday when the mill was closed. Tom Boyle describes one such night when his friend Johnny Lauth, after "first binding me to great secrecy," invited him to observe Johnny's father and uncle work with John Duval and others as they tried different shapes and finally hit on rounds. He also describes how one worker tried fraudulently and unsuccessfully to get the patent for using vitriol to get the scale off: "The rest is easy, the real owners, the ones who had spent their money to bring it to its fruition, got the patent. And Cuddy's head went figureatively [sic] where Richard III literally placed that of Buckingham."[20] When Ben Lauth retired from the partnership in 1861, he sold this patent to Jones & Laughlin for $250,000. Shortly afterward Ben Lauth also rediscovered the idea of the three-high mill, which is simply the placing of a third, smaller roller between the other two. This made it possible to roll in the opposite direction, so that when the catchers pass the rolled iron back to those on the other side of the mill, they could roll it back again, "saving half the time and half the effort."[21] This provided other benefits as well: a reduction in the required torque, hence a reduction in the size of the engine needed, and the elimination of awkward reversing engines. The principle applied for all rolling mills above the two-high.[22]

The source of the metal used in puddling furnaces was pig iron, the product of the primary iron-producing unit called the blast furnace. The American Iron Works initially bought its pig iron from various producers,

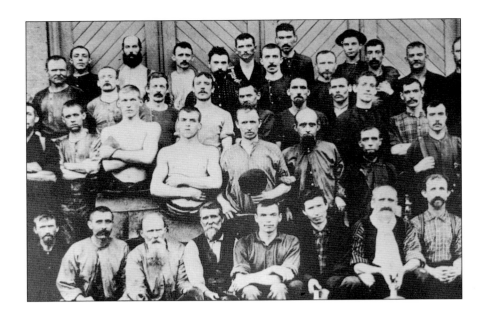

Eliza cast house crew, 1880.

but by 1859, despite the discouragement brought on by the panic of 1857, the production of the thirty-one puddling furnaces and assorted rolling mills had reached six thousand tons per year, and their dependence on others for pig iron was limiting further growth. On July 1, 1859, B. F. Jones was among the first to engage in the process called backward vertical integration when he and his partners formed Laughlin and Company to produce pig iron for the American Iron Works. The location chosen was directly across the Monongahela River from Brownstown; work was begun there on two blast furnaces, called the Eliza furnaces, and some beehive coke ovens. Blast furnaces were usually named after women (wives, daughters, and mothers), and Eliza was a common enough name in both the Jones and Laughlin families to provide ample justification for its use.[23] The Eliza furnaces were only the second blast furnaces built in the Pittsburgh district, begun a short time after the Clinton furnace was built in 1859. These were in operation by 1860 and would be a major step in helping the Jones and Laughlin companies meet the demands of the Civil War and railroads for iron products.

two

Ironmasters in War and Peace

In the late 1850s, conversation among the men of Brownstown at Grierson's Grocery Store turned frequently to the subject of the growing rift between North and South. The sentiments of the many German and Irish Catholics among them lay with the antislavery cause and even more with the Union cause. Some of the older men were veterans of the Mexican War, and as the United States moved towards the fateful spring days of 1861, many workers joined the Federal cause in arms, encouraged perhaps by the support that B. F. Jones himself gave to the Union cause. Jones switched his party affiliation from Democratic to Republican, helped organize the Pittsburgh Subsistence Committee, advocated new financing schemes to provide financial support for the Federal government, encouraged enlistment in the military, and wrote personal letters and newspaper editorials advocating the Union cause.[1] At least one owner's son joined the men in arms; George McCully Laughlin, second youngest son of James Laughlin, was one of the students at Washington and Jefferson College who chose to forgo his senior year to enlist during the summer of 1862. At first a private soldier, he was immediately raised by the governor to second lieutenant in Pennsylvania's 155th Volunteer Infantry Regiment. He served throughout the war in a series of increasingly more demanding positions and was present at numerous engagements, from Antietam to Appomattox. As an aide to one of the generals assigned to arrange the surrender of Lee to Grant, he was present at that momentous occasion. He was mustered out

in June 1865 as a major.[2] Not all the men of the American Iron Works and the Eliza furnaces were so fortunate as to survive the war, let alone rise to such eminence in it.

The Brownstown village green, once the scene of children's play, became again in 1861 the muster field for military units. As Albert Daschbach wrote years later:

> Family records prove today that Brownstown was not slow to give up her sons for the Union. Men threw their tongs into the "bosh," and boys scarcely old enough to carry a musket left the school room to join the army. Hardly enough boys remained to make a ball team, and many never returned. The salt box and the cellar door at Grierson's were well nigh deserted, for there was more than talking to be done. Reports of battles began to come in, and many a familiar name was found on the lists of killed.[3]

When Thomas Boyle reminisced decades later about the millworkers, he noted that Dennis Heaphy, one of the young straighteners, was "killed at Malvern Hill in the 7 day fight" and that Tony "Holy" Heilig was killed in the war as well.[4]

The Jones and Laughlin partnerships sent more than men to the war effort. The Civil War may have disrupted the demand for iron rails, nonmilitary machinery, construction, agricultural machinery, and other civilian products, but it greatly increased the demand for iron products to build the new ironclad ships and to make firearms, munitions, and other essential military items. Some things, such as cut nails and spikes, had both military and nonmilitary uses, and the American Iron Works was a foremost producer of these. After the immediate postwar depression, there came renewed and even increased demand for iron rails for the railroad boom, although a shift to steel rails became evident after 1867. Steel rails proved to be both longer lasting and stronger as well as able to carry the heavier weights of the newer locomotives. By the 1890s they were used almost exclusively.

B. F. Jones advocated extending rail lines to the iron mills to remove congestion from city streets and brought about the development of the Pittsburgh, Virginia, and Charleston Railroad for this purpose. He also helped to get the Pittsburgh and Lake Erie Railroad started, and he served on several railroad company boards. A building boom in bridges and in urban construction likewise followed the postwar depression, and the newly emerging oil and gas industry increased the demand for iron transportation and storage facilities, as well as drilling materials. The westward expan-

sion of the United States was only momentarily diverted by the war, and new iron plows, reapers, and threshers would help to "break the prairie."[5]

Marketing the products of the American Iron Works had been one of B. F. Jones's responsibilities, and it had taken him on semiannual journeys to Philadelphia by horseback. The first warehouse in Pittsburgh was established on Water Street in 1854, and later a new warehouse and office was built on Try Street and Second Avenue. But even before the Civil War, Jones realized that the West was a great market for iron products as well as a source of iron ore, and in 1856 he established an office and warehouse in Chicago, where his brother Thomas M. Jones was put in charge in 1860. All this positioned the company as the first to engage in forward vertical integration by going into marketing. Further, alone among the great iron producers, almost all of the companies' integration, both forward and backward, would be by internal expansion and not by acquisition. This expansion was paid for by a policy of plowing most earnings into the companies rather than paying dividends. Between 1856 and 1869 total earnings amounted to $1.7 million, yet no dividends were paid. During the 1870s small dividends were paid irregularly, with consistent dividends beginning in

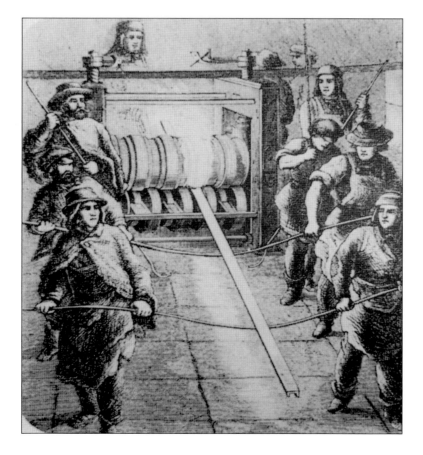

Rolling railroad rails, 1860.

1879. By then profits were so great that dividends averaging over 32 percent of earnings did not deter internal expansion; the 1880s and 1890s were especially profitable for the Jones and Laughlin families. B. F. Jones's own annual income averaged $325,000, "allowing him and the rest of the family to engage in an opulent life-style."[6]

By then the next generation of family members had moved into positions of responsibility in the companies, albeit with B. F. Jones always remaining as the dominant figure. James Laughlin was eighteen years older than Jones, and his sons were the first of the next generation of the two families to reach maturity. Henry and Irwin were associated as partners of the companies when they were in their early twenties, Henry after graduating from Brown University. George and James Jr., although still in their teens, had joined their older brothers as partners with the others in Laughlin and Company in 1859. However, Henry went off to fight in 1862 and was out of company employment for the duration of the war, while James Jr. remained in private school in Pittsburgh until he went to Princeton College; he only joined the companies upon graduation in 1867. By the late 1860s, then, all four of James Laughlin's sons were active in the companies in various capacities. B. F. Jones's brothers Thomas and George were also

J&L's Chicago warehouse on the corner of West Lake, Canal, and West Water Streets, 1915.

An 1866 ad for the American Iron Works.

American Iron and Steel Works headquarters at Try Street and Third Avenue, Pittsburgh. The eight-story building in the background was finished in 1908; in 1917 four more stories would be added.

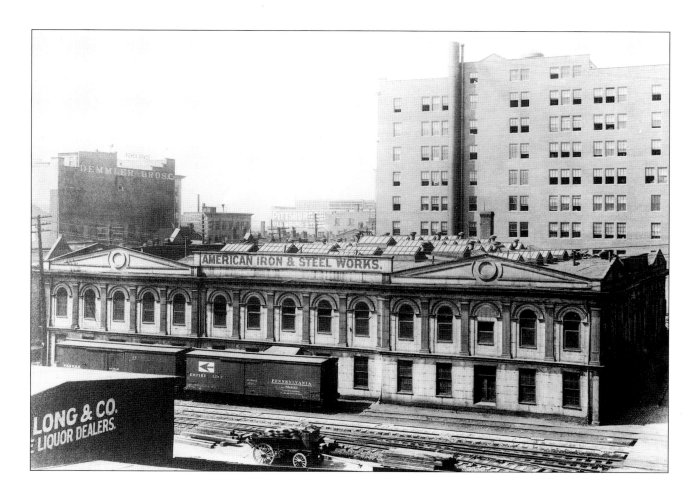

"The Number 6 Group," 1892. The group was comprised of local industrial leaders who met daily in the Number 6 Room of the Duquesne Club. From left: seated, S. Schoyer Jr., C. B. Herron, B. F. Jones, J. W. Chalfont, M. K. Moorhead; standing, J. H. Richardson, A. E. W. Painter, C. L. Fitzhugh, G. Shiras Jr., A. S. H. Childs, F. H. Phipps, C. H. Spang. Member Henry W. Oliver is missing from the photo.

B. F. Jones at work in his office at the old Pittsburgh warehouse office building, 1895.

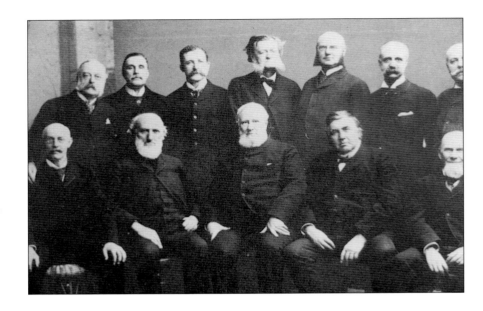

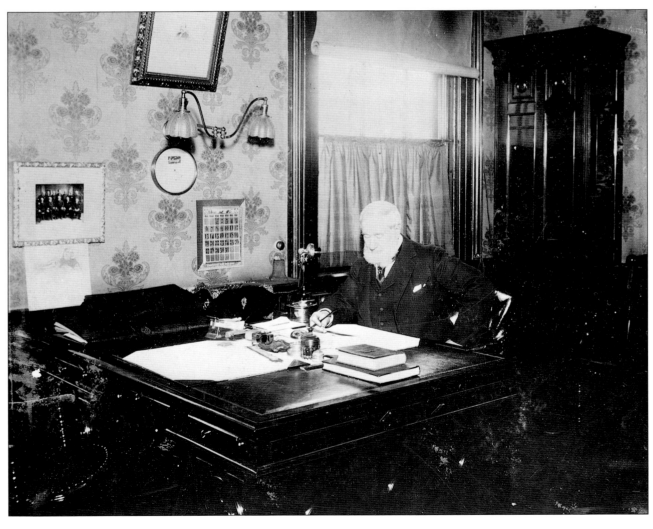

active, generally at a higher level than the younger Laughlin sons. However, long life is not guaranteed, and both families experienced death in the 1870s. In 1871 Irwin Laughlin died at age thirty-one in Nice, France, not long after his marriage; and in 1875 George W. Jones died at age forty, leaving two small sons.[7] Thomas then returned from Chicago to replace him as general manager.

The most significant family loss, however, came in 1882, when James Laughlin himself died on December 18. During his lifetime he had engaged in numerous occupations—from farming in Ireland, to provisioning in Pennsylvania and Indiana, to banking, and finally to iron making. A member of the First Presbyterian Church of Pittsburgh, he served as pres-

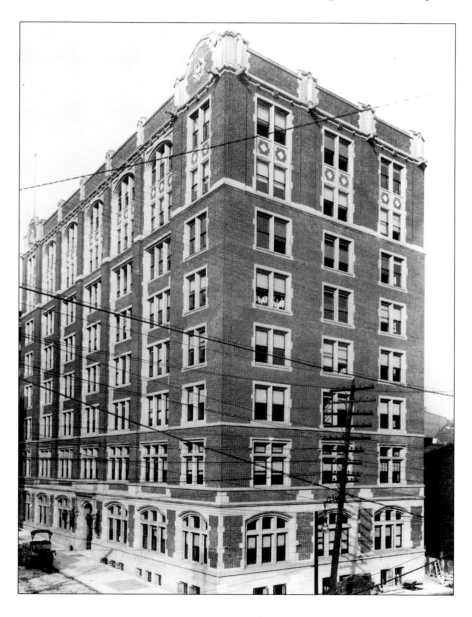

An American Iron Works advertisement from the 1865–66 Pittsburgh and Allegheny directory.

The new J&L office building at Third Avenue and Ross Street, Pittsburgh, after the 1917 renovation.

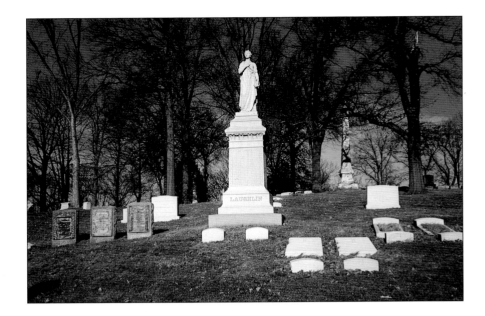

The Laughlin family monument in Allegheny Cemetery. Both James Laughlin and B. F. Jones were incorporators of the cemetery.

ident of the board of trustees of Western Theological Seminary, was an incorporator of the Western Pennsylvania Institute for the Deaf and Dumb, and founded and served as first president of the Pennsylvania Female College.[8]

There had been periodic renewals of the partnerships in 1870, 1873, and 1879, but James Laughlin's death called for a more fundamental reorganization. The main action was to convert the various financial interests into shares of stock, which made inheritance simpler upon the death of any partner thereafter. On August 1, 1883, Jones & Laughlins, Ltd., and Laughlin and Company, Ltd., took over the assets of the previous partnerships, with B. F. Jones, Thomas M. Jones, Henry A. Laughlin, George M. Laughlin, and James Laughlin Jr. as active partners.[9] B. F. Jones, serving as chairman, was still the controlling partner, with George M. Laughlin as secretary-treasurer and Thomas M. Jones as general manager.[10] The subsequent death of Thomas Jones on April 12, 1889, was a severe loss to his brother, who noted in his diary that the mills were shut down until after the funeral on April 15.[11] Only B. F. of the Jones family remained in the leadership of the company, although his nephew Willis L. King, who had begun his service in the companies in July 1869 at the age of eighteen, would eventually reach the upper circles. B. F. Jones's only son, B. F. Jones Jr., was not born until 1868 and would not enter company employ until 1891, after his education at St. Paul's School, in Concord, and Princeton College. Thomas Jones's eldest son, William Larimer Jones, born 1865, joined the companies about the same time and also rose to significant positions during the twentieth century. The family members, including the many

Jones and Laughlin daughters, had varying shares in the companies, but the only active partners left after 1889 were B. F. Jones, Henry A. Laughlin, George M. Laughlin, and James Laughlin Jr. And it was B. F. Jones, now in his sixties, who still ran the companies and made the crucial decisions.

Those decisions revealed a man willing and able to conceive and try new ideas and technologies, a man to whom the next generation of iron- and steelmakers looked for leadership. B. F. Jones Jr. told a story that has been repeated many times regarding his father and Andrew Carnegie:

> The late Andrew Carnegie was attracted to the possibilities of the steel industry when he was a messenger boy for the telegraph company here in Pittsburgh and used to run messages to my father, whom he greatly admired. Mr. Carnegie was fond of telling me whenever we met that his especial reason for liking the job of delivering messages to my father was because he always received a tip of a quarter of a dollar for doing so. He was a sharp and keen youngster and had an eye for business even then, as a result of which he was on the lookout for messages directed to Jones & Laughlins and was usually the first at the desk to obtain them and run out to deliver them. Sometimes, as he was fond of telling, he would meet my father in the street and hurry to him with a telegram for which he never failed to receive his tip and friendly pat and comment.[12]

One wonders if the younger Jones ever got tired of hearing this story "whenever we met" or if Andrew Carnegie told this story so many times to impress on his listener how far he had risen to be the equal or even the superior—financially if not socially[13]—of the man who once tipped him so generously. But then again, perhaps he honestly was appreciative of the magnanimity of the man "he greatly admired." Certainly Carnegie had every reason to admire B. F. Jones for his managerial abilities and his vision of what was possible in iron making.

Between 1859 and 1876 the American Iron Works grew from thirty-one puddling furnaces to seventy-five, with thirty heating furnaces, eighteen rolling mills, seventy-three nail machines, and a production output of 50,000 tons annually; by 1880 the output was 65,000 tons. In 1876 the Eliza furnaces had reached an output of 36,000 tons annually and, after an enlargement of the stacks, 50,000 tons in 1880. This was all transported by barge across the Monongahela River to meet the American Iron Works's pig iron demands; after 1887 a specially constructed hot metal railroad bridge for their own railroad cars took the pig iron to meet the expanding output of

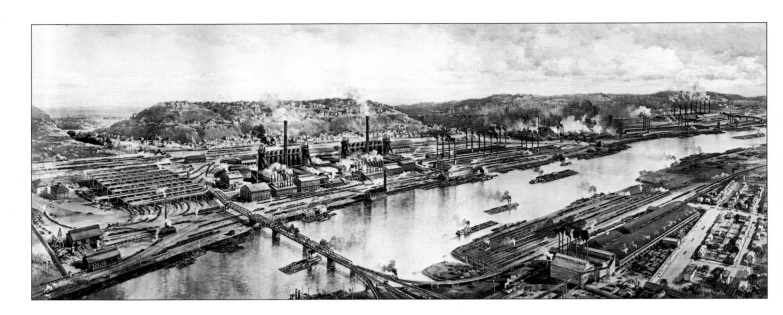

The Pittsburgh Works sometime after the 1887 construction of the railroad bridge used to transport molten ore across the Monongahela. The American Iron and Steel Works is in the foreground, and the Eliza furnaces and coke ovens are on the opposite side of the river in the background.

the puddling furnaces.[14] To provide the raw materials for the Eliza furnaces, Laughlin and Company purchased mines and leases of mineral rights in the rich iron ore country of Lake Superior and were among the first, if not the first, to purchase Connellsville coal mines and use Connellsville coke in Pittsburgh. The Monongahela River was the highway for J&L barges to bring the coal from the Vesta Mines to the beehive ovens of the Eliza furnaces. A towboat called *The Vulcan*, constructed in 1889, was still using its original engine as late as 1946, even though the boat had been completely rebuilt several times.[15] The primary limestone quarries were also in Blair County, Pennsylvania, and in West Virginia. By 1880 the Jones and Laughlin companies were completely integrated, in control of their major sources of raw materials, the transportation means for moving resources to their iron-making facilities and products to markets, and the basic marketing facilities of warehouses.[16] They thus provided a model for others to follow, but in fact few in the industry did, apart from Andrew Carnegie.

In labor relations Jones was also a pioneer and leader of the other Pittsburgh ironmasters. In 1863 he devised the sliding scale for wages, which tied the wages paid the boilers (piece-work per ton) to the prices manufacturers received for the products. After an underground existence for a few years, the Sons of Vulcan reorganized in 1861 in Pittsburgh as a craft union of boilers and puddlers. Its president was Miles S. Humphreys and it quickly established forges at the American Iron Works. Jones was not enthusiastic to have the union but eventually resigned himself to it

and conceived of the sliding scale as "a means to create a community of interests between capital and labor."[17] He first had to sell his sliding scale idea to the union officials, and it would take a strike in 1865 to bring both sides to agree that it was a way to deal with the uncertain economic situation at the end of the Civil War. Humphreys worked out the actual system, but the idea had been Jones's, and B. F. Jones then had the unenviable job of convincing his colleagues on the manufacturers' committee to agree to it. He was successful, and the scale went into effect February 13, 1865. This first effort did not survive the immediate postwar economic downturn. Although it was the union that first gave notice to terminate the scale in ninety days, the manufacturers also wanted some basic changes. The result was a lockout from December 1866 to May 1867, when the manufacturers gave in. A new agreement was concluded on July 23, 1867, with a higher basic scale but also with only a thirty-day termination notice.[18]

The system worked unevenly for over two decades. During economic downturns, such as the 1873–79 depression, the workers found that it worked against them and would agitate for a revision upward in the scale; the manufacturers, seeing their prices fall, would agitate for a revision downward to preserve their profits. A four-month lockout occurred in 1874–75 over a reduction in the scale demanded by the manufacturers (they wanted one dollar; the union would not allow more than fifty cents), and the manufacturers eventually gave in after one company's attempt to use strikebreakers led to mob action in which the mayor refused to intervene. The

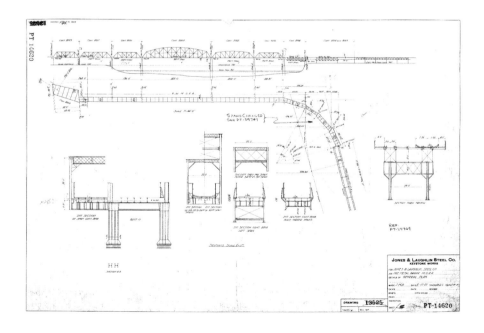

Drawing PT-14620 for the hot metal and Monongahela Connectioning (Mon-Con) railroad bridge, May 17, 1915.

other mill owners were not supportive of the strike-breaking attempt either, perhaps because it was the action of owners who were not part of the upper-class establishment.[19] By then the "core elite" manufacturers had seemingly come to terms with the union; one of them, James I. Bennett, said to a joint meeting of puddlers and manufacturers in December 1874: "There are a number of us who have been puddlers and laborers in the mills and can sympathize with you fully. We don't want to fight the union, but you can make us do it."[20] The strain this fight put on the Sons of Vulcan motivated them the following year to join with the Associated Brotherhood of Iron and Steel Heaters, Rollers, and Roughers and the Iron and Steel

Views of Vesta Mine No. 4, California, Pennsylvania: *(right)* the tipple on the Monongahela River; *(below)* the elevator shaft at Richeyville; *(opposite, above)* of men at the entrance with a 13-ton motor, 1908; *(opposite, below)* the Merchantile Building (the company store), 1910.

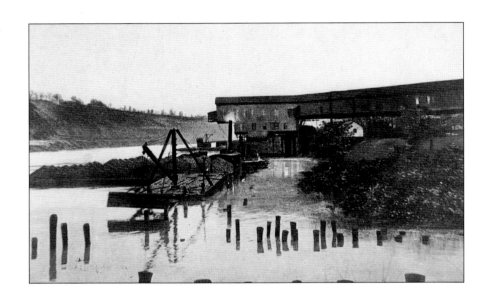

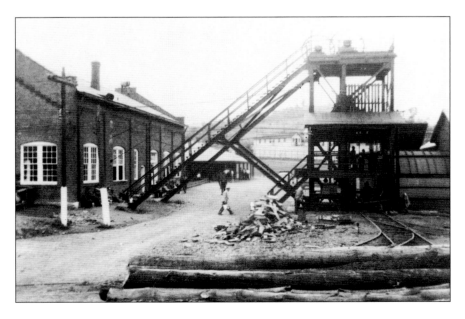

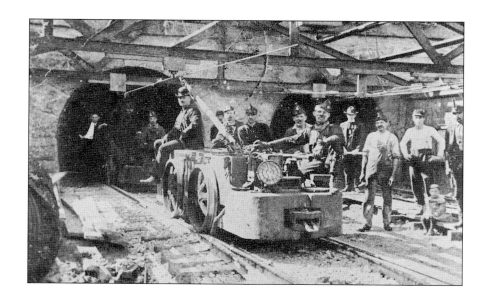

Mercantile Building, California, Pa.

Roll Hands of the United States to form the Amalgamated Association of Iron and Steel Workers.[21]

An issue that troubled labor was the contract system whereby the management would agree to pay a set amount to one person in charge of a mill, usually called a roller, out of which he would pay the other workers, both skilled and semiskilled. The margin between what the owner paid him and what he paid the workers provided his profit. The system was open to serious abuse, and in the later 1880s the Amalgamated Association moved to eliminate it by limiting all union men in good standing to payment for one job only. As early as 1877, however, B. F. Jones noted that one such "bundler," as he called him—William Labbitt by name—made a profit of $862.33 on a contract of $1,642.33, which was to run six mills for six months. He

MEMORANDUM OF AGREEMENT

Made this 13th day of February, 1865, between a Committee of Boilers and a Committee from the Iron Manufacturers, appointed to fix a Scale of Prices to be paid for boiling Pig Iron, based on the Manufacturers' Card of Prices, it being understood either party shall have the right and privilege to terminate this Agreement by giving ninety days notice to the other party, and that there shall be no deviation without such notice.

When the Manufacturers' Card of Prices are at the Rates named below, the Price for Boiling shall be at the Prices opposite, per ton of 2240 pounds.

MANUFACTURERS'.	BOILERS'.	MANUFACTURERS'.	BOILERS'.
8½ cents per lb.	$9.00	5½ & 5¼ cents per lb.	$6.00
8¼ " "	8.75	5 & 4¾ " "	5.75
8 " "	8.50	4½ & 4¼ " "	5.50
7¾ " "	8.25	4 & 3¾ " "	5.00
7½ & 7¼ " "	8.00	3½ & 3¼ " "	4.75
7 & 6¾ " "	7.50	3 & 2¾ " "	4.50
6½ & 6¼ " "	7.00	2½ " "	4.00
6 & 5¾ " "	6.50		

COMMITTEE OF BOILERS.

Miles S. Humpreys. Joseph Chiverton. Richard Thomas.
Patrick Graham. Wm. Sheargold. William Codrington.
B. A. McGinty. John C. O'Donnell. Matthew Haddock.
John D. Evans.

The 1865 Memorandum of Agreement intitiated by the sliding scale first suggested by B. F. Jones.

said "It would be well to look into [this]," implying that the system was unfair to both labor and management.[22]

B. F. Jones expressed his views on labor-management relations in his diary, which unfortunately does not begin until 1875, just after the lockout ended.[23] His most extensive comments concern the Great Railroad Strike of 1877, which spread to other industries and was particularly violent in Pittsburgh. Jones described the events of July 21 to September 18 in some detail, most notably the actions on July 24. His account of the violence that erupted was remarkably even-handed: "a regiment came from Philadelphia, the men hooted at them and annoyed them so that they charged on them killing and wounding quite a number of citizens—this started the riot & the working men through[out] the County & City took it up & on Saturday night [July 21] got beyond all 'law & order' marched through the

streets declaring vengeance & robbing stores where guns or any arms were to be had."

He thus seemed to suggest that the first violence was initiated by the military rather than the workers. However, as the mob swelled it came to be composed of "the worst elements about the city, men out of work and who having nothing to lose were only too glad for this opportunity to become excited by drunks & heroic speeches." Whiskey turned "what at first gave no one much thought" into a challenge to "the safety of the city" as Pennsylvania Railroad property from four miles out into the city was burned, including the Union Station and Hotel. His description of the subsequent pillage in broad daylight reminds one of twentieth-century events in Detroit and Los Angeles.

The disorder spread to the American Iron Works on July 24, when at 2:00 P.M. some 350 men marched out demanding a twenty-five-cents-per-day wage increase. A workers' committee of largely semiskilled workers (laborers, bar mill men, cindermen) met B. F. Jones at 3:00 P.M. to present the demand, which for some amounted to a 25-percent increase. He replied that he would think it over and get back to them in a few days. That things were quiet during the succeeding days he attributed to "the aid of vigilance committees & millitary [sic]." On July 26 he noted that the attempt by the strikers to get the firemen and foundry handlers to join them had failed, and he wrote with emphasis that they "used no force." But he went on to caution that it is "hardly likely they [the strikers] will get the wages asked & when they find out they are *not* to get it there *may* be trouble." He even found a bright side to the work stoppage, because with the year end they had a chance to take stock, "so the *danger* is the only unfortunate thing about it."

The strike dragged on through August, with a rumored increase in demands to fifty cents per day balanced by the restarting of the foundry and machine shops on August 6. Some new men came to help unload ore on August 25, without interference although with leaders of the strikers giving speeches against the action. Jones recorded the names of the speakers, not all of whom were committee members: Thomas Robson, Thomas Haines (or Hearns), and Frank Ossosky from the committee; and William Castle, Frank Prescott, Martin Bea, Frank Miller, John Elmer, and Michael Delaney among the others. Not until September 18 did the strikers give in and agree to return to work. Jones proudly noted that "the firm has made *no* concessions but will of their own accord" grant some wage increase to "some of the 804 men who are deserving of it." He added: "Great rejoicing among all that the mill will start up tomorrow morning. So the strike is ended & we are *all* glad of it for it was becoming very monotonous or had

completely done so."[24] Ingham notes the significance of this comment: "Could anything indicate more clearly the way in which even sometimes bitter labor/management relations had become routinized in Pittsburgh in the 1870s?"[25]

The following year the boilers sought to negotiate with Jones separately from the other manufacturers, but he refused since the depression was driving prices lower. J&L had enough muck iron to "run easily for a short time without the boilers," so Jones thought he could withstand their pressure. However, when the heaters and rollers refused to work unless he signed with the boilers, Jones had to give in after a four-day work stoppage.[26] The next year union solidarity again proved too much for the manufacturers' association. Even though Jones wrote that "both sides appear determined and time only will show which is the more so," it was the manufacturers who decided that it was "inexpedient to further resist the unjust demands of the boilers." Jones himself left it to his brother Thomas to sign the scale for another year while he went to New York City to see his daughter off to Europe.[27] The strength that unity in the Amalgamated Association of Iron and Steel Workers brought had clearly been demonstrated.

Despite such incidents, relations between labor and management during these years were marked by a high degree of civility. The manufacturers were willing to grant the Amalgamated Association's requests in 1884 and 1886 to give their workers the day off to attend union picnics.[28] For their part, workers were willing to support the manufacturers in their favorite causes. On February 9, 1878, over 15,000 marched in support of a protectionist tariff, 1,400 of them from the Jones & Laughlin companies, and on September 24 they joined in welcoming President Rutherford B. Hayes when he visited the mill, even though many of the workers would have supported his opponent in the presidential campaign: "the mill all shut down at noon and every one went to town to see the fun." This visit showed Jones's commitment to the Republican Party, and in 1884 he was rewarded by being chosen to head the Republican National Committee by the convention that nominated James G. Blaine for president. The failure of that campaign was at least in part compensated for by Jones's election as president of the American Iron and Steel Association that same year.[29]

Iron manufacturers had an appreciation for the physical demands of work in the mills. George W. Jones had his residence right next to the American Iron Works[30] and B. F. Jones came daily in his buggy, "rain or shine,"[31] so they could not help but appreciate the noise and heat of the mills. The workday was based on heats (the length of time it took to produce [cast or work] a quantity of iron), and there were limits to how many

would be run in a day; by agreement the limit was five heats with a total weight of 2,500 pounds per turn of about eight hours. Rolling mills worked according to heats as well, but there it tended to take about ten hours per turn. The work week was six days, with the mills closed usually from Saturday evening to Monday morning, the exception being the blast furnaces and necessary repairs and maintenance.[32]

The output of a blast furnace was a function of its size and shape. The bulge, or bosh, of the barrel-shaped structure was typically about 20 feet in diameter, while its height varied between 85 and 100 feet. Four nearby stoves, themselves about 75 to 100 feet in height, provided a continuous source of hot air to blow into the blast furnace proper. The stoves were composed of brick checker work, at the bottom of which gases were burned to heat the air to temperatures of 1000 degrees Fahrenheit. As each stove reached peak temperature, the burning gases were cut off and the blowing engines would then force the blast of hot air into the blast furnace through connecting pipes, called tuyeres (pronounced *tweers*). By alternating among the four stoves, a continuous supply of hot air was maintained in the blast furnace. The tuyeres were kept from melting by the circulation of water in jackets around them. The blast furnace chamber was charged, or filled, from the top by alternating layers of iron ore, coke, and limestone, carried there by men using wheelbarrows. As the intense heat from the stoves circulated through the stock of ore, coke, and limestone, the coke burned, increasing the heat and causing the stock to become molten. The limestone acted as a flux to remove the nonmetallic parts of the mass, forming what is called slag (or cinder). Slag is lighter than molten iron, so it tends to float on top of the molten iron. Two tapping holes (or monkeys) in the hearth, the one for slag a little above the other, provided the means for the removal of the two products. The iron was cast about every four hours when its tapping hole was broken open by a drill and a rod, and the fiery hot metal burst out with a rushing roar down a runner to a pig to cool, or later to ladle cars for transport elsewhere. Then the hole would have to be closed again by fire clay. All of this was a particularly dangerous time since the molten metal could be lethal to men in the way of its course and the still-solid stock in the upper part of the furnace could get caught, "slip," and result in an explosion. The physical labor required for this was great, while the working conditions were intense in terms of heat and danger. Workers' faces were often red from the effects of exposure to intense heat, while the consumption of water and salt was essential to overcome the effects of excessive perspiration. In winter the marked contrast between the heat in the mills and the cold outside led to respiratory ailments since

there were no facilities for showers or changes of clothing in the mill; however, most men did keep a dry shirt in a locker for use at the end of the workday.[33]

The pig iron from the Eliza furnaces was transported across the Monongahela River by a "metal boat . . . shaped like a flat-bottomed barge with the pilot house and engine room in the rear end. The deck was fitted with rails, and the metal was carried on small cars on the boat." This boat, called the *Busy Bee*, made many crossings a day. The cars were then pulled up the slope from the dock by an incline cable to the stockyards of the American Iron Works, where they were unloaded before being returned for another trip. This was the case in 1867 when the son of Chief Engineer Jacob Shook toured the mills.[34] (In 1887 a railroad bridge replaced the metal boat.) Young Shook's account of his tour of the mills provides an interesting picture of life there. It is accompanied by a diagram and key showing the layout of the mills.

His description of the puddling furnace operations is worth reproducing.

Here I saw the puddlers at work; some were throwing pigs of iron in the furnace; others were sitting in the coal bins and throwing chunks of coal into the fire doors; others had long bars of iron with a hook which they put into the furnace door, working it backward and forward, stirring up the molten iron while a liquid stream of white hot cinder flowed out of [a] small opening into a[n] iron ladle below which had wheels so it could be moved easily when full. I was told the iron in the furnace was boiling and, while it was boiling, they were working the cinder out of it. He said the wrought iron floated on top of the cinder. He loaned me a pair of green eye glasses and told me to look into the furnace which I did. There I saw the iron boiling, large pieces of iron floating on the surface, while the cinder kept boiling and running out of the small opening in a stream. This stirring or puddling was continued until all the cinder was worked out of the iron which now lay in a mass in the bowl of the furnace. It reminds me of seeing how butter was churned. The puddler now worked this mass of wrought iron into balls, which made three balls to each; and, when balled, the puddler took them out with a large pair of tongs that was hung from an overhead trolley on a track that ran from each furnace to the squeezers, where it was rolled into a bloom, and then taken to the rolls where it was rolled into long flat bars which were pulled by a man to the cooling floor where the bars were left until cold enough to handle. It

was then picked up by men with short-handled hooks, weighed, and put on a buggy and hauled by a mule to the shears to be cut in short bars, for reheating, and rolled into various kinds of shapes. From where I stood I could see the puddlers bringing their hot balls of iron from all directions to the squeezers to be made into a bloom. It was a hot afternoon and most of the men were working without their shirts, and it was a sight for me to see so many big husky men running about half naked.[35]

Not surprisingly, since his father was chief engineer, young Shook was especially interested in the many steam engines used in the mills. The muck mill engines, one a horizontal slide valve that ran two sets of rolls and one squeezer and the other a vertical Corliss that ran two sets of rolls and two squeezers, were especially impressive in their hissing and banging. Another engine, which ran the bar, plate, and nail mills, was a puppet-valve lever engine able to produce 800 horsepower. One engine, also a horizontal puppet valve, powered all the operations in the so-called new mill, which contained fishbar machines, the sheet mill, and the finishing mills. This was done by a series of "great belts passing from the big fly wheel to the main pulleys above, and along the main overhead shafting to each pulley that drove the mills." Because they were all interconnected, any slackening of speed in one part—for example, to engage a clutch—required a slowdown or even stoppage in another part.[36]

Among the products young Shook saw made were "small wheels, hangers, and other parts of machinery" in the foundry and "railroad spikes, bolts, and nuts" in the shop, where boys "covered with oil" were threading the bolts and nuts and bolting the fishbars together—the only place he noted child labor. J&L was known for the cold rolling process that Ben Lauth had developed, and Shook observed the "small rods, angles, flat bars, squares, and thin narrow sheets" that came out "bright and smooth": "This looked to me as nice clean work for the men," particularly in contrast to the heat of the other furnaces and mills.[37]

The companies were most proud of the cold rolled shafting installed to drive the machinery exhibits in Machinery Hall at the Centennial Exposition in Philadelphia in 1876, particularly appropriate because Jones & Laughlin then "supplied two-thirds of all the shafting, pulleys, hangers and similar equipment used in the great textile mills of the country.... We were awarded a medal for this product and others of our development."[38] This exhibit was later moved to the Smithsonian in Washington, D.C., where it can still be seen.

At the end of his long, tiring day in 1867, young Shook was ready to rest, so one can imagine how much the workers who had had to exert so much physical energy in intense heat would have shared his tiredness.

The big bell rang for quitting time, followed by a number of whistles in the several factories and shops; and men came from all directions toward the gate house. It was like a big parade to see the men leaving the mill. Back of where I sat there were ten steam boilers; and, as many of the steam engines had stopped by this time, all the safety valves on the boilers opened up so the roar of escaping steam was terrifying; and, adding the noises of the squeezers, muck rolls, Bar, Plate, and Nail Mills, it was beyond description,—though I was somewhat hardened to the mill noises by this time, after this afternoon's experience, and felt real brave.[39]

In 1867 the finished products of the mills were still taken by wagons to the city warehouse, freight station, or river wharf. Young Shook and his friends especially admired one of the wagon-train drivers, "a tall mulatto Our hero, Joe Beadon, [who] wore a broad-rimmed hat, and sat on his big horse like a statue . . . and had a cheery word for everyone that greeted him on his early trip to the city." He added that "Jones & Laughlin's horses were noted for their size and beauty."[40]

The American Iron Works that young Shook described would continue to grow and change in the years after 1867, but the processes and the products would remain essentially the same. But the age of iron was coming to a close in the last quarter of the nineteenth century, as technology ushered in the age of steel.

three From Iron to Steel

John Fitch's *The Steel Workers* begins: "There is a glamor about making steel. The very size of things—the immensity of the tools, the scale of production—grips the mind with an overwhelming sense of power. . . . These are the things that cast a spell over the visitor in these workshops of Vulcan. The display of power on every hand, majestic and illimitable, is overwhelming."[1] Superman was not called the "man of steel" for nothing, and the strength and beauty of steel were particularly highlighted in the early twentieth century. Iron was not, of course, without its value as a metaphor, as David Ricardo's "iron law of wages," Max Weber's "iron cage of rationality," and Robert Michels's "iron law of oligarchy" attest. Iron and steel come from the same basic materials, and Fitch's work deals with both iron- and steelworkers as the twentieth century opened, but it was in the late nineteenth century that steel replaced iron as the metal of choice and metaphor.

What then is steel? A dictionary definition is "commercial iron that contains carbon in any amount up to about 1.7 percent as an essential alloying constituent, is malleable when under suitable conditions, and is distinguished from cast iron by its malleability and lower carbon content."[2] Its low-carbon content and its malleability, then, distinguish it from iron, yet its reputation implies a far greater distinction. And the methods of making steel are significantly different, both in the equipment and in the nature of the labor. This would have serious consequences for the Jones & Laughlin companies as well as for other manufacturers.

An early logo of the company, ca. 1890s.

The first major use of steel was in the railroads. J&L had been the main producer of iron rails at the time of the Civil War, but after 1867 the demand for steel rails increased at the expense of iron. Initially steel was produced by the cementation process, but just before the Civil War the crucible or blister process became the preferred method. In both these methods wrought iron was "melted" or heated with carbon in an expensive and slow process; the result was a very high-grade steel, especially suitable for machine tools. The 1850s saw the development of the Bessemer conversion process, however, which, after patent disputes were worked out, was introduced into the United States in 1864. B. F. Jones quickly recognized the value of the new technology and, according to one report, actually "became the first Pittsburgh iron master to build a Bessemer plant in his works, a few years before Carnegie's Edgar Thompson Works." The plant was constructed by the American Bessemer steelmaster Alexander Holley and actually rolled several tons, but the "works were not efficient and were closed down."[3] It was left to Andrew Carnegie to show that Bessemer steel could be produced economically at his Edgar Thompson Works, which began production in 1875. Thereafter the American Iron Works came under increasing competitive pressure, and early in the 1880s B. F. Jones

decided to go back into steel production himself. At the time, other Pittsburgh ironmasters were taking on Carnegie in the ill-fated Pittsburgh Bessemer Steel project at Homestead. Instead of joining them, Jones began construction on two Bessemer converters in 1883 at the American Iron Works, and these were started on August 19, 1886. At the same time he constructed a third blast furnace at the Eliza furnaces and in 1890 replaced and enlarged one of the older stacks to increase production to 160,000 tons of Bessemer iron and 50,000 tons of mill pig iron for use at the newly renamed American Iron *and Steel* Works.[4]

The Bessemer converter is an egg-shaped container made of steel plates and lined by firebrick, with an air chamber below through which hot air is forced into the interior by means of tuyeres. The container is turned on its side to receive the charge of iron and carbon from a cupola (to reheat pig iron) or a mixer (for transporting hot iron directly from the blast furnace); as it is returned to the vertical, the blast of hot air is started, and after a "blow" of eight to twelve minutes, the blast is turned off as the container is again tipped to the horizontal to empty its contents of liquid steel into a ladle, along with an alloy of iron and manganese. A crane then brings the ladle to cast iron molds on buggies, which are filled in succession by means of a taphole. The leftover slag at the end of the pour is then dumped, and the ladle is ready for another use. The whole process is controlled from a "pulpit" by the blower and the regulator men; the blower determines by eye when to turn the converter and shut off the blast, and he bears the greatest responsibility for the success of the process. Converters are run usually in series of two to maintain efficient operation and to provide downtime for replacing the bottoms, which needed to be rebuilt every two days when they were first introduced. The intensity of the labor usually meant as well that Bessemer converter operators worked eight-hour shifts rather than the more usual ten- and twelve-hour turns of the other workers.[5] The first Bessemer converters of J&L used the cupola method of reheating the pig iron, which resulted in a higher sulphur content from the coke used in reheating. This was remedied eventually by using the Jones mixer, developed by William Jones of the Edgar Thompson Works in 1889, which brought the iron, still molten from the blast furnace, to the converter. J&L did not install mixers until 1901, however, continuing to run what was thought to be the largest cupola plant ever built, until all cupola operations were closed down in 1920.[6]

The Bessemer process was a remarkable breakthrough, but it was also a difficult and demanding one, fraught with danger even as it was a beauty to behold with its noise, brilliant colors, intense heat, and spectacular pyrotechnic displays. Explosions and accidents were frequent, despite

successful efforts by Alexander Holley to improve on the original design.[7] Even as it was being adopted and modified in the United States, another process, the open-hearth process, was being developed in Europe by Siemens (England) and Martin Brothers (France). This was introduced into the United States in 1868, and the first commercial open-hearth furnace in America was built in 1873 at the Otis Steel Company's Lakeside Plant in Cleveland.[8] J&L, while not abandoning the Bessemer converter, went into open-hearth production in 1895, when it constructed two 40-ton basic open-hearth furnaces as the foundation for its No. 1 shop, which by 1898 had six 40-ton basic hearths. Shortly it would add one 25-ton acid open-hearth furnace for making steel for steel casings.[9]

The difference between the two open-hearth methods, basic and acid, is metallurgical, determined by the type of material used in the construction of the hearth lining. The basic process removed phosphorus from the pig iron, while the acid process shared with the Bessemer process an inability to do this.[10] In both open-hearth processes, the furnace is a large rectangular box lined with firebrick and other materials. There is a shallow basin or hearth into which the charge of pig iron, scrap steel, and other materials are placed by electrical charging machines, which simply dump boxes of material into the hearth according to a set formula. Regenerators, which are brick checker-works at both ends of the hearth, provide alternating sources of the hot air that plays over the charge to melt it. The composition of the molten metal can be tested frequently during the process, which takes about six to eight hours, and this gives a more precise control of the quality of the steel produced than in the Bessemer process. Once the steel is ready, it is tapped from the side opposite to the charging side by a means similar to that of a blast furnace, in that a taphole is knocked out. The steel pours out into a ladle, to which the usual alloy of iron and manganese is added, and the ladle is manipulated by a crane to fill the molds, as in the Bessemer process.[11] Open-hearth furnaces could be built more cheaply and run more efficiently than Bessemer converters, particularly since they could use the scrap steel that resulted from the Bessemer process. The proportion of steel produced by open-hearth furnaces increased rapidly between 1895 and 1910.[12] Although the process has similarities to the puddling furnace and was likened to milk bubbling,[13] it actually does not require the skilled expertise of iron puddling. Most of the workers provided little more than hard hand labor and were considered as unskilled or at best semiskilled and treated accordingly.

The ingots of steel produced by both Bessemer and open-hearth processes could not be transformed into finished products directly. This is where the various rolling mills come into the process. The first type of

rolling mill broke down the ingots into more convenient sizes and shapes: blooms or the smaller billets and slabs. Depending on their end product, they were generally called blooming or slabbing mills, although they were sometimes called universal mills, and they prepared the metal for the second type, the finishing mills. These mills produced the various shapes, forms, and sizes that were sold to the consumers through the warehouses and offices maintained by J&L in Pittsburgh, Chicago, St. Louis, and other places. An advertisement for Jones & Laughlins in 1895 listed bar, hoop, and sheet iron and steel; I-beams, channels, and structural shapes; blooms and billets; fish bars, piston rods, and finger bars; and patent cold rolled iron and steel shafting as its products.[14] J&L was known for its rails and nails as well, having recently shifted from cut to wire nails; by 1900 it was one of the major rollers of Bessemer steel rails and would become one of the important competitors to the U.S. Steel Corporation in producing steel

Tapping an open-hearth furnace at Aliquippa.

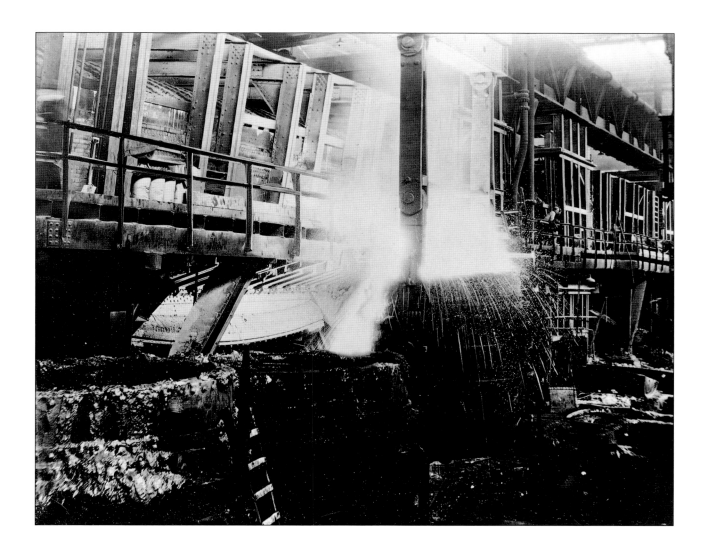

Advertisements for the American
Iron and Steel Works and Laughlin
and Company, 1895. From Walter
F. Clowes, comp., *A Brief History of
the Sons of Veterans U.S.A. . . .*
(Reading, Pa., 1895).

billets west of the Alleghenies.[15] All the rolling mills used soaking pits and
heating furnaces to ensure that the metal being worked had the proper
temperature. In fact, in 1886 J&L was among the first steel companies to
adopt John Gjers's 1882 invention of soaking pits by installing fifteen pits,
known as the A pits.[16] The reputation that B. F. Jones had for being willing
to try new technologies was increased when in 1899 the No. 16 (bar) mill
was built. This revolutionary but expensive mill "was the first of its kind
ever built and its construction in 1899 marked the beginning of yet another
era in bar mill operation—an era that ultimately led to the production of
large tonnages of high quality, uniform bars manufactured to this day."[17]
The various mills that produced the many different J&L products were
clustered together in the increasingly cramped spaces of the American
Iron and Steel Works.

The new steelmaking technology and the expansion in J&L's capacity
resulted in a significant growth in its workforce, from 4,000 in 1885 to
15,000 in 1900.[18] Many of these, however, were not the skilled artisans of
iron making but semiskilled and unskilled workers. Furthermore, more
and more workers came from Central and Eastern Europe and brought
with them different attitudes toward management-labor relations.

The Sons of Vulcan and the Amalgamated Association were craft unions of skilled workers with a strong interest in maintaining their status as the elite of the working class. Their rivals, the Knights of Labor, were organized by industry and included all men working in a given mill, both skilled and unskilled. Even within the Amalgamated Association, puddlers and finishing mill men did not see eye to eye.[19] This fragmentation of the workers did not help them in the challenges of dealing with management in the heady days of the transition from iron to steel.

The interplay between older core elites and upstart new men among the manufacturers has been well developed by John Ingham in his *Making Iron and Steel*.[20] A new antiunion attitude was given greater currency both by outsiders from New England and by manufacturers, such as William Clark, who had themselves "come up from the ranks" of workers. At the same time, welfare capitalism emerged as an antiunion alternative, even if

J&L steel foundry at the Pittsburgh Works, 1890.

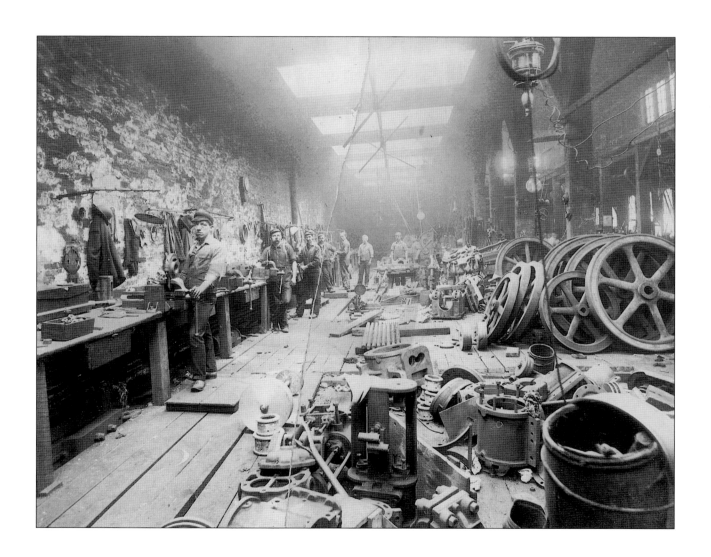

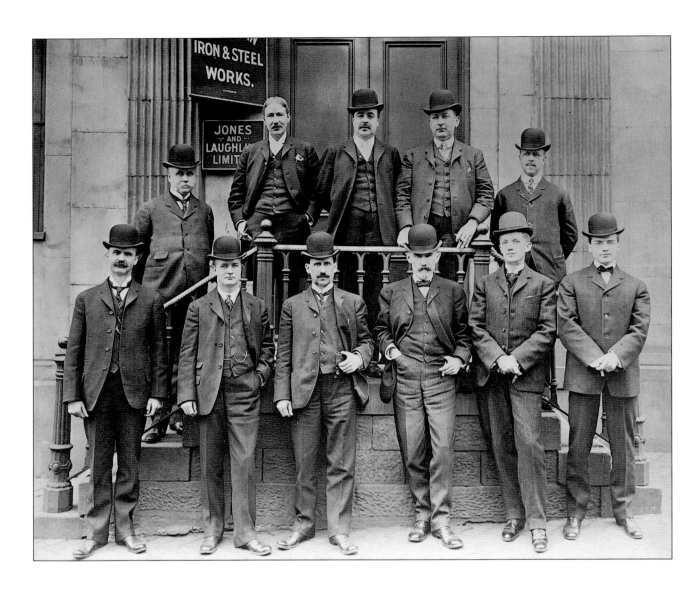

Sales agents at the entrance to the old general office, November 22, 1904.

it did not spread rapidly among the older independent iron and steel manufacturers.[21] By the mid-1880s a significant hardening of attitudes had occurred, and manufacturers and workers in Pittsburgh as well as around the United States were moving on a collision course. A series of strikes in the railroad industry in 1884, 1885, and 1886 resulted in first the victory and then the defeat of the Knights of Labor. The so-called Haymarket Riots of 1886 increased apprehension of radical unionism and foreign socialism in America.

During this period tension was mounting in the relations between the Western Iron Association of Manufacturers (formed in 1882) and the Amalgamated Association of Iron and Steelworkers, culminating in a four-month strike in 1884 that saw the union "defeated, but not routed." It was at this point that Carnegie, taking advantage of the Amalgamated Association's

weakness, closed the Edgar Thompson plant to install new machinery. When he reopened it in January 1885, he established both a lower scale and longer working hours. Unable to block this effectively, the Amalgamated Association lodges there shortly collapsed. The Knights of Labor moved into the vacuum, only to lose in their turn in 1887 to Carnegie, who was now assisted, surprisingly, by the Amalgamated Association. Thereafter only the Homestead Works of Carnegie's steel empire remained a union mill. Indeed, both there and at J&L's mills the Amalgamated Association actually increased in numbers in the late 1880s.[22]

Homestead would turn out to be crucial in what followed. By 1889 Carnegie decided to challenge the growing unionism at Homestead; his decree that workers sign individual contracts was greeted by a strike in July 1889. Nonunion men were imported to work, and only the failure of nerve by William Abbott, president of the Homestead Works, prevented a violent confrontation. Carnegie fired Abbott and brought in Henry Clay Frick as president in preparation for the next opportunity. The story of the Homestead Strike (more properly a lockout) of 1892 has been told many times. Its effect, combined with those of the Bank Panic of 1893 and the Pullman Strike of 1894, contributed to the precipitous decline in union membership in the iron and steel industry, despite the more forceful activities of the American Federation of Labor (AFL), founded in the wake of the 1886 setback for the Knights of Labor. Since the AFL, which included the Amalgamated Association, was based on craft unions, it would do little, except in isolated instances, to enlist the support of the steel industry's semiskilled and unskilled workers.

Mon-Con railroad engine no. 1, 1885. In 1907 the engine was sent to Aliquippa to support construction.

The events of 1886 to 1894 had an impact on B. F. Jones. Although he had never embraced unionism as a positive good, he had in the past seen the value of working with the Sons of Vulcan and the Amalgamated Association to build a community of interest in the iron-making industry. The sliding scale of 1865 had, after all, been his concept, and his relations with the union leadership in the intervening years, while at times tense and punctuated by disputes (strikes and lockouts), had also been marked by civility and grudging respect. But during the course of the 1889 Homestead strike he announced: "This company will make no terms with its men until there is a settlement at Homestead."[23] Thereafter Jones moved toward an antiunion perspective that culminated in the elimination of unions in the J&L mills in 1897.

Several factors may have contributed to this. A significant one was the decimation of the puddlers' ranks by the 1895 decision that after January 1, 1896, J&L would produce only steel. During the previous four years J&L had been phasing out its puddling furnaces, but as late as 1894 there were still ninety-two in operation. By the beginning of 1896 there were only fifteen, and the last of these was dismantled on February 8.[24] The Amalgamated Association had been forged by an alliance of puddlers, heaters, and rollers, but now a major component had been effectively closed out of the American Iron and Steel Works, the victim of technological change and management decision. Employment alternatives would have been scarce for the now-redundant puddlers. Nor were they the only ones adversely affected by technological improvements. At about the same time the general introduction of the skip hoist to carry the charge of iron ore, coke, and limestone to the gaping jaws of the Eliza blast furnaces across the Monongahela River lessened the demand for unskilled wheelbarrow men. However, compared to the skilled puddlers—at the top of labor's social pecking order and disdainful of work that was beneath them—the wheelbarrow men's willingness to seek almost any type of work meant that they had greater opportunities for other employment. The remaining heaters, roughers, and rollers were not in as strong a position after 1895, especially since they had neglected to build any community of interest with the semiskilled and unskilled laborers who worked daily with them.

A second factor may have been the change in the composition of the workforce. John Fitch described the impact of changed immigration patterns on iron and steel. Writing in 1910 he noted: "Fifteen years ago the laborers were largely English-speaking. Today one is surprised in passing through a Pittsburgh steel mill if he comes across an American, a German or an Irishman among the unskilled laborers." He attributed the dramatic increase of "Slavs and Huns" among steelworkers to five causes:

Benjamin Franklin Jones Jr., ca. 1891.

First, the overwhelming Slavic immigration of the last fifteen years, due to causes in this country and abroad not connected with the steel industry; second, a system of petty graft, for which the steel companies are not responsible, but which as a body they have failed to eliminate; third, false standards which have made Americans feel that it is a disgrace to work on a level with a Slav; fourth, conditions in the industry itself which have caused the more ambitious workmen to abandon it when there was not room for promotion; fifth, the apparent fact that the steel companies have definitely sought this class of labor.[25]

These unskilled and largely non-English-speaking workers were not welcomed by the union leadership and were available to manufacturers on a different basis, requiring different methods of manipulation, and responding in different ways both to life in the steel industry and to life in America. Although possibly no less committed to the cause of labor, they were in the late 1890s still finding their way and their strength, happy to be out of

the European "frying pan," even if still uncertain about the prospects of the American "fire."

Finally, another factor in Jones's decision to break with the union might have been the influence of a new generation of owners. His only son, Benjamin Franklin Jones Jr., joined the companies as a manager in 1891. By then the elder Jones was sixty-seven years old, and it would appear that the next generation of Joneses—represented by B. F. Jr. and his cousin, William Larimer Jones, general manager of the American Iron and Steel Works in succession to his deceased father, Thomas M. Jones—was taking over the direction of the family companies. It is noteworthy that when yet another strike was broken in July 1899, B. F. Jones himself was on vacation at Narragansett Pier, Rhode Island, and left the management in the hands of the younger members of the Jones family, albeit assisted by George M. Laughlin.[26]

four "Passing the Torch"

Until 1900 the Jones and Laughlin families continued to maintain two separate limited partnerships with interlocking managers. B. F. Jones was the senior partner both before and after the death of James Laughlin in 1882. However, he seems to have left the daily management of Laughlin and Company to the Laughlin brothers, especially the eldest of James's sons, Henry, who was listed as general manager and chairman in various publications of the day. The American Iron and Steel Works was B.F.'s particular concern, although even here he left the position of general manager to his brothers, first George (until his death in 1875) and then Thomas (until his death in 1889). Thereafter, Thomas's eldest son, William Larimer Jones, seems to have succeeded his father as manager, but in tandem with Maj. George McCully Laughlin as chief financial officer and Willis L. King as procurement and sales officer. Before long, another Benjamin Franklin Jones would join their ranks and eventually move ahead of them in the companies' interlocking hierarchy.

Benjamin Franklin Jones and Benjamin Franklin Jones Jr. had more in common than just their names. Their fathers were in their midforties when they were born; both of them became chief executive officers in their early thirties; and both became well-respected steelmakers. But whereas the first B.F. was one of seven sons, B.F. Jr was the only son. And whereas the elder B.F. had twelve siblings, half of whom were female and eight of whom were older than he, the second B.F. had only three siblings, all of

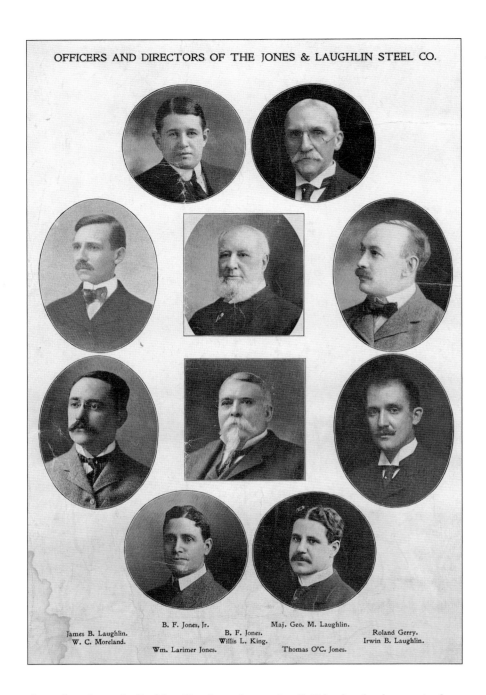

OFFICERS AND DIRECTORS OF THE JONES & LAUGHLIN STEEL CO.

B. F. Jones, Jr.

Maj. Geo. M. Laughlin.

James B. Laughlin.
W. C. Moreland.

B. F. Jones.
Willis L. King.

Roland Gerry.
Irwin B. Laughlin.

Wm. Larimer Jones.

Thomas O'C. Jones.

Officers and directors of the Jones
& Laughlin Steel Company, 1902.

them female and all older. Further, the senior B.F. had only the equivalent of a high school education and went off to Pittsburgh to seek his fortune by the time he was eighteen. When the younger B.F. was eighteen, he was just finishing his high school education at the exclusive St. Paul's School in Concord and would go on to Princeton to complete his formal education.

When B. F. Jones Jr. joined the family firms upon graduation from college in 1891, two of his first cousins were already active in the companies. Willis King, the senior B.F.'s nephew, had entered company service

Various offices in the new building:
(above) room 207, Major
Laughlin's office; *(left)* Willis L.
King's office.

in 1869, when B.F. Jr. was only one, and he seems to have worked primarily in procurement and sales. William Larimer Jones, although only three years older than B.F. Jr., had in his twenties succeeded his father as general manager of the American Iron and Steel Works. During the last years

(Right) B. F. Jones Jr.'s suite in the new building. (Below) The old board room at the Third and Ross office building, ca. 1890.

of the century the three younger Jones offspring with Maj. George M. Laughlin handled the daily operations of the companies, while the older B.F. increasingly withdrew from the day-to-day decisions.[1]

It would be B. F. Jones Jr. who engineered the consolidation of the family firms in 1900 and became president, with William Larimer Jones as general manager. On April 1, 1900, Jones & Laughlins, Ltd., formally acquired Laughlin and Company with its subsidiary holdings, including the Vesta Mines in Washington County. Then, on June 2, 1902, the partnership was reorganized as a corporation, the Jones & Laughlin Steel Company, with twenty-seven shareholders. The first three listed were B. F. Jones, the estate of Thomas M. Jones, and B. F. Jones Jr. Approximately twelve Laughlin family members follow, including Henry A. Laughlin, George M. Laughlin, and James Laughlin Jr. Shareholders listed later included Willis L. King and William Larimer Jones (nos. 17 and 18, respectively).[2]

It is obvious from the listing of shareholders that the immediate Jones family retained primary control of the company, even though the three surviving Laughlin brothers had served the companies in significant positions for decades. And so the torch of leadership went to the next generation of the Joneses, in particular to B. F. Jones Jr. and William L. Jones.[3] B. F. Jones Sr. remained on the board through both reorganizations (1900 and 1902) until his death on May 19, 1903.

Tom Girdler, a later president who worked closely with both of them, wrote: "W. L. Jones and B. F. Jones, Jr., although first cousins, were totally unlike. B. F. was blunt, but full of fun; W. L. was dignified and solemn. They were devoted to each other, but touchy. W. L. owned a lot of the company but B. F. Jones owned a good deal more. This made it extremely important to be considerate of William Larimer Jones's feelings." They were both, he said, "good steel men who had learned steel-making from the ground up."[4]

It would seem as well that both were influenced by the new "social gospel" ideas emanating from Calvary Episcopal Church under the leadership of the Reverend George Hodges in the last decade of the nineteenth century, even though the Joneses remained active at Pittsburgh's First Presbyterian Church.[5] Girdler characterized William Larimer Jones as "just about the finest gentleman I ever met" and went on to recount a very revealing conversation they had when W. L. Jones interviewed him for his first job at Aliquippa in the spring of 1914:

In that first talk with him (the first of hundreds) I had a curious experience unlike any other job-getting of mine. After he had satisfied himself as to my qualifications, we talked scarcely at all about the business. We talked about America and its people, from those early immigrants who came over in the *Mayflower* to the millions who had poured

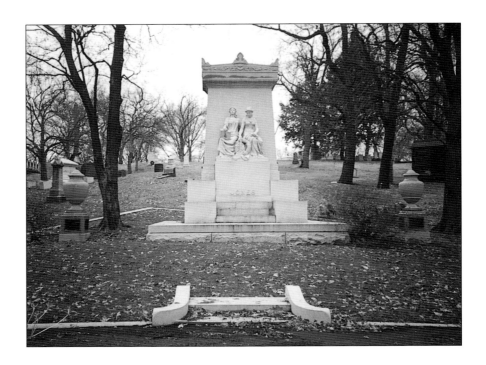

The Jones family monument at the Allegheny Cemetery.

in during the quarter of a century prior to 1914. I say we talked; actually I listened except as now and then Mr. Jones challenged me with questions that reminded me how much ugliness there was in any steel town where I had worked or visited. I found myself remembering the squalor of those 'dobe hovels in Pueblo where the Mexicans lived; of the shacks in Atlanta's Negro slums, of the slums in Pittsburgh in which lived people of more nationalities than I could name.

"Mr. Girdler, I'd hate to bring up children in such neighborhoods."

I cursed, to express my own distaste.

We agreed that industrial operations were not responsible for slums, did not make them. We agreed that women of our own families might conquer household squalor with a five-cent bar of soap. As to saloons, brothels, crime and wayward children, surely these were expressions of something which had come with these later-day immigrants, something that was in part attributable to their bewilderment in a strange land hearing always a strange language. Bad housing was to be blamed on house owners, on real estate men, on municipal authorities, on the antiquated system and high costs of the house-building industry. When we had explored all these conditions, as rationally as we could, Mr. Jones asked me another question.

"Mr. Girdler, is there one word that describes the average steelworker's living conditions?"

"Yes, sir: ugly."

"All right. But we believe we can make a fresh start. Around our Aliquippa Works we have a blank page. We've bought the land. When the plant is fully built the men who work there will constitute, with their families, the population of a good-sized town. We want it to be the best steel town in the world. We want to make it the best possible place for a steelworker to raise a family."

Thus I began an existence in which I became an unofficial caliph, an American Haroun-al-Raschid obligated by my office in a big corporation to consider the whole community as my personal responsibility. Always that responsibility was defined in its original terms as stated to me by W. L. Jones: Aliquippa must be the best town in the world in which a steelworker could rear a family, a family of Americans.

I had adventures and I had headaches. But, paternalistic as it undoubtedly was, when I recall how well we realized the vision of The Family, I am proud to have had a part in the making of Aliquippa.[6]

Aliquippa was to be the realization of the "vision of The Family," the vision of William L. Jones and B. F. Jones Jr. in particular, a vision that would shape a community—unfortunately not always for good. Or perhaps one could say that the vision could be tarnished by always coming up against the built-in tension of any community, even visionary ones, between rights and freedoms on the one hand and law and order on the other. It was a vision that inspired Saltaire and Port Sunlight in Britain in the nineteenth century, as well, with similarly ambiguous results.

The building of Aliquippa resulted from the coming together of several factors in the first decade of the twentieth century. The first was the "vision of The Family" as expressed by William Larimer Jones. This attitude helped to motivate the civic reform movement from 1889 to 1894, which emanated from "The D—— Calvary Crowd" inspired by the leadership of George Hodges. Calvary Episcopal Church became a beacon light of the social gospel program and became the center for the reform movements that changed the face of Pittsburgh politics in the decades around the turn of the century. Ingham notes that although most iron and steel manufacturers had been Presbyterian, their children frequently attended Episcopalian prep schools and many converted to Episcopalianism.[7] The Jones and Laughlin families remained Presbyterians, usually as members of First Presbyterian Church, but this did not make them immune from the influences coming out of Calvary Church.[8] Nor was the vision of building "new model" steel communities unique to "The Family." The newly formed

United States Steel Corporation under Judge Elbert Gary would build Gary, Indiana, and the Crucible Steel Corporation would build Midland, Pennsylvania, during the same decade.[9] Willis L. King, who knew Judge Gary, once said of him: "I think we like him best for showing that a man may be in business, a large business, and still be a gentleman."[10] The usefulness of Gary's brand of welfare capitalism as an alternative to bargaining collectively with a national labor union made it even more attractive to a generation of steelmakers who were determined to crush unionism wherever it raised its ugly head.[11]

The second factor was the necessity to find a new location for expansion if the Jones & Laughlin Steel Company were to maintain its position as second only to Carnegie Steel in production. By 1905, with the addition of two new blast furnaces, the rebuilding of older stacks at Eliza, and the purchase of the adjacent Soho Works, total pig-iron production reached a little over one million tons. At the American Steel Works a third Bessemer converter in 1902 and an increase in the open-hearth furnaces between 1902 and 1905 increased steel production to just over a million tons also. And new or remodeled bar, billet, and rolling mills increased rolled steel products to just under 900,000 tons by 1905.[12]

The J&L display at the American Electric Railway Manufacturing Association convention in Atlantic City, New Jersey, October 1911.

The new open-hearth furnaces were experimental in nature, using the Talbot process. Talbot furnaces, operating on a continuous basis, used a tilting hearth and frequent charging and tapping. This led to much lining erosion and the need for frequent bottom repair and replacement. Five such furnace hearths were built between 1902 and 1905 as a part of shop No. 2; four more (shop No. 3) would start producing in 1909. And four Talbot furnaces would be installed at Aliquippa in 1912.[13] However, the problems of operating them would eventually result in their modification as a part of the duplex process. H. W. Graham, the respected head of J&L's metallurgical research department, would later say:

> Although it would be a bit harsh to speak of the Talbot process as a failure, its performance fell short of being a fully satisfactory and competitive success. By 1912 Jones & Laughlin's management found it advisable to look for some alternative to the Talbot process. Having at hand Bessemer Converters and tilting Open Hearths, they chose to employ a combination procedure in which molten pig-iron was desiliconized and decarburized in the Bessemer and transferred to the Open Hearth for phosphorus removal and final finishing as steel.

> The decision to use this duplex process was an expedient one, but there were strong justifications. Conversion to conventional Open Hearth procedure would have required heavy investment for additional Open Hearths with no increase in overall tonnage capacity. Increasing

Thomas M. Girdler, general superintendent of the Aliquippa Works, 1920–23.

An old Soho furnace on Second Avenue, 1876. This furnace was built in 1872 by Moorhead, McCleane & Company and was later the site of J&L's Soho Works. It was torn down in 1932.

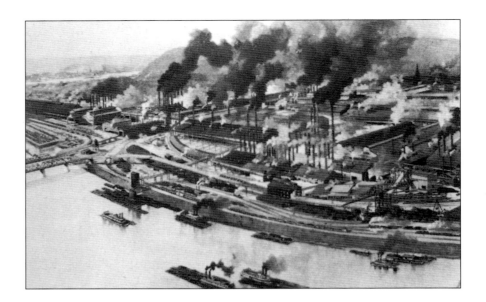

J&L's South Side Works, 1902.

use was made of the Duplex process and after the last heat of Talbot steel in 1920 all the tilting furnaces were used for Duplexing.[14]

By 1905, however, it was evident that further expansion along either side of the Monongahela River would be severely hampered by terrain and urban growth. Further, J&L had no facilities for tubular, tin, or wire products, the demand for which was increasing. As Hogan has written: "If the company was to take advantage of the new markets for steel, it had to diversify; and if it was to diversify, it had to buy new property, to build a new plant where there was room to grow."[15]

The third factor was the availability of capital for investment thanks to the reorganization of the company in 1902, which increased capitalization from $20 million to $30 million. The financial success of the company must have been substantial, although the lack of public data before 1922 makes it hard to quantify. The increase in capitalization from $30 million in 1902 to $115 million in 1922 shows rapid expansion, which had to be paid for in some way.[16] Dividend payments, which from 1874 to 1893 had averaged 32.32 percent, from 1894 to 1913 dropped to 21.56 percent of earnings, as more earnings were plowed back into expansion. However, from 1913 to 1923, dividends rose again to 36.41 percent of earnings. Significant earnings, therefore, were reinvested in the company during the period. This provided funds for some of the expansion, but at the same time the company borrowed $20 million through mortgage bonds "to help defray the cost of the large venture" of building the Aliquippa Works.[17]

The fourth factor was the availability of land in Woodlawn, located about twenty-six miles down the Ohio River from Pittsburgh, where two

pieces of property went on sale. One was a substantial acreage of farmland belonging to the McDonald family. The second was a large amusement park built by the Pittsburgh and Lake Erie Railroad to "increase the passenger trade of the road" but which by 1905 had fallen on bad days and was run-down. The company acquired both properties in 1905 and added other properties in 1906. Construction itself began in 1907. The business panic in October 1907 forced a slowdown in construction, but work was resumed in 1909.[18] The first blast furnace was blown in on December 1, 1909; by the following April two more had been blown in, with a fourth to follow in 1912, all rated five hundred tons or higher. By that year as well four Talbot open-hearth furnaces had been started, each rated at fifty tons. The first tin mill for J&L began production in December 1910, and by 1916 it had been joined by rod, wire, nail, and blooming mills.[19]

Although Aliquippa, a small village named after the Indian queen of pre–Revolutionary War days, existed on the river's edge, the amusement park was called Woodlawn, for the township initially laid out in 1890.[20] Eventually the name was changed to Aliquippa, and the original village became West Aliquippa. J&L turned its landholdings over to a subsidiary, the Woodlawn Land Company, which laid out the town in a series of plans; twelve of these were completed by August 1913. The Woodlawn Land Company built the houses, sometimes averaging more than one a day, and offered them for sale to Jones & Laughlin employees, "thus eliminating real estate speculation."[21] After some legal difficulties, the town gained incorporation as a borough on May 10, 1909, and a municipal building was erected by March 1911.

No. 7 rolling mill crew, Pittsburgh Works, 1900. John Reebel, the boss roller (at rear, second from left), lived to be 102.

Tom Girdler's pride in what the company accomplished in Aliquippa is evident in his autobiography, which also reflects a picture of the town and his attitude toward people, an attitude that illustrates well the problems of paternalism.

A new American town had been born and it was a good town, although born out of a boom . . . [like the undisciplined gold camps of the wild west]. But some day, I think, the supervised growth of Aliquippa, Pennsylvania, will take on glamour too. The magnificence, the genuine splendor of that project, designed to make a decent, dignified community conforming to the best American standards, will be appreciated.

Because work was to be had at top wages men poured in; old-timers of steel: Italians, Poles, Serbs, Greeks, Russians, southern Negroes, and representatives of a score of other nationalities and races. As in the West, the bad men came because there was a boom but none ever remained long in Aliquippa. During the sixteen years I worked for Jones & Laughlin, while I was assistant to the general superintendent of the works and after I was president of the corporation, it was literally true that a woman could get off a train at Aliquippa in the middle of the night and walk to her home without fear of being molested.

Doud's farm house, 1905, later became part of the Aliquippa & Southern Railroad office near the tunnel entrance.

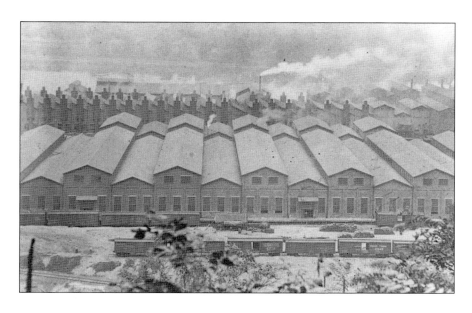

The nail mill and tin house, Aliquippa Works, 1910.

The original site of the Aliquippa Work's south mills (tin plate department), April 23, 1910.

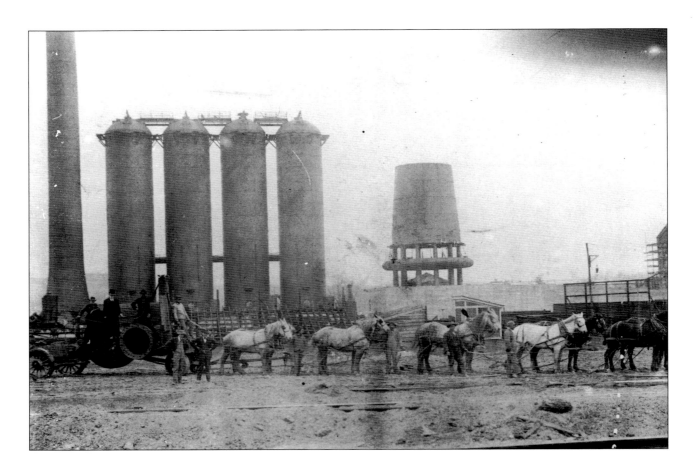

The No. 1 blast furnace at Aliquippa, with the stoves completed.

The Woodlawn Park dance hall before being moved and turned into the main office for the Aliquippa Works.

The entrance to Aliquippa Park; the dance hall is in the left background.

Building the stoves of the No. 1 blast furnace at Aliquippa, July 2, 1907.

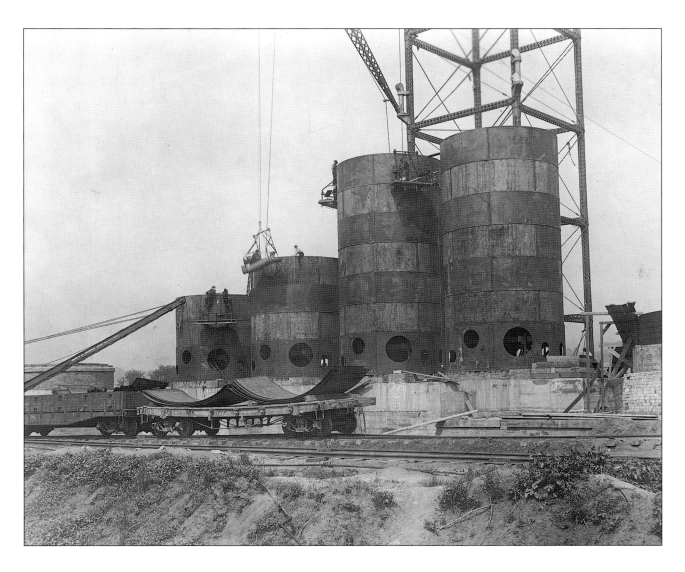

In my time there we policed it in our own way and we policed it well. We began policing it because we had to—if we were to keep faith with the fine intentions of The Family. I found bad spots there when I went to work.

The mushroom growth and the vast sums handed out every month in pay envelopes attracted many undesirable characters whose purposes were unwholesome, to say the least. One hillside that sloped steeply into a valley scarcely wide enough for a street had been withheld when the company was buying its land. That area was outside the borough, and if the bad ones who drifted in might be said to have sanctuary, it was there along the crooked lane known as McDonald Hollow.

On any payday that was a noisy place. Its saloons were dives. There were brothels and gambling houses, jailbirds, prostitutes, and other outcasts. The whole community then had taken the name of the old town, Woodlawn, and down on the other side of the brewery in Woodlawn were several places that were bad. By no conceivable sort of accounting could the viciousness be charged against the Aliquippa Works. When there were robberies and other crimes you could be morally certain the acts had been committed by toughs from these places.

The local police force was inadequate and no better trained for such work than average small-town cops. What could they do about it? What could we do? We had to do something.

When I had been there a year or more, a strike was threatened. Men who had come to foment trouble created disorder outside the plant. Workmen emerging from the gates had to fight for their lives. The company asked state officials to keep order. They said they would. But they sent one man.

He was a lean, rangy, solemn fellow, in a blue uniform. There were spurs on his boots, an unbecoming London Bobby type of helmet on his head, and a pistol on his belt. He was a Pennsylvania State Trooper, one of John Groome's men. And there wasn't any more trouble. He neither blustered nor threatened. But when he fixed his eyes on a group and said "Move on," they moved. His name was Harry Mauk.

First Mr. Hufnagel [Works superintendent] talked with Mauk, then W. L. Jones, and finally B. F. Jones Jr. As a result he was hired to command the plant's force of policemen. He fired some and hired others; he drilled and lectured and scolded his little company of twenty until each had become almost a counterpart, inside and out, of Harry Mauk.

The South Mills Maintenance department, Aliquippa Works, ca. 1910–15.

Further construction on the No. 1 blast furnace at Aliquippa, September 18, 1909.

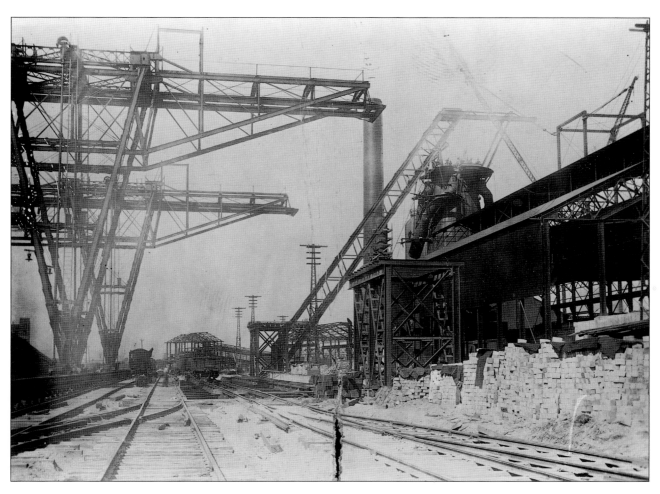

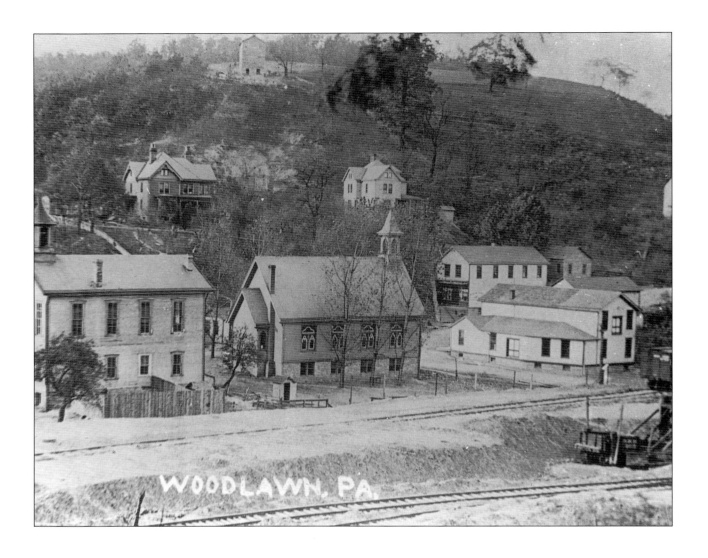

WOODLAWN, PA.

An early (ca. 1905) photograph of Woodlawn (now Franklin Avenue), Aliquippa.

Thereafter Woodlawn began to clean house. The local police force began to raid the centers of vice and crime. Mauk was their pal. If they thought they might need help Mauk would appear with a squad or two.

Not all Mauk's men wore uniforms. They did detective work. Often, I suspect, Mauk knew who was going to commit a crime before it happened. His men knew who got off the train and who left town. Some of those who left went after a chat with the chief of the Woodlawn police, when Mauk generously shared his information with the chief. That was because Mauk was less concerned with putting men in jail than with having Aliquippa clean.

. . . . There were thirteen major groups [in town]. The Italians had their hill, the Serbs another. There were many Slavic people. There were many Negroes. The colored people were in Plan 11 and gradually

Construction of the tin mill at Aliquippa, August 7, 1909.

The Woodlawn Land and Woodlawn Water Companies, October 1915. From left: Edward Parrott, M. B. Moore, H. L. Clark, Olive Inman, J. G. McCandless, L. E. Winter, and J. L. People.

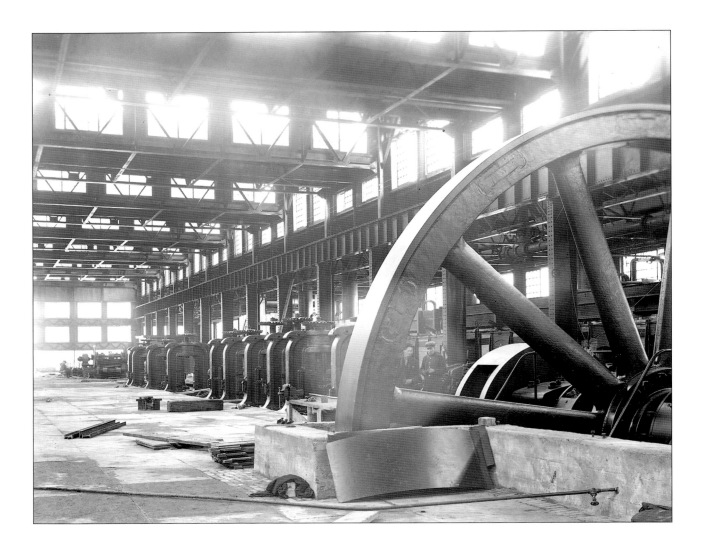

Hot mill and fly wheels in the Aliquippa tin mill, 1910.

(Right) H. G. Mauk, director of Aliquippa's plant protection, 1916–41.

(Far right) F. B. Hufnagel, general superintendent of the Aliquippa Works, 1913–20.

(Opposite) Hot mill engines in the Aliquippa tin mill, 1910.

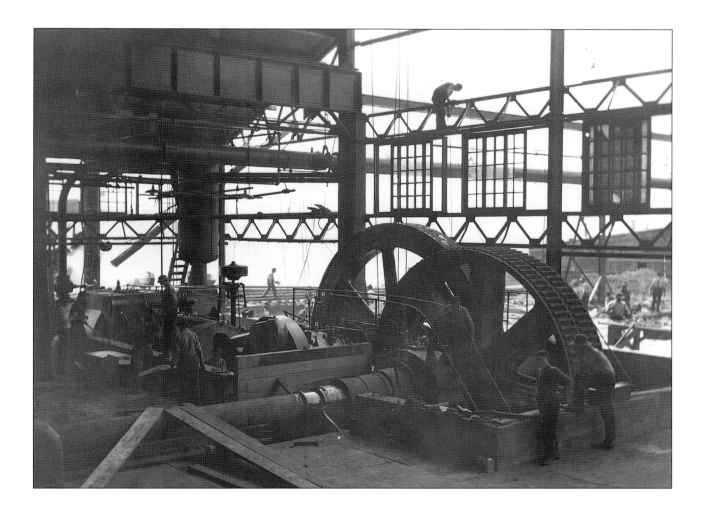

spread until their houses covered the steep slope of a ravine to the top of McDonald Heights. All the company houses had inside baths and toilets, water, gas, electricity. There were lawns and trees and little gardens. No cluster of houses was far from a bit of woodland. Except for one experiment known as "The Bricks," all were individual houses and there was a pleasing variety in the architectural designs. During my years there some thousands of houses were built. Many, I remember, cost $3,200 and because of careful management each contained a good deal more value than you would have found in an ordinary new house offered for sale at that price.

The children who lived in those houses were the schoolmates of the four little Girdlers: Jane, Betty, Joe and Tom. What am I saying? Just this: That any time the influence of the company was exercised in a matter touching the schools I was obliged to consider that whatever was done would affect my own youngsters, along with the others. Therefore, it was decidedly to the advantage of the Girdlers to have the

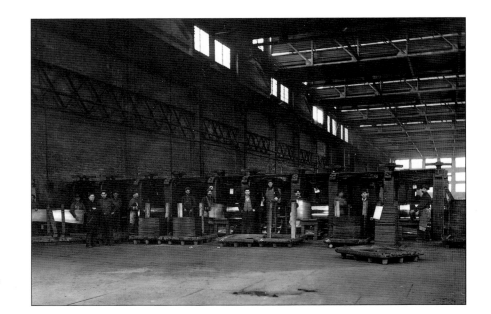

(Right) Aliquippa cold roll mills,
April 23, 1910.

(Below and opposite above)
Women sorting tin plate at the Ali-
quippa tin mill, December 9, 1910/
June 16, 1930.

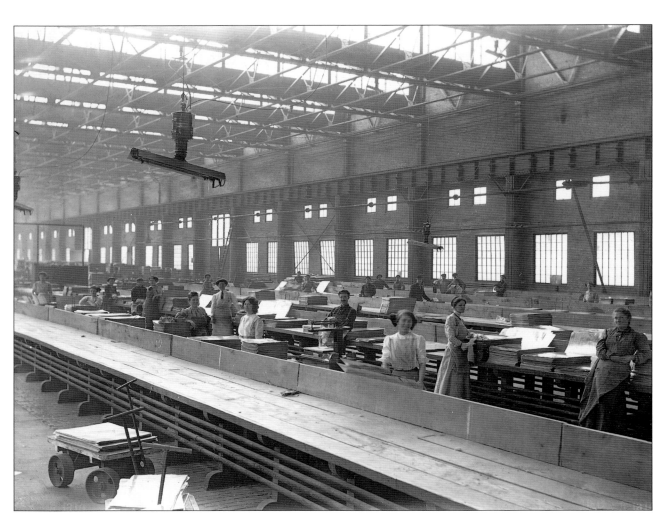

(Left) Aliquippa tin mill, May 1910.

The Aliquippa police department, which was supported by J&L, ca. 1920s.

schools of Woodlawn as good as possible. And that's the way they were. The school system became internationally known. What is known as progressive education was pioneered there.[22]

This tidy, progressive little community was obviously a joy for Tom Girdler. Although Mr. Mauk might be "less concerned with putting men in jail than with having Aliquippa clean," proper judicial procedure, after all, was a way to ensure rights as well as to punish crime. And too often it was left to Mauk and the company to define behavior as criminal that others might interpret as exercising their freedom of speech and of assembly, or even of movement. Stories are told of union organizers who found themselves shadowed by Mauk's plainclothesmen and encouraged to leave. And John Fitch has ample evidence of the fear that company surveillance of workers could inspire.

An employe [*sic*] of this company [J&L] told me of an attempt in 1906 to hold a meeting to protest against Sunday work, but with no intention of organizing a trade union. The men who were interested in the matter had engaged a hall. Word was carried to the company. The superintendent called the men together from the departments which the agitators were supposed to be and ordered them, with threats of discharge, to abandon the plan. When the time for the meeting came, a foreman, with several mill policemen, stationed themselves where they could see every man who went into the hall. As a result, no one attempted to go to the meeting.[23]

This particular incident occurred at the Pittsburgh Works, and one can imagine that the control of the company police was even more extensive in a planned community such as Aliquippa. Stories circulate even today in Aliquippa of the Pittsburgh journalist who came to Aliquippa to find out what had become of a missing worker who had agitated for a union. Some men joined the journalist once he got off the train and, after ascertaining his business, escorted him onto the next train out of Aliquippa with the warning not to return. However, when he reached Coraopolis another passenger put him in contact with a friend in Ambridge. There he rented a room, changed his appearance to look like a panhandler, and thereafter made daily treks across the bridge to Aliquippa to get the information he sought, finally meeting the worker's wife and learning that she had been tricked into having the man committed to a mental institution to keep him out of trouble.[24] Admittedly, this was during the 1930s, but the

Aliquippa's Franklin Avenue, with the railroad station and the Pittsburgh Merchantile Store at far left, ca. 1912.

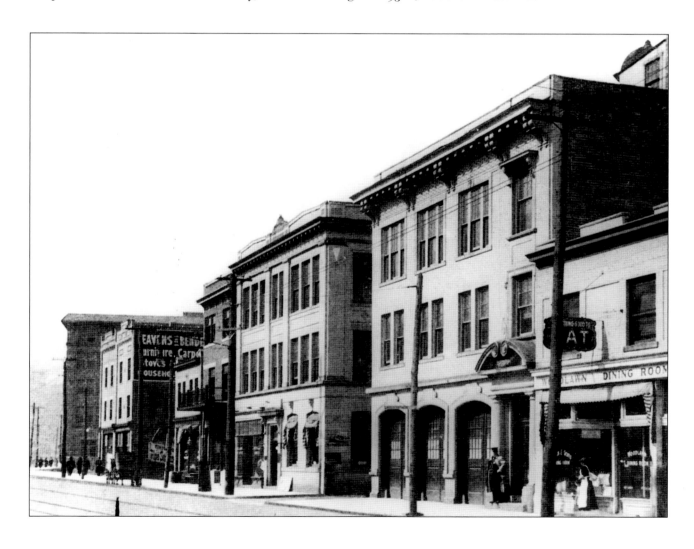

basis for such control was laid even as the town was laid out. And certainly it was firmly installed under the watchful eye of Tom Girdler, assistant superintendent from 1914 to 1920 and superintendent during the early 1920s, before he moved on to become general manager of all of J&L in 1924.[25]

The two J&L Works, Pittsburgh and Aliquippa, were in an excellent position to meet the demand for steel products during the First World War. With the completion of its fourth blast furnace in 1912, the Aliquippa Works had reached an ingot capacity of 250,000 tons. The Pittsburgh Works saw a sixth blast furnace added in 1916 and reached an ingot capacity of 1,740,000 tons per year by 1920.[26] By 1914 J&L was shipping 1,114,916 tons of semifinished, hot-rolled, and other products, with over half of that made up of bars and small shapes, reinforcing bars, structural shapes, plates, spikes, rails, and other items. The new products available due to the Aliquippa Works were primarily wire and tin mill products, especially hot-dipped tinplate used in the new food-container industry. By 1917 it had added tubular products as well.[27] Wartime demand necessitated some

(Opposite above and above) Charles M. White and Harry Fisher residences, ca. 1928.

(Opposite) Building residences for supervisors in Plan 6 at Aliquippa using steel frame and Junior beam construction.

P. M. Moore, the first labor foreman for the Aliquippa Works, founded a company to build houses and supply construction materials for J&L.

Aliquippa & Southern Railroad wrecking crane working to put mill parts together, ca. 1908.

adjustments, both in products for military use and in recruitment of work-
ers to replace the three thousand who joined the military, but the war also
resulted in increased productive capacity, thanks to a fifth blast furnace
and another Bessemer converter at Aliquippa, six new open-hearth fur-
naces at the Pittsburgh Works, and a variety of rolling mills at both places
(a bar mill and a 128-inch plate mill at Pittsburgh and two skelp mills and
five pipe mills at Aliquippa). The new bar mill at Pittsburgh (No. 11, for a

A J&L Steel locomotive, ca. 1920.

An Aliquippa & Southern engine,
July 14, 1930. Left to right: W. F.
Follet, James Whalen, Joe Show-
alter, and Robert DiNardo.

small-size bar used in high-explosive shells) was put together in two months in 1916 by salvaging parts from older equipment.[28] In addition, several more batteries of by-product ovens, so valuable for the production of toluol used in explosives, were added at both locations.[29] In 1916 J&L spent $4,318,000 on capital equipment; in 1917, $6,770,000; and in 1918, $11,753,000. This dropped to $2,014,00 in 1919, following the war, and rose only to $2,101,000 in 1920. Company shipments of semifinished and finished products totaled 1,527,656 tons in 1915, rose to 1,890,142 tons in 1917, and fell to 1,577,535 tons in 1919.[30] The company met the demands of the First World War, but not without great effort. As Hogan stated, "In the face of extensive shortages of manpower and coal, the corporation was called upon to turn out practically every steel commodity usable for war, except armor plate. By 1917, J&L was producing between thirty and forty thousand tons of sheet steel a month, on mills never intended for such a product."[31]

As his father had done in the Civil War, B. F. Jones Jr. "took an active part in many of the activities which arose to meet the emergency," among other things the Red Cross, the Salvation Army, and the YMCA. As a draft for his obituary stated, "In war industry his counsel was sought far and

A J&L Steel diesel locomotive at Aliquippa, September 1949.

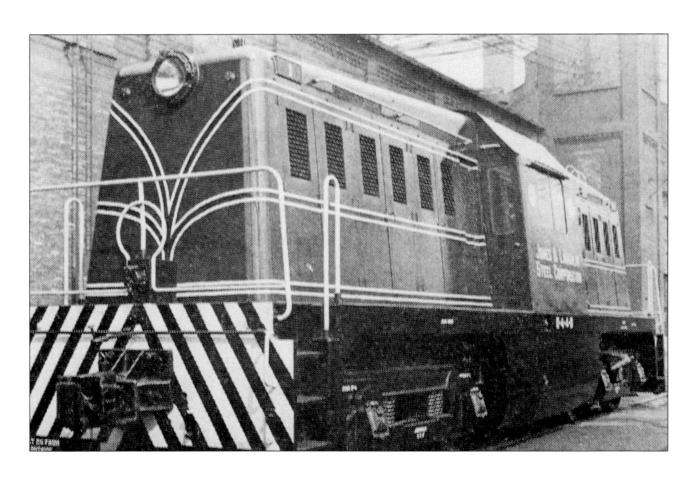

wide and led to his taking a prominent part in the mobilization of industrial forces for winning the war. He served on several boards having to do with war activities and was constantly occupied with problems looking to close coordination of the steel industry with the fighting forces in France."[32] The end of the war saw Jones & Laughlin poised to continue its role as one of the top steelmakers in America. But coming to terms with the new world of modern industry would also change the company itself in the decade that followed.

From Private to Public

five

The Jones & Laughlin Steel Company that emerged from the First World War was a major player in making steel, second only to the United States Steel Corporation. Although family owned, it was well managed, in the forefront of technological developments, and had an excellent reputation. Its relations with other steel companies were good even while they were competitive, thanks especially to the close friendship between Willis King and Judge Gary of United States Steel. J&L's management shared the general view of industrialists in the United States regarding labor, that is, that management knew best how to run a steel company efficiently and that labor should follow management's leadership in all things and avoid the un-American tendency of unions toward Socialist radicalism. A month-long strike by J&L furnace workers in September 1917 failed to gain union recognition.[1]

Company leadership was still primarily in the hands of the families, with B. F. Jones Jr. as president and his cousins, William Larimer Jones and Willis L. King, as vice presidents. William L. Jones was the chief operating officer, while Willis King was the chief marketing officer. Another Jones family member active in the company until his untimely death in 1906 was Thomas O'Connor Jones, son of George W. Jones. The chief Laughlin family member until his death in 1908 had been Maj. George M. Laughlin. Next generation members on the board and active in company affairs were his two sons, Irwin B. and George M. Jr. and his nephew, James B. (son of Henry A., eldest son of the first James Laughlin). Other company

officials owed their positions to close ties to family members. For example, William C. Moreland, secretary of the company (and vice president in 1922), had been private secretary to B. F. Jones in his later years and was a good friend to B. F. Jones Jr. He had been admitted to a small share in the company in the 1902 reorganization, along with Roland Gerry.[2]

Increasingly, however, the families were recruiting top management from within the ranks of employees, from colleges and universities (for engineers and other professionals), and even from other companies. A notable example of this was the recruitment of Tom M. Girdler. Girdler, a 1901 graduate of Lehigh University, had worked successively as a representative for Buffalo Forge in London, England; as a foreman and factory superintendent for Oliver Iron and Steel Company in Pittsburgh; as an assistant mill superintendent for Colorado Fuel and Iron in Pueblo, Colorado; and as a rolling mill superintendent for Atlanta Steel Company in Atlanta, Georgia, before coming to J&L's Aliquippa Works in 1914 as assistant superintendent under Fred Hufnagel.[3] It was Girdler who played a major role in helping J&L meet the demands of the First World War, at tremendous personal cost.[4] When Hufnagel left J&L in 1920 to become president of Crucible Steel Company, Girdler succeeded him as superintendent and was obviously a man on the fast track for promotion in the company, or at least so he thought.[5] Another newcomer in 1914, also fresh out of Lehigh University, was Herbert W. Graham, who would become chief inspector of the Pittsburgh Works in 1923 and eventually vice president for research.[6] Nor were the families unrepresented in the next generation. The third B. F. Jones, known as Frank, joined the company as treasurer on January 7, 1919, after service in the army and graduation from Princeton.[7] However, one question remained: Would the families be able to continue to manage the company effectively as a private preserve in an era of significant technological change and competitive pressures?

Initially, the answer seemed to be in the affirmative. B. F. Jones Jr. and William L. Jones both kept the company on a course of progress. The company weathered the storm of the 1919 strike in concert with the rest of the steel industry. J&L management shared the general view that the strike was inspired by Socialist and Communist agitators and did not represent the "right thinking" of American workers. Girdler certainly reflected this view in his account of the 1919 strike, expressing pride that the Aliquippa Works lost not an hour's labor to it. His hostility toward unions was typical of J&L management and steel management generally. Such hostility contributed to the worker discontent that led to the Great Steel Strike on September 21, 1919. Over three-quarters of the mills in Pittsburgh were affected, and whole districts elsewhere were shut down. The radicalism of William

Z. Foster helped to turn public opinion, initially supportive of the workers, against them, and management used the Red scare argument to good advantage. The result was the failure of the strike in November 1919.[8]

The immediate postwar years were marked by considerable instability in demand as the government cut its purchases abruptly and industry was left with excess capacity. The first years of the decade saw no new major investment by J&L in plant facilities beyond a few minor improvements in existing equipment. The most significant addition in 1921 was a new ore-washing plant at one mine; in 1922 it was a new four-inch welded tube mill at the Aliquippa Works. By 1923 business had picked up enough to justify more improvements in the mines and at both the Aliquippa and Pittsburgh Works. It was not until 1925, however, that significant new installations were built—at Aliquippa a new 9-stand 14-inch bar rolling mill designed for rolling special shapes; at Pittsburgh new soaking pits; and at Memphis a new warehouse—for a total of just over $3 million in 1925, still nowhere near the $11.7 million invested in new installations in 1918.[9]

However, this did not necessarily mean that the company was just marking time or trying to keep its head above water. A major new development occurred in 1921 with the inauguration of the river steel delivery system from Pittsburgh to southern and western points along the Ohio and Mississippi Rivers, usually credited to B. F. Jones Jr.:[10]

Damage from a machine shop fire at the Pittsburgh Works, May 2, 1922.

Oiling the edges of Ford generator steel at the 14-inch mill at Aliquippa, September 2, 1937.

In the matter of transportation the Jones & Laughlin Steel Corporation has never failed to keep fully up with the changing conditions of the country and in one respect at least, has been the leader. I refer to the development of use of the inland waterways. Fully thirty-five years ago [1892] we led the way in making use of the canalized Monongahela river for transport of coal from our mines to our mills, establishing a complete transportation facility for that purpose, consisting of a number of steam towboats and a fleet of steel barges. That facility has enabled us to meet competition from other parts of the country in times when the industry was close pressed. A half dozen years ago [1921] we extended this facility to cover distribution of our manufactured products into the South, West and Southwest by the establishment of a waterways delivery system on the Ohio and Mississippi rivers extending from our works in the Pittsburgh district as far South as New Orleans on the Gulf and as far West as St. Louis on the upper Mississippi. In this development we are likewise the pioneers and today are sending out regularly every month large shipments of all our products loaded into steel barges of our own design and manufacture and transported by our own boats to lower river ports where they are transferred into railroad cars for local delivery or for movement into distant points in the interior of the Southwest and West."

The company held a major celebration for the *Century Tow* (the one hundredth downriver shipment) in April 1930. For several years—from 1927 on—J&L also ran a car ferry service to transport railroad cars fully

loaded with raw materials and unfinished products from the Pittsburgh to the Aliquippa Works. This was to avoid both the cost of loading/unloading and the high rail costs for short hauls charged by the Pittsburgh and Lake Erie line. It was discontinued when the P&LE adjusted their rates downward.[12]

The company also was in the forefront with new products during these years, most notably Jalcase steel, a speciality steel used extensively in

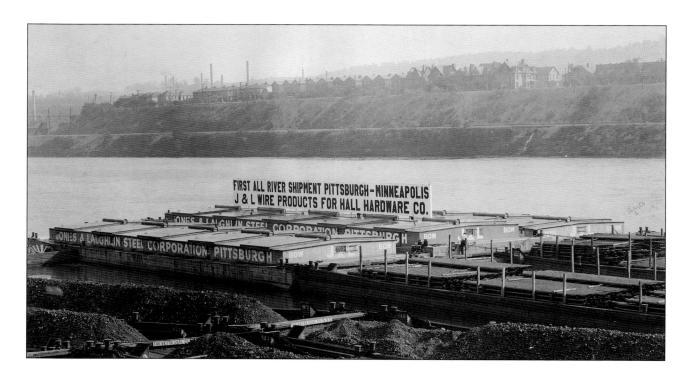

The first all-river steel delivery, from Pittsburgh to Minneapolis, 1921.

The Vesta Coal Company's tow boat *Aliquippa*.

automobile manufacturing. Its chief value was that it would cut freely yet harden readily. "It would be safe to say that somewhere in the moving parts of every make of motor car today there will be found one or more parts made of 'Jalcase' steel," B. F. Jones Jr. wrote with pride in 1927.[13] This was one of the results of a growing commitment J&L made to research. From the employment of their first chemist in 1884, through the addition of metallurgists at Aliquippa in 1912 and Pittsburgh in 1914, to their first geologist in 1927, J&L expanded its research facilities with some consistency. Initially such work was conducted in the plants by plant

"The J&L Century Tow" in April 1930 celebrated the 100th river shipment of J&L steel products.

The steamer James Laughlin at the Union Dock in Ashtabula, Ohio.

The trophy won by employees of the Pittsburgh Works for the best division safety record for November 1927.

personnel, but in 1930 these efforts were centralized in an old house on Carson Street. In 1937 the Hazelwood Metallurgical Research Laboratory was established. Herbert W. Graham became chief metallurgist of the Pittsburgh Works in 1927 and of the company in general in 1928, eventually rising to be vice president for research in 1953. It was J&L researchers who in the early 1920s made significant advances in manganese steels and who in 1925 discovered the role of dissolved nitrogen in the mysterious failures of some steel under heavy pressure in 1925.[14]

Another product that would prove especially significant in the building industry was, in the words of B. F. Jones Jr., "the J & L Junior Structural beam, an I-beam resembling the standard structural beams in appearance, but having only one-third their weight, size for size. In order to produce this beam commercially it was necessary to design a rolling mill which could manufacture the beam with speed and in the volume that would make the operation profitable." He went on to note that the beam, named the Junior I-beam, was especially useful in the construction of dwellings as a means of "obtaining the same security from fire and storm as is enjoyed by the big buildings."[15]

The last half of the 1920s saw significant expansion at J&L to match the improved economic situation. Total expenditures for expansion in 1926 were over $14.6 million and consisted of a new by-product coke plant and two more pipe mills at Aliquippa, new facilities for producing cold-finished steel at Hazelwood, and the purchase of Union Dock Company at Ashtabula, Ohio. New warehouses at Cincinnati and Chicago, a new seamless tube mill and a new Junior I-beam mill at Aliquippa, and the rebuilding of the No. 3 blooming mill at Pittsburgh, among other things, cost the company nearly $15.9 million in 1927. Expenditures for plant and equipment, most notably for a new 30-inch tube round mill and new boilers at Aliquippa and improvements to the Memphis and Cincinnati warehouse, dropped to just over $7.8 million in 1928, but J&L also acquired one of their own major consumers, the Frick-Reid Supply Corporation, the first major acquisition of an already existing company. This was to improve the marketing of products for the oil industry. The following year saw expenditures for equipment rise slightly to just over $8 million, primarily for Aliquippa, where the No. 4 blast furnace was enlarged and a second seamless tube mill was constructed. A warehouse in Detroit was also purchased to facilitate sales to automobile manufacturers. The year 1930 was a banner year for expenditures, with a record $19.5 million spent. The Aliquippa Works again received much of this, with an extension to the coke ovens, enlargement of the No. 3 blast furnace, a new No. 5 boiler house, and miscellaneous other improvements. Pittsburgh added a new bar mill and re-

placed four of its Bessemer converters with two new ones, increasing their output from forty to fifty tons in the process. All this meant that between 1920 and 1930 the capacity of J&L had grown from 2.1 to 3.0 million tons pig iron, from 2.6 to 3.4 million tons ingots, and from 2.1 to 2.7 tons finished hot rolled products.[16]

The rising trend in plant investment in the last years of the decade was one reason, among many, for the 1922 decision to reorganize the company. One company historian said it was "to conform to the exigencies of the period, and also because it was expedient."[17] The reorganization took effect on January 1, 1923, as the Jones & Laughlin Steel Corporation. The major feature of the reorganization was to convert a privately owned family company into a publicly owned corporation. The capitalization of the corporation was substantially increased, from $30 million to $120 million, a figure roughly corresponding to the value of its gross fixed assets. Half of this was in common shares, and half was preferred; a portion of the latter was offered to the public, "the first time in the company's history that any of its

The accounting department of the Frick-Reid Supply Company, Bartlesville, Oklahoma, ca. 1900.

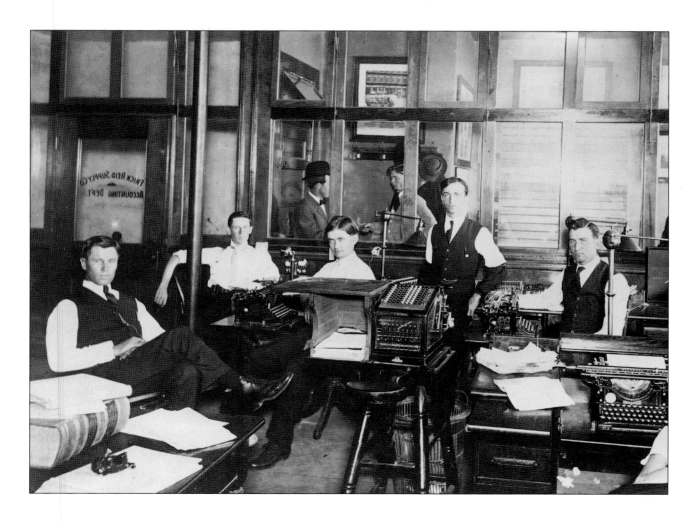

stock was listed on the stock exchange."[18] The effect of this and subsequent public sales of shares was, by 1953, to create a "public ownership by some 41,000 persons today."[19]

The reorganization also involved adopting a different corporate structure, with a board of directors. "There was little change in the official roster of the company, except that it was increased to take care of the additional work that was a natural result of the new corporation."[20] Seven of the board members were family members, headed by B. F. Jones Jr., who served as chairman of the board. Other board members included William Larimer Jones, who served as president of the corporation; George M. Laughlin Jr., who served as a vice president; the third B. F. Jones, who succeeded W. C. Moreland as secretary despite his comparative youth; Willis L. King, nephew to the first B. F. Jones, who continued to serve as a vice president; and W. C. Moreland, sometime secretary and longtime friend of the Jones family, as a vice president.[21] Clearly, despite the transformation into a public corporation, J&L remained firmly in the hands of the families.

Despite its growth, J&L Steel Corporation, which had been the second largest steel producer in the country in 1902, had fallen to third,[22] thanks to the creation and growth of the Bethlehem Steel Corporation between 1904 and 1924, which supplanted J&L in second place. The subsequent growth of Youngstown Sheet and Tube would further reduce it to fourth place by 1929, though only by a small amount.[23] During the merger movement that resulted in the United States Steel Corporation in 1902, it had been reported that J&L would become part of that conglomerate if the asking price of the family had not been too high. The 1920s saw further rumors of mergers and actual mergers in 1923 and 1927–29. At least one rumor included J&L, the effort of Cleveland banker Cyrus Eaton to combine Republic, Youngstown, and J&L in 1928–30.[24] For a variety of reasons the rumored merger did not take place, but Eaton did successfully expand Republic Steel Corporation to be the third largest steel producer in the country, and in the process he took Tom Girdler from J&L to be the first chairman of Republic's board.

Girdler's account of this, while not the whole story, is indicative of the consequences of shifting from a private to a public corporation. In 1924 Girdler had been promoted from Aliquippa to be general manager of J&L, directly under William L. Jones as president and B. F. Jones Jr. as chairman.[25] Relationships with the two Joneses could be complex. Girdler describes how B. F. Jones Jr. "flattered" him with a complaint that he never had a chance to talk with him, "except when W. L. goes out of town—which isn't often." But on those rare occasions he could always count on

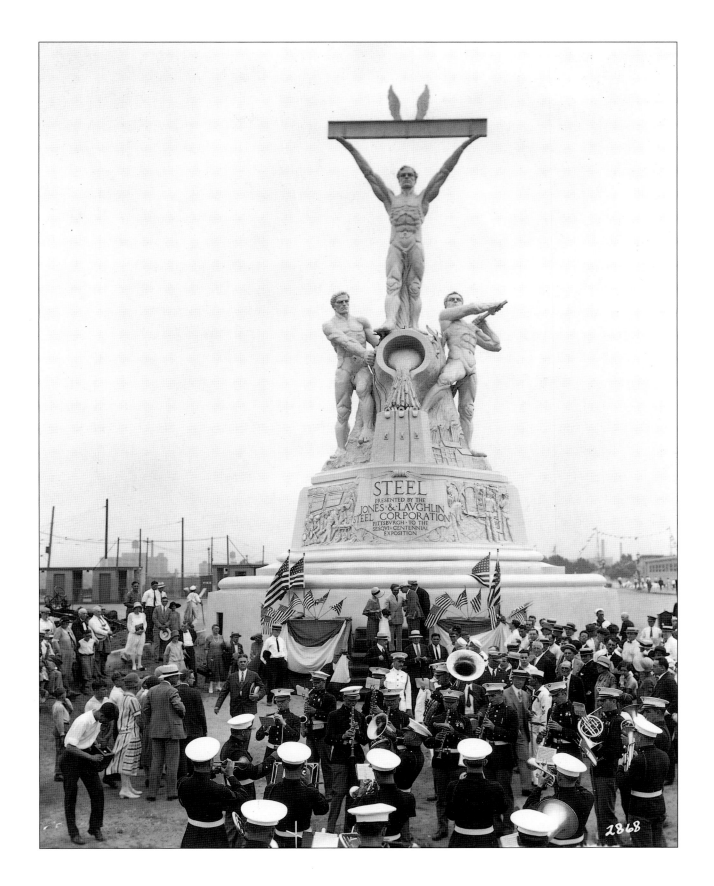

STEEL

PRESENTED BY THE
JONES · & · LAVGHLIN
STEEL CORPORATION
PITTSBVRGH · TO · THE
SESQVI · CENTENNIAL
EXPOSITION

2868

being called in for a chat. Once B.F. suggested that Girdler get an assistant so that he could "think about the problems of the company." Girdler responded with some uneasiness that he worked for the president of the company, to which B.F. replied, "Oh, that's all right, Tom. He'll ask you, too—someday." And a week or so later W.L. did indeed ask him. So Girdler hired R. J. Wysor from Bethlehem Steel even though he had to "go pretty high" in salary to get him, which caused W.L. "a couple of hard swallows."[26]

Relationships with friends of the family in the company could also be complex. One time B.F. told Girdler to take charge of the subsidiary J&L railroads, which had become a headache for the company. When Girdler objected that an officer of a steel company could not legally be an officer of a railroad, he was told, "I didn't say you had to be an officer. I said: 'Run them.'" Girdler then asked, "What about that old friend of the family who is president now?" To which B.F. replied, "make him like it." So Girdler put Charles M. White, a trusted colleague, in charge of doing this.[27] Both Wysor and White would eventually go to Republic Steel with Girdler, as president and vice president for operations, respectively.

Such support from B. F. Jones Jr. and William L. Jones, especially after he was promoted to vice president for operations in 1926, encouraged Girdler to think he was in line for further promotion in the corporation. In late fall 1926 William L. Jones died. Girdler would later write:

A lot of people influential in the company thought I ought to be made president. The Mellons thought so. I thought so.

Always before, the president of Jones & Laughlin had been a member of the family of controlling owners. It was natural that B. F. Jones would have liked to put his son, Frank, in as president. But Frank Jones then was scarcely experienced enough to suit the Laughlins. So when the directors elected Charley Fisher as president it was quite clear to me, at least, that the arrangement was a stopgap. . . . he had in his background no operating experience whatever.

Now there was a bit of sand in gears that had been turning without friction. The kindly intention of making me happier caused B. F. Jones to send for me and say: "When you've got anything to talk about, talk to me."

"But Fisher is president, B.F."

"Never mind that. You and I are operating men."

Mr. Fisher and I hadn't been congenial as co-workers, so I didn't mind that, but I did feel there was a ceiling over my head in Jones & Laughlin.[28]

Charles M. White, general super-intendent of the Aliquippa Works, 1929–30.

That "ceiling" encouraged Girdler to consider employment elsewhere in the years that followed, especially after young Frank Jones was made a vice president in April 1927. So when Cyrus Eaton approached him about his plans for Republic, Girdler was interested and let B. F. Jones know that. Girdler turned down the first offer from Eaton in 1927, but he arranged to see him in Cleveland on New Year's Day 1928 to discuss Eaton's offer to make him chairman of Republic Steel. As Girdler left breakfast he was told by telegram that B. F. Jones Jr. had died unexpectedly that very morning.[29] Calling off the negotiations with Eaton, he returned quickly to Pittsburgh. There, William Evans, J&L general counsel and member of the board, initiated talks with him to remain at J&L despite his negotiations with Eaton. Girdler was in a strong position and he knew it, so he refused Evans's efforts to postpone discussions until after the funeral and insisted instead on an offer later that day. After members of the families on the board—George M. Laughlin Jr., William L. Jones Jr., and Ledlie Laughlin—came to urge Girdler to stay, Evans returned that Monday afternoon. Girdler drove a hard bargain with him:

"Are you representing The Family, Mr. Evans? If so, here's my proposition." I told him how much salary I wanted, how much stock participation, and how much stock to be set aside for future purchase.

"That's pretty big."

"Yes. That's pretty big. I'd have been cheaper after W. L. died. Now it's just about fifty per cent less than I can get by going to work for Cyrus Eaton."

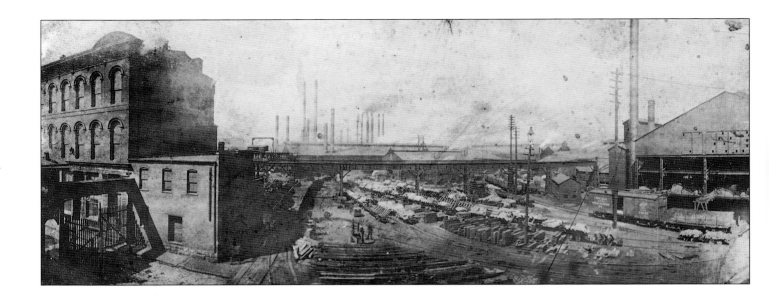

South Side, Pittsburgh Works, in the early twentieth century.

"Well, in a week or two we'll sit down and decide—"

"The funeral is Wednesday. On Thursday you are going to tell me the answer. If it's 'no' I'm going to work for Cyrus Eaton."

Thursday I became president of the Jones & Laughlin Steel Corporation. Later in the month George Laughlin Jr. became chairman of the board.[30]

George M. Laughlin Jr., the son of Maj. George McCully Laughlin, had attended St. Paul's and Yale, after which he went to work in the operating department in 1893 and had gained considerable experience and respect. He would be the last family member to chair the board of directors; he resigned in 1936 because of ill health. Frank Jones, who had been made a vice president in 1927, would continue to serve as secretary and vice president, as well as a member of the executive committee of the board, until his retirement in 1960. Other family members and friends who would serve on the executive committee until their retirements included Willis King, William L. Jones Jr., and W. C. Moreland. But no family member would ever again run Jones & Laughlin Steel Corporation as the first two Benjamin Franklin Joneses had. For all his abilities, Tom Girdler was not a B. F. Jones. And as it turned out, he would be president of J&L for only twenty-two months, leaving just as the stock market collapsed.

six Surviving Depression

The timing of Tom Girdler's departure from J&L Steel Corporation was not auspicious for either of them. Eaton had tried to bring J&L into his new Republic conglomerate, along with Weirton and Inland, but the Jones and Laughlin owners, so Girdler wrote later, "were scared to death of Eaton and could not be brought to see what was plain to me: One or the other of these proposed mergers was vital to the future welfare of everybody concerned. Otherwise the company would be increasingly restricted in its operations. There was such sharp disagreement that I left." Girdler took both Wysor and White with him, thus leaving J&L with a reduced management team at a crucial time. For this was the Friday before "Black Tuesday," October 29, 1929, when the stock market crashed and ushered in the Great Depression.[1]

Company-inspired histories prefer to accentuate the positive and make almost no reference to the impact of the Great Depression. An exception is a single sentence in Moreell's account: "The Depression of the thirties hit 'J&L' hard, as it did most of American industry—particularly heavy industry, including steel."[2] Shipments of products fell from slightly more than 1.7 million tons in 1930 to 566,856 tons in 1932, recovering to just under 1.2 million tons in 1935, only to suffer an additional decline to just over 1 million tons in 1938. Since capacity grew from 2.7 million tons in 1930 to 2.9 million tons of finished hot-rolled products, production obviously was far less than capacity; in 1938 it was only 37 percent. Under the circumstances it is not surprising that J&L, in common with many other

steel companies, experienced significant financial losses in the early 1930s, averaging about $3.9 million per year from 1931 to 1935, and a concomitant reduction in the labor force. The last half of the decade—exclusive of 1938, which registered a $5.9 million deficit—saw improvement in earnings, with net income averaging $5.6 million per year.[3] Dividend payments, which had been $8 per share in 1929, dropped to $5 in 1930 and $1.50 in 1931; they were then suspended for the remainder of the decade, only resuming in 1941 at $1.35 per share.[4] J&L was particularly hard hit because it had let its light-rolled capacity decline and had even ceased production of sheet and strip steel in the last half of the 1920s, concentrating instead on hot-rolled and cold-finished bars; it maintained its position as the largest producer of cold-finished steel in the country.[5] Unfortunately, the Depression caused a sharp cutback in demand for these items, whereas the strongest demand remained in light flat-rolled products for automobiles, appliances, and canning materials. Things only began to pick up in 1934.[6]

Although production and employment were down significantly, the corporation did not go out of business; nor did it cease to expand and modernize its plants. However, new equipment and facilities investments were slight during the early 1930s, at least after 1931. Many improvements dealt with power sources and improved mill facilities. Others were in the distribution system, such as warehouse facilities in New Orleans and Chicago. It was not until mid-decade that significant investment changed production capacities. In 1936 a 96-inch continuous strip mill was built at the Pittsburgh Works, going into production early in 1937; the cost—just under $23.9 million—was the largest single J&L investment in its history.[7] By then, the political and labor situation had been drastically changed by the election of Franklin Delano Roosevelt and the policies of the New Deal.

The management team that had to face the Depression was a combination of families and outsiders, with George M. Laughlin Jr. as chairman of the board. Girdler's departure had left a significant void since he took two other major executives with him to Republic Steel. George G. Crawford was brought in from Tennessee Coal and Iron to serve as president, but in 1934 he was replaced by an insider, Samuel E. Hackett, who had joined the company in 1916 as sales manager in Chicago, moved to Pittsburgh as general manager for sales, and became a vice president in 1923. In 1936 G. M. Laughlin Jr. resigned as chairman of the board because of ill health, and H. Edgar Lewis was brought in from Jaffrey Manufacturing Company to replace him. Lewis, who had worked in both Carnegie Steel and Bethlehem Steel, became president upon Hackett's retirement in 1938. The only family member of any significance left by then was B. F. Jones III, still a vice president and secretary of the corporation and destined to rise no

higher. Willis King was a much-revered figure in the 1930s but was too old to have significant influence; in any case he died in 1936. The corporation was firmly in the hands of people other than the families by the late 1930s. Furthermore, by then management had to deal not only with a new political environment but also with an enlarged group of stockholders.

This does not suggest that the replacement of a family-oriented management by one that was more impersonal and beholden to investment capital was the reason for the poor management/labor relations that marked the early 1930s. However well intentioned the paternalism of their welfare capitalism was, the families were the ones who brought Tom Girdler in to run Aliquippa and eventually the whole corporation, steadily promoting him despite the increasing harshness of the corporation's control of its workforce. The Pittsburgh Works felt it, but Aliquippa as a company-developed town felt it even more. John Fitch's comments in 1910 about company spies and an atmosphere of distrust and coercion in the Pittsburgh Works did predate Girdler's coming to J&L, after all. What Girdler did in Aliquippa, with John Mauk's assistance, was simply to make the situation clearer but harsher and more pervasive. Whether the Jones cousins (B. F. and W. L.) knew in detail what happened in Aliquippa to make it "Little Siberia" might be unclear, but they could not help but understand what was going on in general terms.[8] Thus, the poor relations between labor and management at J&L did not suddenly appear in 1934 but were rather the outgrowth of developments over the previous forty years or more, developments that were not unique to J&L.

Aliquippa became the primary arena of management/labor hostility at J&L.[9] There the company dominated the town politically and socially through the Republican party machine and a subservient press and social structure, including church leadership. One company official was quoted as saying, "The company ought to have something to say about the way the town is run. The company owns pretty near everything in sight."[10] The layout of the town in distinct plans facilitated its fragmentation into ethnic groups not always considerate of each other. African Americans in particular were poorly treated by both white workers and management.[11] Despite Girdler's pride in the quality of housing and education, life in Aliquippa was not easy for millworkers. Many families had taken in boarders to supplement uncertain incomes, with resultant overcrowding in some homes. Life in a steel town was raw even in the best of times, and the 1930s was hardly the best of times.

The passage of the National Industrial Recovery Act in 1933 did not immediately change things, but it began the process of change. Section 7 stated the right of workers to organize and bargain collectively. However,

after some initial success in 1933, the National Labor Board experienced significant challenges (from Weirton Steel, among others) that seriously impaired its reputation and highlighted its lack of effective sanctions. Before its collapse, however, it did motivate some steel companies, among them J&L, to follow the lead of Bethlehem Steel in establishing Employee Representation Plans (ERP) as one way to fulfill the terms of the act without losing total control or recognizing the Amalgamated Association of Iron, Steel, and Tin Workers. In 1933 the ERP was begun at J&L, with thirty-six representatives at the Aliquippa Works and twenty-seven representatives at the Pittsburgh Works.[12] The company published *The J&L Steel Employes* [sic] *Journal*, which carried many social and sports items but only rarely included articles of significant content, primarily as reports of the annual conference of the ERP.[13]

Despite the establishment of the ERP in the summer of 1933, J&L was embarrassed by the revelation of "a pattern of intimidation and harassment" made by Clint Golden, who came as senior mediator for the Pennsylvania Department of Labor and Industry to Aliquippa to investigate the case of George Issoski.[14] Issoski, crippled in a mill accident years before and having a hard time supporting his wife and seven children after being laid off in 1931, was doing some organizational work for the Amalgamated Association by signing up acquaintances as members left the mill. However, late in the evening of September 11, 1934, after some drinks with friends, he was accosted by James Istock, an Aliquippa policeman, who violently

Aliquippa policeman James Istock during the 1937 strike.

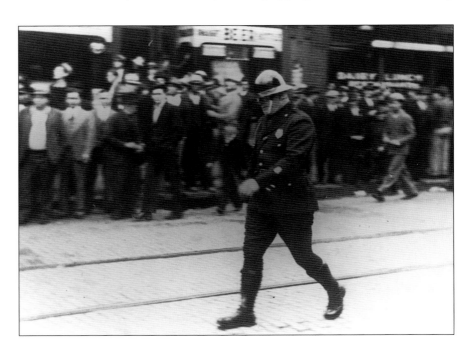

sought to confiscate the two hundred signed union cards he had earlier carried but had subsequently destroyed after being confronted by a company policeman named Opsatnik. Issoski suffered beatings several times in the borough and county jails; the following day he was denied access to his wife, who was told he was "very crazy" and was asked to sign some papers committing him, which she refused to do. However, on September 19, 1934, he was committed to the state hospital at Torrance by a lunacy commission. The fear that enveloped workers in Aliquippa as this story went around the taverns and street corners contributed to the disinclination to speak to strangers or to remain within the surveillance of company police and stoolies very long. Golden eventually was able to track down Issoski, interview him, and make the unsavory affair public. Republican governor Gifford Pinchot, whose wife, Cordelia Bryce Pinchot, was a sympathetic speaker at union-sponsored rallies, appointed a special investigation commission that eventually declared George sane and freed him.

The backlash against the heavy-handed company activities in Aliquippa led to the sending of state police from the Butler barracks into Aliquippa on October 4, 1934, and to an unprecedented public parade and meeting, with Mrs. Pinchot as speaker, on October 14, 1934. As the "first labor meeting the town had ever seen,"[15] the event drew four thousand attendants, many of whom joined the Amalgamated Association, swelling their numbers by three thousand within a few months. It was to be a premature victory, however, for the weaknesses of the National Labor Board had not been sufficiently overcome by Joint Congressional Resolution No. 44 of June 1934. In any case, the 1935 decision of the Supreme Court declaring the National Industrial Recovery Act unconstitutional negated the federal effort to support unionization and collective bargaining. Senator Robert Wagner then introduced the National Labor Relations Bill, which was finally signed into law on July 5, 1935.[16]

The Wagner Act, as it was popularly called, was based upon an interpretation of the interstate commerce clause of the American Constitution whereby strikes caused by employer refusal to bargain collectively with worker-supported unions disrupted interstate commerce. Further, improved employee conditions, such as better wages, could lessen the effect of economic depression by putting more purchasing power in the hands of consumers. It was expected that court challenges would be made, but the act had been crafted to reduce the impact of that by including the court system in the process from the beginning. However, according to Benjamin Taylor and Fred Witney, "Only a clear-cut declaration of constitutionality of the Wagner Act by the Supreme Court could effectuate the law."[17]

1934 parade in Aliquippa featuring Governor Pinchot's wife, Cordelia Bryce Pinchot (front row, second from right), who supported the union.

Although other challenges to the act appeared, it was that of Jones & Laughlin Steel Corporation that would lead to the landmark decision of the U.S. Supreme Court.

To understand why, it is necessary to return to Aliquippa in 1934. The November 1934 election of George H. Earle, the first Democratic governor of Pennsylvania since 1890, seemed to signal the end of the stranglehold of antiunion political forces, and the Amalgamated Association's Aliquippa Lodge 200 finished the year by signing up three thousand members. However, in Aliquippa, as elsewhere in the steel industry, the picture from the worker's point of view was muddled. On the one hand, the leadership of the traditional trade unions of the AFL, of which the Amalgamated Association was a part, sought to expand their organizations on the craft union basis. On the other hand, some were drawn to the approach of John L. Lewis and the United Mine Workers, who sought to organize a whole industry, including unskilled and even African American laborers. Beaver

Lodge 200 of the Amalgamated Association, a hotbed of sympathizers for this view, was one of thirteen lodges expelled early in 1935 by President Michael Tighe for its activities against the leadership of the national union. The Wagner Act gave Lewis the chance to launch a major organizing campaign, and when the AFL convention refused to endorse industrywide unions, he and his supporters formed the Congress of Industrial Organizations (CIO) in November 1935.[18]

Finally, there were still the fledgling Employee Representation Plans that, even though they were company unions and hence suspect to both combatants in the broader labor movement, could form the basis for the improvement of working conditions. This was particularly the case for the ERP in the U.S. Steel Corporation, led by John Mullen, George Patterson, John Kane, Fred Bohne, and Elmer Malloy. A group working for American Sheet and Tin Plate were instrumental in calling a convention in New Castle, Pennsylvania, in September 1935; delegates compiled a list of demands, including a 15 percent wage increase, a more liberal pension system, vacation with pay for all workers, the ending of management's exclusive right to fire, and the appointment of arbitrators. Similar demands were made by employee representatives at Weirton and J&L.[19]

The ERP at Aliquippa included two men who would later figure prominently in the events of 1937: Cliff Shorts, one of the seamless tube representatives, and Paul Normille, a representative of the service department. Both were elected to the five-man rules committee in 1936.[20] The ERP met annually to hear speeches by top management and to pass on suggestions from the workers. Suggestions for changes were also presented by representatives, some of whom were more aggressive in representing the workers' interests than others. Management used the ERP *J&L Steel Employes Journal*, published monthly, to announce changes in benefits, made ostensibly in response to employee representatives' recommendations. Thus, in June 1936 J&L announced the institution of a vacation plan for workers with continuous service of five years or more, "in response to a request made several months ago by the Employes [*sic*] Representation Plan." The

Employee representatives from the Aliquippa Works, 1936–37, including Paul Normille (back row, second from left) and Cliff Shorts (back row, fourth from left).

extension of a vacation benefit to hourly workers as well as some wage increases were announced in March 1937.[21] However, the timing of such announcements seemed to be dictated by events in the wider steel community. Both the examples given coincided with key events in the organizing drives of the Steel Workers' Organizing Committee (SWOC). *The J&L Steel Employes Journal* was also used by management to present its views to the workers; for example, in July 1936 it reprinted the American Iron and Steel Institute's (AISI) strong condemnation of outside efforts to unionize the industry, which was "subscribed to in its entirety by the Jones & Laughlin Steel Corporation." This was presented as a defense of individual rights, and the AISI even stated that it "believes in the principles of collective bargaining," but with representatives chosen by "the employes themselves by secret ballot." It warned that these outsiders "will employ coercion and intimidation of the employes in the Industry and foment strikes" and promised to "protect its Employes and their families from intimidation, coercion and violence and to aid them in maintaining collective bargaining free from interference from any source."[22] Mostly, however, *The J&L Steel*

The first issue of the *J&L Steel Employes Journal*.

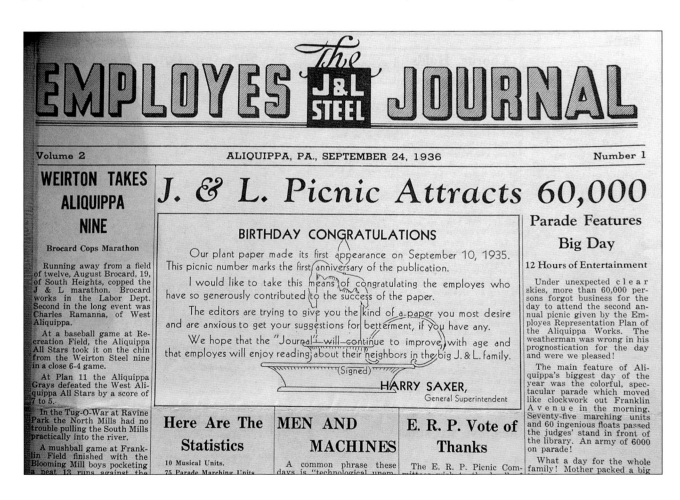

Employes Journal covered social and sports activities and rarely dealt with controversial or substantive matters, such as the growing labor disputes.[23]

During the summer of 1935, relationships between the Amalgamated Association leadership and its rebel lodges were the subject of successful mediation efforts by Clint Golden, and in the process the issue of J&L's harassment of union members in Aliquippa became prominent, especially after J&L fired ten workers active in the union. Several of those fired became active in the Democratic Social Club (DSC), which met in the Romanian Hall and provided a basis for both political and union activities. One of the members almost won the local election for constable in November 1935. With internal dissention working against Lodge 200, the leadership of the DSC became the spokesmen for workers seeking an independent union by the end of the year. A formal complaint by Lodge 200 on behalf of ten of the discharged workers[24] on January 23, 1936, led to a National Labor Relations Board (NLRB) investigation conducted by Golden in which J&L refused to take part on the grounds that the Wagner Act was unconstitutional. J&L's refusal to comply with the NLRB's order of April 9, 1936, to reinstate the workers and to desist from preventing workers from organizing themselves led to a court case that worked its way through the system. Initially, it looked to be the death knell of the Wagner Act when on June 15, 1936, the Fifth Court of Appeals overruled the NLRB's order on the basis of J&L's argument that the federal government had no constitutional powers to regulate labor relations.[25]

The appeals court decision was one factor in the first meeting of the SWOC; it met on June 16, 1936, in Pittsburgh under the leadership of Philip Murray, vice president of the United Mine Workers, who was sent by John L. Lewis to organize the steel industry for the new CIO. Clint Golden was appointed regional director for the crucial Pittsburgh area.[26] Thereafter the defense of workers' rights to organize themselves and to bargain collectively was pursued on two paths: the legal and the organizational. Both were affected by political events during the pivotal election year of 1936.

The election of 1936 was crucial to Roosevelt's New Deal and to the SWOC's efforts to organize steelworkers. Ads by the AISI attacked the CIO, while Randolph Hearst's newspapers and the American Liberty League worked hard to defeat Roosevelt's bid for reelection. Newspaper ads in Aliquippa called John L. Lewis "a bloodsucker" and likened the CIO to communism. For his part, Roosevelt put together a coalition of southern Democrats, urban social reformers, including ethnic and African American leaders, and organized labor in his crusade for the New Deal. The SWOC did its part by publicizing Republican candidate Alf Landon's tie with J&L through his uncle, W. C. Mossman, company lobbyist and

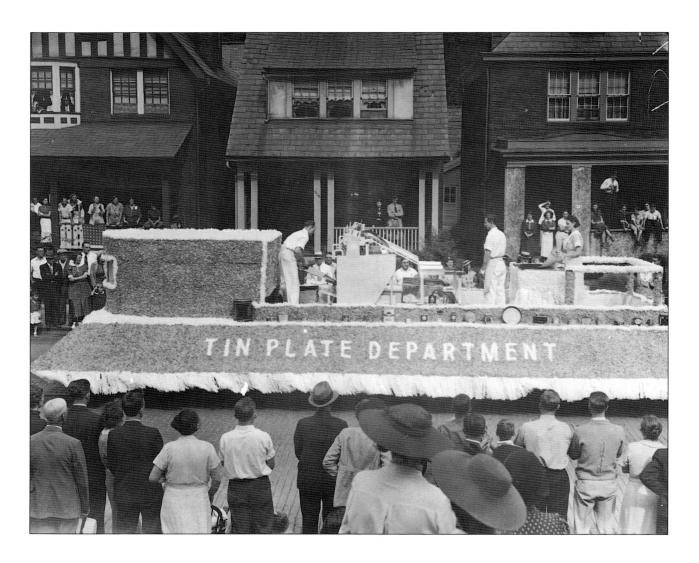

The company-sponsored Labor Day parade down Franklin Avenue, 1936.

public relations official, saying the election of Landon "would establish the steel barons in the President's office."[27] Rival parades were held on Labor Day 1936—J&L's in the morning, with support from the ERP, the Plan 12 Republican Club, and other organizations; in the afternoon, union supporters from near and far, led by the fired J&L workers with American flags. Their political sentiments showed in one "huge banner denouncing the 'Four Horsemen—Landon, the Liberty League, Hearst and the Steel Trust.'" Roosevelt's landslide victory in the country was matched by Democratic victory in Aliquippa. John L. Lewis drew the obvious conclusion, captured in SWOC leaflets: "STEELWORKERS WIN, Labor Vote Defeats Steel Barons at the Polls, Roosevelt Reelected. You must now win in the mills, on the job. ORGANIZE YOUR UNION."[28]

The SWOC had sent in one of its best organizers the previous June, Joe Timko, fresh from a successful year for the United Mine Workers in

Harlan County, Kentucky. His first day on the job revealed the extent of J&L's hostility, as he discovered four J&L agents ensconced on either side of his room in Ambridge. Quick calls to SWOC headquarters and a visit to the Democratic burgess (mayor) of Ambridge led to their speedy removal. Even though the company continued to fire many of the workers who attended organizing meetings, Timko was successful in recruiting new members, aided unwittingly by company intransigence. Workers became incensed by the heavy-handed use of police powers on behalf of the company in unwarranted arrests, illegal searches, and surveillance of union meetings. With some irony Timko thanked them for their aid in a leaflet: "I want to thank the Jones & Laughlin Steel Corporation for aiding our campaign by using such tactics. We have nothing to hide. We have nothing to fear. We conduct our activities openly and above-board. We are pursuing this campaign along peaceful and legal lines. We deplore the fact that others do not do likewise."[29] After secret meetings with Aliquippa ERP leaders in Pittsburgh, Timko even managed to recruit five of them, most notably Paul Normille, who on January 3, 1937, publicly resigned from the ERP and joined the SWOC. He was removed by a recall petition as a representative of the service department in the ERP, but a month later he was elected president of the new SWOC local 1211 in Aliquippa.[30]

The spring of 1937 saw three major union victories that would set the stage for the showdown between management and union at Aliquippa in May. In February the staying power of the CIO was demonstrated by the autoworkers' victory over General Motors, after which the SWOC experienced renewed recruitment success. Then in March the United States Steel

Joe Timko, Steel Workers Organizing Committee (SWOC) organizer (left), and Cliff Shorts, Amalgamated No. 200 leader (right), Aliquippa, 1937.

Corporation agreed to recognize the SWOC as the bargaining agent for its members, granting them their demand of a wage increase to five dollars a day; by early April all U.S. Steel subsidiaries and many smaller steel companies had signed contracts, but the major independents still held out. Finally, on April 12, 1937, the Supreme Court issued its decision in *National Labor Relations Board v. Jones & Laughlin Steel Corporation* (301 U.S. 1 [1937]). By a margin of one vote the court upheld the constitutionality of the Wagner Act, ruled against J&L, and applied federal powers in the interstate commerce clause to manufacturing facilities. It was a sweeping victory for the New Deal and for organized labor.[31]

Although J&L management disbanded their ERP[32] and began negotiations with the SWOC, it appeared by early May that the company was still unwilling to recognize the union and was moving to organize a new company union as an alternative to the SWOC. It was by no means certain that J&L workers would vote for the SWOC, even in an NLRB-sponsored election. Although the company offered a contract that would give them the right to bargain collectively with other worker groups, and that only if the SWOC won an election conducted by the NLRB within ten to fourteen days would they gain exclusive bargaining rights, the union, supported by a vote in favor of a strike by the membership, refused both provisions.[33] Some union leaders felt a strike was necessary to break "the absolute power" that the company had exercised in Aliquippa especially. The strike began late on May 12, 1937, and as the turn ended at 11 P.M. the workers leaving the mills joined the workers at the "tunnel" (under the railroad, entrance to the works) to block access by strikebreakers or anyone else who might aid management. Among the leaders in this were women employees, some of whom blocked a truck bringing mail and discovered it was bringing supplies to those besieged in the works.[34]

One SWOC staff participant, Meyer Bernstein, described the strike to a college friend:

Aliquippa rose up against a tyranny that had held it for years. For all practical purposes, the workers took over the reins of government. They were in complete control. Only for two hours were the police even in sight. They tried to force an allegedly empty bus through the picket line. They had gas and guns. But the bus was pushed back and out. The police were permitted to go through the line on foot, but when they tried to get out again, they were stopped. They had to blast their way through with tear gas. The strike is a rank-and-file affair. S.W.O.C. may have called it, but it is now in the hands of anyone who can lead. It is

a mob, not an organization. They have no more control than their lungs can command.

The strike is doing wonders for the men. Remember that Jefferson once said something about a revolution every twenty years or so being a blessing? The same is true of a strike. There is real solidarity now. And certainly no fear. In fact workers go out of their way to thumb their noses at company police by whom they have been cowed for years. Thousands of men have joined the union during the last few days—especially after the strike was called. . . .

Of course there has been violence. Four or five old men who had no notion of what was going on tried to get through the picket line. They were stopped and led back, but the return was run through a gauntlet. They were badly beaten and most of them were bloody. Even an organizer was just barely saved from an attack. He had to drive in

SWOC strike at Aliquippa Works, May 14, 1937.

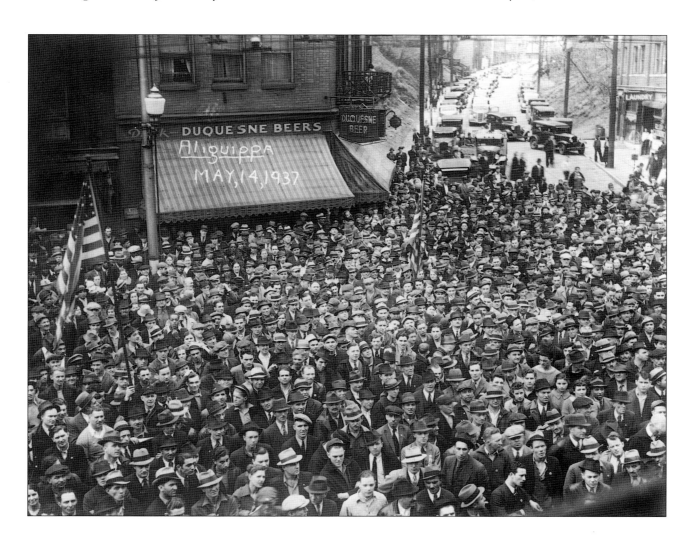

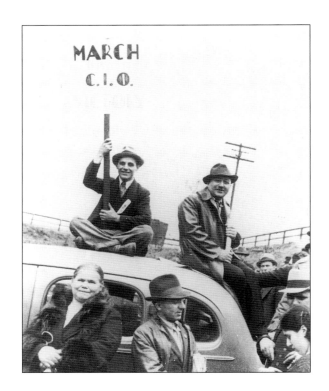

Strikers Angelo Volpe and Andy Matijasic (with sign), May 1937.

SWOC strike at Aliquippa Works, May 14, 1937.

among the men at the main gate to get reinforcements for other gates. Some zealous souls, not knowing who he was, tried to stop him. He was rescued before he met the fate of a foreman who tried to drive through the line. The foreman's windshield was smashed by a picket.[35]

On May 14 Governor Earle arrived to look the situation over and to demonstrate his support for labor (as they had supported him in his election). Brooks tells the story of the reception he and Timko received from the company police: "They drove through the tunnel and on the other side were halted by company police with raised rifles. They didn't recognize the governor until too late. He and Timko got out of the car and the police tried to hide their rifles. Timko reports that the Governor said, 'Never mind. I've seen them. I don't want any trouble here. Let the company and the union get together and settle this peacefully.'"[36]

Bill Smith with a Pennsylvania motor policeman (a "Keystone Cop") at the Aliquippa Tunnel, May 1937.

Women tin snippers at the tunnel, May 1937.

This in fact occurred later that morning in Pittsburgh, and by noon a preliminary agreement was signed. It took a state trooper escort for Timko to get back to the tunnel with the news and then some quick thinking by Timko to get the workers to disband and to keep them from wreaking revenge on the strikebreakers as they left the mills; he hired a band to lead an impromptu parade of some twenty thousand away from the mill. The agreement was even better than the one SWOC got from U.S. Steel. As Bernstein wrote, "Think of it, the toughest Corporation in America brought to its knees in exactly forty hours. The union now has a better contract than that signed by U.S. Steel. The company has signed the U.S. Steel contract already and agreed to sign an exclusive bargaining contract if the union wins a board election to be held in a few days. In the meantime the company agreed not to put any pressure on the men."[37]

The election, held on May 20, was an overwhelming victory for the SWOC, 17,028 to 7,207 at both the Pittsburgh and the Aliquippa Works. On May 25, 1937, the final contract was signed, making the SWOC the "exclusive collective bargaining agent for all of its employees," providing a minimum wage of five dollars per day based on an eight-hour day and forty-hour week, three paid holidays, and one week's paid vacation for employees of five years or more continuous service. It also established

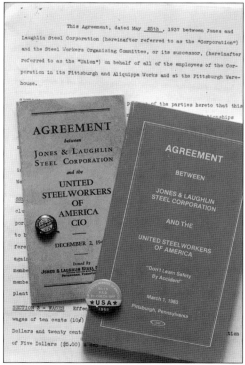

The J&L police force at the Aliquippa Works, ca. 1930.

(Far left) Labor-management agreements grew from a few typed pages to booklets with hundreds of pages. The first such agreement was made on May 25, 1937; the first made with the organized USWA was made on December 2, 1942; and the last made with J&L was on March 1, 1984.

(Left) The initial instruction booklet for handling grievances was issued by the Steel Workers Organizing Committee in 1937.

rules for seniority and procedures for dealing with grievances and promised "reasonable provisions for the safety and health" of workers. Negotiations for the contract for the following year were to commence on February 7, 1938.[38]

In the only reference to the contract in *The J&L Steel Employes Journal*, a statement by H. E. Lewis was simply quoted on the front page: "The Jones & Laughlin Steel Corporation is gratified that such an important issue has been so amicably settled by peaceful and democratic methods under the provisions of the Wagner Act. Now that the election is over and our employes have made their decision, let us forget the tension of the past few weeks and cheerfully apply ourselves to our duties, as there is much for all of us to do with our order books better filled than for some time past."[39] While it would be misleading to say that this did in fact happen, tensions did ease as management of the "toughest anti-union company in America"[40] in the years ahead came to terms with the new labor environment, much as B. F. Jones had two generations before.

Gauging Ford generator steel at Aliquippa's 14-inch mill, 1937.

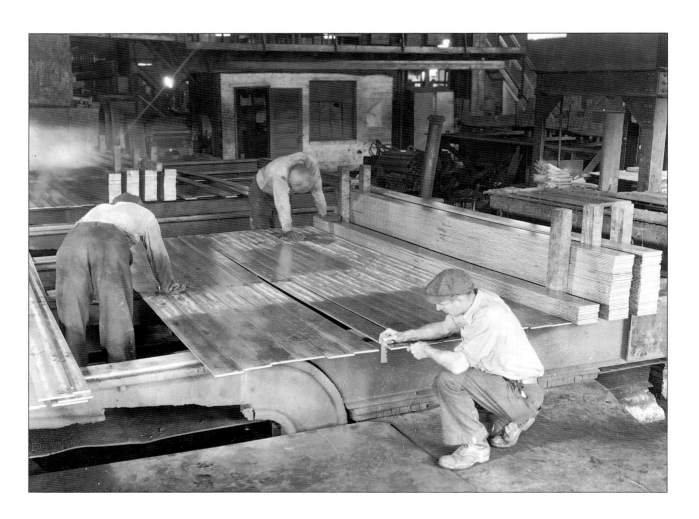

Worker empowerment in Aliquippa in May 1937 carried over into the elections in September as the Democratic Social Club finally nominated pro-union candidates on the Democratic ticket and swept all but one council seat from the Republican borough machine in November. The new mayor announced he would fire the "most brutal of the city's policemen." Thereafter the victorious SWOC had its hands full exercising "tight control and internal discipline" over its rank-and-file members in a union system that was not yet fully democratic.[41]

Victory over J&L at Aliquippa did not mean victory over "Little Steel," as the various independent steel corporations were called. The election of Tom Girdler, an implacable foe of unions, as president of the AISI on May 27, 1937, showed their resolve to resist. That they would do so with force was demonstrated all too clearly on May 30, 1937, when a peaceful picnic by striking Republic steelworkers in south Chicago was turned into tragedy by police violence. At about the same time the only casualty among Aliquippa workers occurred when a picket, supporting his colleagues at Moltrup Steel in Beaver Falls, was killed. Eventually, even Girdler's Republic and Grace's Bethlehem would sign with the United Steel Workers of America (USWA), but that would be years later, in 1941, and under very different circumstances.[42]

Heady Wartime Expansion

seven

War always disrupts things, but disruption is not the same as destruction. The Second World War was both disruptive and destructive, yet it also provided opportunity and stimulation for economic development. This was as true for Jones & Laughlin Steel Corporation as for the rest of the nation. The war did provide a stimulus for employment, facilities expansion, and technological developments. But the war also consumed products, resources, equipment, and human life; in stimulating the economy it distorted it. The end result was a new complex set of social, economic, and political relationships that affected the steel industry of which J&L was a major part.

Even before the entrance of the United States into the war in December 1941, the war in Europe had an impact on demand for steel products. J&L's sales of major steel products rose from just over 1 million tons in 1938 to just over 2.3 million tons in 1940, while its production as a percentage of capacity went from 37 percent in 1938 to 60 percent in 1939, and to 85 percent in 1940. Its net income rose as well, from a deficit of $5.9 million in 1938 to surpluses of $3.2 million in 1939 and $10.3 million in 1940.[1] Once the United States entered the war, demand increased even more, and by 1945 sales of major J&L products had risen to just under 3.2 million tons. During most of the war years production was slightly above total ingot capacity, a capacity that itself increased with the 1942 acquisition of the Otis Steel Company of Cleveland, Ohio. Measurements of capacity, of course, are given in various terms, with the most significant being tonnage of pig iron and steel ingots on the one hand and finished and semifinished

steel products on the other. Peak wartime production for J&L was reached in 1944 at 4.3 million tons of pig iron and 5.1 million tons of steel ingots. Most of the finished products were for wartime use and included "armor plate, shell forgings, shells and bombs, landing craft, mortar discs, powder boxes, bomb fins, containers for airplane parts, gun barrels, processed mortar tubing blanks, copper-clad steel for small arms bullet jackets." By war's end it amounted to just under 3.2 million tons of the rolled steel products produced in 1944.[2]

Prior to 1942 and unlike other major steel corporations, expansion of J&L's basic steel-making capacity had been accomplished through the development of new facilities rather than by acquisition, most notably by the building from scratch of the Aliquippa Works. When J&L had purchased other companies before 1942 they had been mines, transportation, warehousing, or intermediate merchandizing firms. Two—the National Bridge Works (1935) and the Bayonne Steel Barrel Company (1939)—dealt with specialty steel fabrication rather than primary steel production.[3] The acquisition of Otis Steel was a major break with the company's practice. The company's stated motivation included a desire to gain a shipping point outside the Pittsburgh region and thus give the company access to Detroit and other markets "where it has been at a great disadvantage."[4]

The Otis Steel Company, founded in 1873, was "the first in this country, if not in the world, to be formed for the exclusive purpose of producing

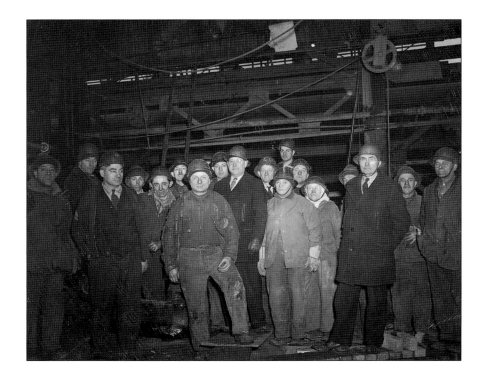

J&L workers during World War II, January 4, 1944.

open hearth steel."[5] It produced steel by the acid open-hearth method; then in 1886 it was the first in North America to produce steel by the basic open-hearth method. By July 1, 1942, when it was acquired by J&L for just over $35 million, it had two major production facilities: the original Lakeside Works on Lake Erie and the Riverside Works on the Cuyahoga River, the latter begun in 1912. In addition to fifteen open-hearth furnaces (of both types), the two works included coke ovens, a by-product plant, two blast furnaces, an electric furnace, a 40-inch reversing blooming mill, 77-inch and 30-inch continuous hot strip mills, a 77-inch tandem cold reducing mill, and various other facilities for rolling steel.[6] The acquisition increased J&L's capacity by 20 percent, to about 3.2 million tons of rolled steel products.[7]

The 72-inch (enlarged to 77 inches) hot strip mill at Otis Steel, Cleveland, September 1938.

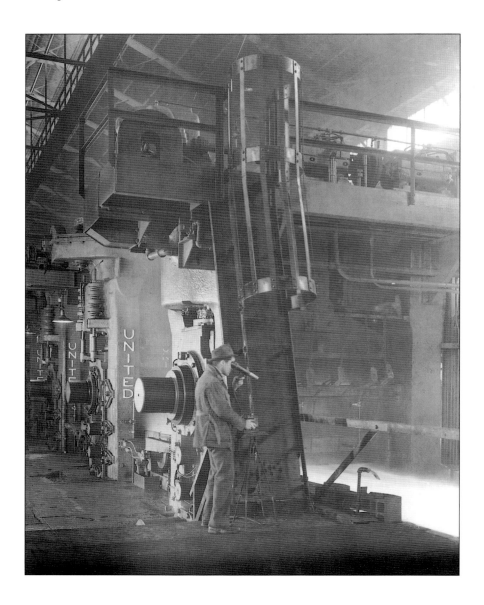

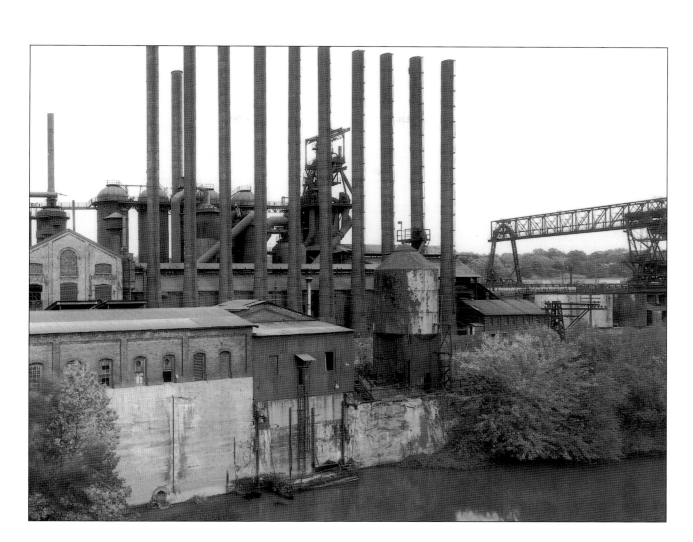

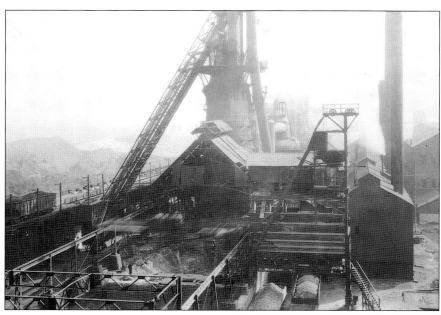

Blast furnaces at J&L's Cleveland
Works: *(above)* Lakeside Works;
(left) Riverside Works.

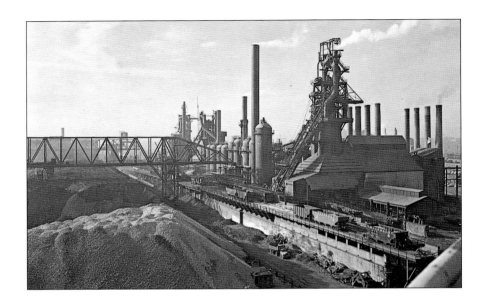

Blast furnaces at J&L's Cleveland Works: *(right)* Riverside Works; *(below)* Riverside coke plant and blast furnace area.

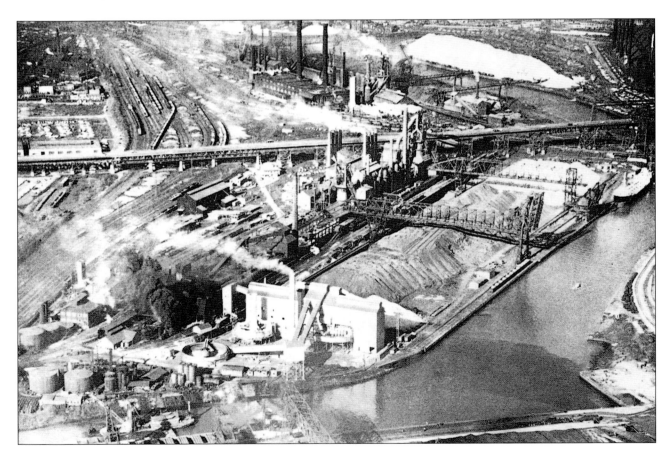

Nor was Otis the only acquisition. J&L purchased Wackman Welded Ware in 1942 and Draper Manufacturing Company in 1944. And the 1944 purchase of Electric Weld Tube, a division of Talon, Inc., in Oil City, Penn-

sylvania, provided facilities that would be useful for postwar consumer products. One temporary acquisition in 1940, of the tin plate plant of the McKeesport Tin Plate Company at Port Vue, Pennsylvania, would be especially useful in meeting wartime demand for shells and bombs. Purchase alone, even temporary, does not tell the whole story, however. For in 1941 J&L entered into a major lease for magnetic iron ore from the Benson Iron Company in St. Lawrence County, New York, to supplement its main ore supply in Minnesota's Mesabi Range and in Michigan's Upper Peninsula. A concentrating and sintering plant was built at Benson during the war with government-provided funds.[8]

Employment figures reflected the increased demand that war brought. Economic recovery and the labor problems of 1935–37 had resulted in an increased workforce anyway, from an average of 22,793 in 1934 to 35,551 in 1937. The recession of 1938 caused a reduction in employment to an average of 26,286 that year. By 1940, however, demand from the European war had increased employment to 32,187; it increased still further in the next two years, to 39,620 on average in 1942. It dropped somewhat during the remaining war years as many joined the military forces; those who remained working went on longer hours. By 1945 it was down to 37,626 on average.[9]

In addition, a significant number of these workers were women, for the necessities of wartime demand overcame in some measure the prejudices against women working in steel mills. Before the war women had worked in some parts of the tin mill, as sorters and floppers (flipping cut tin over to check for holes), and as secretaries and nurses, but during the war they appeared in other parts of the mills as well. Many J&L workers enlisted or were drafted to serve in the armed forces. By November 1944 the dead or

Benson Mines, New York, 1907.

missing numbered 127; another eighteen were listed as prisoners of war.[10] The use of women was especially evident in the production of shells and bombs at the Pittsburgh and Aliquippa Works, and particularly at the newly acquired McKeesport Works (formerly run by McKeesport Tin Plate Company). The role of women in all this was not just in the inspecting and finishing operations, for they worked on the production line itself. "Ingenious lifts and conveyors" made it possible for "the smallest woman operators [to] easily swing the big shells into position."[11]

The first production of shells for the war occurred at Aliquippa in 1940 as a result of British demand for six-inch shell forgings. J&L engineers converted a large "upsetting" machine in the tube mill that had been making J&L integral joint drill pipe into a shell-forging machine capable of making shells that were sixteen pounds lighter than the older shells and did not require the usual additional machining of the cavity. This was later used in the production of 155-millimeter high-explosive shell forgings. In 1942 a small upsetter was converted to produce 90-millimeter shell forgings. Other improvisations to convert existing machines to produce bombs and shells more efficiently included threading equipment for 4.2 chemical shell blanks and 81-millimeter shell blanks. The McKeesport Works became the center for much J&L munitions production at the request of the Army Ordnance Department in 1940, with one of the largest shell production lines in the country. J&L engineers had to scramble to adapt existing machinery and produce new ones to meet what Maj. Gen. Levin H. Campbell, chief of ordnance, so aptly termed "the fluidity of war." For example, they had to retool machinery from producing the 105-millimeter high-explosive shell to producing the 105-millimeter smoke shell, from 8-inch howitzer and gun shells to the 256-pound shell used by the "Black Panther" gun, and from the 500-pound semi-armor piercing bomb to the 500-pound general purpose bomb, and eventually to the 1,000-pound bomb. "The aggressive manner of handling" these problems led the army to bring executives of other shell-producing companies to observe how well J&L surmounted the obstacles to keep production going.[12]

Shells and bombs were not the only war material produced by J&L. A summary appeared in *Of Men and Steel*, published by the publicity department during 1944 and 1945:

The products and facilities of Jones & Laughlin have been turned from peace to war several times during the near century of its existence but never to the extent that they now serve the United States and its Allies. A list of all the items being produced either directly or indirectly for

war by J&L includes all of the products normally produced and which are now being put to war use. These are such items as hot and cold rolled steel for shells and machine parts, pipe for ships and military building, Junior Beams and Junior Channels for ship and submarine construction, Jaltread checker floor plates, wire rope for use by the army and navy, ship plate for cargo vessels, mechanical tubes for truck and jeep axles, and tank drive shafts, sheet and strip for ammunition boxes, tin plate for food containers, blood plasma cans and a number of other containers; spring wire, barbed wire, signal corps wire; Jaltruss for ammunition dumps and a multitude of other products.

The list of war products not normally produced by Jones & Laughlin includes alloy plate for aircraft and tank armor, amphibian tank sprockets, bullet core steel, bullet jackets, cartridge case steel, gas bottle tubes, gun barrel tubes, gun mount forgings, powder boxes, shell steel, shot steel, tank tread sections and tread pins.

The company also is fabricating sections of the famous LST (Landing Ship Tanks) which are sent to a shipyard for assembly. At one warehouse J&L has made a number of the small landing craft known

J&L produced *Of War and J&L* (1945) to show how the company had contributed to the war effort.

as "boars" complete and ready to run upon delivery. In addition, millions of bombs, bomb casings, shells, shell blanks, shell forgings, bomb booster adaptor forgings, bomb fragmentation components and fragmentation bombs have been produced by J&L.

In turning from peace-time operation to providing war material all the experience and know-how gained by J&L in years of producing high quality steel and steel products were called upon. Much of the conversion had to be done quickly and most of it was pioneering work.[13]

The demand for war material led to new records in production. In March 1943 the blooming mill at Aliquippa set a world record by rolling 171,440 tons of ingots, while one crew rolled a record 512 ingots during a single eight-hour turn the same month. And in January 1944 the No. 18 (bar) mill at the Pittsburgh Works rolled 44,125 tons of bars for a world record for 14-inch bar mills, "truly a tribute to the J&L men who designed it and the skilled men who operate it." All three of the major J&L Works (in Aliquippa, Pittsburgh, and Cleveland) received the Army-Navy "E" (Excellence) awards for their contributions to the war effort.[14]

The publication of *Of Men and Steel* was an effort by J&L's publicity department to educate and inform the public and its own employees about J&L's activities. Twenty-two issues appeared on a monthly basis from January 1944 to October 1945. The publication consisted of eight pages following a simple format: The front page was a picture illustrating the main subject of the issue. Pages 4 and 5 held an advertisement that appeared in *Time, Newsweek, The New York Times, The Wall Street Journal*, and local newspapers and leading trade papers. Each ad consisted of a drawing made by Orison MacPherson on the subject of the main article and sketches of people, sometimes by name, who worked in the particular part of the operations highlighted. There was always a sidebar with key information drawn from or supplemental to the article. Fourteen of the issues had a back page devoted to some document from American history, such as the Monroe Doctrine, Washington's Farewell Address, the Bill of Rights. Four or five pages of each issue were dedicated to a major article. The first nine issues described the production of steel from resources to finished products, with particular attention to the role of J&L in the overall story: iron ore mining, coal to coke, making iron, Bessemer converters, two issues on open-hearth furnaces, the soaking pits, and two on rolling mills. The remaining thirteen issues deal with key aspects of J&L activities, usually focusing on one department or product line, such as bombs and shells, metallurgy, safety programs, strip mills, cold rolling, electrolyte tin plating, the "steel box," wire, wire rope, barrels and drums, the warehouses, seamless pipe, and

finally electroweld tubing. Publication ceased when the publicity department shifted over to outside advertising to give "widespread publicity to J&L steel products in order to help our sales organization get orders" for peacetime products.[15]

Most articles touched directly on the role of J&L in the war effort, stressing the J&L innovations that contributed to military success. One such achievement was the development of intermediate manganese steel for armor plate, which used less of the necessary alloys, often in critically low supply, while maintaining strength; the head of J&L metallurgical research, Herbert W. Graham, was the main figure in this. When it survived the testing of the army proving grounds at Aberdeen, Maryland, the attendant J&L metallurgists gave a collective sigh of relief.[16] The use of wire rope produced at J&L's Muncy, Pennsylvania, plant in tank treads was

Pittsburgh "E" award ribbon from WWII.

Liberty band display, Pittsburgh Works, ca. 1943.

Women workers and others at "E" awards ceremony, Aliquippa Works, 1943.

The following is the newsletter image content:

of MEN and STEEL
The story of Jones & Laughlin operations

Steel Box One of War's "Secret Weapons"

This little box pontoon, 5'x7'x5', invented by the Navy, is constructed of light steel plate made watertight over a light structural frame, generally composed of J&L Junior Tees rolled on the versatile 14" mill at Aliquippa Works — only mill of its kind in the industry. Enabling invasion craft to unload on unguarded, shallow beaches, the steel "miracle box" took the Nazis completely by surprise. It now serves in all theaters of war as docks, wharfs, and lighters for Navy and merchant ships, shortening "turn around" time.

THE Germans in Southern Sicily received a rude jolt from an American secret weapon one day in July, 1943. This new weapon enabled the Allies to catch the defenders of Fortress Europe off their guard and accomplish a landing where the enemy—which has built up a boastful fiction of close attention to every detail and every possibility with nothing left to chance—had little expected it because the location was considered an impossible one for putting troops ashore.

The secret weapon was not a new jet-propelled plane, nor was it a rocket-firing war ship. It was a simple watertight steel box, five-by-seven-by-five feet—twice the size of a big office desk. Not much to look at by itself, this pontoon became a potent weapon when fifty or sixty of them were coupled together to form a pontoon runway between a purposely grounded LST and an enemy beach. This mobile causeway began making victories possible from the Mediterranean to the South Pacific by putting troops and equipment ashore on shallow beaches right where the enemy least expected them.

This miracle box is constructed of light steel plates over a framework of light structural steel sections, many of which are J&L Junior Tees rolled on the versatile 14-Inch Mill at Aliquippa Works. The pontoons, with tricky gear to connect them together, were designed by Capt. John N. Laycock of the United States Navy Bureau of Yards and Docks to solve the problem of getting tanks, bulldozers, big guns, trucks and troops—all the equipment for a successful invasion—within wading distance of the sloping beaches of Southern Sicily. The Germans knew that our landing craft were designed to operate in water of normal depth which enables them to be run aground close to shore and lower their ramps right on the beach. Because of this they figured we could not operate on shores such as those of Southern Sicily where the beach extends under water like a gently sloping shelf for more than five-hundred feet off-shore. They knew, and we did too, that our LST's would run aground far from the shore in water that was less than six feet deep. Any vehicles and troops attempting to make shore from this distance through the deep water would be at the mercy of strafing and bombing aircraft, if they

The "rhino-ferry" made up of six strings of thirty pontoons each, and a couple of jumbo outboard motors to form a self propelled barge has been doing great work in unloading ships and transporting material in all the war theaters. The frames of most of these pontoons are made of J&L Junior Tees. This official U. S. Navy photo was taken in the English Channel during the invasion of France.

J&L's "steel box" was one of World War II's secret weapons. It was used to make movable piers, causeways, or jumbo rhino-ferries. It also served as a water container.

worked out by a J&L wire rope engineer and contributed to fewer breakdowns because of stretched or thrown treads. And J&L's Precisionbilt wire rope held many Liberty and Victory ships together, to cite just one of its uses.[17] The Jaltainer, a new type of shipping drum for the safe packaging and shipment of spare parts and other items to the South Pacific, was the work of the J&L Steel Barrel Company.[18] Even the seven warehouses (Pittsburgh, Chicago, Memphis, Cincinnati, Detroit, New Orleans, and Long Island City, N.Y.) made special contributions with their fabricating facilities. For example, sixteen "Landing Crafts, Tank" (LCTs) were built at the New Orleans warehouse.[19]

One distinctive J&L contribution, however, was dubbed by the publicity department as "one of the war's 'secret weapons'": the "steel box." This was a 5×7×5-foot sealed box that could be used in a variety of ways, linked together as a movable pier or mobile causeway or even as a carrier for water. The steel box was made using the patented J&L junior tees rolled on the unique 14-inch mill at the Aliquippa Works. They had been designed by a naval officer, Capt. John N. Laycock, but they depended on the

use of the junior tees for interior structural support. First used in the invasion of southern Sicily, which led opposing forces to treat all waterfronts as potential invasion grounds instead of just those with suitable harbors, then as giant "rhino-ferries" (thirty of them linked together with jumbo outboard motors) in the South Pacific, the versatile steel box demonstrated its tremendous value in the war effort. Aliquippa's 14-inch mill had been uniquely designed by J&L engineers and put into production in 1924, and its patented Junior I-beams, Junior tees, and Junior channels would be widely used by both the army and the navy.[20]

The management team that was called upon to deal with the wartime situation at J&L was headed by H. Edgar Lewis, chairman of the board since 1936 and president of the corporation since 1938. Lewis (1882–1948) was a native of Wales, the son of a Welsh tin mill roller, who came to the United States with his family when he was fourteen. His career in steel began three years later at the Duquesne Works of the Carnegie Steel Corporation. In 1906 he moved over to Bethlehem Steel and rose to become executive vice president by 1916. In 1930 he became president of the Jaffrey Manufacturing Company of Columbus, Ohio. Finally in 1936 he was elected by the board of J&L to succeed George M. Laughlin Jr. as the first nonfamily chairman of the board. He became president of Jones & Laughlin when Samuel Hackett retired two years later. Under him the management group continued to be composed mostly of men who had risen through the ranks at J&L but with a few pulled in from outside. For example, S. S. Marshall Jr., vice president in charge of operations, H. D. Stark, general superintendent of the Pittsburgh Works in 1941, and J. C. Murray, assistant general superintendent of the Pittsburgh Works, had all worked exclusively for J&L, while J. B. Carlock, chief engineer of the Pittsburgh Works, and C. L. McGranahan, assistant general superintendent of the Pittsburgh Works, had both worked for other steel companies before joining J&L.[21]

The earlier paternalistic relationship of J&L management with Aliquippa had been destroyed by the events of the 1930s. The attitude of Lewis and his management team was reflected in an interview he and Marshall gave to the publisher of the *Aliquippa Gazette* early in 1940. Al Tilton, the publisher, wrote a laudatory article that characterized J&L as "a vast democracy, owned by thousands of stockholders, each with a voice in corporate affairs" but with Mr. Lewis as the one able to "explain corporate policy of the moment." And that policy toward Aliquippa was positive. The company would continue to build up the Aliquippa Works and encourage other manufacturers to join them, especially those "which will consume its own products." The company wanted Aliquippa to grow, but

on its own: "The days when J & L would build swimming pools, homes and public buildings and present them—complete and wrapped in an attractive package—to the people of Aliquippa are over." The relationship between company and town should be mutually beneficial, "working together in a spirit of mutual understanding."[22] The publicity department under W. T. Mossman and E. F. Blank was very concerned about how the article would appear and made a number of suggestions before they agreed to its publication, with the statement that it "would do us considerable good in Aliquippa and the Beaver Valley."[23] In any case, as Aliquippa's largest employer, J&L could not help but have significant influence in borough affairs, even if management were to reverse completely its previous anti-union stance.

The commitment of J&L to Aliquippa became especially evident after the war, when the need to replace outmoded and overused facilities was met by a massive improvement and modernization program, estimated to

The north mills at the Aliquippa Works, ca. 1940s. The main office is in the center of the photograph.

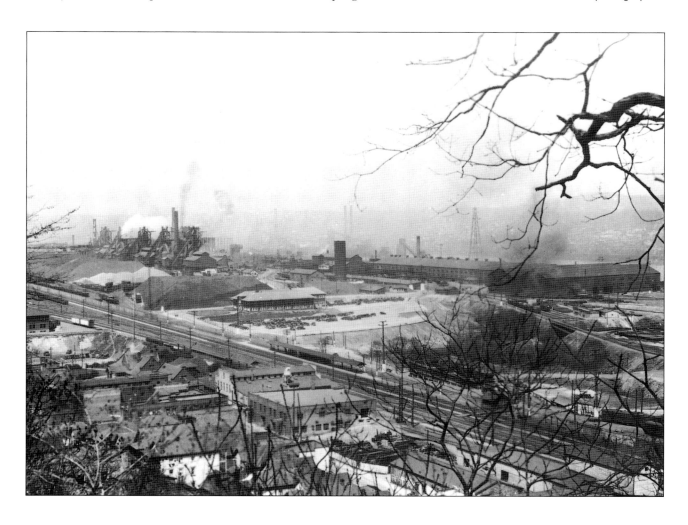

The old beehive ovens at the Aliquippa Works's south coke plant made coke throughout World War II.

cost over $180 million between 1946 and 1950. A new battery and a replacement battery of coke ovens, improved by-product facilities, and a 45-inch tandem rolling mill at Aliquippa, improvements in the electrical system at Pittsburgh, and two new temper mills at Cleveland (Otis Works) began the program in 1946. That same year J&L purchased from federal agencies the two electrolytic tinning lines at Aliquippa and the mine plant and equipment installed at the Benson Mines during the war at government expense. The total cost for all of this in 1946 was just under $19.9 million. At the same time the Lakeside Works of the Otis Steel Company was closed, as were some other outmoded plants and equipment at Aliquippa and the Hill Annex Mine, while the J&L Steel Barrel Company sold two of its plants. In 1947 the expansion program continued, at a cost of over $33.9 million, with a major part of it going for improvements and new facilities at Aliquippa. Nearly $46.6 million was spent in 1948, and again Aliquippa received a disproportionate amount, although Cleveland increased its share. The pace of expenditure fell off in 1949 to $41.8 million, which was spread more equitably among the various J&L facilities, including the Vesta Mines (at one time the largest operating underground coal mine in the world once Nos. 4 and 5 were joined). Although the program was financed mainly by the traditional J&L policy of keeping dividends low and reinvesting much of the earnings, the company did finance some of it by mortgage bonds and bank credit, so that by December 31, 1950, the total outstanding debt was just over $71.8 million.[24]

* * *

Management-labor relationships during the war were circumscribed by the no-strike pledge and the work of the National War Labor Board (NWLB). The year before the war started, the SWOC proved victorious over "Little Steel," as Bethlehem, Youngstown Sheet and Tube, Inland, and even Girdler's Republic Steel all entered into contracts that ended any chance for company unions to challenge the SWOC. The union movement in general was troubled by rivalry between the AFL and CIO; by a series of strikes in 1940–41, culminating in the impressive victory of the United Auto Workers over Ford; and by John L. Lewis's embarrassing support for Wilkie over FDR in the 1940 election and his subsequent puzzling relations with the Communists. SWOC leadership tried to walk a careful line during those uncertain times.[25] In May 1942 the SWOC was reconstituted as the United Steel Workers of America (USWA), with Phillip Murray as president, David MacDonald as secretary-treasurer, and Clinton Golden and Van Bittner as assistants to the president (later vice presidents).[26] Murray served also as president of the CIO after Lewis stepped down in 1940.

After the attack on Pearl Harbor, both AFL and CIO pledged to refrain from strikes for the duration of the war. Union membership increased during the war, despite a shift in the workforce toward greater use of women and African Americans and the resultant tension in some unions that led to a series of "hate" strikes in 1943; the United Auto Workers moved quickly to defuse the tensions in Detroit. In January 1942 FDR established the

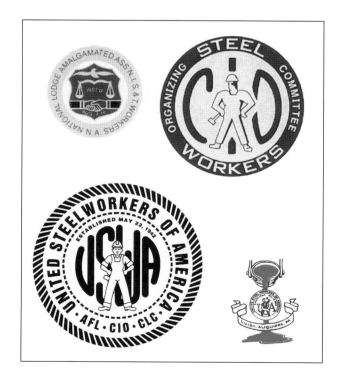

Logos of the Amalgamated Association of Iron, Steel & Tin Workers; the Steel Workers Organizing Committee; the United Steelworkers of America; and Local 1211 (Aliquippa).

National War Labor Board to resolve war industry disagreements, with equal representation from labor, management, and government. As often happens in such cases, board actions were criticized by both management and labor at various times, and bureaucratic regulation became burdensome as time passed. The decision by the NWLB to extend the Little Steel Formula to all wage increases, thus limiting them to the actual increase in living costs, which was considerably less than what the workers felt entitled to, was a crucial part of the government's anti-inflation policy but did not sit well with steelworkers. Union members of the NWLB termed this "a serious blow at the foundations of collective bargaining."[27] On the whole, however, the NWLB worked with union leadership fairly well and even found ways to bend the Little Steel Formula to workers' advantage in later years. The union leadership realized more than did the rank and file that political sentiment in Congress was increasingly antiunion, as was revealed

Teeming ingots from an open-hearth furnace at the Aliquippa Works.

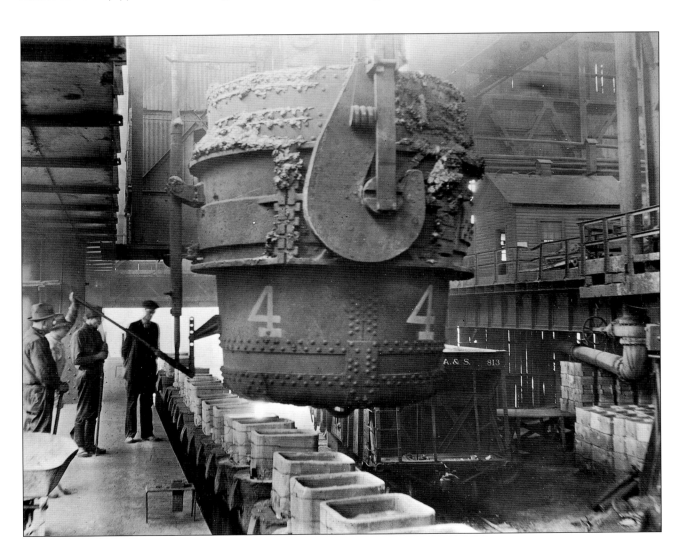

by the Smith-Connally Bill, which would have sharply limited union power. FDR vetoed it, but Murray and the others realized that however much they criticized government policy in private, they had to present a more accommodating stance in public. At least the NWLB did provide support for union security by its maintenance-of-membership policy in the face of management's efforts to take advantage of the no-strike pledge. While unions disliked the wage policy of the NWLB, management hated the security afforded the unions by the maintenance-of-membership policy.[28] In all of this there was little to distinguish J&L's management from the management of the other steel corporations.

The same can be said for the immediate postwar situation, as the end of the war also meant the end of the no-strike pledge and as the cumulative effect of anti-inflation wage controls led to a wave of strikes in 1945–46. The steel industry, including J&L, was struck on January 21, 1946, after management refused the compromise wage increase of 18.5 cents per hour brokered by President Truman. The strike ended about three weeks later when management agreed to the wage increase but also secured the right to raise prices by five dollars a ton and to have price controls lifted.[29] At the same time, labor and management were working on a joint project to establish consistent job classifications as a way to eliminate wage inequities, using U.S. Steel as the pattern for the other companies. The resulting "Cooperative Wage Study Job Description and Classification Manual" (CWS Manual) was completed in 1947, and all jobs were grouped into thirty classes.[30]

In 1946 Republican majorities were elected in both houses of Congress, and in June 1947 the Labor-Management Act (the Taft-Hartley Act) was passed over President Truman's veto. This act amended the Wagner Act and restricted unions while strengthening management; the right to strike was limited and union leaders had to sign anti-Communist affidavits, while individual states were permitted to pass right-to-work laws limiting closed shops. The tilt toward the unions was thus reversed by a tilt toward management. Head of both the USWA and the CIO, Murray refused to sign the affidavit, as did others, and this put their access to NLRB representation elections in jeopardy. Pressured by other officers to reverse his stand, Murray did so reluctantly. The burgeoning Cold War between the United States and the Soviet Union was matched by a fight between pro- and anti-Communists in the American labor movement.[31] Once again, J&L's role was no different from that of the other main steel companies.

The management team that had brought Jones and Laughlin through the war as the fourth-largest steel producer in the country remained much the same until March 1947, when H. Edgar Lewis retired as chairman and

JONES & LAUGHLIN STEEL CORPORATION

H. E. LEWIS
PRESIDENT

PITTSBURGH June 12, 1945

TO ALL J & L MEN AND WOMEN IN THE ARMED SERVICES

We believe that each of our 12,000 employes who have gone into various branches of the military service will enjoy reading the attached pamphlet entitled, "OF WAR AND J & L." This booklet clearly shows the extent to which J & L products and services have been used in this war by our armed forces.

Also, we want to take this occasion to tell you briefly about the plans the Corporation has made in preparation for your return to us. Without going into great detail, the most important features of the J & L Veterans' Reinstatement Plan are as follows:

1. Every permanent employe who applies within 90 days after discharge from military service will be offered the regular job he held at the time of his induction. If for any reason such position has been discontinued, the veteran will be offered a job similar to the one that he formerly held.

2. There are a large number of employes in the service who were hired during the war and are classified as temporary employes. Although the Selective Service Law does not provide any reinstatement rights for temporary employes, the Corporation has decided to grant all temporary employes full seniority credit for time spent in the military service. This means that every such employe is guaranteed his opportunity for obtaining re-employment at J & L on the basis of his fully accumulated seniority.

3. With respect to those employes who may be disabled, our policy provides for granting them the same consideration as able-bodied veterans. This means that if a veteran is unable to return to his old job because of a physical handicap, every effort will be made to place him in a job for which he is qualified.

4. In the transition period from war to peace-time production, there may be temporary delays to immediate re-employment, brought about by changes in equipment, newly developed processes, new products, etc. We hope that these delays, if any, will occur only in the early adjustment period and that they may be of short duration. The Corporation has determined that a veteran's seniority status and re-employment rights shall continue until his old job, or a similar job, becomes available.

5. Many returning veterans will have acquired new skills through special training while in the service. It is the intention of the Corporation to give these employes a chance to use these skills wherever possible. Some employes will have lost their previous skills through lack of application or practice. The Corporation plans to assist these employes to re-acquire these skills as quickly as possible so that they may resume their former status.

We sincerely look forward to your return to J & L, and urge that at your earliest convenience after discharge from military service you contact your former employment office in anticipation of the quickest possible return to a normal peace-time job.

JONES & LAUGHLIN STEEL CORPORATION

H. E. Lewis

President

H. E. Lewis's letter of June 12, 1945, to J&L men and women serving in the armed forces.

president, citing ill health. He died of pneumonia on December 3, 1948, at the age of sixty-eight. The man chosen to replace him in both positions was the wartime head of the navy's Seabees, Admiral Ben Moreell, whose tenure as chief executive of J&L would mark the apogee of the company's fortunes in the twentieth century.

eight The Moreell Years

At the beginning of the century J&L was the second largest producer of steel products; at midcentury it was the fourth largest, and by 1960 it would fall to fifth. How can we then write that Admiral Moreell brought J&L to the "apogee of the company's fortunes in the twentieth century"? The reason, of course, is that under Admiral Moreell the Jones & Laughlin Steel Corporation produced more steel than it ever had on an annual basis. At least three other companies, however, continued to produce more than J&L, and one that previously produced similar amounts had by the end of the decade surpassed J&L. The phrase also suggests that the process of J&L's decline also began during, or at least immediately after, the Moreell years.

Admiral Ben Moreell served as chairman of the board and president from March 1947 until January 1952, when he relinquished the presidency to his executive vice president, C. L. Austin, while retaining his position as chairman and chief executive officer. Lee Austin had worked primarily in finance before coming to J&L from Mellon Bank in 1942 as treasurer; it was Moreell who moved him up to executive vice president in January 1948 and later to president. However, in October 1956 Austin was "kicked upstairs" as vice chairman, and Avery C. Adams was brought in from Pittsburgh Steel as president. Thus, both Austin and Adams, like Moreell himself, were outsiders to J&L. When Moreell finally retired on October 1, 1958, he was succeeded as chairman by Avery C. Adams, who again combined the positions of chairman and president for a while. Adams had had

The management team under J&L
president Admiral Ben Moreell, ca.
1953.

Directors and Officers of JONES & LAUGHLIN STEEL CORPORATION

*BEN MOREELL
Chairman of the Board of Directors*

W. C. ROBINSON
Director

*FRANK R. DENTON
Director*

WM. LARIMER JONES, JR.
Director

*H. W. GRAHAM
Director and Vice President—
Technology*

J. C. WARNER
Director

*V. H. LAWRENCE
Director and Vice President—
Planning and Control*

*B. F. JONES, 3rd
Director, Vice President*

*J. W. BEAVIS
Director*

*C. L. AUSTIN
Director and President*

LESLIE L. LAUGHLIN
Director

A. T. LAWSON
*Vice President—
General Services*

*J. B. MITCHELL
Director and Executive Vice
President—Production*

*A. J. HAZLETT
Director and Executive Vice
President—Distribution*

W. R. ELLIOT
*Vice President—Employee
and Public Relations*

a more traditional career in steel with Republic, Inland, and U.S. Steel,
before becoming president of Pittsburgh Steel in 1950. He replaced Austin
as president of J&L in 1956 as a part of an administrative shake-up. In any
case, it would appear that from 1947 to 1958, despite all the administrative
changes, Ben Moreell was the dominant figure at J&L, much as the two
Benjamin Franklin Joneses had been during their tenures.

Born in Salt Lake City, Ben Moreell (1892–1978) grew up primarily in
St. Louis; he graduated from Washington University with a degree in civil
engineering just before the start of World War I. After working as a city
engineer on sewer construction for a few years, he joined the U.S. Navy in
June 1917 as a commissioned officer (lieutenant, junior grade) and saw
wartime service in the Azores, whereupon he decided to make the navy his

career. The next twenty years saw him serve in Haiti, the Norfolk Navy Yard, Washington, D.C., Puget Sound, France, and Carderock, Maryland, all the time moving up in rank despite his lack of a Naval Academy education. The year in France improved his French and his knowledge of European methods of engineering design and construction, after which his work at the model ship testing basin in Carderock, Maryland, and his research in concrete engineering brought him increasingly more responsible positions in the navy. In December 1937 he was named chief of the bureau of yards and docks and chief of civil engineers of the navy; he was also one of the youngest naval officers to hold the rank of rear admiral, his position when the attack on Pearl Harbor brought the United States into World War II. Moreell oversaw the tremendous $10 billion naval construction program that followed, but he was best known for organizing the naval combat construction battalion, known as the Seabees, or the Can-Do Boys, as he called them. By war's end these 10,000 officers and 240,000 men had built advance bases, roads, and floating drydocks under combat conditions, earning an enviable reputation for their "Paul Bunyan–like exploits." All of this brought him a promotion to vice-admiral, which caused some controversy since he was a staff officer and not on sea duty. However, a favorable legal opinion by the navy's judge advocate general cleared the way for Senate confirmation of the appointment.[1]

The end of the war did not mean the end of his contribution to public life, for in the labor unrest and federal control of key industries that followed in 1945 and 1946, Moreell directed the operations of four oil refineries and pipelines struck by the Oil Workers International, even bringing the hostile parties to a successful ending of the strike by mediating their negotiations. His objectivity was one reason why President Truman chose him in May 1946 to be deputy coal mine administrator in charge of the bituminous mines under Secretary of the Interior Julius Krug, and eventually he was given complete control of the mines. Enough progress had been made in his efforts to mediate a settlement of the miners' strike by June 1946 for President Truman to name him a four-star admiral, the first non-Annapolis graduate and the first staff officer to attain such a rank. When he left active duty at the end of September 1946, however, he had not yet brought the coal mine strike to a conclusion. He said that his retirement, long planned, could not be deferred any longer, but perhaps the disruptive division between northern and southern coal operators contributed to the timing of the retirement.[2]

Shortly after leaving the navy he was chosen as president of the Turner Construction Company, but before long, in February 1947, he was named chairman of the board and president of Jones & Laughlin Steel Corpora-

tion, positions he assumed on March 17, 1947. J&L was not unknown to him since as coal mine administrator he had in July 1946 recognized a United Mine Workers of America subsidiary union of foremen and other supervisors at several government-seized J&L coal mines, a precedent-setting action that brought some opposition from coal mine operators.[3] It would appear that his reputation as an effective administrator and a person who could get things done were key reasons why J&L's board of directors brought him in to succeed the ailing Lewis; his less hostile attitude toward unions also contributed to the decision. J&L was midway through a large expansion project expected to cost $180 million between its start in 1946 and its projected finish in 1950. By the end of 1948 $104 million had been expended, but this was not quite half of what the revised estimated cost would be to finish the project by 1950. Moreell would bring this program to a successful conclusion.

Moreell brought with him some pronounced views about how an organization should be run—views shaped by his navy experiences.[4] They were fairly common in contemporary management circles as well, stressing unity of command and a reasonable span of control, both aspects of the pyramidal organizational model, although he put particular stress on building good communications and an effective management team. Not long after his arrival at J&L he authorized a manual designed to help make "J&L the hard-hitting, tight-fielding team we know it can be," entitled "Major Objectives and Principles of Organization." The "major objectives" were relatively brief and stressed the goals of profitability, competitiveness, debt reduction, long-term financial and resource stability, quality control, research and product development, customer satisfaction, efficiency, recruitment of "good people," and good public relations. Moreell's willingness to work with organized labor was seen in his goal to "improve labor relations and productivity by fair dealings with all employees and their lawful union representatives."[5]

Most of the manual was given over to seventeen principles of organization to "be used as patterns in seeking improved organization at all management levels throughout the corporation." One lengthy principle defined the optimum span of control as no more than seven and inveighed against the "one-over-one" relationship, except under very special circumstances. Both centralization and decentralization were given as principles, but in the foreword Moreell called special attention to decentralization and the delegation of authority and responsibility as necessary for effective leadership. While appropriate channels of contact existed, "contacts between all units of the organization should be carried out in the most direct

way consistent with good sense," which seemed to encourage a greater flexibility in this regard than one might have expected from a military person. However, the principles also contained a clear chain of command and a clear distinction between line and staff, with individual responsibility primary in line functions and group activities predominant in staff functions. An intentional plan for internal promotion through different management levels was also highlighted.[6]

The last two pages provided a "Plan of Organization" that charted no strikingly new course but rather reiterated the known roles of shareholders, directors, the executive committee, the chairman and the president, the management committee, and line and staff departments in "carrying out the basic functions for which the corporation was formed; namely, the manufacturing of quality steel products at low cost and selling them at a profit." Its value was in stating clearly the responsibilities of executives in

An aerial view of the Pittsburgh Works, 1952.

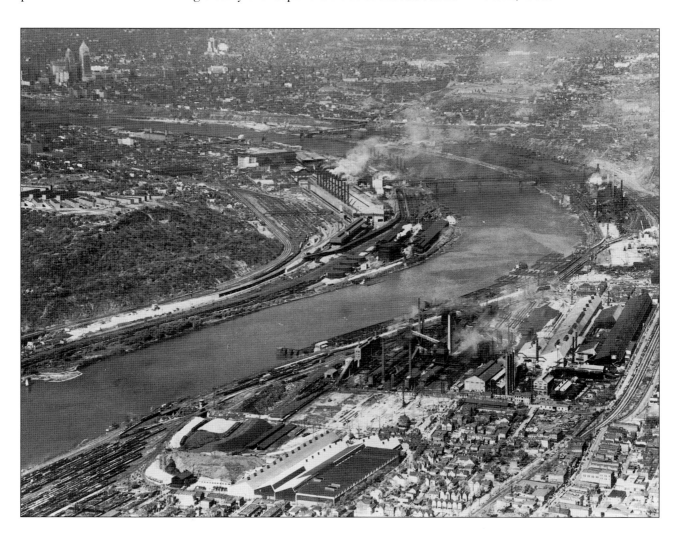

serving the corporation. One remark, interesting in the light of later criticism, was that an executive should "be willing and able to take calculated, reasonable business risks; to make sound decisions promptly; and to stand behind his decisions; yet be willing and able to reverse when proven wrong" and "cooperate willingly and enthusiastically with other executives, and generate that same spirit and teamwork within his own organization."[7]

The more informal atmosphere that Moreell seems to have brought to J&L is illustrated by a story he used to tell about his early experience as chairman. The first time he got on an elevator at the Ross Street headquarters, he was astonished to find that all others already in the elevator promptly exited and he was left to ascend to his floor alone. He wondered if he needed a bath or deodorant, but he discovered that this had been the standard procedure under his predecessors. He quickly changed it; afterward, both there and in the new headquarters in Gateway Center, to which they moved in 1952, anybody could ride with Moreell and other top management in the elevators.[8]

The need to build a sense of teamwork was also a motivator in the Admiral's Luncheon Program instituted in 1947. After lunch every Monday in the boardroom of the general office, a short talk by some executive was given to a group of about forty, including always Moreell himself, his assistant, the vice presidents, and the treasurer. About twenty-eight to thirty people were selected each week by the management committee as representatives of various levels of the whole management team. The goal was to encourage a "free interchange of ideas, technology, research, and thinking of each" of those present, provided their inhibitions could be overcome.[9]

One of Admiral Moreell's major concerns was effective communication within the corporation. Upward communication was dealt with in several of his "principles of organization," while effective downward communication was a major goal of a new publication that he began in November 1947, entitled *Men and Steel* (despite the similar titles, this is a different publication from the wartime *Of Men and Steel*). Moreell announced his goal in the first issue: "Our purpose is to establish a medium whereby we can bring to the attention of employees and of shareholders pertinent facts and the views of the management with respect to the past, current and future operations of the corporation." The combination of shareholders and employees as recipients of the monthly publication is interesting. Despite his stress on the shareholders being the "owners of this corporation," their need for information would seemingly be met by the same mechanism for giving employees the essential facts affecting employee

welfare. "It is my hope that by means of these bulletins we will be able to develop, on the part of both employees and shareholders, a strong feeling of mutual interest in the success of this corporation."[10] In fact, however, shareholders continued to receive more information than employees.

In a later issue Moreell devoted two pages to an analysis of the shareholders. The 293,568 shares of preferred stock were held by 6,583 persons or corporations, with all but 246 owning less than 100 shares each. There were 22,298 registered holders of the 2,476,502 shares of common stock, with only 2,251 owning more than 100 shares each and no individual or corporation owning more than 3.25 percent of the common shares. No individual, group of individuals, or corporation dominated J&L. Moreell concluded, "What began as and was for many years a privately owned business belonging to the Jones and Laughlin families has become in the truest sense a publicly owned business; i.e., it is owned by the public and for the most part in small amounts. If the alleged 'domination' does in fact exist, I have failed to detect any indication of it during my tenure as chairman of the board of directors and president."[11]

The format of *Men and Steel* was fairly consistent. Each issue usually ran to eighteen pages, and a statement by Admiral Moreell on some topic would almost always begin the issue. Thereafter, a series of articles, with lots of pictures, would highlight various parts of the corporation, sometimes through a series of articles in successive issues. There would also be items on personnel changes and awards given, with notices of tonnages and records often included as well. Frequently there would be some notice of safety issues, and sometimes problem areas would be identified. Each issue had an insert of a number of pages specific to a major division, such as the Pittsburgh Works, the Aliquippa Works, or the Otis Works. These inserts would have numerous human interest items, with lots of pictures (babies, newlyweds, retirees; and during the Korean Crisis soldiers seem to predominate); the object seemed to be to let employees see themselves and their families in print as much as possible.[12] The periodical was reduced in size and the separate division inserts eliminated with the fifth issue of volume 5, when it also became bimonthly in order to save money during the threatened strike and governmental seizure of the steel mills early in 1952.[13] The number of pages varied considerably thereafter, and inserts giving reprints of a variety of inspirational and motivational articles were often included; news items from the various parts of the corporation appeared periodically. The final issue with Moreell's comments was volume 11, number 5 (July–August 1958), in which he wished everyone "success in your endeavors, good health, and happiness."[14]

Admiral Moreell's columns provide an interesting insight into the man and the fortunes of the corporation. Many of them are motivational in nature, pep talks in print; many, especially in later issues, were excerpts from his speeches. He seems to have been a popular speaker. Often described as big, bluff, burly, rugged, outspoken and as having a gravel voice, Moreell was an imposing figure who got along well with a variety of people, including Phil Murray and even John L. Lewis.[15] He had pronounced views on a number of subjects, not always related to steel, and was a fervent advocate of them in public speeches, before Senate committees, and in print.[16] He drew frequently from his military experiences and was one of the many military businessmen so prominent during the 1950s. His views were often echoed by other corporation officials, even when they did not deal directly with steel. His views were commonly held by steel executives in other companies as well.[17]

A number of common themes emerge from Moreell's columns: his concern for safety; his view that customers, shareholders, and employees

The new coke ovens at the Pittsburgh Works (P-4 battery), November 1953.

have competing but also complementary interests; his assertion that plant and equipment are tools that must be maintained for steel to be profitable; his fear that inflation undermines prosperity but that steel prices are below what is economically warranted; his belief in free enterprise and individual liberty as crucial to the American way; his opposition to governmental controls and support for the Constitution; and his convictions about the relationships between morality, Christianity, business, and the American way.

The issue of safety was featured in his February 1949 and November 1950 columns, but it also became a major feature with the institution of the Admiral's Safety Award, announced in September 1948. Just about every issue of *Men and Steel* included items about safety, both in terms of which units received awards and in terms of safety information. They even had a contest for naming a cartoon character to accompany safety pictures and

Rolling a billet at Aliquippa's blooming mill.

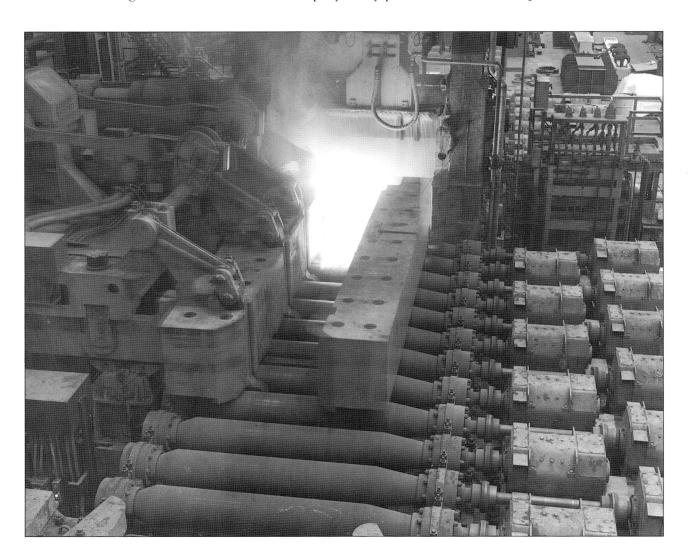

A watch fob was given as an award for those who worked 500,000 hours without having an accident.

information; the winning name was Ray Minder.[18] Nor was the workplace the only area for concern about safety, for numerous items referred to safety at home and in public places (swimming, highways) as well. One of the most obvious safety advertisements was the Burma Shave–type signs that greeted the worker once he passed the tunnel at Aliquippa; these were introduced in 1948.[19] Moreell's stress on safety was motivated, he said, not because it was economically desirable but because "it is the right thing to do" since it "contributed to the health and contentment of our employees and their families." And to answer critics who said J&L only wanted to make money from safety, he established a procedure for giving whatever savings the corporation gained from reduced insurance and compensation payments to improve "welfare and hospital activities in the communities where we operate."[20] The first distribution of these funds amounted to just under $69,000, obviously a minuscule percentage of J&L's total expenditures, but substantial enough in 1950 dollars.[21] J&L had introduced a safety program as early as 1907; a "Safety First" campaign in 1915 reduced accidents by 71 percent. And in 1925 a centralized safety program was instituted.[22] But Moreell's concern for safety would make it an even more constant feature of the corporation culture, so much so that his statement "If we cannot afford safety, we cannot afford to be in business" became something of a mantra for company executives.[23]

His view that shareholders, employees, and customers have competing but also complementary interests came through in many contexts. In his comments on the *Annual Report for 1948*, for example, he wrote:

We all have a big stake in the welfare of this corporation. It is only natural that, speaking generally, each of the three interested parties

(shareholders, employees, customers) wants as big a "piece of the pie" as he can get, with due regard for the rights of the others. Our customers want better steel at lower prices; our shareholders want larger dividends; and our employees want more compensation in the form of wages, salaries, pensions, social benefits, and other emoluments.

The one thing that we can all agree on is that we want a maximum of security, which means that we want a strong, stable company that can hold its own in any kind of competition the future may bring.[24]

On a later occasion he expanded upon the subject:

It is only natural that the three claimants to earnings should plead their cases with vigor and sometimes without sufficient regard for the rights of the others.

Burma Shave–type signs at the entrance to the Aliquippa Works in the 1950s.

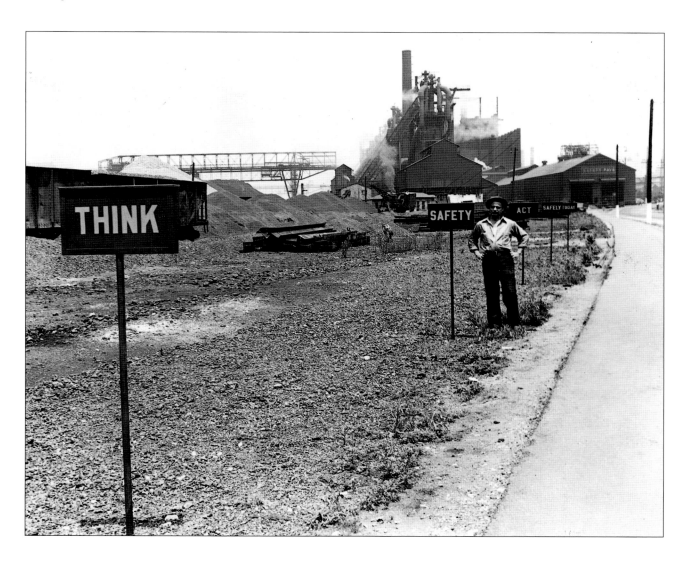

What happens when one of the three parties does not receive his proper share of earnings?

As to consumers, any one individual company in an industry has little control over prices. Prices are established by competitive forces and the law of supply and demand. Member companies of an industry are in competition with each other at all times; and each industry is in competition with other industries for the consumer's dollar. . . . Therefore, the consumer must have his share of the earnings which are available for reducing prices or he will stop buying our products.

As to employees, it is obvious that unless we compensate them fairly, by means of wages and other benefits, they will not produce at maximum efficiency, and costs will go up. At the same time, the consumer's buying power which is so necessary to maintain our whole economy at a high level of activity will not be available.

As to shareholders, current conditions, which, incidentally, apply to practically all of American industry, prove conclusively that unless investors get enough return on the money which they risk, the stream of funds which is essential for industry, will dry up. If we are to provide for the needs of a steadily increasing population and for a steadily rising standard of living among all of our people, we must have additional money to expand our present production equipment and to establish new production industries.[25]

It was in this context that Moreell stressed the need to ensure that shareholders got a fair return for their investment, and he devoted several columns to explaining the need to increase dividends. In February 1948 he gave a lengthy account of the history of profits at J&L, noting particularly the company tradition of plowing profits back to pay for debts, maintain and improve plant and equipment, and provide operating capital for dealing with the vagaries of cash flow. During the period from 1922 to 1947, he noted, J&L took in a total of $3,575,000,000 from sales. Over half of this ($2,021,000,000) was spent on the cost of goods and services from others, depreciation, depletion, interest, and taxes, leaving only $1,554,000,000 for wages, salaries, and dividends. He stated: "Of this amount, $1,448,-000,000 went to the employees and $106,000,000 to the shareholders. The employees received 40 cents out of each dollar of sales and the shareholders 3 cents." And this amounted to a little under 2.5 percent return on their investment, less than the return on United States savings bonds. They could not continue indefinitely to shortchange the more than 22,000 shareholders under these circumstances, particularly since the company was in

the midst of a major program to improve and rehabilitate the plant and equipment that had been run down by excessive use during the war years.[26]

It was also in this context that he likened plant and equipment to tools, a frequent analogy in his columns. The total investment in these tools in February 1948 was over $289 million, or about $6,934 per employee. Further, to replace these tools at present prices would raise that total to about $30,000 per worker.[27] The need to rehabilitate plant and equipment after wartime overuse had been a primary motivator for the postwar modernization program for 1946–50. Moreell took over while this was still in progress, but he was looking more to the future when he announced a major "Plant Improvement Program" in December 1950. This was in response to the burgeoning military needs brought on by the Cold War and its immediate crisis in Korea. The planned six-furnace open-hearth shop at Pittsburgh was to be enlarged to eleven, new rolling mills would increase capacity at both Pittsburgh and Aliquippa, and increased capacity for existing plant and new power sources and raw-material-handling facilities at all three works would facilitate the speed of producing and processing steel products. Capacity would increase from 4,850,000 net tons to 6,400,000 net tons in a little more than a year as a result. The cost for this was estimated to be $200 million, and it was to be raised by using profits, borrowing, and an issue of common stock.[28]

The need to find sources for funding both dividends and plant development probably contributed to Moreell's frequent comments about inflation and government regulations. He expressed concern that inflation was eating away at profits, while government regulations limiting depreciation (amortization) restricted the speed with which companies could write off the taxable value of equipment and gain capital for plant improvement.[29] However, he was caught in something of a dilemma on the inflation issue because he also argued that steel prices were too low in comparison with other industries, although this was in the context of public and governmental pressures over steel price increases after the strike of 1949.[30] It should be noted that the cost per ton of expansion at J&L from 1946 to 1956 was considerably higher than at other major steel companies.[31]

Ben Moreell had gained a reputation for being able to work with unions during his tenure with the oil and coal companies, and he early announced his willingness to work with the USWA at J&L. While he opposed collective bargaining within management itself or with accounting, secretarial, clerical, police, or other similar personnel, he wrote that "J&L is not opposed to the organization of those workers [production and maintenance workers] into collective bargaining units" that were run on a "free, demo-

cratic" basis. He early supported paid vacations as a benefit for the worker, using the wartime analogy of rest and recuperation as well as the likelihood of greater productivity as a result. Citing his experience in the petroleum and coal industries, he went on to suggest that workers get involved in their unions and choose leaders "who have your interests at heart."[32] Even in the days of negotiations and strikes in 1949 and again in 1952, he remained committed to working with the USWA and Phil Murray, whom he liked. Murray's sudden death in November 1952 left Moreell saddened: "I feel I have lost a true friend. We did not always see eye to eye. It would be a miracle if men of strong convictions were always in complete agreement on all matters. But *one* thing we did have in common, that is our deep and abiding concern for the welfare of the men and women who work."[33] Unlike most steel executives, Moreell was even willing, if he could get executive committee approval, to have J&L try some aspect of worker participation, such as the Scanlan Plan, because "the current [1950] labor situation was 'so bad that we must experiment,'" but nothing came of it.[34] This shows, however, that Moreell was open to innovative approaches even in labor-management relationships and not simply a follower of the U.S. Steel leadership, although in 1956 he would join with other steel executives in the Coordinating Committee Steel Companies (CCSC) to introduce industrywide negotiations.[35]

A number of Moreell's columns in *Men and Steel* could be considered motivational pep talks, encouraging every employee to be a salesman for

A classified ad for the Aliquippa Works, April 1953.

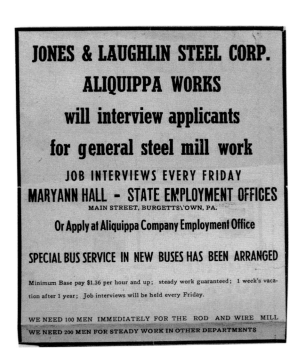

Admiral Ben Moreell at the dedication of Moreell Park in Aliquippa.

J&L or to do his best for conservation,[36] but increasingly even his motivational comments took on a moralistic tone. This was particularly seen in his political views. Ben Moreell's political attitudes were hardly secret and they came through in his comments on many occasions. They were, however, in keeping with legal requirements phrased in general and ideological terms, rather than in partisan political terms, and they often encouraged readers to vote in national and local elections. He early conceded that J&L could "not participate in political campaigns or other political activities," but it would express views on public policy issues that involved the welfare of the corporation and its members. "In essence, this corporation's policy is to advocate the support of efficient and economical government by capable administrators in local, state, and national affairs, and to conform in minute detail with the requirements of the law with respect to its participation as a corporation in political campaigns of all kinds." J&L would support no particular party but would support "those principles and policies which make for a prosperous, stable American economy and the maximum welfare of the whole community."[37]

Such principles and policies always heavily favored free enterprise and individual responsibility and rights. In a column on "J&L Principles" he wrote:

> We at Jones & Laughlin believe in our free enterprise system because we believe in people. The basis of the free enterprise system is freedom for the individual to make his own choice on how he shall live his life. The importance of the individual and his personal liberty is the foundation stone of our concept of government as *servant* of the people—not their *master*.
>
> With this basic concept we have become a great nation because each person could enjoy the fruits of his own labor in the form of spiritual and material rewards. Conversely, we believe that each individual must be responsible for the consequences of his own acts and decisions, and that he has a moral obligation to contribute, voluntarily, to the well-being of all, particularly the less fortunate who need the help of others.[38]

He also firmly believed such principles were "based on and consistent with the moral law of Christianity"[39] for he held that there was a close connection between one's religious views and one's political and social attitudes. Moreell was a very religious person, and he argued that public morality was both religiously based and fundamental to "the American way." His condemnation of communism—and he was strongly anticommunist —did not blind him to the impossibility of denying the idea of communism, even in the name of democracy. "It is just as much a communist idea if the majority imposes it upon a minority in a democracy as it is if done in a dictatorship" because for him communism was the "belief that individual freedom, as a way of life, will not work."[40] He feared the growing tendency of Americans, as he saw it, to let the federal bureaucracy run things. His attack on socialism was based upon his view that socialism meant strong central government and a concomitant destruction of religious and moral freedom:

> I believe that a social order which is designed to function only as government [but] extensively intervenes with its legal power of coercion is a violation of the moral order whose precepts stress education and conversion. There is a rightful place for political action—to maintain the peace of society by restraining whose who break the peace. If men universally understood and accepted the mandates of the moral

law there would be little or no need for political government to curb immorality. If men do not understand and accept the mandates of the moral law, then *coercion* will not correct this condition. The only correctives are education and *conversion;* understanding and a change of heart.[41]

In a speech given to the First Presbyterian Church in Beaver, Pennsylvania, in September 1956—and repeated in the nonreligious context of the California Chamber of Commerce in November—he described the American Revolution as beginning with the religious ideas inherent in the Judeo-Christian tradition:

> The basic concept was that all *power* and all *authority* flow from God, who is Ruler of the universe. Since all men are creatures of God, each man derives his dignity and freedom directly from God. Thus, he is sovereign in his relations with all other men. It follows that no man, and no group of men, can arrogate [*sic*] to themselves the power to trespass on the God-given rights of others without violating God's moral law. . . .
>
> The political application of this religious concept of natural rights gave birth to the idea of limited government and the inalienable right of every individual to control the fruits of his own labor, that is, his honestly acquired property. This "property right" is, in fact, a "human right." It stems from man's right to life, which carries with it the right to sustain that life on the fruits of his own labor.[42]

His conservative and moralistic political views became increasingly evident in his columns during the 1950s, obviously in those whose subject overtly dealt with such issues but also even in those that seemed to deal more directly with corporation business interests. And as his anticommunist pronouncements increased, his day-to-day involvement in the corporate affairs seemed to decline.[43]

While he disclaimed taking any partisan stance in his official capacity, he always called for adherence to the Constitution as the basis for individual rights. The majority had no right to oppress a minority in our "representative government—a Constitutional Republic": "It provided for the protection of every individual from the excesses of all other individuals or groups—and, more importantly, *from the excesses of his own government.*"[44] It should not be surprising that after his retirement he would go on to lead the conservative Americans for Constitutional Action.

But even while he was chairman of J&L his views influenced top management, who often echoed his ideas. When he was executive vice president, for example, Austin spoke strongly to the supervisors of the various works about having a positive relationship with the USWA and that "we intend to keep the agreement in the *spirit* as well as the letter" of its terms. His stated position echoed that of Moreell, as did the views on the same topic expressed several months later by W. R. Elliot, vice president of employee and public relations. Austin likewise echoed Moreell's political views in an address in which he argued for "The Natural Partnership of Labor, Management" in opposition to the false Communist idea that labor and management were natural enemies.[45]

Moreell did not always deal with such global issues in his columns. Many of them dealt with explaining the annual reports, sending Christmas greetings, celebrating the opening of the new open-hearth furnaces at the Pittsburgh Works, taking a tour of the plants, describing the business outlook, noting his service on the Hoover Commission, thanking trusted employees, and explaining layoffs as a result of recession. In addition, *Men and Steel* was used to announce significant changes in the management team. Early in 1952 C. L. Austin was named president, while A. J. Hazlett and J. B. Mitchell were named executive vice presidents in charge of distribution and production respectively. However, this did not mean any change in the division of responsibilities between Moreell as chairman of

J. B. Mitchell, director of personnel relations at the Aliquippa Works (1934–37), became the company's executive vice president in 1952.

the board and Austin as president. Rather, all the changes in titles permitted the three men "to perform their duties and responsibilities more effectively and thus be of greater aid in relieving as far as possible the increasingly heavy task of the chief executive," Moreell himself.[46]

Likewise, when Avery C. Adams replaced Austin as president on October 1, 1956, it was the subject of an extensive article. Austin had been a major figure in gaining financial backing for J&L expansion and would continue at J&L as board vice chairman and chairman of the newly formed finance committee. However, there was more to the change than appeared in the article. Harold Geneen's resignation as vice president and comptroller in June 1956 prompted Moreell and the board to bring in a management consulting firm, which concluded that "the problem is me," as Austin himself stated it. His hard-driving and imperious management style had led to difficulties in the management team, and he was kicked upstairs to a position where he had little power; he soon left to go to the World Bank.[47]

Adams had had a distinguished career in steel, beginning with his years as a laborer in the open-hearth department of Trumbull Steel Company in Warren, Ohio, where he began his rise in management circles. Not long after Trumbull merged with Republic he became vice president of General Fireproofing Corporation; in successive years he served in various capacities in Carnegie-Illinois Steel, Inland Steel, U.S. Steel, Detroit Steel, and finally as president of Pittsburgh Steel Corporation in 1950. There he successfully oversaw its "Program of Progress," which at a cost of $115 million resulted in a substantial improvement in its steel-making and finished-steel product capacity.[48]

Adams joined after the start of the "stepped-up cost-reduction and expansion program," which was expected to cost $320 million during 1956–58. The Aliquippa and Cleveland Works were the main recipients of this project, with a variety of new rolling mills and improvements to existing furnaces and mills, but the most innovative part of the project was the building of two new revolutionary basic-oxygen furnaces at Aliquippa, the first such "oxygen-blown steelmaking furnaces" at a completely integrated steel company in the United States.[49] The basic oxygen furnace (BOF) combined the best features of the Bessemer converter and the open-hearth processes. It was as speedy as the Bessemer process (about twenty to thirty minutes per heat), but it provided the means of control and the low-phosphorus, sulfur, and nitrogen content (and other desirable metallurgical characteristics) of the open-hearth furnace at a substantially reduced cost and with less dependence on the uncertain scrap-metal market.

European and Japanese steelmakers had already switched to the new technology and were gaining a significant cost advantage over American producers as a result. This would seriously hurt American steel producers in the international market, but American management was reluctant to make the necessary capital investment when they still had excess open-hearth capacity, and they were not encouraged to do so by either government or labor. It would be one factor in the decline of American basic steel manufacturing.[50] The adoption of the BOF by J&L at such an early date suggests that J&L management was more open to innovation than other steelmakers.

The BOF is a rotating, basic-lined, solid-bottom (without tuyeres) furnace shaped much like the Bessemer converter. The outer shell is lined permanently by burned magnesite brick, which then has a lining of tar-bonded dolomite magnesite (which is changed with each relining). The furnace bottom resembles the hearth of the open-hearth, being a shallow vessel to contain the processed steel. The raw materials charged into the vessel to form the bath is a combination of scrap (no more than 30 percent) and hot metal (similar to the open-hearth), with appropriate fluxes to remove impurities. Once the vessel has been charged, it is returned to the upright position and a water-cooled lance is lowered to about six feet above the bath; pure oxygen (97 percent or better) is then forced onto the surface of the hot bath (about 2,900 degrees Fahrenheit), where it leads to the rapid formation and diffusion of iron oxide, giving rise to a vigorous boiling action and resulting in refining reactions. The spectacular flames of the Bessemer converters are absent, but dense clouds of reddish-brown gases are emitted into the encircling hood and carried off for treatment. After twenty to thirty minutes the heat is finished and the molten steel and slag are tapped into ladles and pots, just as they are from the other steelmaking processes.[51]

The basic oxygen furnaces constructed at the Aliquippa Works in 1956–57 were the second such furnaces in North America and would double the output of the pioneer furnaces at the small McLouth Steel Corporation's Trenton, Michigan, plant. Eventually other steel corporations would follow, and by 1970 nearly half of the steel in the United States was being produced by the new method. No new open-hearth furnaces were made after 1958, and the last Bessemer converters were closed in the late 1960s; increasingly steel would be made by either the basic-oxygen or the electric-arc methods.[52] Once again, J&L had been in the forefront of steelmaking developments, thanks to the foresight of the J&L management team put together by Admiral Moreell. Unfortunately, the Japanese and Euro-

peans had already long before shifted over to the new technology, which put the American steelmakers, including J&L, at a considerable competitive disadvantage in the years ahead.

Financing such an ambitious expansion program, especially when a recession late in 1957 caused layoffs and a reduction in earnings,[53] however, was expensive and would drive the corporation deeper into debt, which by 1956 amounted to $130.3 million and by 1957 was already costing nearly $4.8 million per year in interest payments.[54]

Nor, as we have already seen, was Moreell's management team always a harmonious one. Tension between Lee Austin and Harold Geneen, both financiers, had been building during the decade. Geneen, who would go on to make a reputation for himself at International Telephone and Telegraph Company (ITT), had come to J&L in May 1950 as assistant to the president for general services, moving up to comptroller in 1951 and still

J&L ran a series of ads in the late 1950s promoting their service centers.

later becoming a vice president. In June 1956, after a particularly annoying incident with Lee Austin, he resigned from J&L to become executive vice president of Raytheon Manufacturing Company.[55]

But it was not only his clashes with Austin that led him to resign. In his autobiographical study, *Managing*, Geneen describes his experiences at J&L in ambivalent terms. He was impressed both by the "sense of family and caring among the men that is seldom seen in corporate life," engendered by hazardous working conditions and the concern for safety, and by the "awe-inspiring" nature of steelmaking. But he also said that the "malaise that the steel industry suffers today began back then. Steel was underpriced; the companies were besieged by union demands; the companies did not have the capital needed to invest in new plants; replacement costs were excessive in relation to the price steel would bring. The handwriting was on the wall. Many could not see it at the time, and those who could see into the future seemed powerless to do anything about it."[56] He agreed then with Moreell that steel was underpriced, but when he tried to talk Moreell into publicizing that a price increase of eight dollars per ton would only add sixteen dollars to the cost of an automobile, Moreell "calmed me down, saying, 'We can't do that—the automobile industry is our best customer.'" And he remembered all too well the "intense battles fought at Jones & Laughlin over fixing responsibility for something that had gone wrong." He was able to get some new ideas accepted at J&L, such as pooling maintenance men (in the process finding one enterprising loafer who for twenty years had done no work by playing off the lack of coordination among different parts of the plant!), but he "had to fight long and hard in the executive suite" to get it, even though it saved millions of dollars. "But it was a losing battle," he wrote. "Jones & Laughlin was a tradition-bound, rigid bureaucracy of a company, as were most of the steel companies. You could address questions or suggestions to the man above you. There were many good, imaginative men in the middle ranks of management, but their ideas were apt to die on the intricate ladder of management. I fought many a battle and lost."

The crucial thing to Geneen was the conviction that steel companies had to diversify to survive. He even suggested that J&L build a chemical company to capitalize on the profits to be made from processing coal by-products. "It never came about," he said. "The top management of Jones & Laughlin could not see it. They were steel men, proud of it, and they would stick to their trade."[57] And so Geneen went on, after his experiences at Raytheon, to prove at ITT what a company could do with diversification.

Geneen's assessment of the malaise of the steel industry was not only critical of management but also critical of labor for its wage demands.

Despite Moreell's reputation for good rapport between union and management in 1946–47, the labor unrest that characterized the immediate post-war years continued to plague the steel industry during Moreell's tenure at J&L, with strikes in 1949, 1952, and 1956 (and with another to follow in 1959). Moreell's political and economic conservatism led him to resist, along with most other steel companies, union demands for including pensions in bargaining in the 1949 dispute. He was always opposed to policies that he felt would be inflationary, and he firmly believed that in the competition between workers and shareholders for a fair share of earnings, the shareholders were on the short end, while the need to modernize equipment required retaining a significant portion of earnings to improve tools. The settlement of the six-week strike that resulted was made, Moreell said, "in a spirit of good will and mutual understanding which holds good promise for our future relationships," but it did result in union victory, confirmed by a Supreme Court decision, on the issue of pensions as a negotiable

Admiral Moreel with David McDonald, president of USWA, during his 1955 visit to the J&L mills.

(Above) An assortment of steel medallions commemorating various events in J&L's history, including (top) the logo celebrating J&L's hundredth anniversary.

(Above, right) J&L's new logo, with later versions.

item.[58] The pension funds established were free from management control.

The next round of negotiations in the spring of 1952 came in the midst of the national emergency brought on by the Korean conflict. Wartime always brings inflationary pressures, and union desires to offset price increases by wage and benefit gains came into direct conflict with Moreell's anti-inflationary biases. The salary increase that Austin received with his promotion to president prompted a celebrated exchange before the Wage Stabilization Board between Moreell and Phil Murray over the relative merits and needs of C. L. Austin and the fictional Joe Doakes and Mrs. Celinsky of Pittsburgh's South Side.[59] President Truman's effort to maintain a basic industry in wartime by seizure frustrated Moreell, who wrote bitterly against the unconstitutional action:

It is my firm conviction that such an action would not benefit the shopkeeper, the clerk, nor the customers of that shop [he had used the analogy of a soldier forcing a shopkeeper to increase his clerk's wages at gunpoint as the equivalent of Truman's actions], and it would be destructive of our concept of individual liberty on which this country is founded.

Every citizen should vigorously oppose this kind of action. Failing this we may well see "the end of the road" for freedom and our Constitutional safeguards against oppression in America.[60]

When the Supreme Court ruled against the president's seizure, the USWA called an industrywide strike to back up its demands for wages and benefit increases. Two months later negotiations and meetings at the White House resulted in a settlement that granted most of the union demands. Phil Murray could not long savor the victory, however, and his death on November 9, 1952, brought David J. McDonald to the leadership of the USWA.[61]

As a part of McDonald's strategy to improve the tone of labor-management relations after the sharp divisions of 1952, he made a series of highly publicized tours of steel plants with company CEOs. It was J&L's turn in January 1955, when Moreell and McDonald made a joint tour of the three major J&L works, which Moreell characterized as helpful in developing the "mutuality of interest" of the parties concerned.[62] Industrywide negotiations in 1954 and 1955 were relatively peaceful, with significant gains for steelworkers (especially compared to auto workers), but negotiations in 1956 failed to reach a satisfactory conclusion without a relatively brief strike. The result, however, was another union victory with the establishment of supplementary unemployment benefits, which with state unemployment benefits could amount to 65 percent of take-home pay for a total of fifty-two weeks, thus stabilizing workers' pay.[63]

Midway through Admiral Moreell's tenure as chairman and CEO of J&L, in 1953, the corporation celebrated a milestone, their centennial as "an American Business,"[64] the subtitle of Moreell's speech in July 1953. The celebration of past accomplishments contributed to optimism about the prospects of future achievements. And that sense of a positive future may have motivated Moreell and Adams to institute a new trademark early in 1956 for Jones & Laughlin Steel—the letters *JL* atop the word *STEEL*—to replace the old J&L logo.[65] But the malaise of the steel industry that Geneen described twenty years later would make the future more a time of rearguard actions as Moreell's successors strove to keep J&L running in the midst of an increasingly desperate situation.

Rearguard Actions

nine

What or who caused the demise of the American basic steel industry during the 1960s and afterward? Geneen faulted Jones & Laughlin management for its failure to break out of its single-industry straitjacket; U.S. Steel would follow the route of diversification and survive, although with difficulty and much personal hardship and pain for workers and management alike. But Geneen's criticism deals only with management of a single steel company; what declined was a whole industry. Why?

Paul Tiffany gives a more global answer in his *The Decline of American Steel: How Management, Labor, and Government Went Wrong* and suggests that there were many to share the blame.[1] He writes that his view differs from more traditional conclusions, which tend to blame managerial inefficiency and arrogance. He would add excessive union demands and inappropriate government policies and actions to his list of reasons. His analysis stresses the unfortunate confrontational history of management and labor and of management and federal government during the period from 1933 to 1953; the failure of government to recognize the peculiar character of the steel industry's capital investment in plant and equipment, its geographical/transportation limitations, and its position in world trade; the paradoxical policies of the Republican Eisenhower administration in supporting free enterprise and noninterference at home and foreign aid to steel industries abroad; escalating labor costs combined with pricing limitations at home and abroad; and inconsistent management actions regarding plant and equipment development.[2] Much of it turns on what could be

called errors of omission rather than errors of commission, and it is always hard to prove one's case by saying "if such-and-such had happened, then things would have been different." Notable examples are his statements commending views that surfaced occasionally but were not followed up, for example, treating the steel industry like a utility or developing industry advisory committees.[3] The contrast he draws with the European and Japanese steel industries is especially striking.

John Hoerr poignantly describes the decline in human terms in his innovative work, *And the Wolf Finally Came: The Decline of the American Steel Industry*. In the process he finds many reasons for the decline:

> . . . the steel companies failed to invest adequately in new technologies at critical junctures, failed to engage in competitive pricing when imports first penetrated the U.S. market, and failed to streamline bureaucratic management systems. Large steelmakers clung too long to the concept of vertical integration when market and technological shifts favored a concentration on fewer products and the purchase of raw materials from outside sources. In some periods, government policies forced the industry into unfair competition with foreign producers.
>
> The overwhelming external problem, of course, was the explosive growth of steel production in developing countries in the 1970s and 1980s. At the same time, demand for steel flattened out as car makers and other manufacturers increasingly used substitute materials. These trends brought on a worldwide restructuring of steel which will continue for many years. Not just the United States, but all of the traditional steelmaking countries suffered—the United Kingdom, West Germany, France, other European nations, and Japan. All faced the common necessity of reducing capacity. . . .
>
> There is one more reason for the American Industry's decline: the inability of the industrial relations system to adapt, soon enough, to changing economic conditions. More than any other factor, this one resulted from a human failure of tragic proportions, a failure to unite people in a common endeavor.[4]

He goes on to fault both the steel companies and the steelworkers for excessive wage increases in the 1970s, for their inability to work toward long-term goals, and for their unwillingness to embrace a more participatory approach to labor-management relations until it was too late. The chief butt of his criticism is U.S. Steel Corporation, but all companies come in for their fair share. However, J&L and National are frequently singled out for being more open to new approaches as the tale unfolds in the 1970s and

1980s, thanks largely to such people as John Kirkwood and Cole Tremain, who were in charge of J&L industrial relations during much of those decades.[5] But that would be primarily after J&L was acquired by LTV in 1968.

The impersonal corporate bureaucracy that John Hoerr describes so tellingly in reference to U.S. Steel was not unique to the dominant steel corporation.[6] While most J&L executives had traditionally been "home-grown," increasingly its top management had had experience at other steel corporations, such as Bethlehem and Pittsburgh, and brought with them attitudes that had not been developed at J&L. In any case, the "native" J&L managers had developed a corporate culture that did not necessarily make them any more open to change.

The top executives who ran J&L in the decade between Moreell's retirement and the acquisition of J&L by the Dallas-based LTV conglomerate put together by James J. Ling was composed of men who made up what aspiring young executives, we are told, disparagingly termed the "J&L Club."[7] Preeminent among them were the two who were successively chairmen of the board and CEOs: Avery Adams and Charles Beeghly. Since Beeghly functioned as executive vice president and then president under Adams, it is appropriate to link them together, even though their careers were different.[8] As has been established, Adams had had a successful career with other steel companies before he was brought into J&L in 1956 from outside. Beeghly, however, had joined J&L some years before when his employer had been taken over by J&L; he rose through the ranks from sales, first gaining responsibility for one of the operating divisions (strip mill) and then in 1957 becoming executive vice president. In 1960 he became president, and on May 1, 1963, he succeeded Adams as chairman of the board.[9]

It was Beeghly whom James Ling approached in April 1968 with his proposal that J&L become a part of his LTV conglomerate. Later that year, Beeghly retired from J&L to become a vice president of Mellon Bank, although he stayed on the J&L board and its executive committee for a while longer.[10] William J. Stephens served as president during those same five years, having been brought in from Bethlehem Steel Corporation, and he moved up to be chairman of the board when Beeghly left J&L. At somewhat lower levels were two men who would become CEOs of J&L in the 1970s before moving on to become chief operating officers of U.S. Steel, William R. Roesch and Thomas C. Graham, both of whom rose through the ranks at J&L.[11]

* * *

The management team that succeeded Moreell had to deal with the industrywide negotiations for a new contract with the USWA in 1959. The resulting 116-day strike was a watershed in the American steel industry. Representatives of U.S. Steel and Bethlehem Steel negotiated for the eleven

The American Iron and Steel Institute's ad against inflation, 1959.

Agreements for insurance benefits (1960), supplemental unemployment benefits (1962), and pensions (1962).

major steel producers, but as one of the four companies that formed the inner circle of the CCSC, J&L was kept informed of the progress of negotiations and had some input into the process, however slight.[12] In the days before the strike, the management letters in *Men and Steel* (and some of the articles as well) presented the management case against substantial wage increases. Adams's "Management Letters" in the January–February and May–June 1959 issues of *Men and Steel* made direct reference to the negotiations then in progress. He focused on how the wage increases of past settlements had significantly outpaced increases in profit and tried to counter what he considered to be unwarranted accusations against management. He even cited David McDonald's own words at a USWA convention the previous year, in which the USWA president proclaimed how much the union had succeeded in gaining higher returns for steelworkers than other American industries, most notably their longtime rival, the United Auto Workers.[13] A six-page article with figures and graphs tried to make

the same point. After the strike was ended by a Taft-Hartley injunction and an agreement was eventually worked out, Adams bluntly stated that it would take much hard work and increased productivity to generate the funds needed for further capital investment, but if all worked together 1960 could be a record year.[14]

Capacities of the J&L facilities as of January 1, 1959.

JONES & LAUGHLIN STEEL CORPORATION

ANNUAL CAPACITIES (NET TONS) AS REPORTED
TO THE AMERICAN IRON AND STEEL INSTITUTE
AS OF JANUARY 1, 1959

Product	Total	Aliquippa Works Division	Pittsburgh Works Division	Cleveland Works Division	Stainless & Strip Division	Other (See Note)
Coke:						
By-Product	3,586,000	2,062,000	1,200,000	324,000		
Pig Iron	5,061,000	2,090,000	2,105,000	866,000		
Steel:						
Basic Open Hearth	6,138,000	1,236,000	3,377,000	1,525,000		
Basic Oxygen	756,000	756,000				
Bessemer	384,000	384,000				
Electric	722,000		2,000	420,000	300,000	
Total	8,000,000	2,376,000	3,379,000	1,945,000	300,000	
Hot Rolled Steel Products (A):						
Structural Shapes-Heavy	256,800	256,800				
" " -Light	63,600	51,600	12,000			
Plates-Sheared	286,000		153,000	133,000		
" -Universal	7,200	7,200				
Hot Rolled Sheets	2,553,900	61,200	1,003,000	1,489,700		
Coils for Cold Reduced Black Plate and Tin Plate	653,500	566,500	87,000			
Coils (Stainless Steel)	40,000		40,000			
Bars-Other Than Concrete Reinforced	604,700	38,700	406,000		160,000	
" -Concrete Reinforcement	48,000		48,000			
Wire Rods	350,600	350,600				
Skelp	772,600	709,600	63,000			
Blanks, Tube Rounds or Pierced Billets	628,000	628,000				
All Other	29,300	12,000(C)			17,300(D)	
	6,294,200	2,682,200	1,812,000	1,622,700	177,300	
Other Finished Products (Annual Capacity) (B):						
Cold Finished Bars	399,600		300,000		30,000	69,600(E)
Sheets-Cold Rolled	1,156,000	22,000	600,000	504,000	30,000	
" - Galvanized	96,000		96,000			
Strip-Cold Rolled	86,100				86,100	
" -Galvanized	6,000				6,000	
" -Electrolytic Copper Coat	3,000				3,000	
Tin Plate-Electrolytic	412,000	412,000				
" & Terne Plate-Hot Dip	112,000	112,000				
Track Spikes	36,000		36,000			
Wire-Plain (Finished)	318,000	315,000			3,000	
" -Barbed	15,000	15,000				
" -Galvanized	68,000	68,000				
" -Nails	60,000	60,000				
" -Staples	6,000	6,000				
Woven Wire Fence	14,000	14,000				
Pipe and Tubing-Buttweld	420,000	420,000				
" " " -Lapweld	120,000	120,000				
" " " -Electricweld	261,000	216,000				45,000(F)
" " " -Seamless	480,000	480,000				
Other Finished Products (Annual Volume):						
Galvanized Pipe	84,000	84,000				
Tubing-Pressure	6,000					6,000(F)
" -Mechanical	49,000	10,000				39,000(F)
Black Plate-Other	80,000	80,000				
Wire Rope	16,200					16,200(G)
Steel Castings	12,000		12,000			
Forgings	2,700		2,700			

(A) Capacities of hot rolled products are limited to steel available from own ingot capacity plus estimated steel supply obtained from others.
(B) Capacities of other finished products are annual capacities without regard to available supply of ingots or semi-finished steel or hot rolled products.
(C) Rim steel.
(D) Ingots, 1,300 T; Blooms & Billets, 8,000 T; Slabs, 8,000 T.
(E) Hammond Cold Finished Bar Division, 48,000 T; Willimantic Division, 21,600 T.
(F) Electricweld Tube Division.
(G) Wire Rope Division.

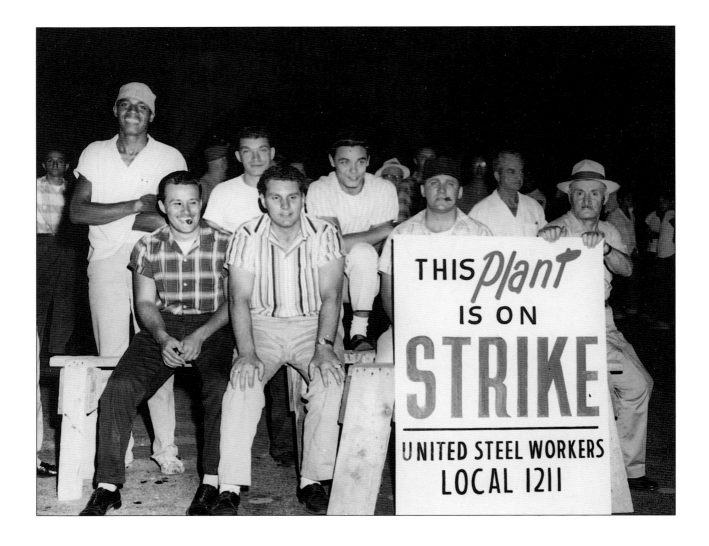

Strikers at Aliquippa, 1959.

Thereafter, Adams's and Beeghly's management letters tended to focus on foreign competition as the explanation for the continuing weaknesses in J&L sales. Two lengthy articles detailed the decline in American steel exports and the increase in foreign steel imports, with the telling remark that in 1960 foreign imports amounted to nearly 4.5 million tons, "more than J&L could have shipped in finished steel from both its Pittsburgh and Aliquippa Works." This was at a time when J&L was operating at a capacity of only 50 percent.[15] J&L sought to improve its market position by encouraging everyone to be a salesman, increasing their efforts to sell abroad, and improving productivity with new, more cost-efficient facilities.[16] It was in Cleveland in 1961 that J&L built its second BOF facility, which was twice the size of its pioneering BOF shop at Aliquippa; two years later it added a huge blast furnace at Cleveland as well, to make the Cleveland Works one of the most modern in the industry. Automation was

a major aspect of these improvements, so now essentially one person could control the process. The early 1960s also saw significant improvements in finishing mills at all three works as a part of a $265-million capital improvement campaign (1962–64).[17] However, management's hopes to help pay for this by increased profits as a result of higher prices came up against President John F. Kennedy's and Senator Estes Kefauver's very public and effective political pressures against increased steel prices, and J&L was forced to increase its indebtedness by a greater rate than management had planned.[18]

The annual shareholders' meeting on April 26, 1962, was the occasion for a strong denunciation of the Kennedy administration's actions by Chairman Adams and a strongly worded resolution introduced by Ben Moreell to affirm that "among their [the directors'] duties is that of establishing, in the light of competitive conditions, the prices which the company will offer its products to its customers, and, that these men shall fulfill their responsibilities without regard to threat or coercion of any kind from any quarter."[19]

The substantial growth in the Cleveland Works was one indication of the shift in J&L's focus away from the Pittsburgh region, a shift dictated in part by increased foreign competition in the American Midwest thanks to the St. Lawrence Seaway. Other American steel companies had a competitive advantage as well with production facilities in Indiana and Illinois. In 1965 J&L decided to improve its position in that market by building a major finishing mill on the Illinois River at Hennepin in downstate Illinois. Both Cleveland and Aliquippa would provide the raw steel, and a second BOF shop was planned for Aliquippa as a result, along with new blast furnaces and new continuous casting facilities. When all of these facilities were completed by 1970, their total cost had risen to $400 million.[20] The improvements even led to changes in the river channels at the Cleveland and Aliquippa Works. To make room for the new strip mill at Cleveland, the Cuyahoga River was moved, which also eliminated a sharp bend. At Aliquippa, the channel of the Ohio River separating Crow Island from the rest of the mill was filled in to provide space for the new BOF shop and two new continuous casting units.[21]

The continuous casting facility was a relatively new process that considerably improved the yield (and hence reduced the cost) in comparison with the traditional methods of converting raw steel to blooms, billets, or slabs. The first effort in the United States was a joint project of Republic Steel and Babcock & Wilcox Steel in Beaver Falls, Pennsylvania, in the late 1940s, but the first commercial unit was installed in Roanoke, Virginia, in 1962. During the 1960s other continuous casting units were set up at various plants. In 1969 J&L started up its first such unit, at Aliquippa,

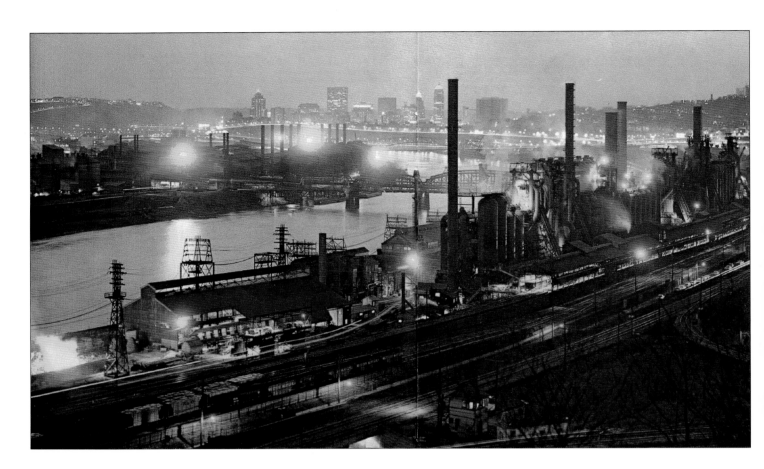

"Steel at Twilight"—Arthur
d'Arazien's 1959 photograph of
the J&L Pittsburgh Works.

The baseball field on Crow Island,
Aliquippa, Pennsylvania, ca. 1910.

The south end of Crow Island, showing the back channel and early construction to build the No. 2 BOF, early 1960s.

Covering over the back channel of Crow Island, 1966.

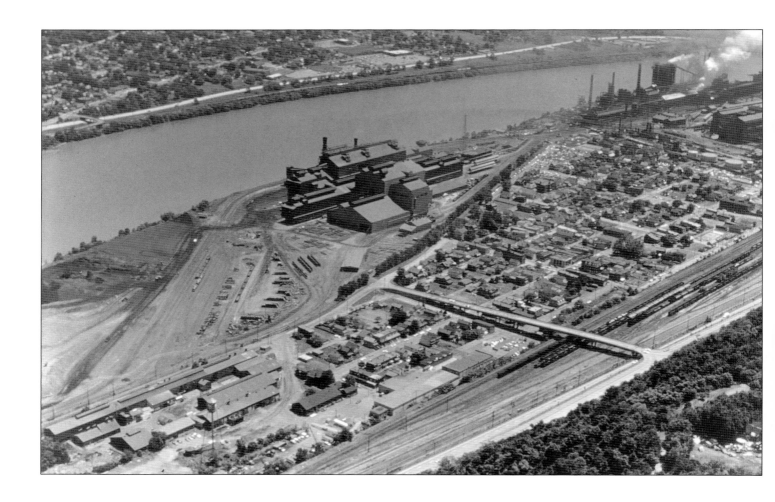

Aerial view of No. 2 BOF on Crow Island, as well as the coke plant.

(Opposite) The company listing of J&L employees, ca. 1960.

with a six-stand double unit producing both blooms and billets. The process eliminates the stages of producing and treating ingots. The molten steel is taken directly by ladle from the furnace to the top of the continuous caster, where it is poured into six water-cooled strands. There it solidifies as it passes downward in a gently curving flow of strands designed to produce the appropriate widths. By the time it reaches the bottom of the six-story (ninety-foot) machine, it has solidified and is ready to be cut into appropriate lengths of blooms or billets for further shaping in the finishing mills.[22]

The 1960s challenged American steelmakers because of foreign competition and technological changes, both of which cost money, albeit in different ways. But the decade also saw growing concerns about pollution, and steelmakers were especially susceptible to criticism for polluting the air and streams. Beeghly addressed himself to these issues in his remarks to the 45th Annual Meeting of Shareholders on April 27, 1967, in which he tried to set the issue in a broader context. Industrial effluents and wastes were but two of fourteen prime sources of pollution, but J&L would do all

Unit	Local Union Nos.		Hourly	Salary	Total
Jones & Laughlin Steel Corporation					
Pittsburgh Works	1843	1272	10,509	1308	11,817
Aliquippa Works	1211		13,550	1339	14,889
Cleveland Works	188	185	3,487	659	4,146
General Office, Pittsburgh				896	896
Stainless and Strip Steel Division					
Detroit, Michigan	1357		1,186	335	1,541
Youngstown, Ohio	3047		299	95	394
Louisville, Ohio			181	79	260
Los Angeles, California	1981		69	54	123
Metallon Stamping Plant, Canfield, O.	5635		27	4	31
Indianapolis, Indiana	5131		70	29	99
Kenilworth, New Jersey			74	45	119
Electroweld Tube Division					
Oil City, Pennsylvania	2989		238	36	274
Wire Rope Division					
Muncy, Pennsylvania	3181		203	61	264
Minnesota Ore Division	1437	4222	745	95	843
	3005	1934			
	3107	4793			
Michigan Ore			350	32	382
New York Ore Division					
Star Lake, New York	3494		746	94	840
River Transportation Division			115	44	159
Marine Ways					
Floreffe, Pennsylvania	1535		52	7	59
Union Dock Company					
Ashtabula, Ohio	4298		105	10	115
Vesta Shannopin			1,914	260	2,174
Blair Limestone			159	21	180
Container Division					
Atlanta, Georgia	3980		97	20	117
Bayonne, New Jersey	2612		115	19	134
Cleveland, Ohio			144	23	167
Kansas City, Kansas	2125		105	18	123
Lancaster, Pennsylvania	5156		21	5	26
Lebanon, Indiana			109	28	137
New Orleans, Louisiana	3380		55	13	68
Philadelphia, Pennsylvania	3830		44	12	56
Port Arthur, Texas			65	12	77
Toledo, Ohio			374	44	418
Warehouse Division					
Chicago, Illinois			55	72	127
Cincinnati, Ohio			76	35	111
Cleveland, Ohio			19	23	42
Detroit, Michigan			37	38	75
Hammond, Indiana	5208		59	16	75
Indianapolis, Indiana					
Warehouse			123	101	224
Headquarters				49	49
Lancaster, Pennsylvania	5156		8	8	16
Louisville, Kentucky			19	17	36
Memphis, Tennessee	3449		76	31	107
Nashville, Tennessee			12	11	23
New Orleans, Louisiana	5168		103	37	140
New York, New York	53 - 36		52	37	89
Pittsburgh, Pennsylvania			51	34	85

42,1274 *total*

Various badges from the Pittsburgh Works. At upper left is a badge dating from 1902–7; the rest are from the 1960s on.

within their means to meet legal requirements to install pollution abatement devices. These had already cost $73 million, and he hoped special tax incentives would be forthcoming to aid in financing these expensive projects. This was particularly needed because of a major power outage at the Aliquippa Works on February 11, 1967, which resulted in an emergency shutdown, extensive damage to facilities (including explosions), and a reduction in production that lasted over a month. Although fortunately there were no injuries, the cost to the company in lost sales and repairs was extensive, reducing income by nearly 35 percent for the first quarter. He hoped that the second half of the year would recoup at least some of the loss.[23]

The early 1960s saw two labor contracts signed without strikes, in 1962 and 1963. Both increased labor costs, particularly the 1963 agreement, which introduced the thirteen-week sabbatical leave every five years. On both occasions the dramatic increase in demand for steel products in the months before a potential strike, called "hedge buying," was followed by an equally dramatic decline in demand that led to layoffs, and in 1965 President Stephens called for some way to "get off the roller coaster" of such artificially produced swings in demand.[24] It would take some years, but eventually, in 1973, the experimental negotiating agreement (ENA), with its "no-strike" aspect, would provide the means, albeit at some cost.[25] By then it was already becoming too late for J&L.

During the postwar period James Ling had put together a variety of businesses involved in electrical and electronic products, military aircraft, and

Various badges from the Aliquippa Works: (upper left) Glenn Inman's badge during the 1930s; (upper right) a World War II–era badge; (center and bottom) Donald Inman's badges.

(Overleaf and page 175) Views of the blast furnaces at the Pittsburgh Works, 1962.

engineering with the aid of creative (and often risky) financing. In 1961 Ling-Temco-Vought, Inc., emerged as a troubled but potentially profitable giant in American business, number 244 on the *Fortune* 500 list. Following the success of Geneen's ITT in becoming a conglomerate, Ling worked diligently and creatively to make LTV another success. In 1966–67 he acquired Wilson and Company, which he then reorganized as three companies: meatpacking, sporting goods, and pharmaceutical and chemical companies. This contributed to a dramatic rise in share value for the various parts of the conglomerate and whetted Ling's appetite for more. Acquisition of Greatamerica brought him an interest in insurance, banking, an airline (Braniff), and car rental (National), but it also stretched his financial resources to—some would say past—the limit. A chance encounter with an executive of Youngstown Sheet and Tube Company gave him a taste for steel, and in 1968 he turned his attention to J&L as a possible acquisition.[26]

Ling's goal in doing this is not altogether clear. A desire to break into a "bastion of the Eastern Establishment," a lack of understanding about the nature of steel's peculiar ratio of assets to sales (which made steel seem to have a usable cash flow), a desire to get at J&L pension funds to

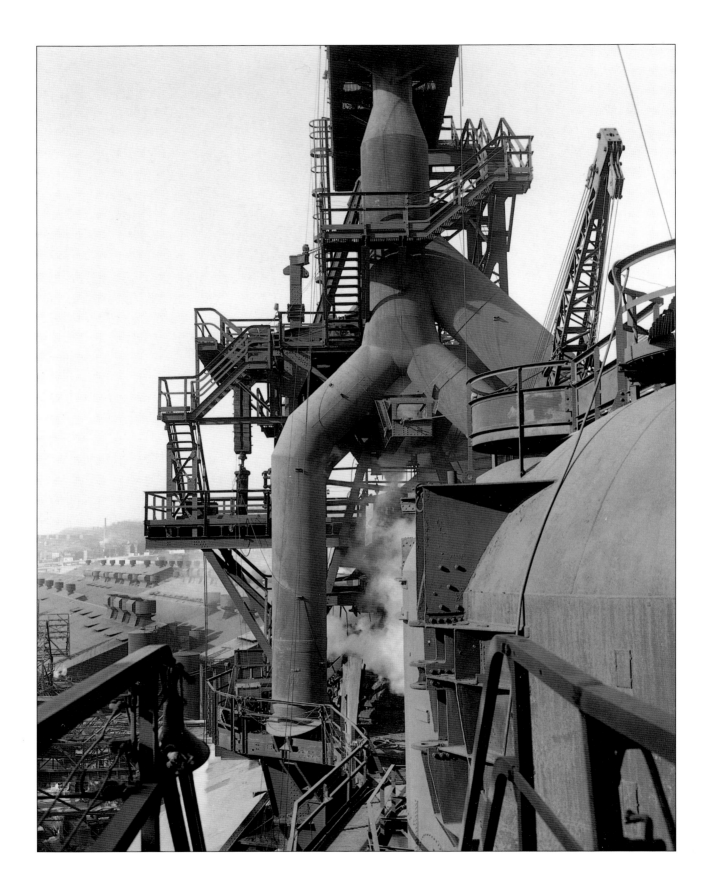

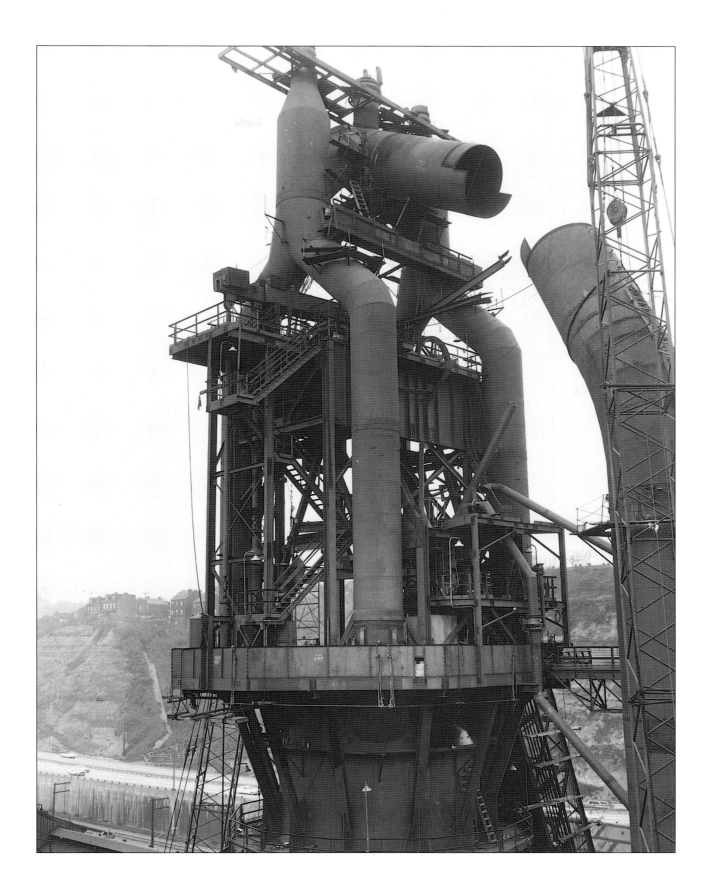

One of the "torpedo" cars used to transport molten metal at the Pittsburgh Works.

help buttress LTV's shaky financial underpinnings, a desire to reorganize J&L as he had Wilson and Company have all been suggested. Whatever it was, it would be a gamble that would cost him his fortune and ultimately result in bankruptcy for both LTV and J&L.[27]

In April 1968 Ling first met Charles Beeghly, chairman and CEO of J&L, in Cleveland in a meeting arranged at Ling's request through intermediaries. Cleveland was chosen to avoid public notice. Beeghly at first seemed surprised and skeptical, but apparently before long he determined that Ling had the means to pay and would be reasonable about the terms insofar as they would affect J&L management. Beeghly got Ling to agree to buy a higher proportion (63 percent) of the outstanding shares than the 51 percent Ling had initially suggested, to pay $85 per share (the book value rather than the then–market value of J&L's shares) at a total cash outlay of

(Left) Charles M. Beeghly, chairman and CEO of J&L, ca. 1968.

(Above) James Ling, founder of Ling-Temco-Vought, Inc., ca. 1968.

$425 million, and to put his controlling shares in a voting trust, which for the first three years would be composed of a majority of J&L people.[28] By the time a public announcement was made on May 11, 1968, speculation had already driven J&L's stock up to $77 before trading was suspended. By June 25 LTV announced it had acquired slightly over five million shares for more than $425 million. The cash for this came from internal LTV funds and loans from various American, Canadian, and European sources.[29]

Among the potential benefits to J&L were "a broadening of the corporate image nationally and in the marketplace through its relationship with a corporation which is active in aerospace, electronics, food products, sporting goods, drugs, chemicals, an airline, and car rental service, among other lines." And Stephens, as J&L's president and the one who would have the most immediate responsibility for making the connection work, said, "If LTV becomes a major stockholder, we will be living in a new corporate world, and we must learn how to operate in this new relationship. This could generate an exciting and quite different future for J&L. Together we might be able to move forward faster than we would be able to do alone."[30] Stephens was being predictably optimistic, and the actual future turned out very differently. But one thing was quite clear: For the first time in its long history as an American business, J&L was no longer an independent entity.

ten "Going Down for the Count"

The acquisition of Jones & Laughlin by LTV set off "profound shock waves through J&L, and, for that matter, the entire Pittsburgh business community."

> The Pittsburgh community feared the worst—the removal of J&L as a major employer and business leader in Western Pennsylvania. Customers, reacting to the constant barrage of publicity in national news media, began to question the stability of the company. Competitors were quick to take advantage of the situation. Rumors multiplied. Employees, from sweepers to vice presidents, became uneasy about their futures with the company as unfamiliar business concepts like "redeployment of assets" were expounded, modified, amplified and reexamined in machinegun-like bursts.
>
> Labor union leaders, financial analysts and politicians added their voices to the uproar of uncertainty.[1]

J&L management tried to deal with some of the uncertainty by having James Ling answer questions about the situation in an interview published in the company periodical *Men & Steel* later that year. Ling was appropriately supportive of the existing management and aware in general terms of the problems with foreign steel imports, but his answers were vague and more tied to what LTV had accomplished with Wilson and Company than anything else. Further, his regret that J&L was "geographically separated

from most of our other groups" was unlikely to allay fears that J&L's focus would shift still further from the Pittsburgh region.[2]

In any case, the acquisition encountered the opposition of the U.S. Department of Justice's antitrust division, headed by Richard W. McLaren, an opposition some say Ling asked for by his provocative advertisement in response to McLaren's announced hostility to conglomerates. The federal hostility, combined with poor earnings for J&L in the second half of 1968 (the first time LTV could have claimed J&L's earning as its own), helped drive LTV shares down, from a high of nearly $136 shortly after the official announcement of the acquisition in June to $100 by January 1969 and $65 the end of February.[3] It was an inauspicious beginning to the final chapter of the story of Jones & Laughlin Steel.

From 1968 until 1984 J&L continued to function as a separate steel-maker, despite LTV's majority ownership. This was the result both of the original terms of the acquisition worked out by Beeghly and Ling, which provided for a three-year voting trust controlled by J&L personnel, and of the impact of the federal antitrust action.[4] On January 30, 1969, a new holding company, Jones & Laughlin Industries, Inc. (JLI), was established

Debenture of the Jones & Laughlin Steel Corporation, 1969.

William J. Stephens, chairman and president of J&L, ca. 1969.

as a holding company for all LTV stock in J&L, which soon rose to 81.4 percent by an exchange offer with other J&L shareholders. It was a wholly owned subsidiary of LTV, and its three voting trustees, all members of the J&L board, had the right to vote its shares until February 1, 1971, or until the federal antitrust litigation had been resolved. On March 10, 1970, a proposed final judgment of that case was filed, by which LTV had to divest itself either of J&L Steel or of Braniff and the Okonite Company. Until the judgment was made final by divestiture, LTV/JLI would have only two voting members of the five voting trustees.[5]

The voting trust was controlled by three J&L executives, who could thus facilitate or frustrate Ling's ideas to restructure the steel company along geographic or other lines. Some of his ideas were unrealistic, given the nature of the steel industry. One idea was to take over J&L's computer services with a new subsidiary, Computer Technology, but he later changed his approach. The voting trust grated on Ling, and he sought to eliminate it early in discussions with Stephens, but this resulted in a negative response

Aerial view of Hennepin, Illinois, as work was begun on the works, 1966.

from Beeghly. Ling was also impatient with the start-up costs of the new Hennepin plant, one of Beeghly's pet projects but considered by Ling to be "a great big lemon sitting out there in the Illinois prairie" since it was dependent on raw steel from J&L's Pittsburgh region facilities.[6] This may be a measure of Ling's frustration with his inability to get cash out of his J&L acquisition to help bail out his financially troubled conglomerate, which was being buffeted on the stock market and in the public press. A brief rise in stock prices followed the announcement of the settlement of the antitrust action, but it was followed by a more realistic fall in prices in light of J&L's "worst year in a decade" and LTV's net losses and suspension of dividends. Ling had to give his "personal assurance" to the USWA local at the Pittsburgh Works "that LTV has no plans to close the Pittsburgh Works, or any other facility, or to decrease the hourly paid work force" to get final court approval for the antitrust settlement that he hoped would turn the declining situation of LTV around. And that same month (June 1970) Ling and two other LTV executives were elected to J&L's board. The settlement had also lifted the court injunction against their active participation in the management of J&L. Eventually, however, internal developments in LTV would result in Ling's being eased out of control of

LTV and J&L Steel by mid-1970. The subsequent improvement in J&L's earnings during 1971, however, came as a result of other factors. Eventually, in the spring of 1972, even the official name of the company was changed from Ling-Temco-Vought, Inc., to The LTV Corporation. [7]

The pickle line at the Hennepin Works.

The tandem mill at the Hennepin Works.

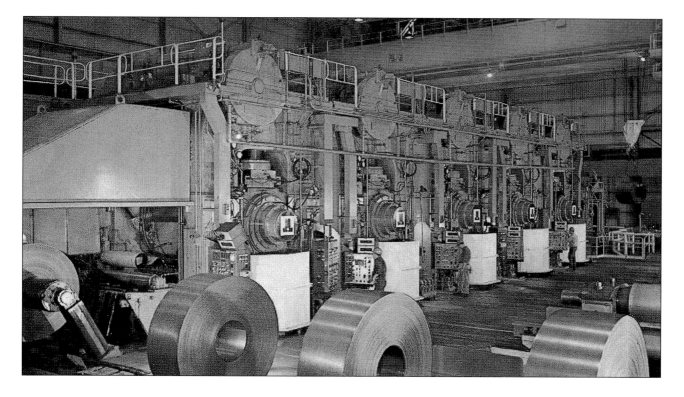

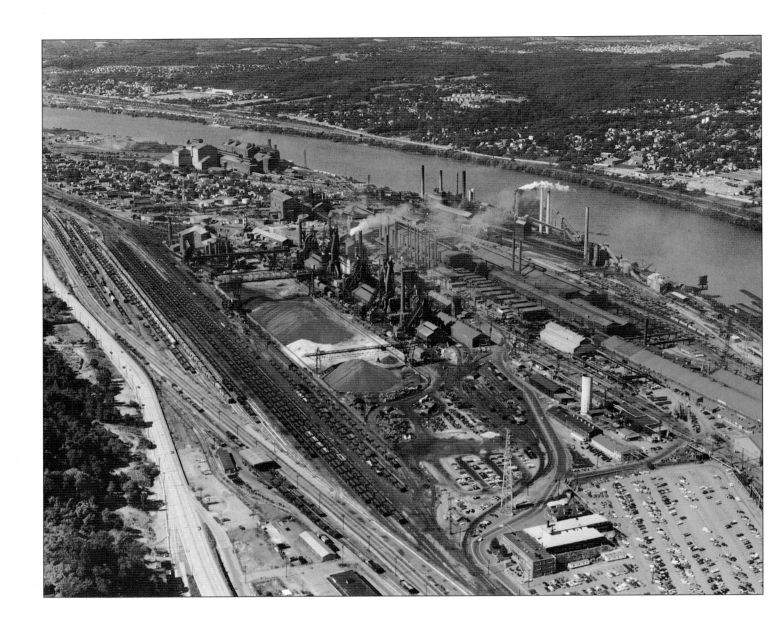

An aerial view of the North Mill, Aliquippa Works, showing blast furnaces (center) and BOF (upper left), ca. 1970. (Courtesy of Charles Fluharty.)

The relationships of Stephens and other J&L executives with Ling had always been marked by uncertainty and differences of purpose in any case. By marshaling facts and figures during numerous meetings with Ling and his associates in 1969 and 1970, Stephens had managed to persuade them "that there was nothing to be gained by indiscriminately breaking J&L apart"; he had "kept 'a finger in the dyke' until a sense of stability began to return to the company's public image."[8] By the time he retired at the end of 1971, J&L had already begun a recovery that would put it back in the black.[9]

A key figure in this was the new president, William R. Roesch. Roesch had begun his career at age twenty-one with J&L in his native Vestaburg,

Pennsylvania, working in the J&L coal mine as a mechanic. In the succeeding twenty-eight years he rose through the ranks to become president on October 1, 1970. And on January 1, 1972, he succeeded Stephens as chairman of the board, at forty-six "the youngest chief executive officer of any major steel company in the United States" and the "first 'home-grown' chief executive officer since 1936 when G. M. Laughlin Jr. retired." Roesch retained the title of president, and in his first management letter he was optimistic about the future.[10]

Unfortunately, he had to sound a note of caution in his second management letter because J&L "has yet to achieve a competitive earnings position in the steel industry."[11] He may also have been finding the relationship with the parent company, The LTV Corporation, too limiting. What followed could be interpreted that way, although it could also be taken at face value and simply indicate, as his obituary suggested, that "He did such a good job rebuilding Jones & Laughlin" that Edgar Kaiser, an automotive and metallurgical entrepreneur, just made him too good an offer to refuse.[12] In any case, late in 1973 he announced his decision to leave J&L on January 1, 1974, to assume the presidency of Kaiser Industries Corporation, and he was succeeded by Roscoe G. Haynie, president of The LTV Corporation, as chairman and CEO, and Thomas C. Graham, J&L vice president, as president and chief operating officer, effective in both cases with the new year.[13]

Haynie was essentially an outsider, but Tom Graham, then age forty-six, had like Roesch come up through the ranks. A native of Greensburg, Pennsylvania, he had joined J&L in 1947 as a draftsman fresh out of college and moved through a variety of engineering jobs in New York, Pittsburgh, and Hennepin before he was tapped by Roesch to become vice president of purchasing in 1972 and assistant to the chairman and vice president in 1973. It was his work at Hennepin and his successful jump to purchasing from engineering that gave him his final rapid ascent to the top operating position, pretty much as a protégé of Roesch. And it was Graham whose management style became dominant in the years that followed.[14] This became even more apparent on August 14, 1975, when it was announced that Roscoe Haynie was retiring as chairman and CEO and that Tom Graham would be the new chief executive officer.[15]

The workers at J&L continued to have a strong commitment to the company during the early years of LTV ownership, even after J&L became a wholly owned subsidiary of LTV in 1974.[16] But, as in the country at large, strains began to appear during the period marked by the traumas of the Vietnam War, the Watergate scandal, the Organization of Petroleum Exporting Countries (OPEC) and oil shortages, heightened political passions,

William R. Roesch, chairman and president of J&L, 1972–73.

Thomas C. Graham, chairman and president of J&L, ca. 1976.

Roscoe G. Haynie, chairman of
J&L, 1974–75.

and international terrorism. These strains were not so much tensions be-
tween management and union leadership, however, as between manage-
ment and the workers themselves and especially between generations. Com-
menting on the tensions across generations, John Hoerr focused on the
demoralization that resulted from companies' hiring as supervisors gradu-
ates who were fresh out of college, and paying them more than general
foremen (who had come up through the ranks), and who, to the senior
employees in the plants, did not really have a sensitivity to the workers:
"This helped destroy working relationships. In the early seventies, they
began hiring attorneys to run personnel services. Most of them used it as a
stepping-stone and became tough bastards. 'If you want something, arbi-
trate!' they told us." Another worker added: "It wasn't a partnership any
more. We were considered stupid. In earlier years, the foremen listened to
us and were more on our level. Then there was a widening."[17] A second
passage focused on the workers themselves:

> Jack Bergman said too many younger workers seemed to feel that "jobs
> should be created for people where there were no jobs. It seemed that
> was the American way. You get paid top dollar for doing as little as you
> can. I had four men in a shipping crew, loading pipe in a bay area, I'd
> get a report that two would be working, two sleeping. I'd go there.
> They'd be smoking pot, actually. The stench in the air . . . people in
> the cranes would almost be overcome by the stench coming up."
>
> Practically everybody who worked in the plants after the 1950s,
> that I talked to, expressed unusually strong opinions that the 1970s
> generation of workers did not measure up to earlier groups.[18]

The USWA had begun industrywide negotiations in 1956, and after the
disastrous strike of 1959 the union had managed to work out increasingly
beneficial terms with successive contracts during the 1960s and 1970s,
frequently in competitive rivalry with the United Auto Workers and to suit
the political demands of union leadership. The thirteen-week sabbatical
or extended vacation in 1962, the maintenance of section 2B rules govern-
ing crew size (and leading, according to management, to "featherbedding"),
the regaining of the cost-of-living-adjustments (COLA) in 1971, and a guar-
anteed 3 percent increase in return for a no-strike agreement in 1973 all
drove up production costs for steel companies at a time when competition
from foreign steel producers was increasing.[19]

Despite the intergenerational tensions and perhaps aided by the benefi-
cial terms of their contracts, J&L workers continued to be strongly com-

mitted to the company and strongly supportive of efforts to make it more profitable, hence more viable in an unstable economic environment.

The J&L management team used *Men & Steel* both to improve relationships and to encourage quality and productivity. Under Graham the editorial staff instituted a new look for the magazine, which introduced the talents of Lee Sokol, Pittsburgh Works Eliza stove tender and the cartoonist of "Jake & Looey," whose exploits and separate section, including the JALMate of the month centerfold (for a few issues, at least), would enliven future issues.[20] A major change in the magazine came with the winter 1974 issue; its name was changed to *JALTeam Almanac*. The reason was given in "An open letter to male chauvinists": "Let's face it men, it's no longer a man's world. What you see on the cover of this magazine is symbolic of wide-spread changes that are beginning to take place in American life. Women's roles in life are changing. . . . It was called to our attention that the name of J&L's employee magazine MEN & STEEL didn't take into account the fact that we also have many women working for J&L and that more are

The first *JALTeam Almanac* (Autumn 1973) centerfold, steelworker Harvey J. Miller.

on the way."[21] In several of the following issues the roles of women in the mills were highlighted, showing them in positions that had previously been male bastions. The names of many positions likewise were changed, some of them by reversion to older titles (crane operator rather than craneman) and others with little necessity for comment (sales representative rather than salesman). But the most difficult name to change was also the most pervasive: "foreman" was to be replaced by "supervisor" in all its forms (such as turn supervisor, general supervisor). This would also have the effect of removing the distinction between a factory foreman and an office supervisor.[22]

Management also made a more conscious effort to work with all employees in finding ways to improve efficiency, reduce waste, save energy, and in general ways make the company more viable. Graham instituted a series of meetings with managers, described by John Kirkwood, director of employee services, as "an experiment in communications and an important exercise in self-development for J&L managers a key element in

(Opposite) The second JALTeam Almanac centerfold, a secretary (Spring 1974).

(Above) The third and last JALTeam Almanac centerfold—Jake & Looie "streaking" through the boardroom (Summer 1974).

our overall development program."[23] He also encouraged the widespread use of incentives for ideas for improvements, especially those that would cut costs, reduce energy consumption, and improve quality.[24]

John H. Kirkwood was a major figure in J&L's efforts under Graham to improve management-labor relations. He had joined J&L in 1968 as labor attorney and served in various capacities in employee services to become, in August 1976, general manager of personnel and eventually vice president for industrial relations.[25] He was described by John Hoerr as "one of the more innovative labor executives in the industry." Graham was willing to give Kirkwood considerable latitude, and it reflected well on his leadership at J&L, although Hoerr has pointed out that Graham's espousal of a participatory management style was implemented by dictation, a manner contradictory to the preferred style.[26]

It was as an expert on increased productivity through new technology and reduced manpower requirements that Graham made his reputation "as one of the best steel managers of the 1970s and 1980s."[27] The international economic situation changed dramatically with the oil embargo of 1973, which drove up energy prices but also opened opportunities for a major growth in oil country products for J&L. Shipments of tubular products went up from 11 percent to 14 percent of the total product mix/tonnage between 1973 and 1974, at a time when total tonnage was also reaching record heights. With other increases in agriculture, food containers, and transportation products, J&L more than compensated for a significant decline in automotive market products.[28] Dealing with the energy shortage and with a growing mandated concern about pollution required J&L to look to the acquisition of alternate energy sources (primarily natural gas) and to changes in technology. A major expansion of the Aliquippa Works was projected, at a cost of $200 million, making Aliquippa "one of the largest integrated steelmaking plants in Pennsylvania." New BOF facilities and a new blooming mill were the main features of this capital expansion, which would increase production capacity by about one million tons per year.[29] This was followed in 1975 by a major rehabilitation of the Pittsburgh Works, at a cost of another $200 million, with an emphasis this time on electric-furnace production and in compliance with a consent order signed in October 1975 by J&L, Allegheny County officials, and the U.S. Environmental Protection Agency.[30]

All this planned expansion of production facilities, however, came at a time when J&L was having to deal with a decline in income due to an economic recession and was running at under 60 percent of capacity, the "break-even point for a capital intensive company like J&L" and a situation necessitating "an excess of 20 per cent of our hourly force on layoff."

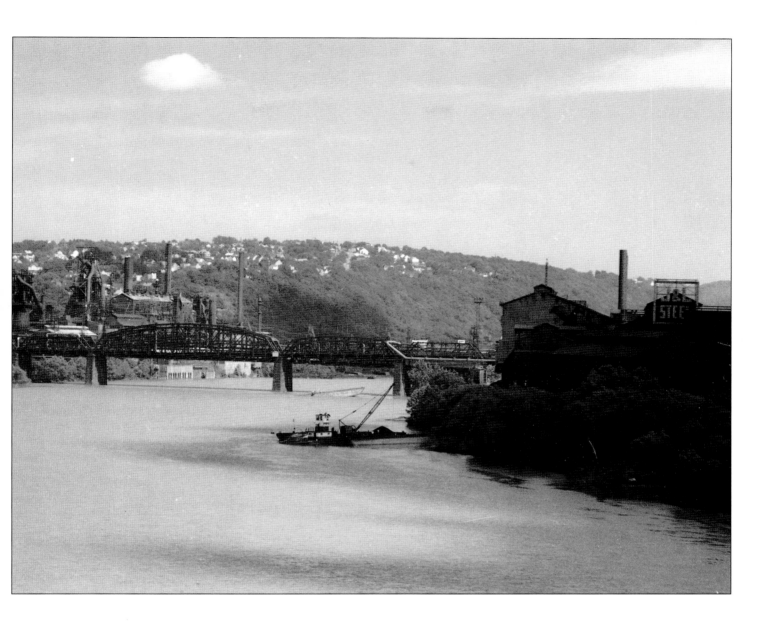

Sunken barges at the Pittsburgh Works, 1981. Note the connecting bridge.

It was largely the demand for oil-country products that was still fairly strong.[31] This demand continued during the 1970s as oil and gas market consumption of J&L tonnage rose steadily from 3 percent in 1973 to 12 percent in 1981, with the larger increases coming in 1979–81.[32]

By then an additional significant increase in production capacity had also occurred with the merger in 1978 of the Lykes Corporation, owners of Youngstown Sheet and Tube, and The LTV Corporation. This made the new steel group, which continued to be called the Jones & Laughlin Steel Corporation, the third largest steel producer in the country. The first year of the formal integration of the two steel-making facilities was not until 1981, by which time Youngstown's Indiana Harbor plant had been integrat-

The Pittsburgh Works, ca. 1975, with the Civic Arena and U.S. Steel Building in the distance.

The Pittsburgh Works, ca. 1975, with the Cathedral of Learning in the background.

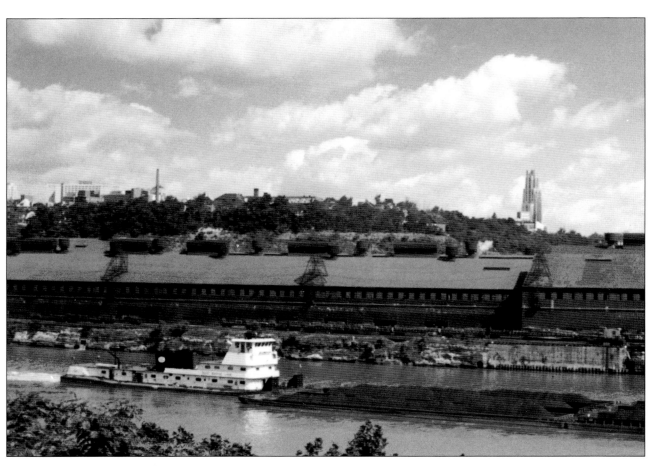

ed with J&L's Hennepin finishing plant. This helped to reduce Hennepin's costs but it also further shifted the focus of J&L away from the Pittsburgh region. However, the merger also led to improved productivity without much increased capital investment and a decline of 17 percent in the number of man-hours necessary to produce a ton of raw steel. The capital investment that did occur took place mostly in Indiana and Ohio.[33] Increases in raw steel capacity, however, came as American steelmakers were finding it hard to compete with foreign (European and Japanese) steelmakers; it was primarily finished steel products and in particular specialty steel products that were keeping American steelmakers afloat in the increasingly rough waters of world trade.

Overcapacity in America was matched by overcapacity in the world steel-making facilities, fueled in part by faulty predictions of capacity needs in the early 1970s. By 1982 it was becoming apparent that the American basic steel industry was in serious distress, the result of "market myopia and organizational rigidity," among other things, according to John Hoerr.[34] Competition from foreign steelmakers, the failure of USWA leadership to come to terms with economic realities, the shortsightedness of so many steel executives in realizing that what was then happening did not fall into the traditional cyclical character of steel, and the changed political environment of the 1980s signaled by President Ronald Reagan's election and subsequent federal antipathy both to unions and to federal regulations combined to bring to a close an era of steelmaking in America.

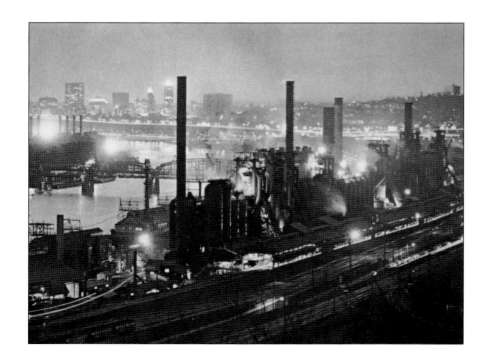

An evening shot of the Pittsburgh Works, ca. 1975, with the "Golden Triangle" buildings in the distance.

J&L management was actually more open to innovation than this grim picture of steel executives suggests. Although J&L had been part of the inner circle on the industry negotiating teams, by 1977 John Kirkwood was already recommending the end of industrywide negotiations, and his frustration was especially acute in 1982.[35] Further, J&L was willing to try new approaches in union-management relations, most notably the use of labor-management participation teams (LMPT) and the exchange of enhanced early-retirement benefits for job-classification reform to reduce positions. The LMPTs at Aliquippa were particularly effective in identifying and implementing changes that would enhance productivity in a mutually supportive manner between workers and management. Indeed, the Aliquippa Works was one of the bright spots in improved labor-management relations during the 1970s and 1980s.[36] Thus it is somewhat ironic that U.S. Steel continued to be the problem area in this regard, even after Graham went there as second in command to David Roderick in May 1983. Hoerr suggested that a large part of Graham's success at J&L was due to Kirkwood's restraining influence.[37] His successor at J&L Steel was another longtime J&L man, David Hoag, who now had to face the growing economic crisis caused by the recession of 1982 and the collapse of the American oil boom.

(Right) A variety of LMPTs at the Aliquippa Works in the 1980s. (Below left) "Tin snips" LMPT, Aliquippa, 1980s.

Original LMPT facilitators at the Aliquippa Works: (back row, left to right) Terry Bush, Don Mancini, Rich Kerlin, Paul Martella; (front row) Gary Wuslich, director (at left), and Carl Snyder, coordinator (at right).

LTV had been positioning itself as a manufacturing and technology corporation in the years since the merger with Lykes. In July 1981 it completed its spin-off of the consumer product company, Wilson Food, and thereafter steel represented the dominant portion of LTV's mix of products ($4,786 million out of a total of $7,511 million in 1981), with only energy products and services coming anywhere close.[38] Thus, the dramatic fall in the economic fortunes of the energy-related fields was sure to hit LTV especially hard. The acquisition of Colt's Midland, Pennsylvania, speciality steel facility (formerly owned by Crucible Steel) early in 1983 helped it in one of the few surviving steel markets, and modernization efforts at the Campbell Works in Youngstown and the Indiana Harbor Works helped reduce production costs as well, but the "current sluggishness and inher-

ent cyclicality of oil and gas drilling" more than outweighed them and LTV's efforts to shift its focus into other markets (elastomeric, rubber, and plastic, for example, by the acquisition of Oil States Industries). Aerospace/defense sales increased, but steel and energy products fell dramatically.[39]

By the end of 1983 the days of J&L Steel Corporation were numbered. In September 1983 The LTV Corporation and Republic Steel Corporation announced a merger of the two to form LTV Steel, which would now become the nation's second largest steelmaker ahead of Bethlehem Steel. LTV management reported to its shareholders:

> The proposed merger is based on the recognition that a new environment exists in the steel industry—one in which an integrated worldwide steel market has replaced the once-isolated domestic market, and one in which foreign steelmakers often enjoy a distinct competitive advantage because of lower-cost labor, cheaper raw materials and more modern facilities built largely through government assistance. Even though we have spent large amounts of capital to modernize facilities, it has not been enough to make us fully competitive.

(Opposite above) Attendees to the 1988 LMPT Conference, Dearborn, Michigan: (left to right) David Hoag (CEO of LTV Steel), Gary Wuslich, Paul Martella, and Don Vernon.

(Opposite below) Other attendees to the 1988 LMPT Conference: (left to right) Don Broadnax, Bernie Brennan, Don Inman, and Cole Tremain.

"Tin Snips Team" giving a presentation at the 1988 LMPT Conference: (left to right) Don Inman (at podium), Bill Cropper, Bob "Red" Jones (kneeling), Paul Laving, Bernie Brennan, Terry Cole, and Don Broadnax.

Blast furnaces at the Aliquippa Works just before demolition in 1990.

The area where Aliquippa's blast furnaces used to be, 1996.

A merger of LTV and Republic is a logical response to this problem. The combined resources of the two companies will create a stronger steel operation than either can accomplish as a stand-alone company. Realignment and rationalization of the merged raw material and steelmaking facilities will greatly reduce costs, improve capacity utilization, increase productivity and enable us to make more efficient use of scarce capital.

It was not until a compromise agreement was reached with the antitrust division of the U.S. Department of Justice on March 21, 1984, that the

merger could move forward, and then the new steelmaker would have to sell off two of Republic's large facilities (Gadsden, Alabama, and Massillon, Ohio) after shareholders approved the merger.[40]

The corporation's *Annual Report* put the best construction on the merger, but others have described it as combining "the resources of two sick companies to make one healthy producer,"[41] and in the circumstances of the early 1980s this was inherently improbable. In any case, with the implementation of the merger in June 1984 the J&L Steel Corporation came to an end as both names, Republic and Jones & Laughlin, disappeared from the rolls of American businesses. The long and glorious history of Jones & Laughlin Steel Corporation was over.

Epilogue

When the Jones & Laughlin Steel Company was first constituted in 1902 after the merger of the Jones & Laughlins and Laughlin and Company partnerships in 1900, it was the second-largest steel manufacturer in the United States. Ironically, the new LTV Steel Company produced by the merger of Republic Steel with Jones & Laughlin Steel Corporation was also the second-largest steel producer in America. But it was no longer Jones & Laughlin Steel Corporation.

The focus of our attention in this book has been Jones & Laughlin Steel. The subsequent story of LTV Steel is very interesting, informative, and controversial. John Hoerr has done an excellent job describing a significant part of it in his *And the Wolf Finally Came*, and it is not our intention simply to repeat what he has given us.[1] Rather this epilogue will seek to tie up some loose ends regarding those elements that in one way or another carry on the J&L name. In the process some less tangible survivals of J&L will also be touched upon.

The new corporation was named after the parent LTV Corporation, but eventually LTV Steel would become synonymous with its parent corporation. The chairman and CEO of The LTV Corporation, after the retirement of Raymond Hay in 1991, was the former head of J&L Steel, David H. Hoag. Hoag was fifty-one at the time and was seen by some as "LTV's man of steel."[2] Hoag had reduced overall steel capacity by 60 percent, improved productivity by 70 percent, and had concentrated on flat-rolled steel for automobiles, appliances, and construction. This reduced LTV Steel to third

largest in the country but made it "a scrappy competitor" and lowered its operating losses below those of its competitors.[3] This was, however, after eight years of pain and hardship for everyone in the company.

The implementation of the merger of Republic Steel and J&L Steel took some time, particularly the consolidation of headquarters in Cleveland and the amalgamation of their steel-making facilities. Both actions signaled a further retreat from the Pittsburgh district that had been a feature of the steel industry generally, and J&L specifically, for many decades. The transfer of about 450 executives to Cleveland was costly, although not all changed their places of residence. More than two thousand salaried positions were eliminated and other cost-cutting measures helped, but the merger turned out to be difficult on remaining personnel, particularly those from Republic, who found themselves outnumbered by J&L people in the upper echelons of management. The merger also resulted in excess capacity in some areas and excess expenses in others, especially pensions. LTV Steel's losses continued to pile up in 1985.[4]

Some facilities had to be sold off to secure the federal antitrust agreement, most notably Republic's Gadsden, Alabama, plant; and the two Cuyahoga Valley facilities that faced each other across the river in Cleveland had to be consolidated into one massive, modern facility. This became LTV Steel's primary steel-making facility, with the Pittsburgh and Aliquippa Works increasingly redundant in the depressed steel market of the 1980s. All the efforts that were made, and Hoerr recounts very well what some of those efforts were,[5] in the end were not enough to avoid the company's bankruptcy.

As late as 1981 almost 10,000 were still employed at J&L's Aliquippa Works; but by May 17, 1985, fewer than 2,500 remained when LTV Steel announced the closure of most of the facilities. By then the Pittsburgh Works had also been reduced to a few workers in the coke plant at Hazelwood.[6] Most of the major layoffs had occurred during 1982 and 1983. Union-management negotiations in 1986 focused on reductions and deferred cost-of-living-allowance increases in an effort to save hundreds of jobs in an interim agreement on January 29, 1986, and on further wage relief and contracting out in a long-term contract on March 15, 1986. This passed the union rank and file by a 61 percent margin on the basis of overwhelming support in Pittsburgh and Aliquippa and in the face of strong opposition by workers in Cleveland and Indiana Harbor.[7]

By 1986 LTV's indebtedness amounted to $2.6 billion, with over $2 billion in additional pension liabilities, and it had a monumental cash-flow problem. Securing wage concessions of $3.60 per hour from workers was insufficient, and Hoerr argues that even $10 per hour would not have

been enough without other major improvements. On July 17, 1986, LTV Steel filed for Chapter Eleven bankruptcy protection. With only 25,000 active workers shipping 8.7 million tons, it was impossible for the company to support the pension requirements for 71,000 retirees, especially when The LTV Corporation had only contributed the legally required minimum to the pension funds in earlier years.[8] The subsequent controversy over pension rights, including a selective six-day strike at the Indiana Harbor Works, was extremely complex, involving as it did LTV corporate headquarters in Dallas, LTV Steel management in Cleveland, the USWA in Pittsburgh, the federal bankruptcy court in New York City, and the federal Pension Benefit and Guaranty Corporation (and behind it the Reagan administration), each with their own agendas, limitations, and perspectives.[9] The pensioned workers themselves found it necessary to organize separately as the Steelworkers Organization of Active Retirees (SOAR) to make sure their distinctive viewpoint was represented. The controversy aroused deep emotions and harsh language and actions. Everyone lost something in the process.

The depth of these feelings showed several years later when a group of volunteers from SOAR were stripping the old paint and gunk off the speed pulpit of the hot strip mill that the Beaver County Industrial Museum at Geneva College had acquired. One steelworker, who had worked in the pulpit, said firmly to the director of the museum, "You know what color you're going to paint this!" Since it was not a question, the director asked, "What color do you think?" The retiree stated with conviction in his voice, "Green and yellow, that's what!" The reason was simple. He and his friends there that day, whose combined service at J&L's Aliquippa Works was over 150 years, wanted the original J&L colors rather than the blue and white of LTV, the company that had purchased J&L and whom they blamed for later closing down the Aliquippa Works.[10]

By the time LTV Steel emerged from bankruptcy in June 1993, it would be a narrower, more focused company. Its nonsteel divisions had largely been sold off, and David H. Hoag had become chairman and chief executive officer of the whole corporation, now headquartered in Cleveland and with only an office in Dallas.[11] In the Pittsburgh region it had only two small facilities, the Aliquippa Tin Mill and the Hazelwood Coke Plant (the closure of the latter occurred in 1998). Most of the once-massive Pittsburgh and Aliquippa Works had been demolished both to escape property taxes and to make way for newer developments, including a technology park on the north shore of the Monongahela. Some mills were turned into cash, such as the hot strip mill at Aliquippa, which was sold, dismantled, and shipped to Texas for possible future use. The old 14-inch mill at Ali-

quippa also was sold, but to a group including former J&L management, and it has continued to operate as J&L Structural, Inc. It was merged with CPT Industries in 1995 but continued to use the J&L name. The J&L name also lived on in the J&L Specialty Products Corporation, formed in 1986 by another group that included former J&L executives. It has produced stainless steel at the former Midland, Pennsylvania, Works of Crucible Steel, which LTV Steel had acquired early in 1983 from Colt Industry.[12] It likewise was purchased by another company in 1990, in this case the French steelmaker Usinor, but continued to use the J&L name. J&L's Otis Works, acquired in 1942, has become the major part of LTV Steel's Cleveland Works, which also includes the old Republic Steel Works across the Cuyahoga River, and LTV Steel has continued to run the former Youngstown Sheet and Tube's Indian Harbor Works and the Hennepin Works that J&L built in the 1960s. Other than these facilities, little has remained of the once-extensive facilities of Jones & Laughlin Steel Corporation.[13]

The J&L name may only survive today in two small companies in Beaver County, Pennsylvania—and ironically the Midland facility was only under the J&L name for about a year—yet J&L lives on in the memories of the many thousands of workers who committed their lives to the Jones & Laughlin Steel Corporation and who still remember it fondly. It is somehow appropriate that Beaver County, where the young Benjamin Franklin Jones reached maturity and where his parents are buried, should also be the repository of the ongoing efforts to maintain the heritage of this outstanding American business in the Beaver County Industrial Museum.

Appendix one

Advertising at J&L, 1958–60

During the years 1958 to 1960 Jones & Laughlin conducted a corporate advertising campaign that concentrated on projecting a positive image of the company rather than promoting specific products, although in the process a wide range of J&L products was highlighted. The campaign was the joint responsibility of Gene Jannuzi, assistant director of public relations and advertising for J&L, and Ketchum, McLeod, and Grove (KMG), J&L's advertising agency. Gene Jannuzi wrote much of the copy, while KMG did much of the layout. A variety of photographers, among them Arthur d'Arazien, Clyde Hare, and Ivan Massar, were employed by the company, most of them recruited by Roy Stryker, a consultant for J&L in building a photo library for the company.

One of the most innovative features of the campaign was the placement of products in the specific mills that produced their steel. Arthur d'Arazien photographed automobiles in the hot strip mill at the Aliquippa Works (*Time*, August 22, 1960), cans in a mock supermarket setup in the tin mill (*Business Week*, October 22, 1960; slightly different versions appeared in the *Saturday Evening Post*, *Time*, and *Food Processing* the same month), and kitchen utensils laid out in the hot strip mill at the Cleveland Works (*Saturday Evening Post*, September 24, 1960). He also took the picture of Aliquippa's strip mill (*Business Week* and *Time*, March 1958), while

Clyde Hare photographed the Pittsburgh Works's hot slabs (*Business Week* and *Time*, May 1958).

The periodicals targeted included such popular magazines as *Time* and the *Saturday Evening Post*, as well as business periodicals (*Wall Street Journal, Business Week*) and, most of all, steel product–related publications (*Food Processing, Journal of Plumbing, Heating & Air Conditioning, Industrial Distribution, Domestic Engineering, Mill and Factory, Heating, Piping & Air Conditioning, Iron Age, Steel, American Machinist, Purchasing, Architectural Record, Architectural Forum, Engineering News-Record, Automotive Industries, Appliance Manufacturer*, and so on). Early ads were largely black and white.

Travel, Adventure, Excitement – 76¢/lb.

The cost per pound of the typical American auto is actually about 76 cents—less than almost any other manufactured product you own—even less than a pound can of coffee. This makes the modern steel auto one of America's best bargains. Over 100 different grades of steel give strength and beauty to the typical car—sheets for the body, alloy bars for springs and torsion bars, special valve steels to withstand high temperatures, stainless steel for the gleaming brightwork.

It takes big mills to feed the auto industry today. The one behind our make-believe Main Street is the new cold reducing mill in our Cleveland Works. It rolls out 3,750 feet of smooth, flat, steel sheet per minute. *Demand* was the reason for this mill, your demand for a better car

with the strength of steel, translated into auto industry demand for flatter, smoother steel, more uniform in quality. Thus, the sheets of steel from this mill are uniformly thick, held that way by an automatic X-ray device.

Do cars last as long as they used to?

Sometimes people say, "Boy, they knew how to build cars back in those days. . . ." The facts belie the statement. In 1937, the average age of all cars on the road was 5.5 years. Now, the average age is even greater—5.7 years. With proper care, your new car could last 13 years or more, and deliver over 200,000 miles of transportation (enough to get you around the world eight times!).

Do cars cost more or less today?

Believe it or not, you actually pay *less* for what you get

d'Arazien

than you would have thirty years ago! But prices were lower then, you say. Well, don't let the dollar marks fool you. Value is the important thing. And in terms of value, you do *less work* now to pay for your car than you would have back in "the good old days."

You probably spend more for your car than for anything else you own, except your house. But like your house, its usefulness far outweighs its cost. Without a car you couldn't live in a quiet suburban town. You couldn't take your family to the mountains or the beach as easily. There'd be no drive-in movies, no convenient suburban shopping centers or easy trips to the fairways.

For comfort and safety your car's way ahead of anything built thirty years ago, or twenty, or ten. That's because United States automobile manufacturers are the most efficient and productive in the world—and because steel mills such as J&L's provide economically to the auto industry the strong, tough, precision steels that make cars strong, safe and beautiful.

Look again

If you've put off buying a new car, take another look. Today's auto offers you greater value than almost anything else you buy—price, about 76¢ per pound, polished and ready to go. A better value because of steel!

This Steelmark identifies products made of steel—look for it when you buy.

Jones & Laughlin Steel Corporation
PITTSBURGH, PENNSYLVANIA

This advertisement is scheduled to appear in Time — August 22, 1960.

SPECIAL TODAY — Steel and Soda

Just 150 years ago a pickle maker named Nicolas Appert developed a "canning" process to supply Napoleon's armies with better vegetables. The American container industry today helps to provide us not only with better vegetables, but with floor wax, gas-powered toothpaste and soft drinks as well. And they've given us such a bargain in the sturdy tin-plated steel can that we can afford to throw away enough used cans every year to reach, end to end, twice the distance to the moon.

Nearly every product made of steel is a better bargain today than it was just 10 years ago — let alone in Napoleon's time. Design, production efficiency and materials — all have been improved in these 10 years, all have become more specialized. The electrolytic tinning line in J&L's Aliquippa (Pa.) Works (behind the sym-

bolic supermarket) does just one job but does it well — it imparts a coating of tin to steel strip to make better "tin" cans.

In the last important decade, Jones & Laughlin has invested about $700 million in new plants and new equipment like this tinning line to give all industry the improved steel it demanded. J&L, today, is a leading source for a great number of standard and specialty steels — tin plate for the container industry, stainless steel for the aviation industry, sheet steel and bars for the materials handling equipment industry and countless other specialized steels for countless other specialized industries.

Better products get a better start — with Jones & Laughlin steel.

CONTAINER

Soda, soup, sundries, even precious military instruments and documents, are now protected in sealed cans. J&L has invested over $50 million in the last 10 years — including a new continuous annealing line this year and a new electrolytic tinning line early next year — to make more and better tin-plated steel for more and better tin cans.

MATERIALS HANDLING EQUIPMENT

J&L now supplies literally hundreds of different grades and shapes of steel to the builders of materials handling equipment — hot and cold rolled sheets for housings; hot rolled and cold finished bars; high-strength steels; wire rope, and many others.

AVIATION

It takes the strength and corrosion resistance of stainless steel to meet the reliability requirements of today's jet engines. J&L's shipments to the aviation industry are typical of the increased demands of all industry for specialized steel — and of J&L's ability to meet those demands with better steels.

d'Arazien

but <u>she</u> set the production record

This modern mill at J & L's Cleveland Works rolls out orange-hot slabs of steel at the rate of over 5,000 tons a day. That's enough steel to make 40,000 refrigerators, 45,000 ranges, 50,000 clothes dryers, or 80,000 dishwashers—quite a production tally for those men up in the control booth. But the biggest production trophy should go to the modern American mother in our make-believe kitchen. Each year she washes, dries and folds 2,600 pounds of laundry, prepares and serves 4,100 meals and does over 21,000 dishes—*without a maid.*

Luckily, like the steelworkers at J & L, she has the finest machines to help her. She has a bright, beautiful and frost-free refrigerator and freezer combination. Her automatic range turns itself on and off,

bastes the roast or spins the shish-kabobs, while she folds the cleaner, fluffier laundry turned out by her automatic washer and dryer. And, after supper's over, the automatic garbage disposer and dishwasher under her gleaming stainless steel sink speed-up the clean-up so she can spend more time with her family.

She's a modern wonder—and the modern wonder of sturdy steel appliances helps make her production record possible. Products made of steel are strong, durable, efficient—a better value today than ever before because industry has invested fortunes in research and equipment to make its production as efficient as the lady in the kitchen.

This Steelmark identifies the better value of products made of steel—look for it when you buy.

Jones & Laughlin Steel Corporation
PITTSBURGH, PENNSYLVANIA

This advertisement is scheduled to appear in Saturday Evening Post — September 24, 1960

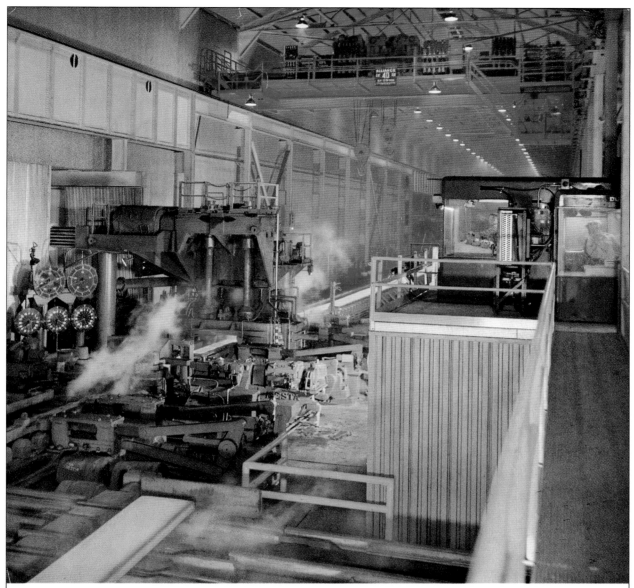

REVERSING ROUGHER ON NEW STRIP MILL—FIRST PHASE OF REDUCING SLABS TO STRIP STEEL D'ARAZIEN

Big strip mill goes to work at the new J&L

Strip steel of high uniformity is produced on this ultra-modern 44-inch hot strip mill at Jones & Laughlin's Aliquippa (Pa.) Works.

This $36 million addition to J&L's facilities supplies fine-quality steel strip for tubular products and tin plate produced at the Aliquippa Works.

In the rolling operation the reversing rougher receives the white hot slabs from the furnace, rolls and squeezes them thinner and longer and sends them to the finishing stands. The rougher may be placed under automatic controls by inserting punch cards in a "reading" unit.

This new mill is another reflection of the forward thinking at the "new" Jones & Laughlin—the *modern* steel company —the nation's fourth largest producer of steel and steel products.

Jones & Laughlin
STEEL CORPORATION·PITTSBURGH

J & L . . . A G R E A T N A M E I N S T E E L

Business Week—March 29 • Time—March 31, 1958

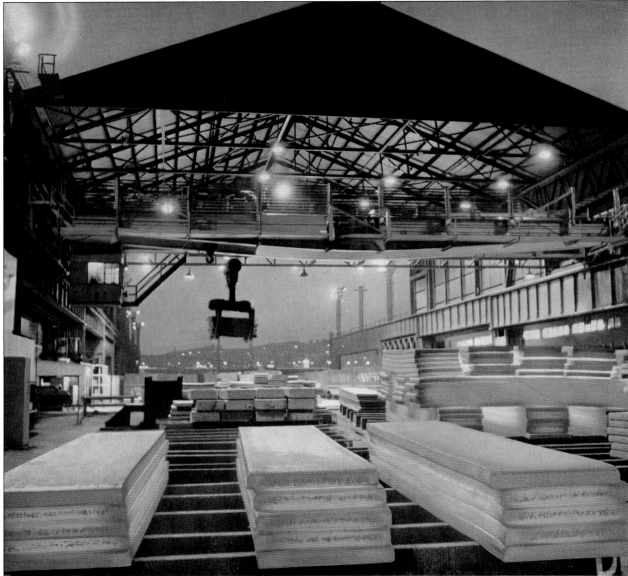

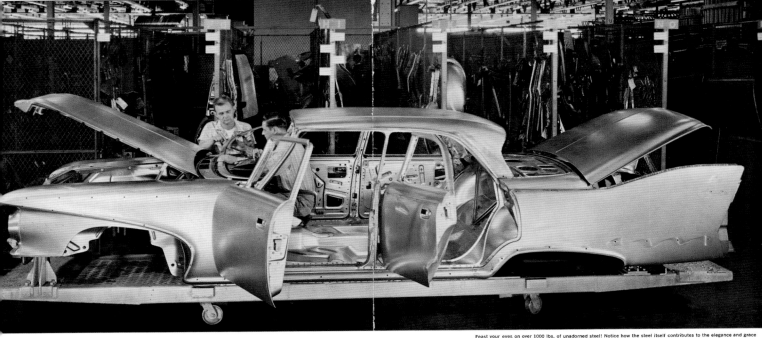

Feast your eyes on over 1000 lbs. of unadorned steel! Notice how the steel itself contributes to the elegance and grace of Chrysler styling—how, even in this raw metal stage, the "body-in-white" has a lustrous finish of real beauty.

uch of the beauty of Chrysler cars

comes from the steel itself

The proper foundation of a Chrysler-style paint job shows itself in this gleaming Plymouth "body-in-white"—steel with the surface finish a truly fine car must have.

Body parts for Chrysler cars emerge from a complex of huge presses and coils and sheets of flat rolled steel. Floor pans are formed, to be wed further on into single unitized assemblies of 50 major parts by fully-automated resistance welders. Doors are stamped with great precision, and 100 ton presses squeeze out car roofs, without a break or blemish.

This is Chrysler Corporation's Ohio Stamping Plant, giant of the auto industry, where 28 major stamping lines eat 2000 tons of steel a day and produce 600 different body parts. Steel is the basic raw material of this amazing plant—and the men who buy and use it know exactly what they need. As a regular supplier, J&L matches their needs *consistently*.

Each die-forming situation is individual and demands a specific set of metallurgical properties from the steel. In many cases, the factor of extreme importance is surface finish of the steel. Other times, drawing quality is paramount. And often, *combinations* of these and other qualities are needed, balanced one against the other with metallurgical precision.

The Ohio Stamping Plant may be big. But it is a tight operation—efficient, competitive, economical, with full control of quality at all times to insure the beauty and soundness of Chrysler bodies. That J&L steel is bought regularly, and used at one time or another in all the major parts produced by the Ohio Stamping Plant, speaks well indeed for J&L quality.

This is the roof line—at full rate of production. J&L is one of only three suppliers who can provide the 80-inch, 0.038-gage coils Chrysler needs here. Breaks and strain lines cannot be tolerated on roofs, so drawing quality is vital—as is surface finish, for reasons of appearance.

Jones & Laughlin Steel Corporation

3 GATEWAY CENTER, PITTSBURGH 30, PA.

This Steelmark identifies products made of steel. Look for it when you buy.

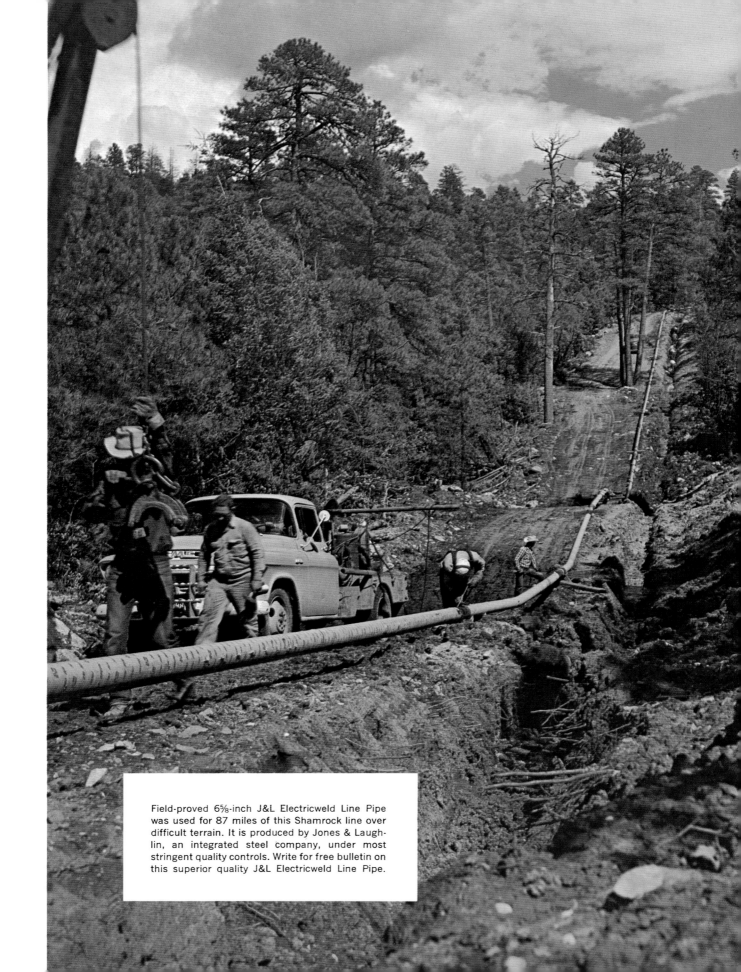

Field-proved 6⅝-inch J&L Electricweld Line Pipe was used for 87 miles of this Shamrock line over difficult terrain. It is produced by Jones & Laughlin, an integrated steel company, under most stringent quality controls. Write for free bulletin on this superior quality J&L Electricweld Line Pipe.

New six-inch products line will be operated
by Shamrock for its affiliate,
West Emerald Pipe Line Corporation.

Welders on this Shamrock line reported that
J&L Electricweld Line Pipe was
uniformly round, easy to weld.

Pipe is produced under strict com-
pliance with appropriate A.P.I.
and A.S.T.M. specifications.

Contractors for the rugged section from
Palma, N.M., to Albuquerque were
Groninger & King, Pampa, Texas.

Pipe is A.P.I. Standard 5 LX,
Grade X 42, 12.89 pounds per foot,
with a .188 inch wall thickness.

"Superior weldability of J&L Electricweld Line Pipe was proved on this mountainous operation"

...reports pipe line contractor

Steep, mountainous terrain presented a real challenge to pipeliners working on this Shamrock Oil and Gas Corporation line from Amarillo to Albuquerque. Eighty-seven miles of 6⅝-inch J&L Electricweld Line Pipe were used in the rugged section from Palma, N.M., to Albuquerque. Performance proved conclusively that J&L Electricweld Line Pipe bends readily to contour, is easy to weld and is uniformly round. It is readily available from 6⅝ inches through 12¾ inches.

Jones & Laughlin Steel Corporation
PITTSBURGH, PENNSYLVANIA

J&L Electricweld Line Pipe is produced on
one of the most modern mills in the world.

Hydrostatic test is one of a series of inspec-
tions and tests given every length of pipe.

This modern J&L ultra-sonic tester
assures superior weld quality.

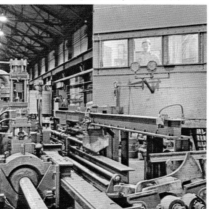

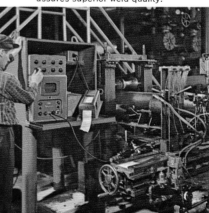

COMMUNITY ICE ESCAPADES are increasing in popularity with modern indoor rinks such as this one in Lewiston, Maine. This 85 x 200-foot Central Maine Youth Center Rink was built for the Order of Dominican Fathers with the aid of funds contributed by friends. Local skating clubs and hockey leagues—and novices, too—are enthusiastic about having this opportunity for rink recreation. And under that ice is a network of more than 10½ miles of 1¼-inch Jal-Con-Weld steel pipe.

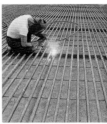

New skating facilities have been added recently in two of Cleveland's public parks. Both rinks have utilized 1-inch J&L Jal-Con-Weld pipe. Architect—Damon, Worely, Samuels & Assoc. Contractor—Smylie Bros., Inc. Distributor—Clark Goodman Supply Co., Inc.

The Woodland Hills Park installation required over 9½ miles of pipe and 2,000 welds.

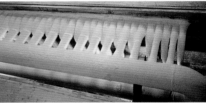

This cross trench shows arrangement of supply and return headers for the Central Maine Youth Center ice rink. Jal-Con-Weld pipe was selected because of its successful performance in similar installations over the past 15 years. Architect—Alonzo J. Harriman, Inc. Contractor—Jarvis Engineering Company. Distributor—Independent Pipe & Supply Corp.

America's Next Ice Age is on the move

What started it? It started with man-made ice and a new awareness of the genuine enjoyment to be found in skating. But nationwide interest in ice sports really began with the wide-spread application of dependable, low-cost refrigeration systems of *steel pipe*.

Steel piping systems, with their low initial cost and low-cost long-term maintenance, have made it possible for almost every community in the country to build an ice rink, permitting a full season of fall and winter skating.

Now, every year, more communities are building rinks wisely and economically with steel pipe. Many steel pipe rinks have been in operation for more than 20 years.

J&L's Jal-Con-Weld pipe is being specified for many of the new ice rinks. Close production control and rigid inspection assure a top quality product that will form and weld easily and provide dependable service for years.

Ask your nearby J&L pipe distributor for details, or write direct.

This Steelmark identifies products made of steel. Place this mark on your products. And look for it when you buy.

Jones & Laughlin Steel Corporation
PITTSBURGH, PENNSYLVANIA

Released April, 1960 for publication in Journal of Plumbing, Heating & Air Conditioning; Industrial Distribution; Domestic Engineering; Mill and Factory; Heating, Piping & Air Conditioning

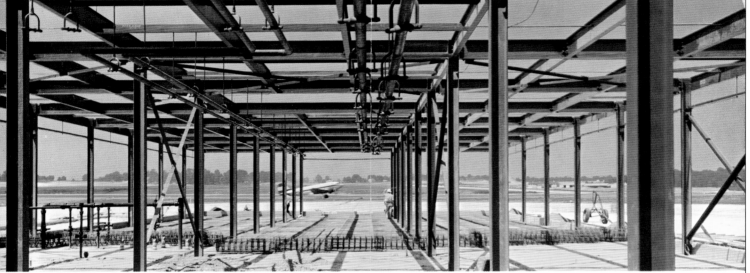

"The 14-inch J&L Light Beam was the most economical member we could use for the spans," say Robert and Company Associates of Atlanta, the designers.

New Atlanta Airport Terminal...Designed

for the Jet Age with J&L Light Beams

Air traffic comes in, all at once, in Atlanta, Georgia. Often there are as many as 60 planes in the terminal, all loading and unloading. Atlanta is one of the most important airlines transfer points in the country. Everyone wants to hold lay-over times to a minimum, so heavy traffic peaks are unavoidable.

The problem was to design a new terminal that would make life easy for passengers and airlines people. And do it as inexpensively as possible.

That's why the compact, 11-story central terminal building (with control tower on top) was conceived—with six long concourses splayed out like fingers to provide plenty of parking space for planes—with easy access everywhere for passengers and airlines personnel — with 8 special second-story "jetways" that telescope out from above the concourses to let jet passengers on and off with no stair climbing, high and dry

out of the weather — and with underpasses beneath each concourse for baggage trains to run, safely separated from passenger walks.

Design Economy was gained in concourse construction and in stair stringer fabrication by selecting J&L lightweight structurals — 14-inch J&L Light Beams for concourse and main terminal roof purlins — 10-inch J&L Junior Channels for stair stringers.

Because they are easy to adapt, you can use J&L lightweight structurals in a wide variety of architectural designs. They reduce the steel tonnage you'll require. And because they're easy to fabricate, raise, and position, they cut labor costs.

To find out more about J&L lightweight structurals, call or write direct to *Jones & Laughlin Steel Corporation, 3 Gateway Center, Pittsburgh 30, Pennsylvania.*

Jones & Laughlin Steel Corporation
3 Gateway Center, Pittsburgh 30, Pennsylvania

Key factor in concourse design was use of J&L 14-inch Light Beams as purlins. Span between rigid bents varies from 19' 7" to 24' 0". Formed metal decking, which supports insulation and built-up roofing material, is welded to the purlins. Purlins and girders also support a maze of concealed piping.

J&L 14-inch Light Beams and J&L 10-inch Junior Channels were used extensively throughout the new "Jet Age" Atlanta Airport Terminal. J&L 10-inch Junior Channels were used as stair stringers. J&L 14-inch Light Beams are purlins, mainly in two-story concourse sections.

Released August, 1960 for publication in Architectural Record; Architectural Forum; Engineering News-Record

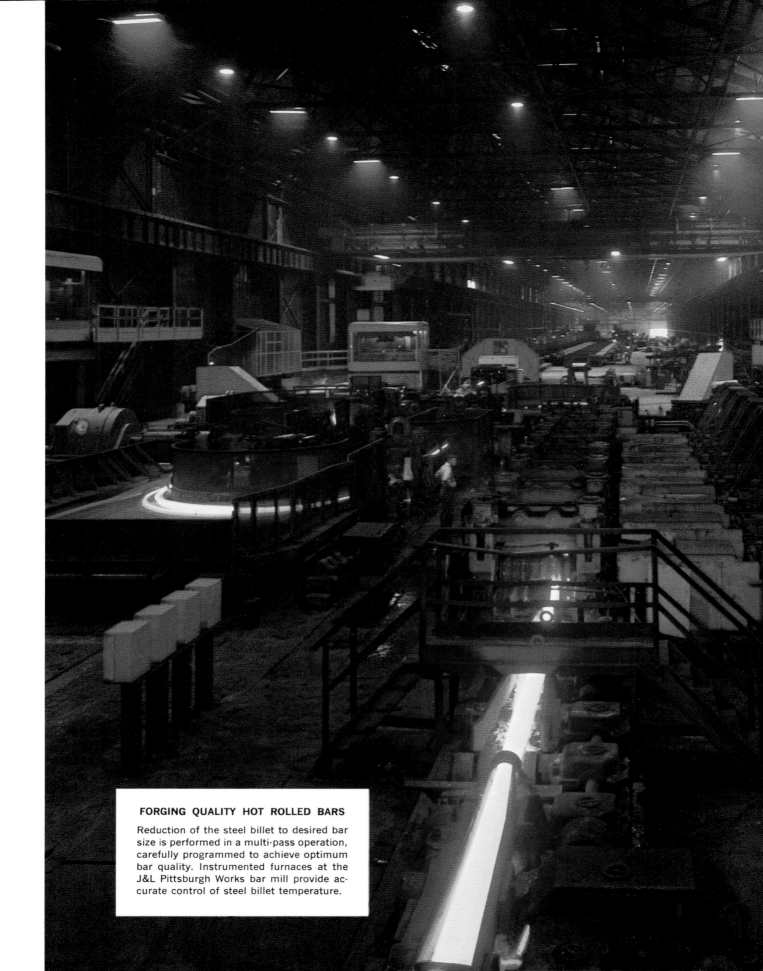

FORGING QUALITY HOT ROLLED BARS

Reduction of the steel billet to desired bar size is performed in a multi-pass operation, carefully programmed to achieve optimum bar quality. Instrumented furnaces at the J&L Pittsburgh Works bar mill provide accurate control of steel billet temperature.

Hot flame scarfer removes surface imperfections from the bloom to assure top quality steel billets, basic raw material for the bar mill.

3″ x 3″ steel billets emerge from the billet mill to this cooling bed where they are tested by J&L metallurgists for product uniformity.

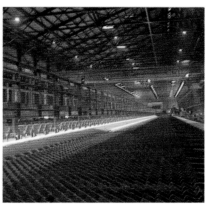

Forging quality hot rolled bars leave the bar mill on this runout table. They are inspected for accuracy of section.

Refrigerator cam shaft, forged from a 57/64″ coarse grained C-1117 square, has a perfect balance of properties for long, hard usage.

Automobile transmission part, forged from a 2¼″ round, has exact balance of properties that helps reduce production cost. AISI Grade 4027.

Automobile steering knuckle support is forged from 1-15/16″ J&L round. AISI Grade 1340.

J&L Forging Quality Hot Rolled Bars are carefully detailed for precise balance of chemistry and physical properties to meet your special requirements. As an integrated producer, J&L combines control of raw materials with the special facilities and successful production experience that are necessary **to provide exactly the right forging quality steel for any application.** A field staff of J&L metallurgical consultants will work with you to determine the steel which will best serve your particular requirements for forging, machining and end product use. The consultant then works directly with the J&L mill to obtain a forging steel that **is tailor-made for your operation.** Simply call your local J&L district office for a preliminary discussion, or you may write directly to Jones & Laughlin Steel Corporation, 3 Gateway Center, Pittsburgh 30, Pennsylvania.

Jones & Laughlin Steel Corporation
PITTSBURGH, PENNSYLVANIA

Between | **the hook and the load...it's J&L**

It's J&L all the way between the hook and the load, because the complete J&L line covers every lifting need. The illustrations here are only a sample. J&L hand and power hoists are not shown. Nor many other wire ropes, wire rope slings, alloy chain slings, fittings, assemblies and accessories. But, illustrated or not, you'll find in the J&L line everything you want for all your lifting jobs.

Your J&L industrial distributor has the complete lifting line for complete safety

Your authorized J&L Wire Rope Distributor is fully equipped to help you. He can provide you with any item from this complete line and can give fast service, too—right down to securing *while-you-wait* fabrication and repair of alloy chain slings with JalLink (another exclusive J&L development).

In addition, if you are faced with an unusually tough lifting operation, he can arrange for skilled J&L engineers to help you. They'll advise on the most suitable method—or even design a lifting mechanism specifically to meet your problem.

Hundreds of J&L Distributors give you all the advantages of local, personal service, *plus* the delivery back-up of 15 strategically placed J&L Wire Rope Service Centers, *plus* the applications help of J&L factory engineers. When you select from the complete J&L line, you get more than everything you need between the hook and the load. You also get service, safety and confidence in lifting—because it's J&L. Call your Jones & Laughlin Wire Rope Service Center or Wire Rope Distributor today—they're listed in the yellow pages.

1. Safety-Weave Nylon Sling. 2. Woven Wire Belting. 3. Manila Cordage. 4. Swaged Assembly with Fork Eye. 5. JalKlamp Bridle Sling. 6. Braided Sling. 7. Alloy Chain Sling.

FOR SAFETY IN LIFTING
Jones & Laughlin Steel Corporation
WIRE ROPE DIVISION, Muncy, Pennsylvania

WIRE ROPE

This advertisement is scheduled to appear in:
Mill & Factory—Sept. 1960—January, 1961
Purchasing Mag.—August 15 and December 5, 1960

PRECISE HARDNESS CONTROL
to your specifications with
J&L Cold Rolled Strip Steels

Variations within standard commercial limits of hardness for strip steels may not provide the quality needed for most critical applications.

At J&L the newest equipment and techniques are used to provide controlled hardness—to your specifications.

Basic oxygen furnaces, high standard open hearth practice and electric furnaces provide optimum melting conditions, new hot strip mills are specifically designed to produce the finishing temperatures needed for inherent quality. Cold mills, annealing and normalizing furnaces and other equipment are designed specifically for precision strip steel processing.

With an organization experienced in specialized strip steel processing, your most rigid specifications can be met consistently.

For your convenience, precision strip facilities are available to you in our plants at Youngstown, Indianapolis, Los Angeles and Kenilworth (N. J.)

The small unit rotary annealing method assures precision temperature control and develops optimum hardness and microstructure for high carbon, low carbon and alloy strip.

STRIP
**LOW CARBON · HIGH CARBON · ALLOY · STAINLESS
TEMPERED SPRING STEEL · ZINC AND COPPER COATED**

Jones & Laughlin Steel Corporation · STAINLESS and STRIP DIVISION · Youngstown 1, Ohio

Following is a portfolio of
J&L Stainless & Strip Division Advertisements
produced in 1959.

They have appeared in the following publications:

STAINLESS STEELS

American Metal Market

American Machinist

Iron Age

Steel

Automatic Machining

Metal Progress

Automotive News

Automotive Industries

D.A.C. News

SAE Journal

Metal Products Manufacturing

Aircraft and Missiles Manufacturing

Western Aviation

American Artisan

Electrical Engineering

Electrical Manufacturing

Product Engineering

Materials in Design Engineering

Wire and Wire Products

Chemical Engineering

Chemical Processing

Purchasing

Purchasing News

Chicago Purchasor

Detroit Purchasor

Mid-West Purchasing Agent

New England Purchaser

New York State Purchasor

Philadelphia Purchasor

Southwestern Purchasing Agent

STRIP STEELS

Iron Age

Steel

American Metal Market

Metal Progress

Production

Materials in Design Engineering

Electrical Manufacturing

Product Engineering

Hoosier Purchasor

Mid-West Purchasing Agent

New England Purchaser

Philadelphia Purchasor

Detroit Purchasor

Chicago Purchasor

New York State Purchasor

Brightness is Not Enough

Wheel covers must be more than just bright. They must have strength, spring temper, durability and low unit cost in volume production.

Other materials may claim some of these characteristics, but only stainless steel actually possesses all of them — and has a performance record to prove it.

It is easy to **make cheaper wheel covers.** Just forget that customer complaints, lost goodwill and the inevitable replacement of parts eventually show up on the balance sheet.

In wheel covers there is no substitute for stainless steel's lasting brightness, strength and durability.

Can you name the cars represented by these stainless steel wheel covers? A postcard request will bring you the answers.

STAINLESS
SHEET · STRIP · BAR · WIRE

Plants and Service Centers:
Los Angeles · Kenilworth (N. J.) · Youngstown · Louisville (Ohio) · Indianapolis · Detroit

Jones & Laughlin Steel Corporation · STAINLESS and STRIP DIVISION · Box 4606, Detroit 34

This hot-dipped, galvanized Cream City round wash tub is built for hard, long service. Bottom is paneled for extra strength. Attractive appearance sells on sight.

CREAM CITY WARE
...long life, eye appeal, streamlined designs

Cream City ware is a long time favorite because of its handsome design, sparkling appearance, sturdy construction. And this popular line is now produced by J&L, a major integrated steel company with complete control of quality from ore to finished ware. This assures you a reliable source of supply and premium quality. It pays to stock and sell Cream City galvanized ware.

 Jones & Laughlin Steel Corporation

STEEL Consumer Products—Container Division

Lebanon, Indiana

Released June 1958 for publication in: HARDWARE AGE • HARDWARE RETAILER • SOUTHERN HARDWARE

JL-7906

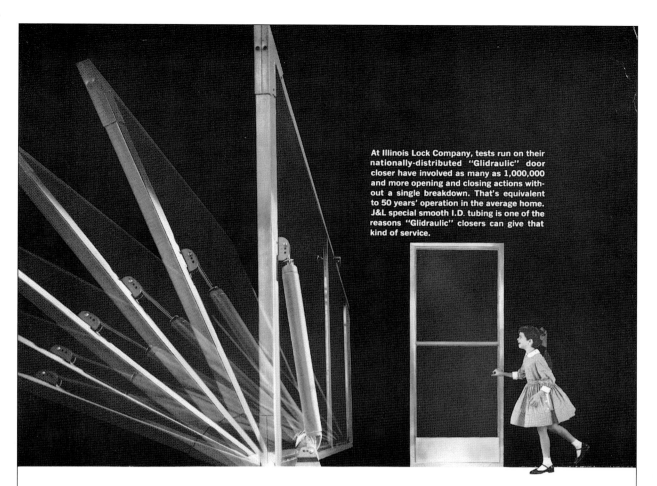

At Illinois Lock Company, tests run on their nationally-distributed "Glidraulic" door closer have involved as many as 1,000,000 and more opening and closing actions without a single breakdown. That's equivalent to 50 years' operation in the average home. J&L special smooth I.D. tubing is one of the reasons "Glidraulic" closers can give that kind of service.

OVER 1,000,000 OPENING-CLOSING ACTIONS

of "Glidraulic" door closer prove quality of J&L Electricweld cylinder tubing

"The consistently high quality of J&L special smooth I.D. tubing is a must for us because we guarantee our sealed hydraulic door closers for 15 years," says Stanley Wolniak, product engineer of the Illinois Lock Company, Chicago, Ill. J&L tubing has to be rugged to take continuous operation like this *without failure of any kind.*

"The excellent inside finish of J&L Electricweld cylinder tubing requires no machining and prevents wear due to piston travel," Mr. Wolniak adds. "Its great wall strength resists bending under heavy pressure. And because of the uniform true diameter of J&L special smooth I.D. tubing, we don't have to pay the added cost for restricted tolerance tubing.

"As our door closers use hydraulic action, the cylinder tubing must meet critical requirements. For our purposes, J&L electric-resistance-welded tubing is the finest available."

Illinois Lock Company purchases J&L Electricweld tubing in ready-to-use 12" lengths, deburred at the mill. No inside honing or other cylinder machining operations are necessary.

Jones & Laughlin Steel Corporation

ELECTRICWELD TUBE DIVISION
PITTSBURGH, PA.

This advertisement appears in:
APPLIED HYDRAULICS & PNEUMATICS.

two Appendix

Making Steel with Jake & Looie

Jake and Looey were cartoon characters created by Lee Sokol, a stove tender at a blast furnace in the Pittsburgh Works and a self-taught artist. They appeared in many J&L publications after 1974, and in 1978 they provided the basis for a tour of steelmaking at Jones & Laughlin Steel Corporation in the little booklet entitled *Making Steel at J&L with Jake & Looey*. Most of the pages from this booklet are reproduced in the pages that follow, interspersed with photographs of the steel-making facilities that these two irrepressible characters describe. Since some of the methods used earlier were no longer in use by J&L when the booklet was produced, descriptions of these processes and facilities have been included, based on some steelmaking flow charts produced by the American Iron and Steel Institute. Our tour begins after Jake and Looey have given their readers some information about the history of J&L Steel.

 When Jake and Looey produced their guide in 1978, J&L was only using the basic oxygen furnace (BOF) and electric furnace methods to transform iron into steel. Earlier they had used two additional methods: the Bessemer converter and the open hearth furnace (both acid and basic).

A Few Things You Should Know About Steel

If you were a chemist, you could analyze a chunk of steel in your laboratory and discover that it consists of: lots of iron; a bit of carbon; small amounts of other chemical elements including manganese, silicon, copper, phosphorus, aluminum, molybdenum and others.

By varying the amounts of carbon and other elements that are combined with the iron, many different kinds of steel, each with its own properties, can be made. This is why steel is such a versatile material and why it can be custom-tailored for specific applications.

Carbon steel is "ordinary" steel. It has an extraordinary range of uses, every-thing from car bodies to bed springs. Most of the steel we make is carbon steel.

Alloy steel is used in those applications that require extreme hardness, strength or toughness, for example, engine parts and car transmission gears. Alloy steels contain carefully controlled amounts of the other elements we mentioned above, particularly molybdenum, chromium and nickel.

Stainless steel is a special kind of alloy steel that contains a large amount of chromium and nickel. It is far more resistant to staining and corrosion (rusting) than carbon or alloy steels. Stainless steels are often used to manufacture products that will come into contact with food and chemicals or will be subjected to high temperatures.

As you'll soon see, the making of steel is a two-step process. First, iron is made in a blast furnace. Second, the impurities in the iron are removed and certain elements are added to produce a metal that has a specific mix of ingredients and physical properties. This is steel.

In many ways, a steel mill is like a huge kitchen, where the ingredients are measured in hundreds of tons rather than by cups or ounces. A fundamental challenge of steelmaking is to make each batch or heat of steel according to a specific recipe, the recipe that yields the properties called for by the customer.

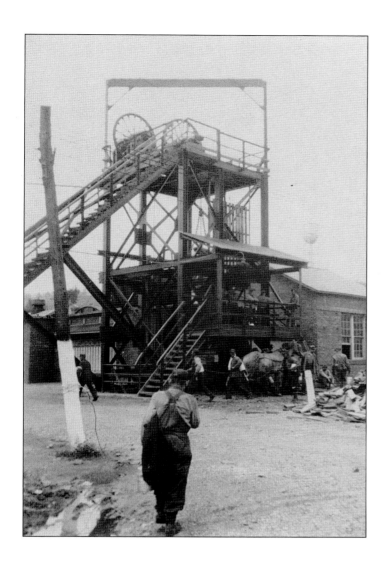

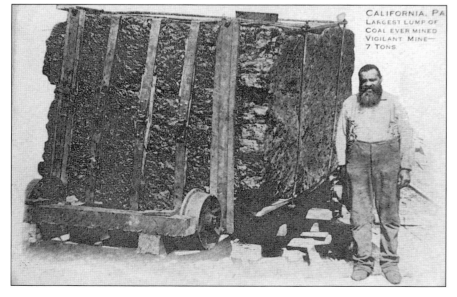

(Above left) Vesta Mine No. 4/5; the elevator entrance at Richeyville.

(Above) A lump of coke with an antique lamp on a hard hat.

(Left) The largest lump of coal ever mined, Vesta Mine No. 4.

(Opposite) Behive coke ovens,
Pittsburgh Works, 1900.

COKEMAKING

A coke oven is a tall (20-feet high), narrow (1½-feet wide), deep (up to 50 feet front-to-back) metal box lined with heat-resistant brick. Fifty or more individual ovens are usually placed side-by-side to make a coke oven battery.

Each oven is heated to a temperature over 2000°F by gas fires that burn in flues within the dividing walls. When coal is baked inside the oven, the moisture and volatile chemicals are driven off, leaving a porous material that is almost pure carbon. This is coke.

A single oven will hold between 15 and 35 tons of coal, depending on its size. The coal spends about 17 hours inside the hot oven as it is transformed into a load of coke.

J&L's coke batteries are located at Aliquippa, Pittsburgh, Youngstown and East Chicago. Most are conventional ovens. However, our new A-5 coke battery is one of the most advanced units in use today (above).

Unlike conventional ovens, the A-5 ovens do not have "charging holes" in their tops. Instead, coal is fed into the A-5 ovens via a pipeline system. This method reduces the leakage of gas and particulates that can pollute the air.

Coal for the A-5 is preheated to 500°F before it's fed into the ovens. This step lowers coking time to only 12 hours.

How is coke removed from a coke oven? That's a good question...and the answer is simple: large doors at the front and back of the oven are removed and the hot coke is pushed by a huge pushing machine into a railway car. Then, the car moves under a special tower where sprays of water cool the coke.

During the coking cycle, gases and volatile substances are baked out of the coal.

We capture the gas and burn some of it in the flues of the coke ovens. The rest is used as a fuel for other steelmaking operations. The production of this valuable fuel is important to the entire steel plant and, for example, amounts to 80 million cubic feet each day at both Aliquippa and Pittsburgh.

We collect the oils, tars and other volatiles and send them to a by-product recovery plant, a miniature refinery that turns them into many valuable chemicals.

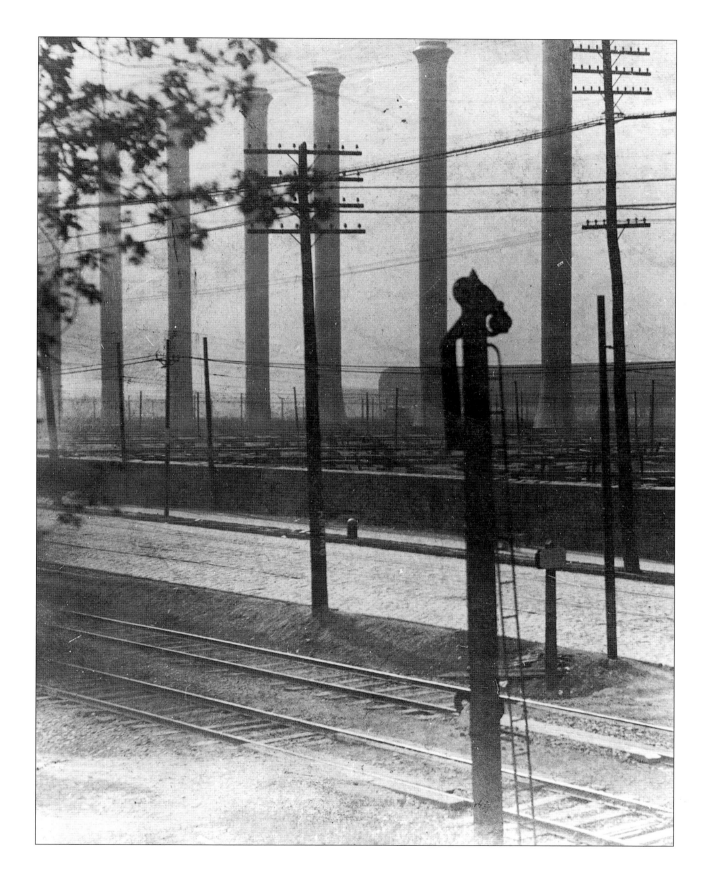

(Below) Pittsburgh Works coke ovens, 1945.

(Right) Hot coke pushed from a coke oven battery at Aliquippa.

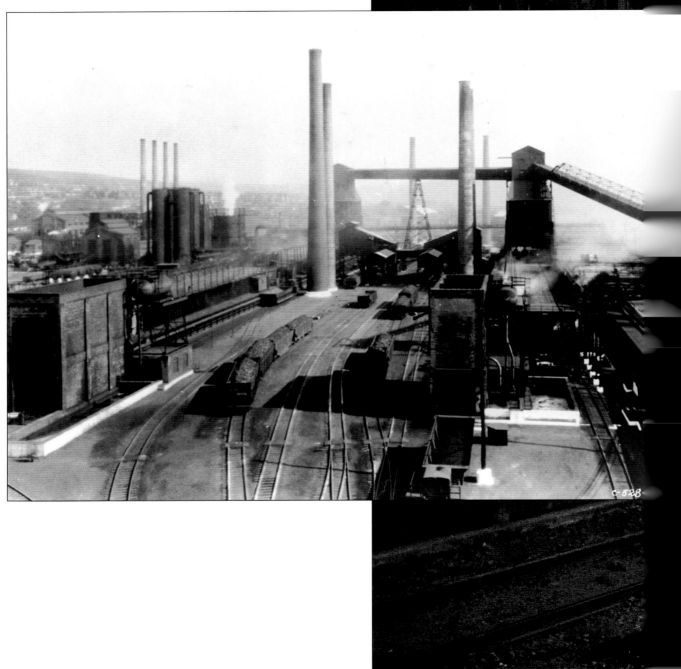

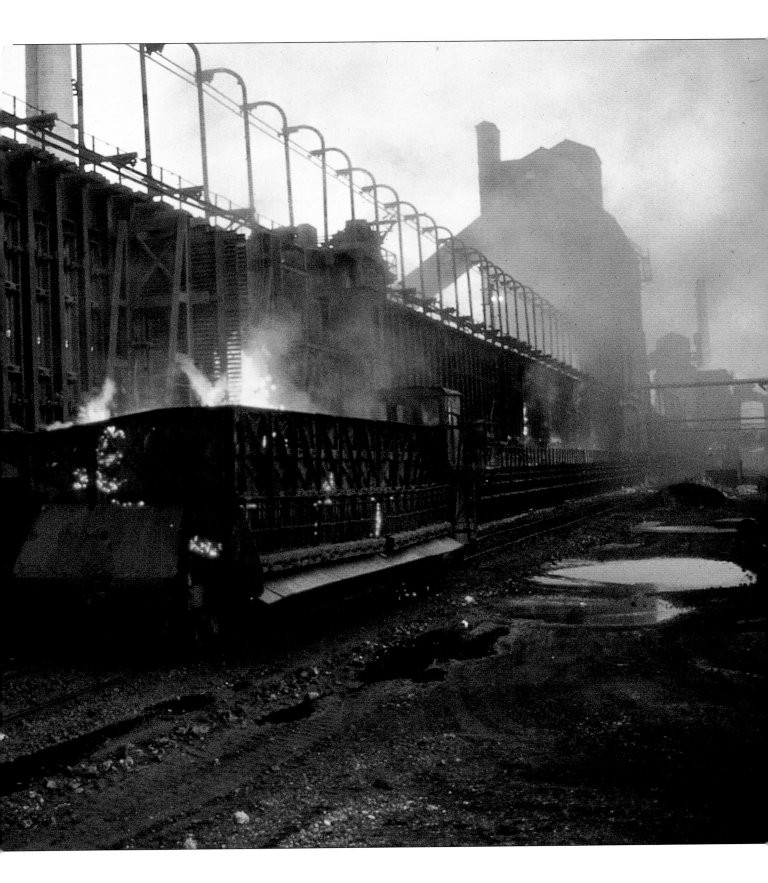

MAKING IRON IN A BLAST FURNACE

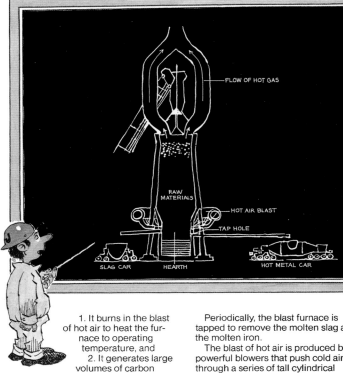

FLOW OF HOT GAS

RAW MATERIALS

HOT AIR BLAST

TAP HOLE

SLAG CAR HEARTH HOT METAL CAR

A blast furnace gets its name from the way it works: in operation, a blast of hot air blows upward through the molten ingredients inside the furnace.

When you get down to basics, a blast furnace is little more than a tall metal chamber lined with special heat-resistant bricks (above right).

Raw materials are fed into the top of the furnace and gradually work their way down to the bottom. In the process they are heated to over 3000°F; they melt, and chemically react together to liberate molten iron from the iron ore.

Interestingly, once a blast furnace is fired up, or "blown-in," it runs contin-uously until the heat-resistant bricks need replacing. J&L's blast furnaces at Aliquippa, Cleveland, Pittsburgh, Youngs-town and East Chicago often operate for years at a stretch without being shut down.

Iron ore, coke and limestone are the primary raw materials dropped into a blast furnace. On the average, 3300 pounds of ore, 1200 pounds of coke and 500 pounds of limestone are needed to produce 2000 pounds of iron. The coke performs two vital functions:

1. It burns in the blast of hot air to heat the fur-nace to operating temperature, and
2. It generates large volumes of carbon monoxide gas as it burns. This gas is the chemical agent that strips away the oxygen in the iron ore, leaving a pool of molten iron in the bottom of the furnace.

The limestone is present to form a layer of molten slag on top of the molten iron that traps and holds impurities that were present in the ore and coke.

Periodically, the blast furnace is tapped to remove the molten slag and the molten iron.

The blast of hot air is produced by powerful blowers that push cold air through a series of tall cylindrical structures called stoves. Gas, produced at the top of the blast furnace, is burned in the stoves to heat the incoming air about 2000°F. The excess gas produced by the blast furnace is burned in boiler to generate steam. This makes the blast furnace one of industry's most energy efficient production units.

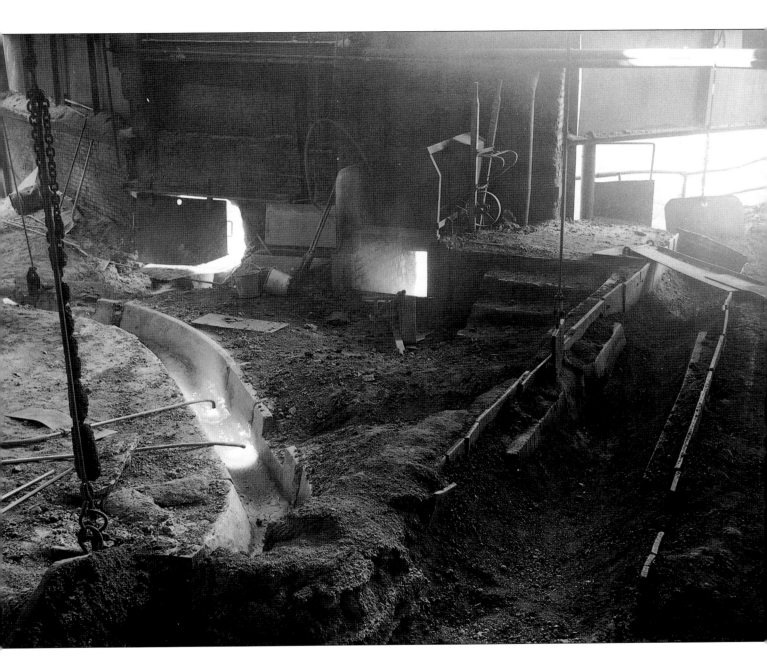

The Pittsburgh Works P-1 furnace
cast house, 1962.

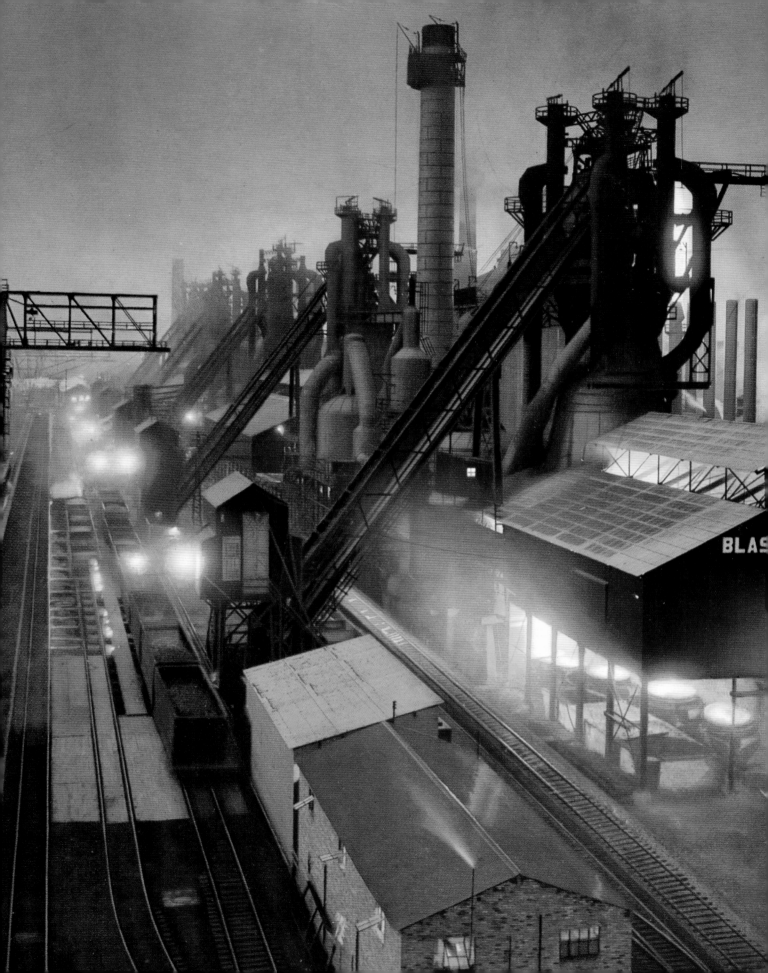

Making Steel in a Bessemer Converter

The Bessemer converter from its introduction into America in the 1860s until well into the twentieth century was the major method for converting iron into steel. Henry Bessemer, an Englishman, and William Kelly, an American, developed the process independently (a long battle was fought over patent rights), but it was Robert Mushet, a metallurgist, who made it more practicable when he discovered that the addition of manganese to the blown metal, combined with sulphur and oxygen, would make it malleable, forgeable. Otherwise the resultant steel would crumble in the rolling mills. The charge of molten iron is placed in a horizontal converter and the blow of air begins to oxidize the added silicon and manganese, producing first a dull red flame for about two minutes, while the converter is slowly uprighted. Then the brilliant flames, first yellow for the silicon and then white for the carbon, come out of the now-upright converter for about ten minutes. The blower, who controls the blast from his pulpit, regulates the air pressure carefully to make sure all impurities are removed, and when the flame drops he knows to reduce the air pressure and to move the converter back to the horizontal position to keep the iron itself from burning. The process is spectacular with the roar of escaping carbon monoxide, whose burning produces bright flames that are visible for miles. The converter is then turned over to pour out the molten steel into ladles before being turned over yet again to pour out the molten slag, which has risen to the top to form a sort of bridge. A blow takes only about thirty minutes from start to finish. The last blow of the Bessemer converters at Aliquippa occurred on April 24, 1968. There were no Bessemer converters operating in the Western world by the 1990s, although some remained in operation in Russia.

(Opposite) Five blast furnaces in cast at Aliquippa.

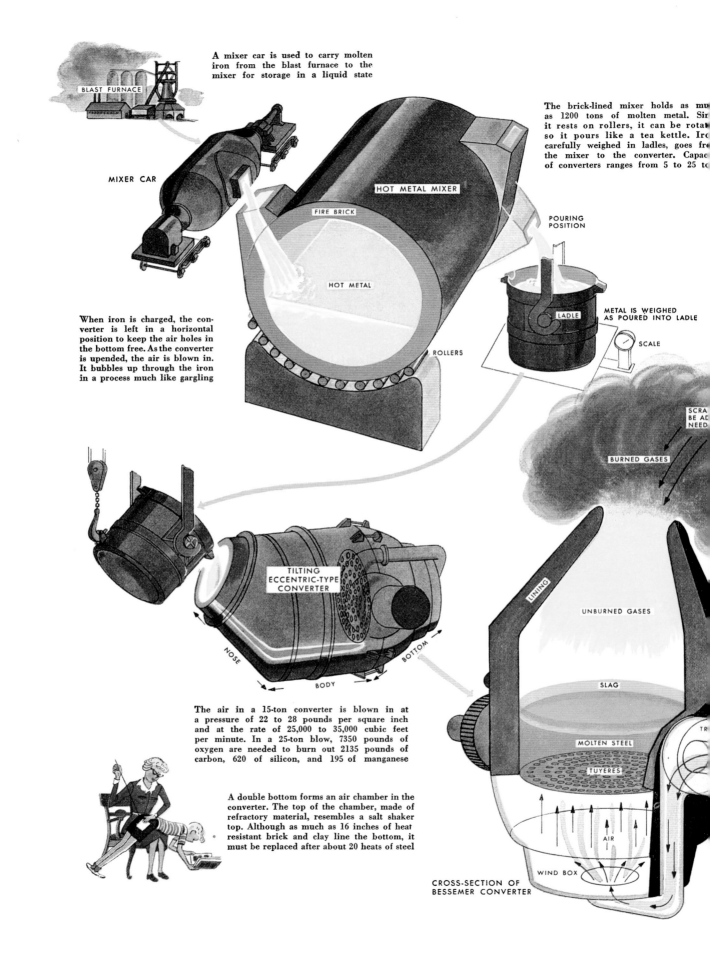

A mixer car is used to carry molten iron from the blast furnace to the mixer for storage in a liquid state

BLAST FURNACE

MIXER CAR

The brick-lined mixer holds as mu~~ch~~ as 1200 tons of molten metal. Si~~nce~~ it rests on rollers, it can be rota~~ted~~ so it pours like a tea kettle. Ir~~on~~ carefully weighed in ladles, goes fr~~om~~ the mixer to the converter. Capac~~ity~~ of converters ranges from 5 to 25 to~~ns~~

HOT METAL MIXER

FIRE BRICK

HOT METAL

POURING POSITION

When iron is charged, the converter is left in a horizontal position to keep the air holes in the bottom free. As the converter is upended, the air is blown in. It bubbles up through the iron in a process much like gargling

LADLE

METAL IS WEIGHED AS POURED INTO LADLE

SCALE

ROLLERS

SCRA~~P~~ BE A~~DDED~~ NEED~~ED~~

BURNED GASES

TILTING ECCENTRIC-TYPE CONVERTER

NOSE

BODY

BOTTOM

LINING

UNBURNED GASES

SLAG

The air in a 15-ton converter is blown in at a pressure of 22 to 28 pounds per square inch and at the rate of 25,000 to 35,000 cubic feet per minute. In a 25-ton blow, 7350 pounds of oxygen are needed to burn out 2135 pounds of carbon, 620 of silicon, and 195 of manganese

MOLTEN STEEL

TUYERES

A double bottom forms an air chamber in the converter. The top of the chamber, made of refractory material, resembles a salt shaker top. Although as much as 16 inches of heat resistant brick and clay line the bottom, it must be replaced after about 20 heats of steel

AIR

WIND BOX

CROSS-SECTION OF BESSEMER CONVERTER

THE BIG BLOWOUT

How the Bessemer Converter Makes Steel

The Bessemer converter, being its own best press agent, long ranked as the steel industry's matinee idol. In 1866, 86 per cent of the steel poured in America came from converters. Today, however, 90 per cent comes from the open hearth, and the converter has advantages only in making certain products such as free machining steels and steels for some kinds of wire and pipe.

The old trouper is still something to see though, as it warms up to the subject of turning a load of molten iron into steel. When air roars up through the hot charge, silicon and manganese are oxidized and the temperature rises rapidly. Sparks shower and ruddy flames appear. The charge grows steadily hotter and the flames turn yellow as silicon takes fire, then white as carbon is oxidized. Carbon monoxide escapes with a roar and burns at the mouth of the converter with a bright flame visible for miles at night.

All at once the flame drops, an important sign to the blower in the pulpit who must reduce the air pressure to keep the iron itself from burning. Then the metal is poured into a ladle, and the show is over.

BLOWER

The blower, who controls the blast from his pulpit, has to keep close watch on the air pressure. If the temperature gets too high while the silicon is burning, the carbon might suddenly grab the oxygen, leaving a residue of silicon after the blow

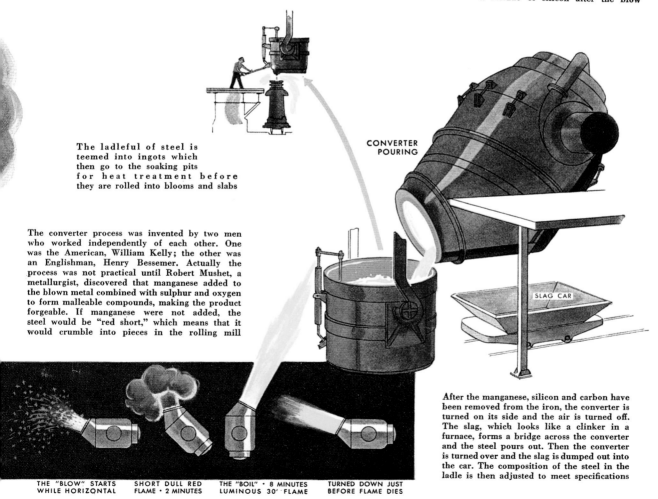

The ladleful of steel is teemed into ingots which then go to the soaking pits for heat treatment before they are rolled into blooms and slabs

CONVERTER POURING

SLAG CAR

The converter process was invented by two men who worked independently of each other. One was the American, William Kelly; the other was an Englishman, Henry Bessemer. Actually the process was not practical until Robert Mushet, a metallurgist, discovered that manganese added to the blown metal combined with sulphur and oxygen to form malleable compounds, making the product forgeable. If manganese were not added, the steel would be "red short," which means that it would crumble into pieces in the rolling mill

After the manganese, silicon and carbon have been removed from the iron, the converter is turned on its side and the air is turned off. The slag, which looks like a clinker in a furnace, forms a bridge across the converter and the steel pours out. Then the converter is turned over and the slag is dumped out into the car. The composition of the steel in the ladle is then adjusted to meet specifications

| THE "BLOW" STARTS WHILE HORIZONTAL | SHORT DULL RED FLAME · 2 MINUTES | THE "BOIL" · 8 MINUTES LUMINOUS 30' FLAME | TURNED DOWN JUST BEFORE FLAME DIES |

SUCCESSIVE STAGES OF A HEAT BEING BLOWN
TOTAL TIME · 12 MINUTES

Seventh in a series of charts on steelmaking

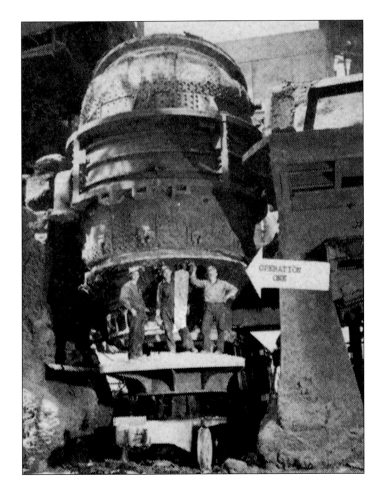

(Right) A crew removing the bottom of the No. 1 Bessemer converter at the Aliquippa Works in the late 1940s.

(Below) Bessemer in blow at Aliquippa, 1948.

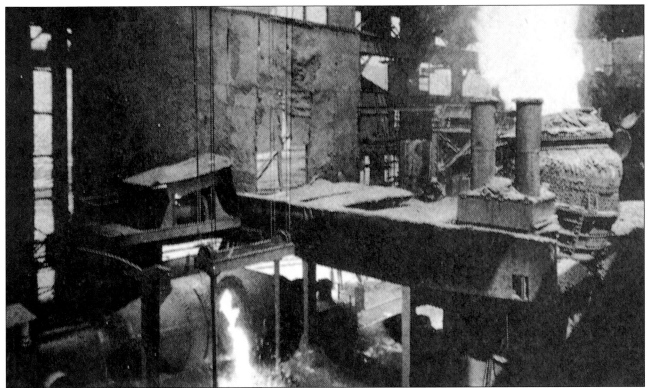

Making Steel in an Open-Hearth Furnace

The open-hearth furnace takes longer to produce steel than the Bessemer converter and is not nearly as spectacular to watch, but it can produce more at one time, the steel's composition can be controlled better, and it uses scrap steel and is more economical. Charging of the open hearth is done from one side, while tapping of the resultant materials is done on the opposite side. The hearth, shaped like a large oven, is lined with bricks. Acid bricks came to be replaced by basic bricks because they withstood the extreme heat better. The hearths are "open" because the charge is exposed to the sweep of flames that play over its surface. The flames come from alternating sides via flues from checker chambers through which hot gases are blown; oxygen is introduced by lances directly on top of the molten charge. The first charge is limestone as flux, then scrap steel. Once the scrap begins to melt, molten pig iron is added. Periodically the molten brew is tapped for analysis to ensure the right composition, and other materials, such as burnt lime to hasten the absorption of sulphur and phosphorus, are added as needed. Once the heat is complete, after eight to twelve hours, the molten steel and slag are tapped into a steel ladle (and from thence the slag, which has risen to the top, is tapped into a slag thimble, which also taps the slag directly from a taphole higher in the hearth itself). Alloys would be added to the molten steel as needed. Some early open hearths (called Talbot open hearths) could be tilted for the tapping process, but these turned out not to be as efficient.

A Bessemer bottom, showing
tuyeres, 1949.

(Right) A Bessemer converter at
Aliquippa during the last night
blow before being closed down,
April 24, 1968.

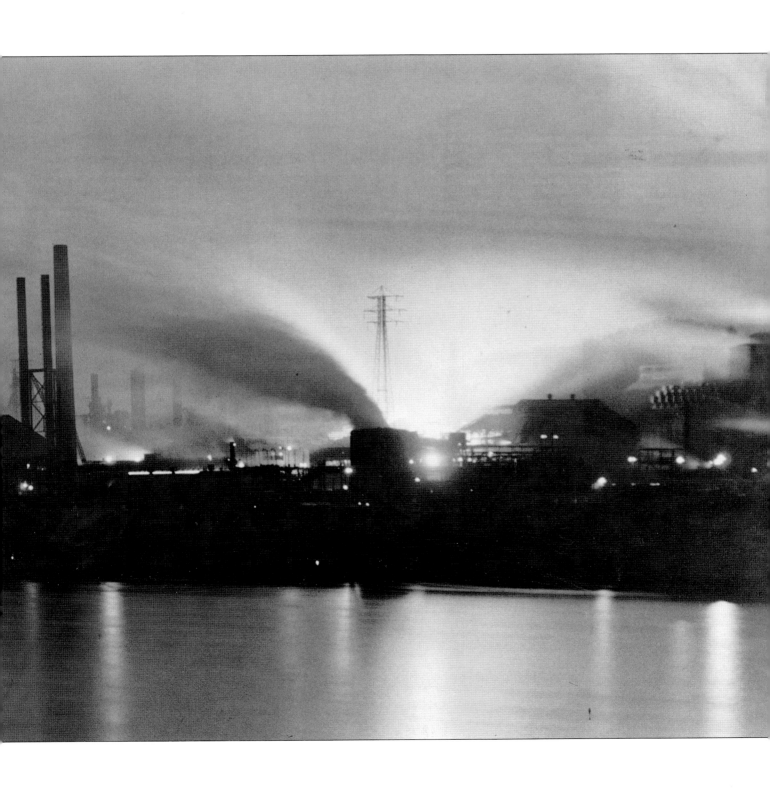

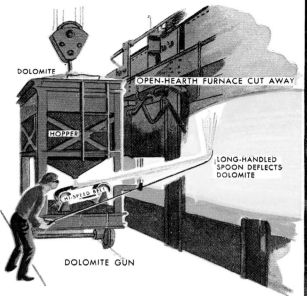

Years ago, steelmen had to make repairs in the furnace lining with a wheelbarrow, shovel and plenty of hard work. Today, a gun and a spoon take care of the job. Dolomite, a refractory "putty," is shot from the gun in a steady stream and deflected by the spoon. Here it is shown being deflected upward for illustrative purposes but actually it repairs the walls, bottom

The open hearth is charged by a long-armed machine that picks up one at the steel charging boxes full of carefully weighed raw materials, pushe through the furnace door and turns them over, dumping contents onto the

An open hearth that will produce 175 tons of steel in 12 hours is about 70 feet long and 20 feet wide. The hearth slopes down toward the taphole where it is 32 inches deep

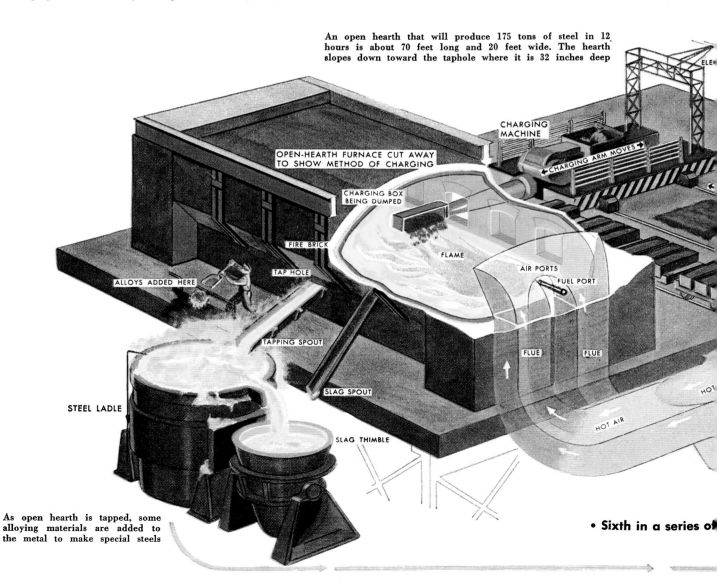

As open hearth is tapped, some alloying materials are added to the metal to make special steels

• Sixth in a series of

The Birth of an Ingot

How Steel is Brewed in the Open Hearth

The open hearth furnace comes about as close as anything to disproving the adage about not having your cake and eating it too. Because of the furnace's efficient way with scrap, steel never grows old. Yesterday's junk heap turns into tomorrow's limousine; the sorry harvest of an attic cleanup campaign may become armor on a heavy cruiser.

Even the burning fuel oil, tar or gas that melts the charge of pig iron, scrap and limestone does double duty. As flames surge over the charge, first from one end of the furnace, then from the other, much of the heat in their exhaust is stored in bricks that are used to preheat the incoming air (and the fuel if gas is used). Because of the open hearth's efficiency, it is used to make **90 per cent** of the steel made today.

The scrap appetite of the steel industry is enormous. The amount of scrap consumed each year in open hearth furnaces hovers at about half the total tonnage of new steel produced

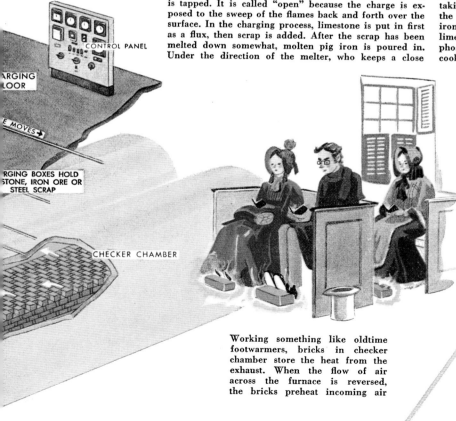

The open hearth is shaped something like a child's wading pool set on stilts. It is up in the air so the molten metal will flow by gravity into the ladle when the furnace is tapped. It is called "open" because the charge is exposed to the sweep of the flames back and forth over the surface. In the charging process, limestone is put in first as a flux, then scrap is added. After the scrap has been melted down somewhat, molten pig iron is poured in. Under the direction of the melter, who keeps a close watch on the control panel and makes sure that frequent samples are taken, the heaving, bubbling metal is then brought to the analysis the customer wants. This means taking out some elements and adding others. In general the impurities are removed by oxidizing agents such as iron ore and fluxing agents such as limestone. Burnt lime may be added to hasten the absorption of sulphur and phosphorus. With the sharp eye of a French chef, the melter cooks a steel that will do just what is expected of it

CONTROL PANEL

ARGING FLOOR

E MOVES

RGING BOXES HOLD STONE, IRON ORE OR STEEL SCRAP

CHECKER CHAMBER

STEEL LADLE

INGOT MOLD

Working something like oldtime footwarmers, bricks in checker chamber store the heat from the exhaust. When the flow of air across the furnace is reversed, the bricks preheat incoming air

To shape the steel to convenient size it is "teemed" into ingot molds. It flows through a nozzle in the bottom of the ladle. Great care must be taken so that none of the steel overflows or splashes on the rim of the mold

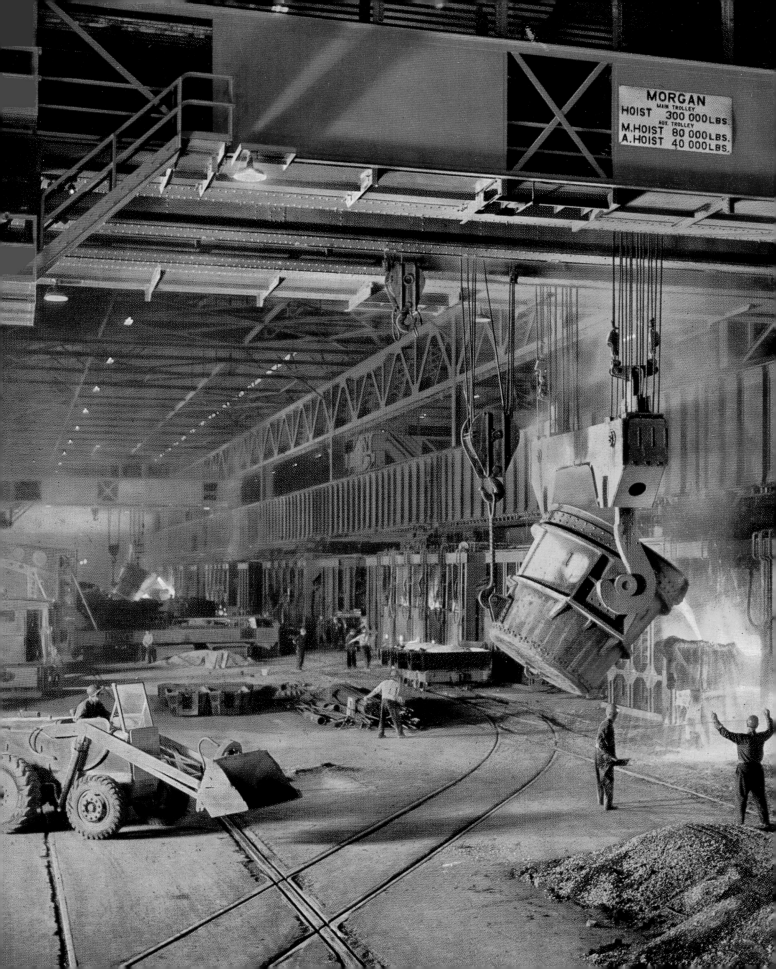

MORGAN
MAIN TROLLEY
HOIST 300 000 LBS.
AUX. TROLLEY
M. HOIST 80 000 LBS.
A. HOIST 40 000 LBS.

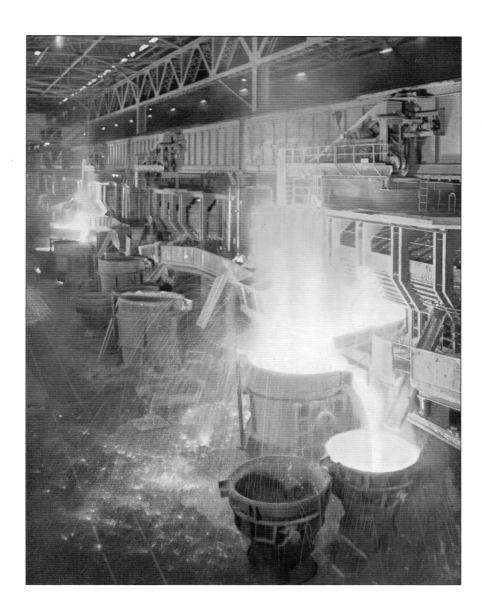

(Opposite) Charging molten metal into open hearths, Pittsburgh Works.

(Left) Tapping the open hearths, Pittsburgh Works.

(Overleaf) Teeming ingots, Pittsburgh Works.

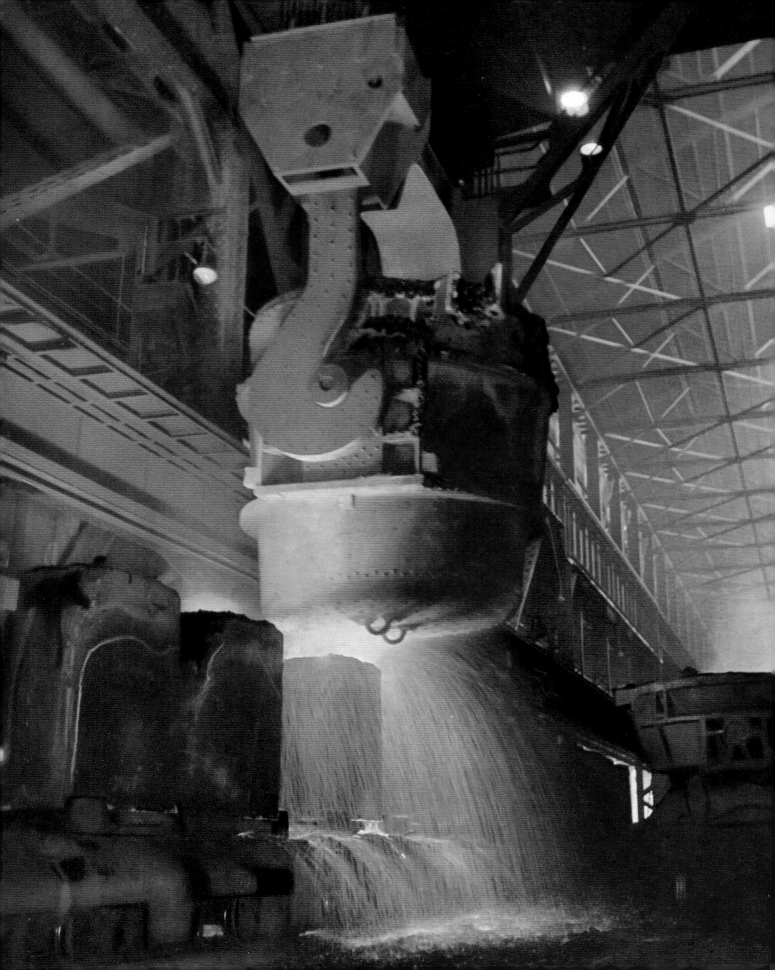

MAKING STEEL IN A BASIC OXYGEN FURNACE (BOF)

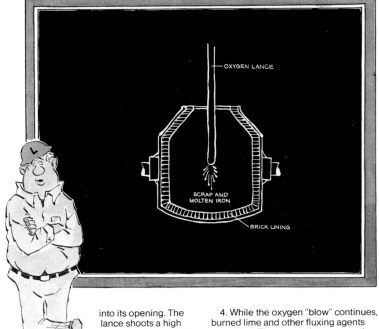

The iron that flows out of a blast furnace contains large amounts of carbon, left over from the coke, and several other impurities. To transform this iron into steel, the excess carbon and the impurities must be removed.

The basic oxygen furnace, or BOF, offers an efficient, economical way of accomplishing this metallurgical trick. [..]L's BOFs at Aliquippa, Cleveland and [In]diana Harbor refine the major portion [of] the steel we make.

A BOF is nothing more than a pear-shaped metal bowl lined with a special chemically active heat-resistant brick. The word "basic" in BOF refers to the brick's chemistry, not to the simplicity of a BOF's operation.

Making steel in a BOF involves a five-step process:

1. The BOF is tilted sideways and is charged with a partial load of steel scrap.

2. Molten iron from the blast furnace is added on top of the scrap. Typically, the iron represents 70 per cent of the metal in the vessel.

3. The BOF is turned upright and a water-cooled oxygen lance is inserted into its opening. The lance shoots a high pressure stream of nearly pure oxygen against the charge's surface (above).

The oxygen-induced chemical reactions cause a rapid heating that completely melts the scrap and brings the charge to proper refining temperature. The turbulence of the oxygen stream stirs and agitates the molten metal.

4. While the oxygen "blow" continues, burned lime and other fluxing agents are added. The oxygen burns away the excess carbon and many of the impurities; the slag formed by the fluxing agents captures the rest.

5. At the end of the blow certain elements, manganese, aluminum, silicon and sulfur, for example, may be added to the molten steel to produce specific properties.

Making a 200-ton batch of steel in a BOF takes about 45 minutes...including the 15-minute oxygen blow.

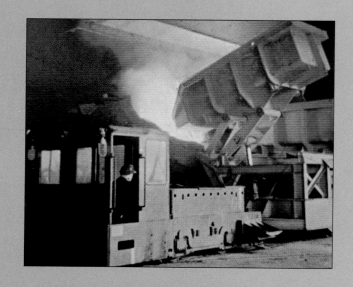

(Right) Charging scrap into BOF No. 1, Aliquippa Works.

(Below) Raking slag off hot metal before charging BOF No. 2, Aliquippa Works.

(Opposite) Charging hot metal into BOF No. 1, Aliquippa Works.

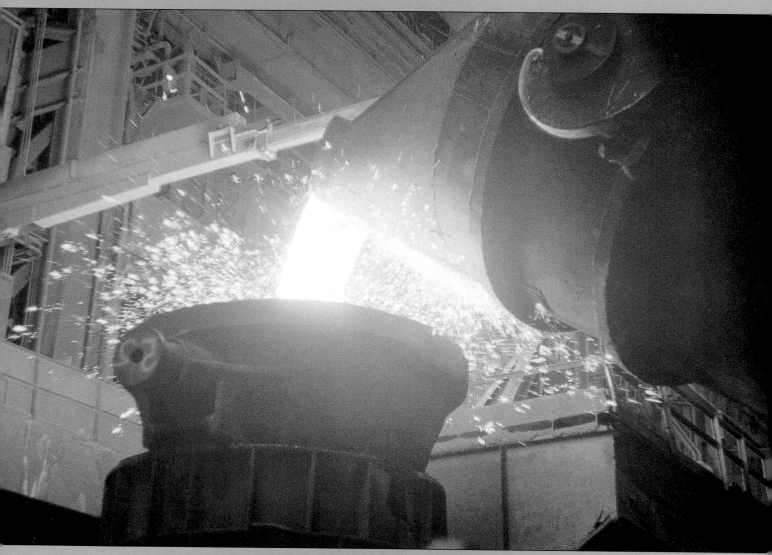

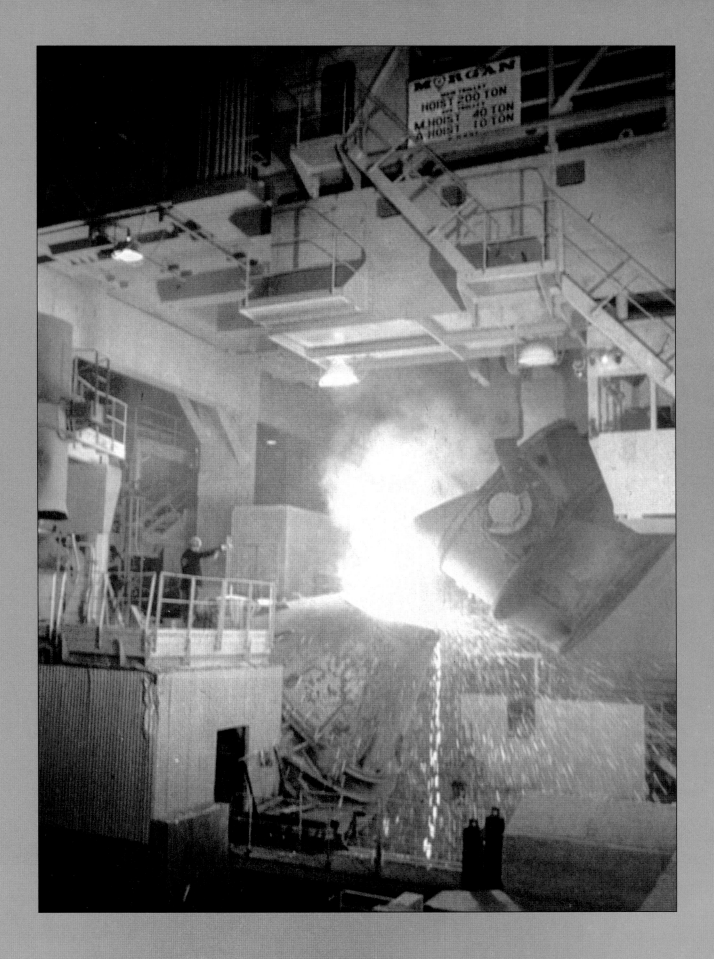

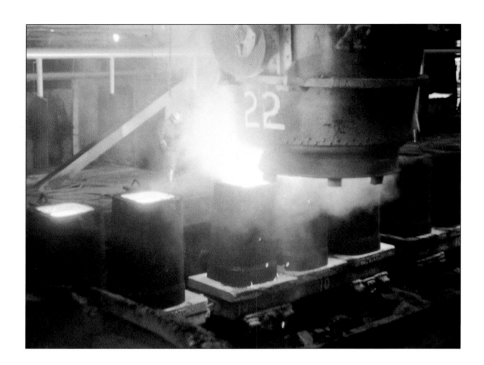

(*Right*) Teeling steel into ingots, BOF No. 1, Aliquippa Works.

MAKING STEEL IN AN ELECTRIC FURNACE

Until fairly recently, electric furnaces were used mostly to make specialty steels, such as stainless steel, and to refine small batches of carbon and alloy steel. However, the development of large furnaces now makes the electric furnace process a practical way to produce high tonnages of carbon steel.

J&L currently operates five small electric furnaces (70-80 ton capacity) at our Warren Plant, and two medium-size furnaces (195-ton capacity) in Cleveland. In 1979, we will complete installation of two large units (350-ton capacity) at our Pittsburgh Works. These electrics will replace six open hearth furnaces at the Pittsburgh Works. Basically the quality of steel from an open hearth is excellent but the process, which takes from 8 to 10 hours, is too slow to remain competitive in today's steel market.

An electric furnace, or more properly, an electric arc furnace, is a round-bottom pot lined with heat-resistant brick. It has a removable lid, or roof, that swings aside when the furnace is charged.

The modern electric arc furnace is an extremely versatile steelmaking furnace. Almost any type of carbon steel can be made in it at a rate of 100 tons per hour.

Virtually all electric furnaces are charged with cold metal. This can be carefully selected steel scrap, the most common charge, or chunks of solidified blast furnace iron called pig iron.

An electric furnace has three large electrodes that protrude through its roof (above). These electrodes are lowered close to the surface of the charge, then energized to produce powerful lightening-like electric arcs that pass between the electrodes and the metal. The enormous energy in the arcs melts the charge rapidly and keeps it molten.

Limestone is usually added to the melt to create a slag that captures the impurities in the charge. And, some iron ore may be thrown in to provide an internal source of oxygen to remove excess carbon.

It's common electric furnace practice to insert a hand-held oxygen lance through the furnace's side-mounted door. The oxygen helps burn away excess carbon.

The refining process then reduces the carbon level to the proper value for the kind of steel being made.

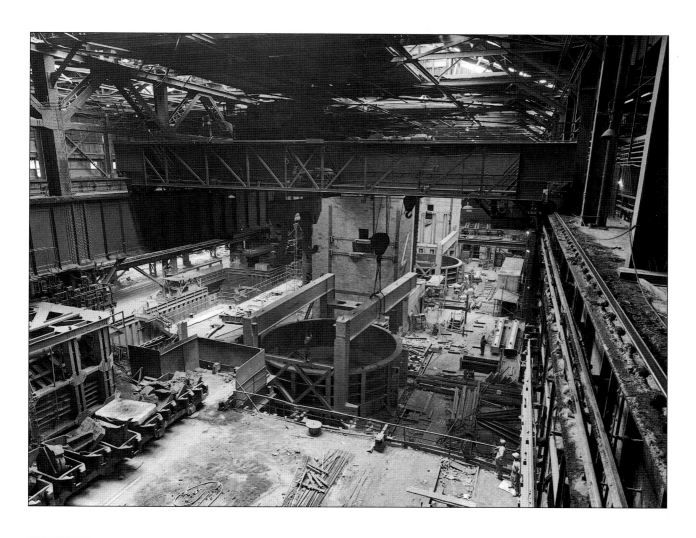

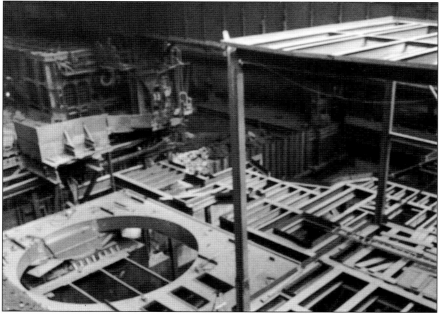

(Above) Building the electric furnace at the Pittsburgh Works, 1979.

(Left) Building the electric furnace at the Pittsburgh Works. No. 4 open-hearth shop on the left.

MAKING STAINLESS STEEL

Stainless steel contains lots of chromium and nickel, expensive metals that are in short supply. Consequently, J&L's Warren Plant makes stainless steel by a two-step process that prevents needless wastage of chromium.

Step 1: Carefully selected stainless steel scrap is melted in an electric furnace along with chrome-containing alloys and slag-forming flux materials. The steel is partially refined during this step.

Step 2: Molten steel is transferred to an argon-oxygen decarburization vessel (AOD vessel) for final refining (above).

Don't let this technical-sounding mouthful throw you; an AOD vessel looks and works much like a basic oxygen furnace, with two major differences:

1. A mixture of argon and oxygen gas, rather than pure oxygen, is used to burn away the excess carbon in the molten metal. "Decarburization" is a technical way to say "remove carbon."

2. The gases are blown up through the bottom of the vessel; an external lance is not used (above right).

The purpose of the argon is to help prevent the loss of chromium. Simply stated, the argon reduces the amount of chromium that is burned off along with carbon.

At the start of the gas blow, more oxygen is used than argon, but as the process continues, oxygen is gradually replaced with argon. The relative proportions of the two gases must be carefully controlled at all times. The molten metal spends about two hours in the AOD vessel.

Our Warren Plant does not manufacture finished stainless steel products. Instead, it produces stainless steel slabs (see page 23) that are rolled at our Cleveland Works and Louisville, Ohio, plant.

Stainless steel is a specialty product, both in the ways it is used and made. Our Warren Plant makes only about 25 tons of stainless steel each hour. Contrast this with the more than 400 tons an hour of carbon steel we can make at Aliquippa.

Semifinishing Operations

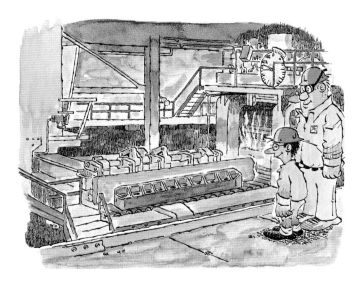

Now we come to the first step in manufacturing finished steel products. As you might expect, our rolling mills, bar mills, wire mills and other facilities cannot work with molten steel. Instead, they are designed to process large chunks of solidified steel.

Depending on size and shape, these chunks are called slabs, billets or blooms. All of these are classified as semifinished steel products because they are intended for subsequent finishing into sheet, strip, bars, wire and other salable products.

When a batch of molten steel leaves the BOF, open-hearth or electric furnace, it is usually poured into ingot molds and allowed to solidify. Then, the molds are stripped away. Each ingot weighs as much as 30 tons and stands about six feet high.

Next, the ingots are moved to soaking pits, especially designed furnaces that "soak" the steel in a 2000+°F temperature for many hours.

When the temperature of an ingot is uniform throughout its entire mass, it is ready to be taken to the blooming mill.

The term "bloom" stems from the old Anglo-Saxon word "bloma," which means

a mass of iron. In modern steelmaking, bloom has come to mean a chunk of steel that has a square cross-section measuring more than six inches on each side.

A billet is similar to a bloom, except that its square cross-section is less than six inches high and wide.

A slab is a chunk of steel with an oblong cross-section, typically two to nine inches thick and 24 to 60 inches wide.

These terms are not very precise; it's often difficult to decide if a specific chunk of steel is a bloom or a billet.

All of these shapes are made in a blooming mill by squeezing a hot ingot between large steel rolls. Because the steel is white hot, it is soft and shapable (above right).

The ingot passes back and forth through the pair of rolls. Each pass reduces its cross-section area and extends its length. The process is much like shaping a piece of pie dough with a rolling pin. Finally, the blooms, billets or slabs are cut to specified length.

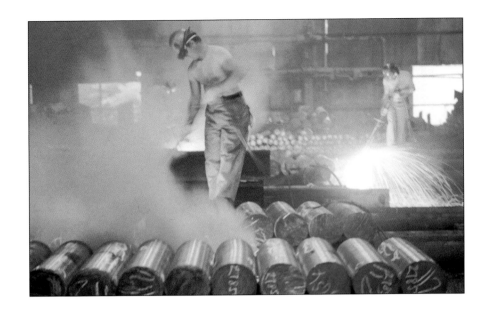

(Right) Scarfing rounds to remove surface impurities, Aliquippa Works.

MAKING BLOOMS AND BILLETS BY STRAND CASTING

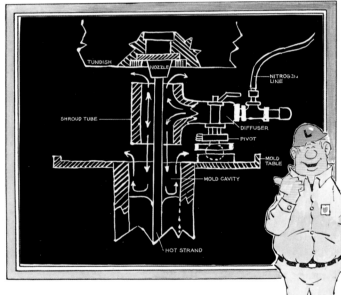

At our Aliquippa Works we have a machine that makes blooms and billets directly from molten steel without the need to make ingots first. Strand casting (also called "continuous casting") is a fairly recent addition to steelmaking technology.

Our strand casting machine is 19 stories tall. Molten steel is carried to the top in large ladles and poured into water-cooled molds. Six continuous strands of steel, either of bloom or billet dimensions, are drawn out of the bottom of the molds.

When each strand emerges from the mold, its outer surface is solidified, but its inner core is still molten. As the strand travels downward, away from the mold, water sprays help solidify it throughout. Solidification is complete by the time the strand reaches the bottom of the machine (above).

A system of guide rolls bends the vertical strand horizontal and straightens it. Then, it's cut into blooms or billets of convenient length by a shear or a torch.

Strand casting is a valuable technique for manufacturing certain kinds of steel that are not easy to roll into billets using the traditional blooming mill method.

Though strand casting sounds simple, it can be a tricky process to control. Operators must work hard to prevent "blow outs" of the strand's thin solidified surface. A blow out will allow molten steel to pour out of the inner core.

J&L recently developed a device that improves the quality of strand cast steel. It's called the Pollard Shroud, and it is designed to protect the stream of molten steel that flows into the mold.

The Pollard Shroud keeps oxygen in the atmosphere away from the molten steel (above). This prevents the formation of undesirable chemical compounds within the steel. J&L is making Pollard Shroud technology available to other steel companies.

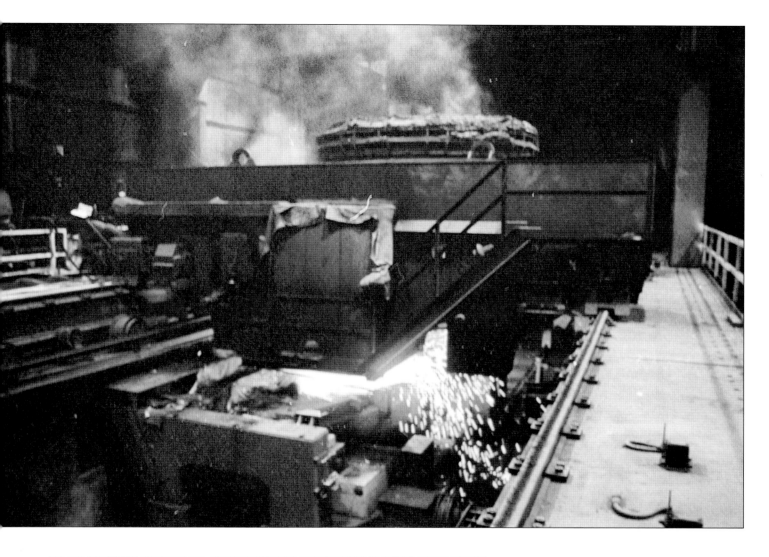

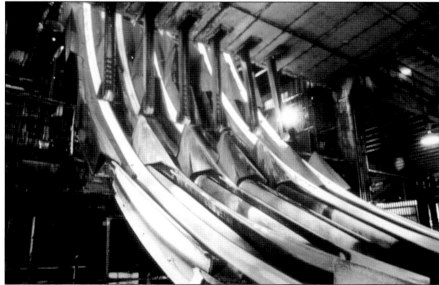

(Above) Charging molten metal into tundish on top of a strand caster.

(Left) A continuous strand caster, Aliquippa Works.

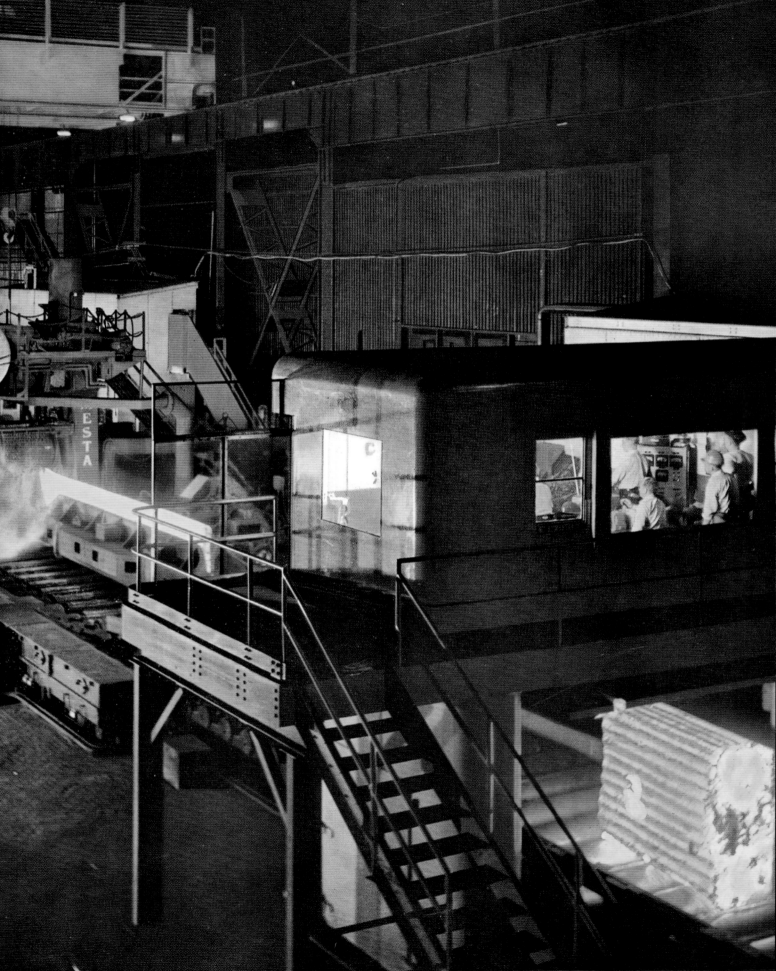

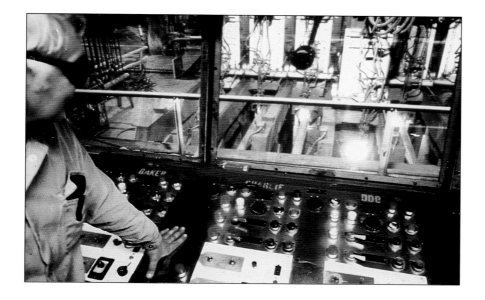

(Opposite) Rolling slabs at the Pittsburgh Works's blooming mill.

(Left) The view from inside the pulpit at the continuous caster running cut-off machine, Aliquippa Works.

MaKing Sheet & Strip Products

Well over half of the steel we make ends up as sheet and strip products. This includes the hot and cold rolled sheet and strip described in this section, and the flat rolled coated products you'll read about next.

Both steel sheet and steel strip are thin (less than ½ inch), flat products. The major difference between them is width. Sheet can be up to 75-inches wide, while strip is less than 24-inches wide and may be as narrow as ½ inch. Generally speaking, the thickness of steel strip is more tightly controlled than the thickness of sheet.

These products have countless appli-cations: sheet is used to make auto-mobile bodies, appliances, cabinets and many other familiar products. Strip is transformed into seat belt buckles, chain saw blades, washers, machine parts and many other "small" steel products you see every day.

The first step in making sheet and strip is to heat a slab of steel (see page 23) to proper hot rolling temperature, some-where above 2100°F. Next, the scale on the slab's surface, essentially a thick layer of rust, is broken loose by the action of heavy steel rolls and high-pressure water sprays. Then, the red-hot slab passes between several pairs of rolls in the hot strip mill (above left). The rolls squeeze the steel down to the proper thickness, and in the process, increase the slab's length to upwards of 2000 feet.

As hot rolled sheet or strip emerges from the rolling mill, it is wound into coils or "bands" for easy handling (above right). Some of the bands are shipped to customers, but others are sent to J&L mills to be cold rolled.

Cold rolling is also accomplished by squeezing the steel between pairs of hardened rolls. It reduces thickness even more, improves the surface finish and makes the dimensions of the sheet or strip more uniform.

Cold rolling tends to harden the steel, and often this is not desirable in sheet or strip applications. For this reason, most cold rolled sheet and strip is softened by heating it to carefully con-trolled temperatures in an annealing furnace. Then, the annealed product is run through the rolls of a temper mill to reharden it slightly, and to give it proper flatness and surface quality.

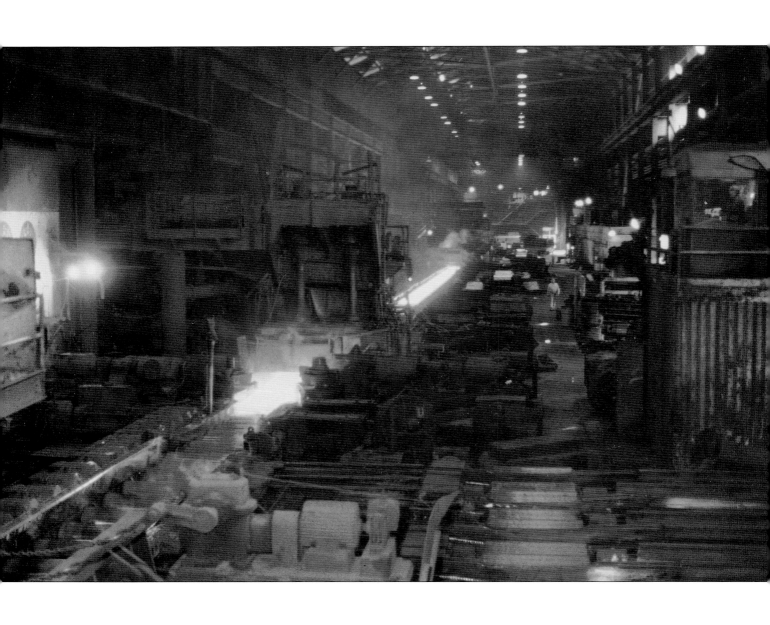

FLAT ROLLED COATED PRODUCTS

Because iron has a great affinity for oxygen, an unprotected steel surface will tend to combine with oxygen in the air to form iron oxide. This is another way of saying that it will rust. One way to help protect steel from corrosion is to coat its surface with thin coatings of other metals that do not combine readily with oxygen. Zinc and tin are the two most widely used metals. Zinc-coated steel is called galvanized steel; tin-coated steel is called tin plate.

An important point to keep in mind is that this coating of tin or zinc does not simply cling to the steel surface like paint. Instead, the bottom of the zinc or tin layer actually forms an alloy with the steel surface to create a durable protective barrier.

Galvanized steel has numerous applications, including car body components, buckets and tubs, air conditioning ductwork and water storage tanks. J&L galvanizes steel sheet products at our Hennepin, Pittsburgh, and Indiana Harbor works via the hot-dip process. In this process, carefully cleaned steel sheet is annealed to give it desirable

mechanical properties and then drawn through a bath of molten zinc (above left). The coated sheet is allowed to cool slowly, giving the molten zinc sufficient time to alloy with the steel surface. Finally, the sheet is rolled into coils or cut into flat sheets.

The major application of tin plate is the manufacture of "tin cans" for food and beverages. Actually, the familiar name is a misnomer: a tin can is 98 per cent steel and only two per cent tin.

Tin is applied to the surface of steel

sheet by an electrolytic process. J&L's tin mills at our Aliquippa and Indiana Harbor works first roll hot rolled bands to make cold rolled sheet. Then, the tin layer is applied.
Here's how:

The surface of the steel sheet is carefully cleaned and rinsed. Next, a solution that can conduct electricity, called an electrolyte, is applied to the surface and the sheet is drawn past in electrodes. An electric current flowing between the sheet and the electrodes deposits tin on the sheet's surface. Finally, the tin plate is heated to melt the tin and create a smooth, shiny surface (above).

(Opposite left) A rod mill at the
Pittsburgh Works, 1960.

(Opposite right) Hot coils of rods in
a Pittsburgh bar mill, 1960.

(Opposite below) Nos. 3 and 4 tin
line and shears at the Aliquippa
Works, 1988.

MAKING HOT ROLLED BAR PRODUCTS

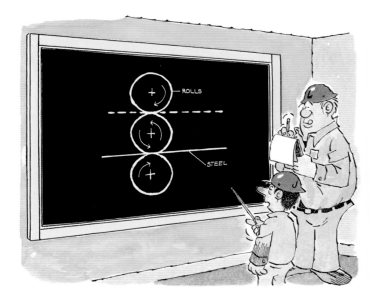

It's been said, without much exaggeration, that the world rolls on hot rolled steel bars. These bars are the raw material for car and truck components such as axles, driveshafts, engine and transmission parts, and bearings. And, hot rolled bars are used to make tools, chains, fasteners of all types and many other familiar items.

Hot rolled bars are made by squeezing red-hot billets of steel between shaped steel rolls (above right). There are 10 or more pairs of rolls arranged in a series of stands. Each pair of rolls reduces the cross-section diameter of the bar. The process reshapes the hot steel much like a child shapes a block of clay into a clay rope.

Not all hot rolled bars are round. Many have square, hexagonal, rectangular or special cross-sectional shapes. It's all a matter of designing rolls that impart the shape desired by the customer.

The illustration (above left), shows partially rolled bar speeding around a looping table on its way to another group of roll stands. One reason to reverse direction like this is to allow the construction of a more compact rolling mill.

Depending on its diameter, a length of bar emerging from the rolling mill can be upwards of 300 feet long. The hot rolled bar is cooled on long open tables and then cut to desired length and straightened, if necessary.

We make hot rolled bar products in two mills at Pittsburgh and one at Aliquippa. Carbon steel bars represent the bulk of our shipments, but we also roll alloy steel bars.

Because hot rolled bars find their way into tough applications, J&L bar-makers exercise great care during every step of manufacture. We work hard to ensure internal soundness of the steel and freedom from serious surface defects.

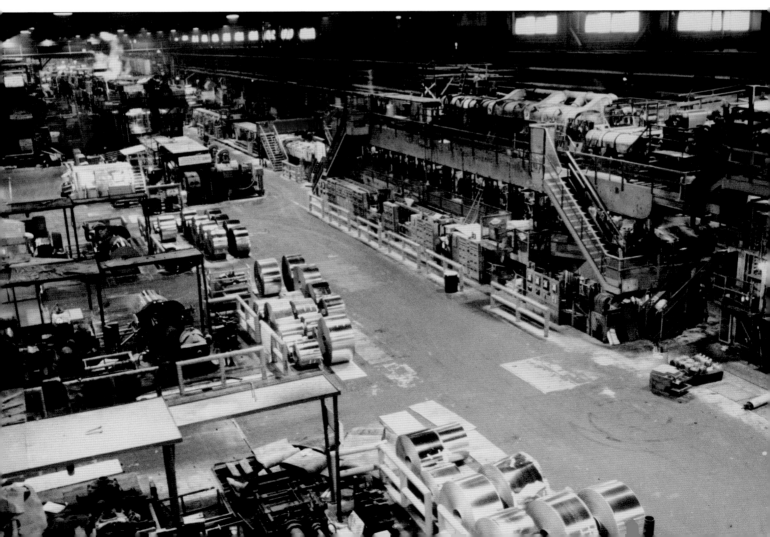

MAKING COLD FINISHED BAR PRODUCTS

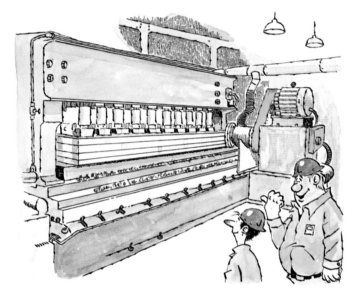

J&L invented the cold finishing process nearly 120 years ago. It happened when an engineer at Jones, Lauth & Company (see page 4) watched a worker drop a pair of tongs into a rolling mill. All that emerged from between the rolls was a mangled mass of iron, or so it seemed at first glance. Closer inspection revealed that squeezing the cold metal between rolls had both increased its strength and given it a good surface finish.

Cold rolling of bar products is still used today to cold finish wide, rectangular pieces of steel called flats. However, virtually all other cold finished bar products are made by drawing hot rolled bars through hardened steel dies.

A typical die has a slightly smaller cross-section than the hot rolled bar it finishes. Thus, the cold finished bar that emerges from the die is slightly smaller and slightly longer than the hot rolled bar that entered the die. And, it is stronger, tougher, harder and has a far superior surface finish.

J&L cold finishes bars of many different shapes and sizes at our facilities at Pittsburgh; Hammond, Indiana; Willimantic, Connecticut and Youngstown, Ohio. As you might expect, substantial force is necessary to pull a hot rolled bar through a die. The primary tool of cold finishing is the motor-driven draw bench (above left).

Most of the cold finished bar we make is used as a raw material to manufacture machined parts, everything from motor shafts to ball bearings to engine camshafts to water valves. For a number of reasons, cold finished bars are easier to machine than hot rolled bars.

Cold rolled milled-edge flats are exclusive J&L cold finished products. These are cold rolled flats that are milled by a special machine to trim their edges square. The illustration (above right) shows this machine in action. The unique flats are used in many different applications that require sharp, square, precise edges.

MAKING ROD AND WIRE

Chances are the word wire conjures up visions of coiled springs and coat hangers in your mind. Though it's true that these familiar products are made of steel wire, there are literally hundreds of thousands of other uses for wire. To list a few: paper clips, nails, screws of all kinds, bed springs, machine nuts, fan grilles, wire baskets, wire rope, staples, chain link fencing, belt buckles, radial tire belts and refrigerator shelving.

Wire is manufactured by drawing hot rolled rod through one or more dies. Rod is made by a hot rolling process that's almost identical to the process used to manufacture hot rolled bars.

A major difference is its smaller size. Most rod is $7/32$-inch in diameter. Another is the controlled cooling step (above). Hot rolled rod is allowed to cool slowly and evenly to give it properties that enhance its suitability for wiremaking.

Incidentally, steel rod has few applications in its as-rolled state. Almost all the rod we make at our Aliquippa rod mill is eventually drawn into wire by us or by our customers.

Rod becomes wire the instant it is drawn through a die. Like other cold finishing operations (see page 32), cold drawing reduces cross-section size, increases strength and imparts a good surface finish to the steel. Depending on the end use application, wire may be drawn through as many as eight dies. The great strength developed by repetitive drawing explains why wire is steel in its strongest form. A typical wire drawing machine at J&L's Aliquippa wire mill (above) uses motor-driven "blocks" or reels to pull the wire through the dies.

Along with strength, the wiremaking process increases the stiffness and hardness of the steel. Many wire applications, though, require supple, flexible steel. Consequently, we heat-treat much of the wire we make to soften the steel. We use several different heat treatment processes, but all involve heating the steel to a specific temperature and then cooling it at a carefully controlled rate.

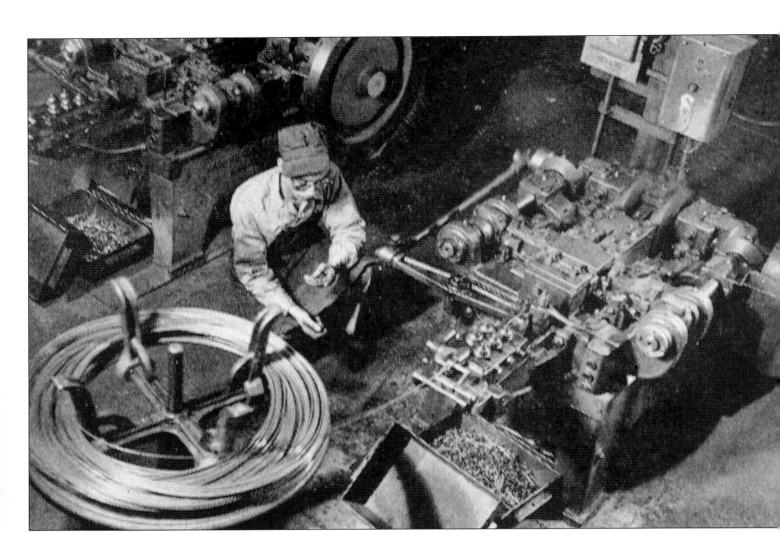

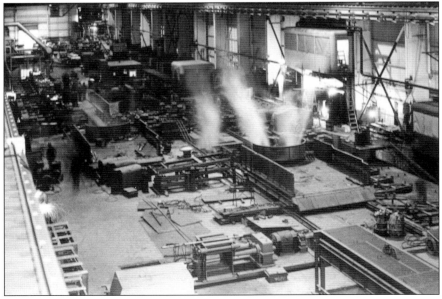

(Above) High-speed nail machine at the Aliquippa Works, September 1950.

(Right) Rod mill, Aliquippa Works.

(Left) Making field fencing at the wire mill, Aliquippa Works.

(Below) The 14-inch mill making structural shapes, Aliquippa Works.

MAKING JUNIOR BEAMS AND OTHER STRUCTURALS

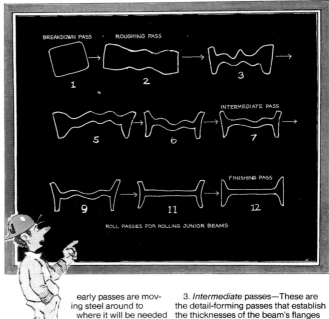

A junior beam is a miniature structural I beam that is widely used in mobile homes and other light construction. It is a hot rolled product made by reducing a heated steel billet on our 14-inch rolling mill at Aliquippa (above). We also manufacture junior channels and a line of rolled steel angles and tees.

Junior beams and structurals are really special kinds of hot rolled bar products. The rolling mill's hardened steel rolls are shaped to squeeze the hot steel into the structural's cross section. You might find it hard to believe that rolling can transform a square-section billet into an I section beam. To show you how it's done, we've diagrammed the different roll passes in the illustration (above right). Each pass is a trip between one pair of rolls.

As you can see, the process has four distinct stages:

1. *Breakdown* passes—The first groups of rolls squeeze the billet slightly smaller, then give its cross section a strange four-eared shape that doesn't look much like an I. Essentially, these early passes are moving steel around to where it will be needed farther down the line.

2. *Roughing* passes—Now, the beam's true cross section begins to take shape, although the arms of the I are still too bulbous and they are tilted at odd angles.

3. *Intermediate* passes—These are the detail-forming passes that establish the thicknesses of the beam's flanges and webs. Simply stated, the intermediate roll pairs move steel into all of the right places and give the developing beam the proper I shape.

4. *Finishing* pass—The last step is to adjust the length of the flanges and push them into the correct position.

Other structural shapes are made by different combinations of passes, although the concept of breakdown/roughing/intermediate/finishing passes applies to all.

MAKING TUBULAR PRODUCTS

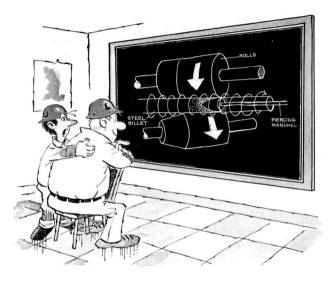

Broadly speaking, all tubular steel products can be divided into two large categories according to how they are manufactured:

1. Welded pipe and tubing
2. Seamless pipe and tubing

Incidentally, the distinction between tubing and pipe is often hazy. Tubing is usually available in many more sizes, is made to a higher level of precision, and is intended for more specialized applications than pipe. Thus, a shock absorber or a hydraulic cylinder is made of steel tubing while many plumbing systems use steel piping.

J&L makes tubular products at Aliquippa, Youngstown and East Chicago, at our specialty tube plants in Oil City, Pennsylvania and Gainesville, Texas, and at the Van Huffel Tube Corporation in Warren, Ohio and Gardner, Massachusetts. We use three different tube-making technologies:

1. Continuous welding—Here, a strip-like steel product called skelp is passed through a furnace that heats it to welding temperatures. As the continuous strip of hot skelp emerges from the furnace, a series of rolls bend it into a tube and push the molten edges against each other to weld them together. Finally, a series of sizing rolls squeezes the still-

hot tube to proper size and a saw cuts the tube to desired length.

2. Electric welding—First, the skelp's edges are trimmed to make them parallel. Next, a series of forming rolls bends the cold steel into a tube and presses the edges together. Then, the tube rolls under an electrode wheel, a pair of side-by-side copper electrodes, that feeds an intense electric current through the seam. The heat generated by the current flow melts the skelp's edges and welds them together.

3. Seamless tubemaking—The important thing to remember about this process is that it does not remove metal to make a tube. Instead, a heated round billet of steel is pushed against a pointed mandrel by a pair of rolls (above right). As the rolls rotate, they simultaneously turn the billet and propel it forward. The mandrel pushes through the hot metal to form a hollow tube (above left). This mandrel serves as a supporting core when the tube passes between several series of rolls that reduce the tube's wall thickness and diameter to the desired dimensions.

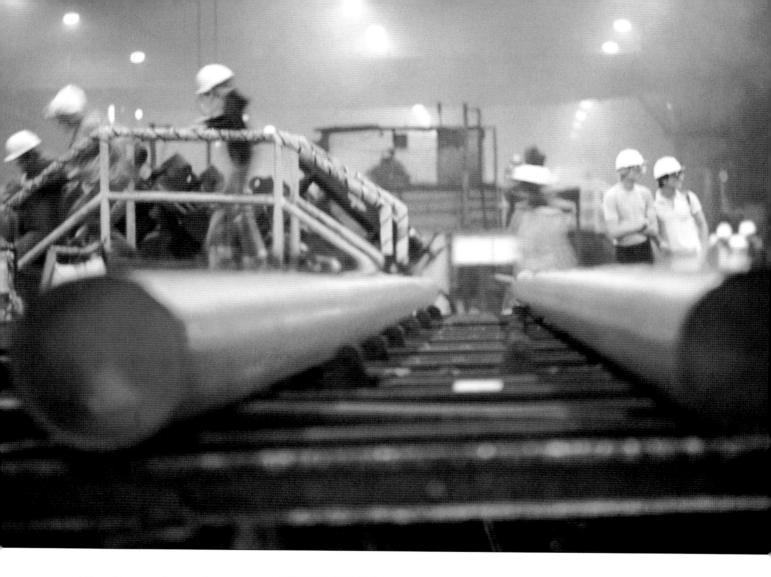

(Above) Pipe ready to make into tubing, Alquippa Works.

(Right) Scarfing rounds at the seamless mill, Aliquippa Works.

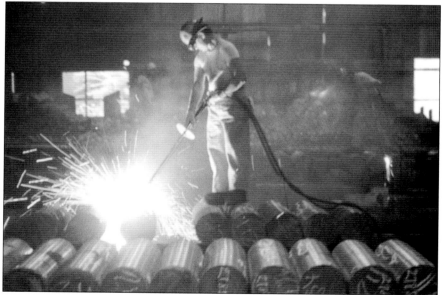

J&L AND THE ENVIRONMENT

Cokemaking, ironmaking and steel-making operations all produce large volumes of waste materials that can cause air and water pollution if they enter our environment. J&L is working hard to control pollution. We've pledged that new facilities will be designed to meet or exceed reasonable government standards for air and water quality, and that existing facilities will be brought into compliance as quickly as technology and economics permit.

To date, we've spent more than $325 million to install pollution control equipment at different works and plants like the smoke abatement facility at our Warren Plant (above right). We plan to spend another $375 million in the near future to buy more equipment and to modify existing facilities to improve air and water quality.

Operating and maintaining this equipment costs money too: right now, we spend about $45 million every year and we will spend more in the future as new pollution control gear is put in place.

Our major works offer the greatest challenges; we're proud of our recent accomplishments. For example:

The A-5 coke battery at Aliquippa uses an advanced pipeline charging system that eliminates charging emissions (see page 12). The battery also has a large hood that collects pollutants released when hot coke is pushed out of each oven.

The water recycling systems at Cleveland (above left) and Indiana Harbor have been cited for their excellence by the Federal Environmental Protection Agency. In 1976, the Cleveland Works received the Region V Environmental Quality Award from the U.S. EPA.

J&L is constructing an electric furnace complex for the Pittsburgh Works that will replace the six existing open hearth furnaces and four existing blast furnaces. The new facility will be equipped with the most modern pollution abatement technology. The planned completion date is May, 1979.

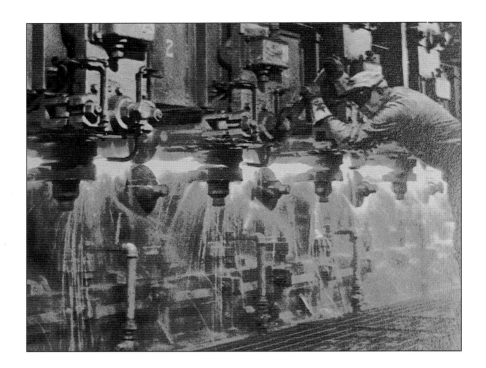

(Right) Rolling skelp into pipe at a welding temperature of 2,450°F, 1960.

(Below) "J&L Steel Products," mid-1950s.

PRODUCTS

HOT ROLLED PRODUCTS

Skelp
Floor Plates—Jal-Tread and Junior Jal-Tread Pattern
Plates
Bars and Small Shapes
 Rounds ⎫ In
 Squares ⎬ Standard
 Hexagons ⎪ Steel
 Flats ⎭ Grades
 Angles
 Special Sections
 Die Rolled Sections
 Concrete Reinforcing Bars—
 Straight, Bent, and Fabricated
Structural Shapes
 Angles
 Beams
 Channels
 Junior Beams
 Junior Channels
 Junior Tees
 Jaltruss Sections
Railroad Track Fasteners
 Railroad Spikes
Forgings
 Plain Rounds and Squares

COLD FINISHED PRODUCTS

(Carbon and Alloy Steels, as Drawn, Rolled, Turned, Ground and Furnace Treated)

Bars and Shapes
 Rounds
 Squares
 Hexagons
 Flats
 Special Shapes
Forgings—Turned and Finished
Shafting
 Ground and Polished from Cold Drawn Bars
 Turned, Ground and Polished
 Turned and Polished
 Butt-Welded and Seamless Mechanical Tubing—Cold Drawn or Ground

SHEETS AND STRIP

Hot Rolled Sheets
Hot Rolled Sheets, ⎫ In Coils
 Pickled and Oiled ⎬ or Cut
Cold Rolled Sheets ⎪ Lengths
Cold Rolled Strip ⎭
Cold Rolled Circles

TUBULAR PRODUCTS

Standard Pipe
Line Pipe ⎫ In Welded
Oil Well Casing ⎬ and
Oil Well Tubing ⎪ Seamless
Drive Pipe ⎭
Oil Well Drill Pipe

ELECTRICWELD TUBING PRODUCTS

Straight Mechanical Tubing
Cold Drawn Mechanical Tubing
Steel Condenser and Heat Exchanger Tubing
Fabricated Tubing
 Shot Hole Casing
 Perma-Tube
 Other Special Fabrications

WIRE MILL PRODUCTS

Bright, Annealed and Galvanized Wire
Electromatic Oil Tempered Spring Wire
Spring Wire (Hard Drawn)
Woven Wire Fencing
Barbed Wire
Fence Staples
Bright, Coated, Blued and Galvanized Nails

WIRE ROPE

(In full range—both Permaset Preformed and Non-Preformed)

General Purpose
Logging
Material Handling
Excavating
Marine
Oil Country
Mining

TIN MILL PRODUCTS

Hot Dipped Tin Plate
Electrolytic Tin Plate
Black Plate, Can Making Quality

SPECIAL STEEL PRODUCTS

Jalten
(High Tensile Low Alloy Steel)

Structurals
Plates
Bars and Small Shapes
Hot and Cold Rolled Sheets
Wire Products
Electricweld Mechanical Tubing

Jalloy
(High Strength Alloy Steel)

Structurals
Bars and Small Shapes
Hot Rolled Sheets and Strip
Wire Products
Heat Treated Plates

FABRICATED STRUCTURAL STEEL

Bridges
Buildings
Tanks
Miscellaneous Items

STEEL CONTAINERS

Steel Drums
Asphalt Casings
Special Containers—Steel Shipping Pails
Galvanized Ware
 Wash Tubs—Garbage Cans
 Pails

COAL CHEMICALS

Benzol
Toluol
Xylol
Crude Solvent
Benzol Still Residue
Pyridine
Picoline
Tar
Tar Acid Oil
Sodium Phenolate
Sulphate of Ammonia
Crude Ammonia Liquor
Creosote

LOCATION OF OPERATIONS — JONES & LAUGHLIN STEEL CORPORATION

STEEL WORKS
Aliquippa, Pa.
Cleveland, Ohio
Pittsburgh, Pa.

☆ STEEL WAREHOUSES
Chicago, Ill.
Cincinnati, Ohio
Detroit, Mich.
Long Island City, N.Y.
Memphis, Tenn.
Nashville, Tenn.
New Orleans, La.
Pittsburgh, Pa.

ELECTRICWELD TUBE DIVISION
Oil City, Pa.

WIRE ROPE DIVISION
Muncy, Pa.

● WIRE ROPE WAREHOUSES
Birmingham, Ala.
Cleveland, Ohio
Denver, Colo.
Houston, Texas
Los Angeles, Calif.
Odessa, Texas
Philadelphia, Pa.
Pittsburgh, Pa.
St. Louis, Mo.
Salem, N.H.
Savannah, Ga.

▲ STEEL DRUM & CONTAINER PLANTS
Container Division
Atlanta, Ga.
Bayonne, N.J.
Cleveland, Ohio
Kansas City, Kans.
New Orleans, La.
Philadelphia, Pa.
Port Arthur, Texas
Washington, D.C.

△ STEEL FABRICATING PLANTS
Chicago, Ill.
Cincinnati, Ohio
Long Island City, N.Y.
New Orleans, La.

○ SALES OFFICES
Jones & Laughlin Steel Corporation
Atlanta, Ga.
Baltimore, Md.
Boston, Mass.
Buffalo, N.Y.
Chicago, Ill.
Cincinnati, Ohio
Cleveland, Ohio
Columbus, Ohio
Dallas, Texas
Denver, Colo.
Detroit, Mich.
Harrisburg, Pa.
Houston, Texas
Indianapolis, Ind.
Kansas City, Kans.

Los Angeles, Calif.
Louisville, Ky.
Memphis, Tenn.
Minneapolis, Minn.
New Haven, Conn.
New Orleans, La.
New York, N.Y.
Philadelphia, Pa.
Pittsburgh, Pa.
St. Louis, Mo.
San Francisco, Calif.
Washington, D.C.
Wilkes-Barre, Pa.

● SALES OFFICES
J&L Supply Division
Abilene, Texas
Amarillo, Texas
Chicago, Ill.
Cleveland, Ohio
Dallas, Texas
Denver, Colo.
Ft. Worth, Texas
Houston, Texas
Midland, Texas
New York, N.Y.
Oklahoma City, Okla.
Pittsburgh, Pa.
Ponca City, Okla.
San Antonio, Texas
Shreveport, La.
Tulsa, Okla.
Wewoka, Okla.
Wichita, Kans.
Calgary, Alberta, Canada

★ STORES
J&L Supply Division

87 Stores in 17 States
3 Stores in Alberta, Canada
1 Saskatchewan, Canada

COAL MINES
Pennsylvania
West Virginia

ORE MINES
Minnesota
New York
Michigan

LIMESTONE QUARRIES
West Virginia

WATER TRANSPORTATION DIVISION
Operates a fleet of river towboats and barges for transportation of coal from mines to Pittsburgh and Aliquippa Works.

RAILROADS
Aliquippa and Southern Railroad Co., Aliquippa, Pa.
The Cuyahoga Valley Railway Co., Cleveland, Ohio
The Monongahela Connecting Railroad Co., Pittsburgh, Pa.

FOREIGN REPRESENTATIVES
J. & L. Export Division, N. Y.
Jones & Laughlin Steel Sales Co., Ltd., Toronto 1, Ontario, Can.
Jones & Laughlin International Co., Rio de Janeiro, Brazil, S.A.

three Appendix

Chronology of the Jones & Laughlin Steel Corporation

1853 Partnership formed between Bernard and John Lauth, B. F. Jones, and S. M. Kier for a new ironworks called Jones, Lauth, and Company. Jones's Brownsville, Pennsylvania, furnaces and mills, packed in boxes, were floated downriver to new mill site and rebuilt. Four puddling furnaces produced about four tons a day.

1854 Average hours worked per week, seventy-two; average wage per hour, 7.5 cents.

1856 John Lauth sold his interest to the other partners. James A. Laughlin, president of the Pittsburgh Trust Company, bought an interest in the firm.

1858 Jones, Lauth and Co. advertisements listed iron, nails, and cut and pressed spikes as principal products for sale.

1859 Laughlin & Company built two blast (or Eliza) furnaces on north bank of Monongahela River to supply pig iron to J&L's American Iron Works on the south bank (South Side). Cold rolling of iron bars patented by Bernard Lauth. Lauth began developing first four-high

rolling mills, using two small work rolls between two heavy back-up rolls.

1860 The company's first warehouse for iron and heavy hardware was established in Chicago. United Sons of Vulcan, a labor organization of puddlers, heaters, rollers, and roughers, was established in Pittsburgh and recognized by district employers. South Side cold-finished bar mill was started.

1861 Bernard Lauth retired. James Laughlin bought his interest, and the company became known as Jones and Laughlin's American Iron Works.

1862 New mills and furnaces built at American Iron Works to meet Civil War needs.

1863 B. F. Jones worked out a sliding scale of wages related to the selling price of iron.

1864 Bernard Lauth's four-high rolling mill was patented. J&L bought a self-propelled barge to transport iron ore on the rivers to Pittsburgh.

1865 Production in new cold rolling mills totaled 500 tons for the year. J&L's cold-rolled steel was becoming world famous. United Sons of Vulcan agreed to the sliding scale of wages pegged to the market price of iron that B. F. Jones had developed. This was the first labor agreement in Pittsburgh.

1870 J&L established a warehouse at Pittsburgh and built the steamer *James Laughlin*, a stern paddle wheeler, to tow iron across the Monongahela River from the Eliza furnaces to the American Iron Works.

1873 J&L built a new warehouse and office building at Second Avenue and Try Street in Pittsburgh. The Otis Steel Co., later a vital part of J&L, was organized in Cleveland, Ohio. It was the first works built exclusively for open-hearth steel production in the United States.

1874 The first two seven-ton open-hearth furnaces were built at the Otis plant. There were seventy-five puddling furnaces, with a 50,000-ton per year capacity, at the Pittsburgh Works.

1878 Two fifteen-ton open-hearth furnaces were built at the Otis plant.

1881 Two more fifteen-ton open-hearth furnaces were built at the Otis plant.

1883 J&L became Jones & Laughlins, Limited, with B. F. Jones as chairman, G. M. Laughlin as secretary-treasurer, and T. M. Jones as general manager. J&L's first two Bessemer converters (with seven-ton capacity) were built at Pittsburgh. The first heavy steam-powered blooming mill was built. New bar mills were added, and an old one was rebuilt for steel products.

1884 B. F. Jones became president of the American Iron and Steel Association, a position he would hold for eighteen years. J&L added seventy-six puddling furnaces, with a 75,000-ton per year capacity, one five-ton Bessemer converter, a rail mill, and fifty-four beehive ovens.

1885 Fifty-four beehive ovens were started at Pittsburgh. J&L employed approximately four thousand people in all its operations.

1886 J&L's first soaking pits for heating steel ingots to rolling temperature were built at the Pittsburgh Works. Otis Steel Co. pioneered the change from acid to basic open-hearth practice, thereby making better steel. Two nine-ton Bessemer converters were added at Pittsburgh.

1887 A new blast furnace was built in Pittsburgh to supply more iron for the Bessemer converters. A hot metal bridge connecting the Eliza furnaces and the South Side Works was built. Two more open-hearth furnaces were built at the Otis Works.

1889 Controlling interest in the Otis Steel Co. was sold to English investors, who retained control of the company until 1919.

1891 The steamer *Titan* was bought and remodeled. It became the first J&L towboat for river transportation of coal.

1892 J&L began closing puddling furnaces en masse; none were left by 1900.

1893 16-inch Morgan billet mill started at Pittsburgh.

1894 J&L was a large tonnage producer of cold-rolled shafting, nails, bars, plates, rails, and sheets. The average hourly wage rate in steel was 21 cents.

1895 J&L's first two open-hearth furnaces (50-ton capacity) were built at Pittsburgh, increasing the range of steels produced. Ore properties in the Great Lakes region were bought and leased, a key step in the further vertical integration of the company.

1896 No. 3 blooming mill was built and two more 50-ton capacity open-hearth furnaces were added at Pittsburgh.

1897 Two more open-hearth furnaces built at Pittsburgh. The companies leased the Soho Iron Co., consisting of the Moorhead furnace, built in 1859, demolished 1932; one 12-ton open-hearth furnace, built 1883 and shut down 1888; and two 15-ton open-hearth furnaces, built in 1888.

1898 Otis Works installed metallographic equipment for testing steel for internal defects, which marked the beginning of quality control. What would become P-2 and P-4 blast furnaces were started at Pittsburgh Works.

1899 No. 16 mill, a new hot bar mill with a revolutionary looping design, was built at Pittsburgh, starting a new era in hot-rolled bar production for the industry. New soaking pits were also built.

1900 Laughlin and Sons, Ltd., was merged into Jones & Laughlins, Ltd. J&L's annual production was 650,000 tons of steel ingots. A new hot bar mill (No. 13) was built at Pittsburgh. What would become P-1 and P-3 blast furnaces were also started. Approximately 1,200 beehive ovens were in operation at Pittsburgh Works, which was reportedly the largest coke plant in the world. (It was shut down in March 1926, presumably because an air pollution law in Pittsburgh banned beehive coke production.) Average hours per week had dropped to sixty, and wages were now 15 cents per hour.

1902 Five new open-hearth furnaces (capacity: 160 tons each) were under construction at Pittsburgh Works; they were Talbot furnaces,

with a "tilting" design, the first in use by J&L. The company was reorganized as the Jones & Laughlin Steel Company, with a capitalization of $30 million. Company output was 3,000 tons per day; employment totaled 15,000.

1903 B. F. Jones Sr. died. What would become P-6 blast furnace started at Pittsburgh Works.

1904 28-inch billet mill started at Pittsburgh Works.

1905 J&L purchased Woodlawn Park and various farms twenty miles down the Ohio River from Pittsburgh as the site of a new steelworks, the Aliquippa Works.

1906 A new eight-story J&L office building was built at Third Avenue and Ross Street in Pittsburgh. No. 3 blooming mill at Pittsburgh was rebuilt with a larger capacity. First two freighters of J&L's lake fleet, the steamers—the *B. F. Jones* and the *James Laughlin*—each 530 feet long with a capacity of 11,000 tons, were launched.

1907 Financial panic halted construction at the new Aliquippa Works. The first "safety first" program to reduce hazards in J&L mills was started.

1908 Four new open-hearth furnaces (225 tons each) were installed at Pittsburgh Works.

1909 First blast furnace (A-1) completed at Aliquippa Works. No. 17 bar mill built at Pittsburgh Works to produce greater tonnage of hot rolled bars and shapes.

1910 Coke ovens, soaking pits, and billet mills were under construction at Aliquippa Works. Tin mills (old hot mills Nos. 1–12), A-2 and A-3 blast furnaces, and South coal hoist all started operation at Aliquippa Works; J&L entered the wire business with the completion of the new rod (old No. 1) and wire mills at Aliquippa Works.

1911 Another rod mill completed at Aliquippa Works. Third and fourth steamers, the *Willis L. King* and the *Thomas Walters*, were launched.

1912 First Bessemer converter (25-ton capacity) went into operation at

Aliquippa Works; four new open-hearth furnaces (Nos. 61, 62, 63, 64; one 225-ton and three 275-ton capacity) began making steel there as well. Blooming mill and 21- and 18-inch billet mills with steam engine for power, along with A-4 blast furnace, also were completed at Aliquippa Works.

1913 Second Bessemer converter (25-ton capacity) and rectangular coke department were operating at Aliquippa Works. Otis Steel started the Riverside Plant with a plate mill and three sheet mills.

1915 J&L built the Hazelwood cold finishing mills at Pittsburgh to meet the demand for smaller sizes. Sinter plant at Aliquippa Works came on line.

1916 J&L entered the tubular products business with the completion of two buttweld mills and one lapweld mill at Aliquippa Works. The 21- and 18-inch bar mills and the A-1 10-inch skelp rolling mill were started at Aliquippa Works as well. No. 11 bar mill was built at Pittsburgh Works. The plate mill at Otis Steel was widened for larger capacity.

1917 Four stories were added to the main office building.

1918 A-5 blast furnace completed at Aliquippa Works, the last of the set. What became P-5 blast furnace at Pittsburgh started.

1919 Otis Steel Company was purchased from English investors by new American owners, who also bought two blast furnaces and a hundred coke ovens to add to the Riverside Plant. Blooming mill at Aliquippa redesigned for greater capacity and power; A-5 blast furnace at Aliquippa Works started up. A through F coke batteries started at Pittsburgh Works.

1920 Eight more sheet mills built at new Otis plant. No. 8 lapweld mill added at Aliquippa Works.

1921 With the steel *Argosy,* J&L sent its first tow downriver to New Orleans, opening a new phase of commerce on the rivers.

1923 J&L became a corporation and sold its first stock on the open market. B. F. Jones Jr. was chairman of the board, and William L. Jones

was president. Otis Steel built four new open-hearth furnaces (125-ton capacity) with a blooming mill, a 30-inch continuous strip mill, and four cold rolling mills. Eight-hour day introduced, with a six-day work week.

1924 J&L soaking pits at Pittsburgh Works redesigned for 500-ton ingots. New 14-inch bar mill (merchant mill) to roll special shapes was started at Aliquippa Works. New Memphis warehouse built.

1926 Union Dock Company, consisting of four Hulett unloaders and other facilities at Ashtabula, Ohio, was bought to unload and stockpile iron ore. Turning, polishing, and grinding facilities for cold-finished steel were added to the Hazelwood plant. New Cincinnati warehouse built. By-product coke (old B) battery built at Aliquippa Works.

1927 No. 3 blooming mill at Pittsburgh Works rebuilt. First of three seamless tube mills (A-1, 14-inch) and A-3 30-inch round mill built at Aliquippa. Four new 125-ton open-hearth furnaces and a new electricity-driven blooming mill were built at Otis Works.

1929 Detroit warehouse established.

1930 Two 25-ton Bessemer converters built at Pittsburgh Works to replace four 10-ton units. First 1,500-ton capacity blast furnace in the country built at Aliquippa Works. A-2 coke battery built at Aliquippa Works.

1931 No. 18 mill, one of the fastest in the industry, built at Pittsburgh Works. A 72-inch-wide continuous hot strip mill, widest in the industry at the time, was built at Otis Works. J&L bought warehouse and fabricating facilities at New Orleans.

1932 A new 72-inch cold rolling mill (four high, two stands in tandem) built at Otis Works.

1933 Rotary Electric Steel Company of Detroit organized to produce stainless steels; this company would be acquired by J&L on May 1, 1957, as the stainless steel division.

1935 No. 1 blooming mill at Pittsburgh rebuilt. Warehouse and fabricating facilities purchased at Long Island City, New York.

1936 96-inch wide continuous hot strip mill and two high-speed tandem mills for cold rolling of steel sheet built at Pittsburgh Works.

1937 New open-hearth furnace (No. 65, 150-ton) built and four others remodeled at Aliquippa Works; No. 2 & 3 temper mills and No. 2 tin house installed at tin mill, Aliquippa. J&L signed first contract with the Steelworkers Organizing Committee of the CIO.

1938 Research Laboratory opened in Pittsburgh for metallurgical exploration and experimentation. Wire rope plant built at Muncy, Pennsylvania.

1939 Bayonne Steel Barrel Company started with purchase of fabricating plant at Bayonne, New Jersey.

1940 "Flame control," first basic improvement in quality control of Bessemer steel, patented by J&L. At U.S. Army's request, J&L began setting up one of the largest shell production lines in the United States at McKeesport, Pennsylvania. Gulf Coast Steel Barrel Company, a subsidiary company, erected a plant at Port Arthur, Texas.

1941 J&L leased Benson Mines to develop world's largest open-pit quarry for magnetite iron ore, at Star Lake, New York. All steel barrel operations were consolidated in the J&L Steel Barrel Company, which would be enlarged in succeeding years by various acquisitions.

1942 J&L acquired the entire Otis Steel Company, Cleveland, Ohio, which became the Cleveland Works of J&L.

1943 To conserve tin, J&L installed two electrolytic tin-plating lines at Aliquippa. World's rolling record was set at the blooming mill and world's production record was set on the A-3 blast furnace at Aliquippa Works, which also received the army-navy "E" award for excellence. Ferrite welding rod was developed by J&L metallurgists for faster and better welding of armor plate. In one month Pittsburgh Works made enough steel for thirty-two ships, slightly more than one ship a day, for which Pittsburgh Works was also awarded the army-navy "E" award for production.

1944 Army-navy "E" award given to Cleveland Works for production excellence. Pittsburgh's five bar mills were setting new production records, with No. 18 rolling a world's record for any bar mill. (From 1942 through 1944 J&L broke at least 2,018 production records in all operations, from mines through mills.) J&L acquired Frick-Reid Supply Corporation, changing its name to Jones & Laughlin Supply Company, with seventy-one stores and thirteen sales offices serving the oil industry. J&L purchased Electricweld Tubing Company's production facilities at Oil City, Pennsylvania.

1945 Old Lakeside Works of Otis Steel abandoned. A-1 coke battery at Aliquippa started.

1946 New battery of 106 coke ovens built at Aliquippa.

1947 World's fastest steel rolling mill (70 mph), a five-stand cold reducing mill, batch annealing, electro cleaning line, and continuous pickling line all built at Aliquippa for tin plate.

1948 New battery of 107 coke ovens (A-4), one of the largest single coke-producing batteries built, was constructed at Aliquippa. Two new open-hearth furnaces (150-ton capacity) added at Cleveland Works. The fiftieth barge and the first mine car were built at McKeesport Works. "F" coke battery at Pittsburgh Works finally completed.

1949 New Bessemer converter added to two already in operation at Pittsburgh Works. Consolidation of Vesta Mines Nos. 4 and 5 resulted in the largest underground coal mine operation in the world. World's largest coal preparation plant built near Brownsville, Pennsylvania, to process coal from the Vesta Mines.

1951 Eleven new open-hearth furnaces (250-ton capacity each) under construction at Pittsburgh Works, as well as a new blooming mill. New coal hoist and battery (A-3) of fifty by-product coke ovens completed at Aliquippa, giving Aliquippa a total of 350 ovens. No. 4 temper mill at the tin plate department and the 11-inch rod mill were also added at Aliquippa. Two new open hearths (150 tons each) under construction at Cleveland Works, along with more soaking pits. New mine shaft (Tracy) sunk to get iron ore in Northern Michigan. Equipment installed at Benson Mines to get nonmagnetic ore. Time clocks installed at Aliquippa to replace brass checks. Em-

ployment of company at 43,000; average earnings were $1.85 per hour, with an eight-hour day and a five-day week.

1952 New plant improvements included No. 11 furnace open-hearth shop and 46-inch blooming mill at Pittsburgh; two new 210-ton open-hearth furnaces (bringing Cleveland's total to eleven), a new No. 2 blast furnace, and a modern blooming mill at Cleveland. After fifty-six years at Third and Ross in Pittsburgh, the main offices moved to 3 Gateway Center.

1953 New 10-inch bar mill, a battery of seventy-nine coke ovens, 96-inch hot strip mill, and No. 5 chain bench were put into operation at Pittsburgh Works. At Aliquippa Works the 14-inch mill was improved, the tin mill warehouse was completed, and an electric drive was installed on the 44-inch blooming mills. A new ore concentrating plant went into operation at Hill Annex Mine, Minnesota, ore division. The stern wheeler towboat the *Aliquippa*, built in 1914, was replaced by a new diesel boat, also called the *Aliquippa*. All thirteen blast furnaces owned by J&L were operating.

1954 New combination warehouse-container plant opened at Lancaster, Pennsylvania. At Aliquippa Works new seamless tube-finishing facilities (Annex) opened and No. 1 electrolytic tinning line converted to halogen process. At Pittsburgh Works a new hot extrusion press put into operation. Six new continuous mining machines installed at Vesta Mines.

1955 J&L purchased W. J. Holliday Warehouse in Indianapolis and Hammond, Indiana, the Hamilton Steel Company's warehouse operations in Cleveland, Ohio, and Monarch Steel Company (a cold-finished bar company) in Hammond, Indiana. A new container division plant was established at Port Arthur, Texas. The Graham Laboratory for J&L Research was dedicated in honor of the vice president for research, Herbert W. Graham. Tracy mine at Michigan ore division went into production.

1956 Continuous sheet galvanizing line went into production at Pittsburgh. A new stretch reduction mill went into production at Aliquippa. A new cold reducing mill and two electric furnaces started up at Cleveland. Two BOFs and a new 44-inch hot strip mill were under construction at Aliquippa.

1957 Rotary Electric Steel Company became the stainless steel division of J&L. Shareholders now numbered 46,561, up from 26,018 in 1950. No. 1 BOF Shop started at Aliquippa, the first successfully operated BOF in North America. The first slab was rolled by the 44-inch hot strip mill at Aliquippa, the first computer-controlled mill. Electric weld tube mill and the A-1 continuous weld tube mill started at Aliquippa as well. The last day J&L paid its employees in cash at Aliquippa was June 7. Cold-finished bar plant started at Willimantic, Connecticut.

1958 A-2 continuous weld tube mill started at Aliquippa. Cleveland Works completely shut down for installation of new equipment. New 52-inch sendizmar mill opened at the stainless and strip division's New Louisville, Ohio, plant.

1959 Eight 175-ton open-hearth furnaces removed at Cleveland (three 220-ton units remained) to make way for new BOF shop. Average steelworker wage was $3.03 per hour, $24.24 per day. Longest strike in history of steel industry occurred.

1960 Continuous annealing line at tin plate department and new sinter plant in blast furnace department started at Aliquippa. Three inactive by-product coke batteries dismantled at Cleveland as part of site preparation for new blast furnace. First push was made from new battery of fifty-nine coke ovens at Pittsburgh.

1961 First 200-ton BOF shop at Cleveland Works went into production. No. 4 electrolytic tin line started at Aliquippa.

1962 Three-stand cold double reducing mill at Aliquippa came on line. The Cuyahoga River at the Cleveland Works was moved to make space for the new 80-inch strip mill.

1964 Conduit products division established. Vacuum degassing unit went into production at No. 4 open-hearth shop, Pittsburgh Works. Hot dip tinning at Aliquippa (the last six of forty-two machines) was shut down on November 5. The new 80-inch hot strip mill started at Cleveland.

1965 J&L warehouse division became service center division. Aliquippa's Crow Island project started, to fill in channel between main works

and Crow Island in the Ohio River to provide space for expansion of the BOF facilities. New twin vacuum degassing process unit went into production at Detroit plant of the stainless and strip division.

1966 J&L started construction of the Hennepin Works in Illinois. The A-4 blast furnace at Aliquippa was enlarged to be one of the largest in the industry. A-2 11-inch rod mill at Aliquippa expanded. The last seventy of the original 234 nail and staple machines at Aliquippa were shut down in April. New annealing and pickling line set up at the New Louisville, Ohio, plant. P-5 blast furnace at Pittsburgh shut down.

1967 New line for the manufacture of electricweld heat exchanger and condenser tubing established at electricweld tube division in Oil City, Pennsylvania.

1968 Ling-Temco-Vought, Inc. (later The LTV Corporation) acquired controlling interest in J&L Steel Corporation. Hennepin Works shipped its first order. No. 2 BOF shop installed on Aliquippa's Crow Island.

1969 J&L became the first steel company to market high-strength, low-alloy steels. J&L's first caster unit, a six-strand billet caster, installed at Aliquippa.

1970 New electricweld tube plant started at Gainesville, Texas. Electricweld tube name changed to specialty tube division.

1971 Iron and steel foundry shut down at Pittsburgh Works, but the electric furnace located at the foundry now transferred to the research department for experiments in continuous strip casting. J&L obtained patents for successful continuous strip-casting machine. This particular furnace is currently on display at Station Square in Pittsburgh.

1972 Blow engine house No. 2 at Pittsburgh with five steam powered engines demolished. At one time there were thirteen blow engines at Pittsburgh. No. 2 was built about 1896; the others were built about 1918.

1974 J&L became a wholly owned subsidiary of The LTV Corporation. A $200 million expansion program for the Aliquippa Works was

announced, including facilities to increase the output of the BOF shop, installation of a second blooming mill, upgrading of the tubular products facilities, and improvements and additions to the coke division with a new coke battery.

1978 The LTV Corporation merged with the Lykes Corporation, whose Youngstown Sheet and Tube Company was placed under the J&L name, the J&L Steel Division of The LTV Corporation.

1979 The remaining five blast furnaces and the open-hearth shop at Pittsburgh Works were closed as two 350-ton electric furnaces (Nos. 91 and 92) came on line.

1981 The Detroit Stainless Plant and additional cold-finished bar mills were added to J&L, but the hot strip mill and the temper mills at Pittsburgh were shut down.

1983 The continuous slab caster was started up at the Indiana Harbor Works (formerly a Youngstown Sheet and Tube facility). The specialty steels plant at Midland, Pennsylvania, was purchased from Colt Industries (which had been part of Crucible Steel Company). Blast furnaces P-1 through P-6 at the Pittsburgh Works were demolished.

1984 The Jones and Laughlin name was ended with the merger of The LTV Corporation with Republic Steel Corporation. The combined steel divisions were called LTV Steel.

Appendix four

Chronology of the LTV Corporation

1947 James J. Ling formed Ling Electric Company, a Dallas-based electrical construction and engineering company, with an investment of $2,000.

1955 Ling Electric sold stock to the public at two dollars per share.

1956 Ling Electric merged with L.M. Electronics of California to form Ling Electronics, Inc.

1959 Ling Electronics merged with Altec, Inc., to become Ling-Altec Electronics, Inc.

1960 Ling-Altec Electronics merged with Dallas-based Temco Electronics and Missile Company to become Ling-Temco Electronics, Inc.

1961 Ling-Temco Electronics merged with Chance Vought Aircraft of Dallas to become Ling-Temco-Vought, Inc.

1965 Ling-Temco-Vought acquired the Okonite Company.

1967 Ling-Temco-Vought bought Wilson & Company. It was ranked fourteenth on the Fortune 500 list.

1968 Ling-Temco-Vought purchased majority interest in the Jones & Laughlin Steel Corporation; it also acquired Greatamerica Corporation.

1969 J&L acquisition prompted a federal antitrust investigation and lawsuit.

1970 Paul Thayer became chairman of the board of Ling-Temco-Vought and began streamlining the company through the sale of some subsidiaries. James Ling ceased to be an employee but remained a member of the board of directors.

1972 The company changed direction, management philosophy, and name. Ling-Temco-Vought, by now a holding company, became The LTV Corporation, an operating company directly involved with its subsidiaries. LTV Electrosystems was sold.

1974 The LTV Corporation increased its ownership of J&L to 100 percent.

1975 Raymond A. Hay joined LTV as president and chief operating officer.

1978 LTV merged with Lykes Corporation, parent of Youngstown Sheet and Tube (YS&T), Lykes Brothers Steamship Company, and Continental Emsco. YS&T was consolidated with J&L, making J&L the nation's third largest steel producer.

1981 Wilson Foods was sold.

1982 Raymond Hay was named chairman and CEO when Thayer left to become deputy secretary of defense.

1983 Lykes Steamship was sold to its management. LTV acquired Sierra Research Corporation and AM General Corporation. Vought Corporation was renamed LTV Aerospace and Defense Company.

1984 The LTV Corporation merged with Republic Steel Corporation. Both the Republic and the J&L names were lost as the resultant new steel-producing company was called LTV Steel, now the nation's second largest steel producer.

In the succeeding years The LTV Corporation went into Chapter Eleven bankruptcy (July 1986), from which it finally emerged in June 1993. By then much had been sold off, and the steel operations had become its main focus; it was known now as LTV Steel Corporation. The once-extensive facilities at the Pittsburgh Works and the Aliquippa Works had been dismantled, with only one facility still being operated by LTV Steel at each: the tin plate division at Aliquippa and the by-products coke division at Hazelwood. The Hazelwood plant was closed during 1998. The Cleveland Works remained as the primary production facility, with other facilities in Indiana Harbor and Hennepin; the corporation headquarters was in Cleveland.

five Appendix

Facilities for Jones & Laughlin Steel Corporation

ALIQUIPPA WORKS

Start of Operations	Coke Production	Ceased Operations
1913	rectangular coke ovens	1951
1926	"A" & "B" by-product coke batteries	1948
1930	A-2 by-product coke battery	1960
1945	A-1 by-product coke battery	1985
1948	A-4 by-product coke battery	1980
1951	A-3 by-product coke battery	1978
1976	A-5 by-product coke battery	idle 1984, cold 1985

	Blast Furnaces	
1909	A-1 furnace (rebuilt, enlarged 1963)	1982
1910	A-2 furnace (rebuilt, enlarged 1970)	1985
1910	A-3 furnace (rebuilt, enlarged 1933)	1976
1912	A-4 furnace (rebuilt, enlarged 1966)	1981
1915	old sinter plant	1960
1919	A-5 furnace (rebuilt, enlarged 1967)	1979
1960	new sinter plant	1979

Steel Works

1912	Nos. 61, 62, 63, 64 open hearths	1968
1912	Nos. 1, 2, 3 Bessemer converters	1968
1916	Bessemer ingots	1968
1937	Nos. 59, 65 open hearths	1968
1957	No. 1 BOF (basic oxygen furnace)	1968
1968	No. 2 BOF	1985
1969	billet strand cast	1985

Blooming and Rolling Mills

1912	40-inch blooming mill (steam-driven until 1953)	1984
1912	Morgan 21-inch & 18-inch billet mill	1984
1916	Morgan 21-inch and 18-inch bar mill	1984
1916	A-1 10-inch rolling mill—skelp	1963
1924	A-2 14-inch rolling mill—bars	sold
1953	A-1 44-inch blooming mill (electric-driven)	1984
1957	A-1 44-inch hot strip mill	1982
1977	45-inch blooming mill	1981

Rod and Wire Department

1910	No. 1 rod mill	1952
1910	wire mill	1981
1910	nail mill	1966
1910	field fence	1964
1910	barbed wire	1965
1911	No. 2 rod mill	1953
1941	wet wire	1960
1944	Lee Wilson annealing	1981
1947	wire galvanizing	1968
1951	A-2 11-inch rod mill	1967
1966	continuous annealing	1981
1967	A-2 two-strand rod mill converted	1981
1970	billet conditioning	1984

Tin Plate Department

1910	Nos. 1–32 hot mills	1939
1910	No. 1 hot mill engine (1–12)	1939
1910	No. 2 hot mill engine (13–24)	1938

1910	No. 3 hot mill engine (25–31)	1937
1910	cold rolling	1939
1910	white pickler	1956
1910	hot dip tinning (42 machines)	1964
1933	four-high cold reducing	1947
1936	electro cleaning	
1936	temper mills (No. 2)	1982
1936	batch annealing	
1937	shearing (No. 9 in 1956)	March 1995
1943	No. 1 electrolytic tinning line	1977
1943	No. 2 electrolytic tinning line	1960
1947	42-inch continuous pickler	1982
1947	five-stand 42-inch cold reducing mill	
1951	No. 3 electrolytic tinning line	
1951	No. 4 electrolytic cleaner	
1951	No. 4 48-inch tandem temper mill	
1952	Nos. 3 & 4 coil preparation lines	
1955	Lee Wilson annealing	1995
1960	continuous annealing line	
1961	No. 4 electrolytic tinning line	
1962	48-inch three-stand cold reducing mill	
1965	No. 6 coil slitting & preparation line	
1995	H2 annealing	

Welded Tube Department

1916	No. Three buttweld	1930
1916	No. Four buttweld	1929
1916	No. Seven buttweld	1942
1916	galvanizing	?
1917	No. Six lapweld	1939
1920	No. Eight lapweld	1958
1926	Nos. One & Two buttweld	1957
1931	coupling shop	1985
1932	No. Four seamless (push bench)	1946
1939	cement lining	1970
1957	A-1 electric weld mill	1985
1957	A-1 continuous weld	1985
1958	A-2 continuous weld	1985
1962	plastic coating	1966
1973	½"–4" threading & bundling line	?

Seamless Tube Department

1927	A-3 30-inch rolling mills-rounds (updated 1977)	1984
1927	A-1 14-inch seamless tube	1982
1928	A-2 6-inch seamless tube	1982
1930	coupling shot	1982
1954	annex specialties shop	1982
1956	stretch reducing mill	1982

CLEVELAND WORKS

Start of Operations	Plant	Ceased Operations
1874	Lakeside	1945
1913	Riverside	

Coke Production

?	C-1 by-product coke battery	1960
?	C-2 by-product coke battery	1960
?	C-3 by-product coke battery	1960

Blast Furnaces

1901	Old No. 2 blast furnace	1944?
1902	Old No. 1 blast furnace	1944?
1919	C-1 blast furnace	
1919	C-2 blast furnace (rebuilt 1952)	1989
1963	C-3 blast furnace	1989
1957	sintering plant	

Steel Works

1874	Lakeside open hearths (2)	1945
1878	Lakeside 15-ton open hearths (2)	1945
1880	Lakeside open hearths (first basic in U.S.) five 50-ton stationary (basic) two 25-ton open hearths (acid)	1945
1923	Riverside 8 stationary (basic)	1959
1948	new 150-ton open hearth furnaces	1959
1951	new 150-ton open hearth furnaces	1959

1952	two 210-ton open hearth furnaces	
1959	electric furnace shop	1989
1961	BOF shop	

Slabbing Mill Department

1927	Riverside 40-inch blooming mill	
1957	46-inch blooming mill	
1957	46-x-120-inch horizontal slabbing mill	
1967	revamp 45-x-90-inch universal mill	1993
1993	63-inch twin strand caster	

Hot Strip Mill Department

1920	30-inch hot strip mill	1932
1932	72-inch hot strip mill	?
	(77-inch in 1939 and to cold mill in 1947)	
1936	77-inch hot strip mill (reversing rougher)	1964
1964	80-inch hot strip mill	

Finishing Department

1948	77-inch temper mill	?
?	30-inch cold mill	
1952	80-inch cold-rolled shear line	
1952	80-inch "B" pickle line	
1957	56-inch pickle line	1997
1957	77-inch tandem mill	
?	77-inch box anneal	
1957	annealing department	
1957	56-inch temper mill	?
1957	54-inch cold-rolled shear line	
1957	¼-x-80-inch hot-rolled shear line	
1958	⅜-x-80-inch hot-rolled shear line	
?	48-inch slitter	1969
1965	75-inch slitter	
1966	84-inch temper mill	
1997	72-inch push/pull pickler	

Shock Shears

1936	Cincinnati	
1917	Hilles & Jones	1972

	Strip Sheet Department	
1913	Riverside plate mill and three sheet mills	
1920	8 new sheet mills	

HENNEPIN WORKS

Start of Operations	*Mill Facility*	*Ceased Operations*
1967	84-inch pickle line	
1968	84-inch tandem mill	
1968	batch annealing	
1968	84-inch temper mill	
1968	60-inch galvanize line	
1968	76-inch shearing and slitting line	
1968	corrugating machine	1977
1971	hot-roll shear	1979

PITTSBURGH WORKS

Start of Operations	*Coke Production*	*Ceased Operations*
	Coke Ovens	
1884	54 beehive ovens	by 1926
1885	54 beehive ovens	by 1926
1905	beehive ovens	1926
	Coke Batteries	
1919	"A," "B," "C" coke batteries	1959, dem.*1988
1919	"D," "E" coke batteries	1959
1919	"F" coke battery	1961
1953	P-4 by-product coke battery	1998
1960	P-1 by-product coke battery	1998
1961	P-2 by-product coke battery	1998
1961	P-3 by-product coke battery	1998
	Iron Producing	
1853	4 puddling furnaces (Jones, Lauth & Co)	1892–1900
1874	75 puddling furnaces (50,000 tpy** cap.)	1900
1884	76 puddling furnaces (75,000 tpy cap.)	1900

Blast Furnaces

1859	Moorhead furnace	dem. 1932
1859	Eliza furnaces Nos. 1 & 2	?
1887	Eliza furnace No. 3	?
1898	P-4 furnace (rebuilt 1948)	1979, dem. 1983
1899	P-3 furnace (rebuilt 1953, 1966)	1979, dem. 1983
1900	P-1 furnace (rebuilt 1952)	1979, dem. 1983
19??	P-2 furnace (rebuilt 1958)	1979, dem. 1983
1903	P-6 furnace (rebuilt 1955)	1979, dem. 1983
1918	P-5 furnace (rebuilt 1951)	1966, dem. 1983
1943	sinter plant (modified 1960)	?

Steel Works

1870–75	first Bessemer converter (tried)	1875
1883	two Bessemer converters (7 ton)	1930
1883	Moorhead 12-ton open hearth	1888
1888	Moorhead 15-ton open hearth	?
1930	Two Bessemer converters (25 ton)	1959
1883	Soho Iron One open hearth (12 ton)	?
1888	Soho Iron Two open hearth (15 ton)	?
1917	Soho Six fixed basic open hearths (65 ton)	ca. 1945

No. 1 Open-Hearth Shop

1895	two 50-ton furnaces	?
1896	two 70-ton furnaces	?
1897	two 70-ton furnaces	?

No. 2 Open-Hearth Shop

1909	Nos. 21–24 stationary (220 ton)	1959
1902	No. 25 tilting 160-ton furnaces (4)	1959
1905	Nos. 19, 26–28 tilting furnaces (160 ton)	1959

No. 3 Open-Hearth Shop

1909	three 220-ton furnaces	1959
1916	No. 16 (acid) 42-ton (used by foundry)	ca. 1970

No. 4 Open-Hearth Shop

1951–52	Nos. 41–51 250-ton furnaces (fixed basic, enlarged to 350 ton)	1979

Electric Furnaces

1932	2-ton (in foundry)	ca. 1970

Hot Metal Mixers

1898	Nos. 1 & 2 Bessemer shops (850-ton)	ca. 1961
1917	one 1200-ton	ca. 1961
1952	No. 4 Bessemer shop (two 800-ton)	1979
1979	Nos. 91 & 92 at 350-ton each (in electric furnace shop)	1986

Blooming Mills Department

1883	No. 1 blooming mill (replaced 1903)	1935
1890	No. 2 blooming mill	1935
1896	No. 3 blooming mill (rebuilt 1906, 1927)	?
1952	P-1 46-inch blooming mill (updated 1982)	1985
1935	P-2 44-inch blooming mill	pre-1977?
1893	16-inch Morgan billet mill (rehab. 1940)	1971
1904	28-inch mill (rehab. 1948)	1980s

Rolling Mills Department

1853	Rolling mills (Jones, Lauth & Co.)	?
1884	rail mill	?
?	Nos. 1–10 bar mills	1985
1953	P-1 10-inch bar mill (No. 19 mill)	?
1931	P-2 14-inch bar mill (No. 18 mill)	1985
?	concrete bar equipment	?
?	spike factory	1981
?	Soho heat-treating facilities	1981
?	chain works	?
1899	No. 16 10-inch hot bar mill	?
1900	No. 13 22-inch hot bar mill	1950
1916	No. 11 12-inch hot bar mill	pre-1983
1931	No. 18 14-inch hot bar mill	?
1909	No. 17 10-inch hot bar mill	?

Cold Finishing Department

1860	South Side polishing mill	?
1860	South Side cold finishing department	1985
1922	Nos. 1, 2, 4 chain draw bench	pre-1983
1909	No. 5 chain draw bench	?
1915	No. 7 chain draw bench	pre-1983
1916	Nos. 9, 12–15, 17 chain draw bench	?

1915	Hazelwood cold-finishing department	1985
1915	Nos. 10–11 drawing drums	pre-1983
1915	No. 1 turning machine	pre-1983
1922	No. 2–3 turning machines	pre-1983
1923	No. 4 turning machine	pre-1983
1930	No. 5–7 drawing drums	pre-1983
1946	No. 12–14 drawing drums	?
1948	No. 15–16 drawing drums	?
1953	No. 17–20 drawing drums	?

Strip Sheet Department

1936	96-inch hot strip mill	1981
?	A-line continuous pickler (54-inch)	1981
?	B-line continuous pickler (93-inch)	1981
1954	hot extrusion press	?
1936	54-inch cold reducing tamden mill	1981
1936	93-inch cold reducing tamden mill	1979
?	annealing furnaces	?
?	93-inch flying shear (No. 1)	?
?	77-inch flying shear	?
?	93-inch flying shear (No. 3)	?
?	36-inch slitter	?
?	93-inch temper mill (No. 8)	?
?	93-inch temper mill (No. 9)	1981
?	93-inch temper mill (No. 10)	?
1956	continuous galvanizing line	sold

Shops and Foundries Area

1924	brass foundry	?
1940	ingot mold and green sand foundry	?
1927	iron foundry	?
1927	steel foundry	?

* dem. = demolished

** tpy = tons per year

Unknown dates are indicated by question mark (?); no entry or mark indicates that the facility is still operational as of 1998.

Notes

Introduction

1. *81 Years of Iron and Steel* (Pittsburgh: Jones & Laughlin Steel Corporation, 1931); Willis L. King, "On the History of the Jones & Laughlin Steel Corporation" (an address before the Aliquippa Engineers' Institute, Nov. 19, 1930); B. F. Jones Jr., "Jones & Laughlin Steel Corporation" (typescript, 1926), all found in the Inman Collection, Beaver County Industrial Museum (BCIM), Geneva College, Beaver Falls, Pennsylvania.

2. See, for example, handwritten notes on excerpt from a 1902 article by James M. Swank made by W. R. Creighton and E. F. Blank in February 1949, Inman Collection.

3. Admiral Ben Moreell, *"J&L": The Growth of an American Business (1853–1953)* (Pittsburgh: Jones & Laughlin Steel Corporation, 1953); H. W. Graham, *One Hundred Years*, (Pittsburgh: Jones & Laughlin Steel Corporation, 1953). Both are found in the Inman Collection.

1. "Present at the Creation"

1. John N. Ingham, *Making Iron and Steel: Independent Mills in Pittsburgh, 1820–1920* (Columbus: Ohio State University Press, 1991), 28, 80–81.

2. William died May 27, 1850, six days after Benjamin married Mary McMasters in Pittsburgh. Ironically, James died two weeks before his brother George's wedding in 1866. The oldest brother, Alexander, married a woman in Mount Vernon, Ohio, at about the same time the family moved to New Brighton. "Family Register and Last Will and Testament of Jacob Jones," copies in Inman Collection.

3. *Dictionary of American Biography (DAB)*, s.v. "Jones, Benjamin Franklin"; William A. White, "From Canal Clerk to Steel Magnate," *Romances of Industry*, found in Inman Collection.

4. DAB, s.v. "Jones, Benjamin Franklin"; Thomas Boyle to William Larimer Jones, 1910, letter, in Inman Collection.

5. Moreell, "*J&L*," 11–12.

6. Boyle to W. L. Jones, 1910; listing of organizational changes, J&L Records, Inman Collection; William T. Hogan, *Economic History of the Iron and Steel Industry in the United States*, 5 vols. (Lexington, Mass.: Heath and Company, 1971), 1:101–2.

7. Typescript excerpts from *American Families of Historic Lineage* and John W. Jordan, ed., *A Century and a Half of Pittsburg and Her People;* listing of organizational changes and record of deeds June 29, 1853, Dec. 3, 1853, and Aug. 21, 1856, all in J&L Papers, Inman Collection. Kier sold his shares to Jones in March 1855. John Lauth sold his interest to Jones and Ben Lauth in August 1856. Moreell, "*J&L*," 12–13.

8. Boyle to W. L. Jones, 1910; Hogan, *Economic History of the Iron and Steel Industry* 1:44–46.

9. See Ingham, *Making Iron and Steel*, 31–32, 55–58. See appendixes A, B, C, and D for his classification of both Jones and Laughlin as members of Pittsburgh's core upper class.

10. Listing of organizational changes in Inman Collection; Moreell, "*J&L*," 14.

11. Quoted in Moreell, "*J&L*," 12.

12. Boyle to W. L. Jones, 1910; Albert Daschbach, "The Busy Southside," typescript, 1898, Inman Collection. Joseph Daschbach was the bar mill roller foreman at the American Iron Works in 1867–68.

13. Daschbach, "The Busy Southside," 11, 14; Boyle to W. L. Jones, 1910. The first baseball team in Brownsville, founded in 1866, was called the Mechanics Baseball Club, out of which grew the Mechanics Library.

14. Boyle to W. L. Jones, 1910. Daschbach in "The Busy Southside," 14, says it was the Lauths who told the English brickworker, "This is the American Iron Works, and we'll operate it without a crown." Jones and the Lauths were strongly patriotic, so both might have given similar instructions to change the top of the stack.

15. Boyle to W. L. Jones, 1910.

16. Daschbach, "The Busy Southside," 12.

17. Boyle to W. L. Jones, 1910.

18. He mistakenly gives his middle initial as H. "Composition of the Son of Jacob Shook, Chief Engineer, Jones & Laughlins—1867 Re Trip Through Mills," typescript found in Inman Collection.

19. Daschbach, "The Busy Southside," 15.

20. "History of Pittsburgh: Development of the Iron and Steel Industry," typescript found in Inman Collection; Hogan, *Economic History of Iron and Steel Industry* 1:41–42, 103.

21. Boyle to W. L. Jones, 1910; Daschbach, "The Busy Southside," 16–17; An excerpt from "History of Pittsburgh: Development of the Iron and Steel Industry," 10, gives the date as 1859 and adds that Lauth obtained the patent on August 23. The date is given as 1860 in "In 1860, J&L Invented Process for Cold Rolling Steel Bars," *Of Men and Steel* 14 (Feb. 1945): 3, 5; this is also the date given in Charles Longenecker, "Jones & Laughlin Steel Corporation, 1850–1941," 31, a reprint from *Blast Furnace and Steel Plant* (Aug. 1941), found in Inman Collection.

22. Daschbach, "The Busy Southside," 17.

23. Hogan, *Economic History of Iron and Steel Industry* 1:45–46. The four-high rolling mill was patented by J&L in 1864. "Let's Look at the Records," *Men and Steel* 10, no. 4 (May–June 1957): 47. Lauth apparently continued to work at the mill after he formally left the partnership in 1861.

24. B. F. Jones had a mother and daughter named Elizabeth and a sister named Eliza; James Laughlin had a daughter named Eliza, and it is possible that his mother's name was also Eliza or Elizabeth. See Family Register in the Inman Collection; also see family genealogies in J&L Miscellanea, Archives for Industrial Society, Hillman Library, University of Pittsburgh (hereafter cited as AIS); Jordan, *Century and a Half of Pittsburg* 4:213–15. Willis L. King wrote in 1930 that it was named for James Laughlin's daughter. See "On the History of Jones & Laughlin Steel Corporation before the Aliquippa Engineers' Institute," Nov. 19, 1938, in Inman Collection. However, the "Bill Harvey version" of the "History of Jones & Laughlin Steel Corporation" (typescript in Inman Collection) says that it was named for B. F. Jones's mother. James Laughlin is listed as the first partner, and so more likely he had the opportunity to name the furnaces.

2. Ironmasters in War and Peace

1. Thomas Cushing, ed., *Genealogical and Biographical History of Allegheny County, Pennsylvania* (1889; reprint, Baltimore: Genealogical Publishing, 1975), 236.

2. Jordan, *Century and a Half of Pittsburg* 4:216–17.

3. Daschbach, "The Busy Southside," 2.

4. Boyle to W. L. Jones, 1910.

5. "J&L—The Institution—The Men Who Made It" (ca. 1930), typescript in Inman Collection; Cushing, *Genealogical and Biographical History of Allegheny County*, 234; Hogan, *Economic History of Iron and Steel Industry* 1:111–72.

6. Thomas E. Lloyd, "History of the Jones & Laughlin Steel Corporation" (Dec. 1, 1938), 5, typescript in Inman Collection; W. T. Mossman, "History of Jones & Laughlin Steel Corporation," 2, typescript in Inman Collection; Ingham, *Making Iron and Steel*, 32, 92–93.

7. Jordan, *Century and a Half of Pittsburg* 4:215–17. B. F. Jones diary, entry for May 24, 1875; and family genealogies, both in in J&L Miscellanea, AIS.

8. Jordan, *Century and a Half of Pittsburg* 4:215.

9. "Brief History of Jones & Laughlin Steel Corporation," Jan. 9, 1949, Inman Collection, appears to be a draft for the article "Pioneer in Steel Progress—A Brief History of J & L," which appeared in *Men and Steel* 3, no. 5 (May 1950): 4–8. Irwin Laughlin died in 1871 and George Jones in 1875. See genealogy charts in Jones and Laughlin Steel Corporation Historical Miscellanea, AIS. George's death might have been especially upsetting since he seems to have been a favorite of the workmen from his early years, actually working with them in the mill. See Boyle to W. L. Jones, 1910. It is possible that the George M. Jones referred to in this letter in not the younger brother of B. F. Jones, since the ages are not fully consistent.

10. Hogan, *Economic History of the Iron and Steel Industry* 1:299.

11. B. F. Jones diary, Apr. 12 and 15, 1889, J&L Miscellanea, AIS. The diary is more a memorandum book kept by and for B. F. Jones, with entries in more than one hand, especially in the later years. The last entry was in 1901.

12. B. F. Jones Jr., "Jones & Laughlin Steel Corporation," 3.

13. In *Making Iron and Steel*, 47–73, Ingham asserts that Carnegie was always an outsider to the Pittsburgh core elite, that he was never fully accepted by them.

14. Moreell, "*J&L*," 19–20; Hogan. *Economic History of Iron and Steel Industry* 1:101–4, which erroneously gives 1877 as the date of the hot metal bridge. Longenecker, "Jones & Laughlin Steel Corporation, 1850–1941," 36, gives a date of 1887, and an official Pittsburgh city map of 1884 does not show the bridge. A plaque on the bridge (removed about 1995) gave a date of 1900, which may have been the date of a reconstruction.

15. Mossman, "History of Jones & Laughlin Steel Corporation," 3–4.

16. Cushing, *Genealogical and Biographical History of Allegheny Co.*, 234–35. In the nineteenth century J&L's Blair Limestone Division operated in what is now the Canoe Creek State Park in Blair County, Pennsylvania. In 1910, after closing the Pennsylvania mine, the division opened an open-pit mine near Martinsburg, West Virginia, and later another one near Riverton, West Virginia. These mines closed in 1975, and the one near Riverton was sold to Riverton Corporation of Winchester, Virginia.

17. Ingham, *Making Iron and Steel*, 103.

18. Hogan, *Economic History of Iron and Steel Industry*, 1:86–88; Ingham, *Making Iron and Steel*, 102–4. See *JALTeam Almanac* 29, no. 3 (May–June 1976): 9, for copy of the original agreement, where it is said to be the first labor agreement in Pittsburgh.

19. Ingham, *Making Iron and Steel*, 104–7.

20. Quoted in ibid., 105. "Let's Look at the Records," 47–49, notes the "revolutionary" character of Jones's sliding scale and that it was used between 1865 and 1874.

21. Hogan, *Economic History of Iron and Steel Industry* 1:88–89.

22. B. F. Jones diary, May 26, 1877.

23. The first entry, dated May 24, 1875, announces the death of his brother George on February 8, 1875; the funeral was on February 11.

24. The account of the railway strike appears in B. F. Jones's diary entries dated July 21 to September 18, 1877.

25. Ingham, *Making Iron and Steel*, 111.

26. B. F. Jones diary, June 1–10, 1878. The machine shop, polishing, foundry, and bolt workers did not go out, however.

27. B. F. Jones diary, May 26–June 7, 1879.

28. John Fitch, *The Steel Workers* (1911; reprint, Pittsburgh: University of Pittsburgh Press, 1989), 87–88n. The picnic in 1886 was to be in Beaver Falls.

29. B. F. Jones diary, Feb. 7 and Sept. 25, 1878; *History of Allegheny County, Pennsylvania*, 2 vols. (Chicago: A. Warner and Co., 1889), 2:233–36; Hogan, *Economic History of Iron and Steel Industry* 1:348–55. He would serve as president of the Iron and Steel Institute for eighteen years. "Let's Look at the Records," 52.

30. "Composition of the Son of Jacob Shook."

31. Boyle to W. L. Jones, 1910.

32. B. F. Jones diary, Sept. 29, 1876, and May 1, 1877; Fitch, *The Steel Workers*, 92–95, 168.

33. Fitch, *The Steel Workers*, 22–25, 59–62.

34. "Composition of the Son of Jacob Shook," 6.

35. Ibid., 4–5.

36. Ibid., 3–4, 7–9, 8 (quotation), 14, 17–18. Tallow, lard, and suet were the main lubricants.

37. Ibid., 11–12.

38. B. F. Jones Jr., "Jones & Laughlin Steel Corporation," 5.

39. "Composition of the Son of Jacob Shook," 13–14.

40. Ibid., 19.

3. From Iron to Steel

1. Fitch, *The Steel Workers*, 3.

2. *Webster's Ninth New Collegiate Dictionary* (1990), s.v. "steel."

3. Ingham, *Making Iron and Steel*, 37–38, 45-46, 92 (quotation); see also Hogan, *Economic History of Iron and Steel Industry* 1:31–38.

4. Capacity was seven tons at first, raised to nine in 1894 and ten in 1895. Moreell, "*J&L*," 20–22. Ingham, *Making Iron and Steel*, 93, has the initial converters blown in at nine tons. John L. Haines's notebook listing the starting dates and capacities for different parts of J&L has the capacity as ten tons right from the start; Haines's notebook is found in the Inman Collection. For the Pittsburgh Bessemer Steel project, which Carnegie eventually acquired and made his Homestead Works, see Ingham, *Making Iron and Steel*, 60–67. The beginning date for work on the converters as 1883 is given in several company drafts of history, such as the "Bill Harvey Version" of "History of Jones & Laughlin Steel Corporation."

5. Fitch, *The Steel Workers*, 39–42, 170.

6. Graham, *One Hundred Years*, 9–10.

7. Hogan, *Economic History of Iron and Steel Industry* 1:34–36; see especially the quoted description by John Fritz.

8. Graham, *One Hundred Years*, 13; Hogan, *Economic History of Iron and Steel Industry* 1:221–23. In its only major acquisition of a competitor, J&L acquired the Otis Steel Company in 1942. The 1873 furnace was an acid one. In 1886 Otis was "the scene of what is thought to be the first American experiments with the basic open hearth method." "Otis Steel Has Colorful History," *The Otis Sheet* 10 (Nov. 1939): 3–4.

9. Moreell, "*J&L*," 21–22; Graham, *One Hundred Years*, 15.

10. Hogan, *Economic History of Iron and Steel Industry* 1:224.

11. Fitch, *The Steel Workers*, 42–44; excerpt from "History of Pittsburgh: Development of the Iron and Steel Industry," 3.

12. Graham, *One Hundred Years*, 14.

13. Hogan, *Economic History of Iron and Steel Industry* 1:222.

14. Walter F. Clowes, comp., *A Brief History of the Sons of Veterans U.S.A., Dealing Separately with the Commander-in-Chief and the Division of Pennsylvania* (Reading, Pa., 1895), 36.

15. Moreell, "*J&L*," 20; Hogan, *Economic History of Iron and Steel Industry* 1:300–301.

16. "John Gjers Invented Soaking Pits in 1882," *Of Men and Steel* 7 (July 1944): 2–3.

17. "J&L Bar Mills Roll Steel for Countless Uses," ibid. 9 (Sept. 1944): 7.

18. The numbers grew to 25,000 in 1926 and 43,000 in 1951. See "Let's Look at the Records," *Men and Steel* 10, no. 4 (May–June 1957): 52, 54, 60–61, 66.

19. Fitch, *The Steel Workers*, 111.

20. Ingham, *Making Iron and Steel*, chaps. 2, 4, and esp. 5.

21. Ibid., 63, 131, 138.

22. Ibid., 124, 130–31.

23. Quoted in ibid., 133.

24. Moreell, "*J&L,*" 21–22.

25. Fitch, *The Steel Workers*, 142–43.

26. William L. Jones to B. F. Jones, July 26, 27, 28, 1899, Inman Collection.

4. "Passing the Torch"

1. W. L. Jones to B. F. Jones, July 26, 27, 28, 1899.

2. Listing of company charges and members, Company Records, Inman Collection.

3. W. L. King was a vice president in 1902, while W. L. Jones did not become a vice president until 1906. W. C. Moreland was secretary in 1902, becoming a vice president only in 1922. Moreell, "*J&L,*" 3.

4. Tom M. Girdler, with Boyden Sparkes, *Boot Straps: The Autobiography of Tom M. Girdler* (New York: Charles Scribner's Sons, 1943), 183, 164.

5. Ingham, *Making Iron and Steel*, 169–82, describes the elite reform coalitions associated with Calvary Episcopal Church and the role of Episcopal schools in influencing the younger generation of Pittsburgh's elite.

6. Girdler, *Boot Straps*, 164–65. Girdler was an active Episcopalian, what would be called a "cradle" Episcopalian (p.176). He also recounts how readily William L. Jones agreed to a timid request by a committee for a swimming pool at Aliquippa, saying, "Why not? A swimming pool will make this a better town for steelworkers to live in" (p.175).

7. Ingham, *Making Iron and Steel*, 168–82. Kingsley House and The Pittsburgh Survey, of which John Fitch's *The Steel Workers* was the best-known product, came out of the same group. Ingham wrote that "Although the *Survey* has been viewed as an attack on Pittsburgh's wealthy, it was, in fact, strongly supported by the city's older elite, especially members of the independent iron and steel mill families" (p.174). Fitch based his study "chiefly, upon the practice in the mills owned by the companies subsidiary to the United States Steel Corporation, and by Jones & Laughlin Steel Company, the largest of the independents in the Pittsburgh District." Fitch, *The Steel Workers*, 45.

8. B. F. Jones Jr. and his son B. F. Jones III both attended St. Paul's School in Concord. The latter remained a member of First Presbyterian Church and chaired the committee that called Clarence McCartney as pastor in 1931. He married Katherine White Holdship, a member of St. Stephen's Episcopal Church, Sewickley, the community in which they lived.

9. For Gary, Indiana, see Hogan, *Economic History of Iron and Steel Industry* 2:506ff. For Midland, Pennsylvania, see Dwight W. Kaufmann, *Crucible: The Story of a Steel Company* (privately printed, 1986), 87–89.

10. Quoted in Gerald G. Eggert, *Steelmasters and Labor Reform, 1886–1923* (Pittsburgh: University of Pittsburgh Press, 1981), 66. This was said at a dinner in Gary's honor in October 1909.

11. One said in a U.S. Steel Executive Committee meeting in 1901: "I have always had one rule. If a workman sticks up his head, hit it." To this Judge Gary responded they would not do so as long as he was chairman of U.S. Steel. He and other "lawyer-bankers" might be opposed to unions, but they intended to "treat the men fairly as individuals and give them good, liberal wages." Eggert, *Steelmasters and Labor Reform*, 34.

12. Hogan, *Economic History of Iron and Steel Industry* 2:592.

13. Haines notebook; Graham, *One Hundred Years*, 15–17.

14. Graham, *One Hundred Years*, 17–18. Hogan states that this made J&L less dependent on scrap steel than the conventional open-hearth process, an advantage in good times but a problem in times of depression when scrap steel was available at rates less than pig iron. Hogan, *Economic History of Iron and Steel Industry* 2:598.

15. Ibid. 2:594; the growth and nature of consumer demands are dealt with extensively in Hogan's chapter "The Growth of Steel Demand and Development Among the Steel-Consuming Industries," 2:649–773.

16. Gertrude G. Schroeder, *The Growth of Major Steel Companies, 1900–1950* (Baltimore: Johns Hopkins Press, 1953), 54–55.

17. Moreell, *"J&L,"* 18.

18. Lloyd, "History of the Jones & Laughlin Steel Corporation," 5, 6.

19. J&L Production Book 1910, Inman Collection; Lloyd, "History of J&L Steel Corporation," 6; Haines notebook.

20. Girdler, *Boot Straps*, 167–68.

21. Lloyd, "History of Jones & Laughlin Steel Corporation," 6. The original brochure offering houses for sale is in the Inman Collection.

22. Girdler, *Boot Straps*, 169–72.

23. Fitch, *The Steel Workers*, 218. Girdler's statement that "if any man on our payroll wanted to join a union he could do so and without the slightest fear that his union membership would get the company 'down' on him" cannot be taken at face value; his own description of a union organizer's visit to Aliquippa contradicts it. Girdler, *Boot Straps*, 176.

24. This story is probably based on the experience of Clinton Golden in the Issoski case, for which see Thomas R. Brooks, *Clint: A Biography of a Labor Intellectual, Clinton S. Golden* (New York: Athenaeum, 1978), 128–35; also James Green, "Democracy Comes to 'Little Siberia,'" *Labor's Heritage* 5 (Summer 1993): 4–27.

25. Girdler's account of a union organizer's visit to Aliquippa may also be an early version of this story. Girdler, *Boot Straps*, 176.

26. Moreell, *"J&L,"* 26.

27. Lloyd, "History of Jones & Laughlin Steel Corporation," 7; Hogan, *Economic History of Iron and Steel Industry* 2:596–99.

28. "J&L Bar Mills Roll Steel for Countless Uses," *Of Men and Steel* 9 (Sept. 1944): 7.

29. Hogan, *Economic History of Iron and Steel Industry* 2:378–85, describes the replacement of beehive ovens by by-product ovens in the first part of the century.

30. Ibid. 2:598–601; Lloyd, "History of Jones & Laughlin Steel Corporation," 7.

31. Hogan, *Economic History of Iron and Steel Industry* 2:601.

32. Untitled draft (for an obituary?) in J&L Papers, Inman Collection.

5. From Private to Public

1. David Brody, *Steelworkers in America: The Nonunion Era* (Cambridge, Mass.: Harvard University Press, 1960), 200.

2. Ledlie Laughlin, son of James B., also was on the board at least by the time of his father's death in 1928. This conclusion is based on a variety of sources found in the Inman Collection, including family registers, genealogies, lists of company officers and shareholders

3. Girdler describes his childhood experience in the family cement business, education, and early career in his autobiography, *Boot Straps*, 1–162. He actually did not become assistant superintendent until a year or two had passed (p.171).

4. His wife died in 1917, and he had to take a leave "to get warm" in Atlanta (and have his appendix removed to relieve chronic appendicitis!). Ibid., 174.

5. Ibid., 176, 181–82.

6. See Graham's biography at end of *One Hundred Years*.

7. "B. F. Jones, 3rd, Retires," in *Men and Steel* 13, no. 3 (May–June 1960): 14. Born on March 15, 1895, "Frank" attended St. Paul's School, Concord, New Hampshire, as his father had.

8. Girdler, *Boot Straps*, 175–76; Hogan, *Economic History of Iron and Steel Industry* 2:457–60. For a view of the strike strongly sympathetic to the radical workers, see Richard O. Boyer and Herbert M. Morais, *Labor's Untold Story*, 3d ed. (New York: United Electrical, Radio & Machine Workers of America, 1976), 202–9.

9. Hogan, *Economic History of Iron and Steel Industry* 3:960.

10. See various company historical sketches in the Inman Collection.

11. B. F. Jones Jr., "Jones & Laughlin Steel Corporation," 7. There is no date given for the piece, but internal evidence points to 1927 as the year of composition.

12. Lloyd, "History of Jones & Laughlin Steel Corporation," 7–8.

13. B. F. Jones Jr., "Jones & Laughlin Steel Corporation," 5.

14. Graham, *One Hundred Years*, 30–36.

15. B. F. Jones Jr., "Jones & Laughlin Steel Corporation," 6.

16. Hogan, *Economic History of Iron and Steel Industry* 3:960–63.

17. Longenecker, "Jones & Laughlin Steel Corporation, 1850-1941," 6.

18. Lloyd, "History of the Jones & Laughlin Steel Corporation," and drafts for same in J&L Papers, Inman Collection; see also listing of J&L entities. Value of the company's gross fixed assets was given as $121,203,000 in 1922; by 1950 it stood at $462,656,000. See Schroeder, *The Growth of Major Steel Companies*, 55.

19. Moreell, "*J&L*," 19.

20. Lloyd, "History of the Jones & Laughlin Steel Corporation," 8.

21. Schroeder, *Growth of Major Steel Companies*, 55; listings of corporation officers in *81 Years of Iron and Steel*; and Moreell, "*J&L*," 3.

22. "History of the Jones & Laughlin Steel Corporation," anonymous draft in J&L Papers, Inman Collection.

23. Schroeder, *Growth of Major Steel Companies*, 46–51, 62–67, and appendix tables 2, 4, 7.

24. Ibid., 96–97, 51–53, 98–99.

25. Girdler wrote in *Boot Straps*, "My special skill is organizing ability" (p.182). He moved from Aliquippa to Sewickley at this time as well to give his successor space to work without interference; Sewickley was also where B. F. Jones Jr. lived.

26. Ibid., 183–86.

27. Ibid., 182–83. Girdler's manner was shown in his refusal to give White a requested raise because he (Girdler) had not initiated it, even though he had, he said, intended to.

28. Ibid., 187–88.

29. A draft of his obituary found in the J&L Papers notes that he had chaired the electoral college of Pennsylvania in 1908 and that he was "a lover of the fine arts and his collection of paintings is among the most notable in the city," among other things. See the printed obituaries in the *Pittsburgh Post Gazette*, January 2, 1928.

30. Girdler, *Boot Straps*, 191–92. Girdler adds that as a result of this he became a millionaire during his twenty-two months as president of J&L, on paper at least; but since he did not sell his stock while it was high, he ended up as less than a millionaire in fact, despite his salary of $100,000 and bonus of $125,000 in 1928 and his salary and bonus of $350,000 in 1929.

6. Surviving Depression

1. Girdler, *Boot Straps*, 193–95. Girdler goes on to describe his own trials as chairman of Republic Steel in the following chapters. He also said that they still had hopes of bringing J&L into the new company when he left: "Probably if the stock market had boomed for several years more it would have happened that way" (p.194).

2. Moreell, "*J&L*," 27. He goes on, however, to note the value of the new continuous strip mill in contrast to older rolling mills in maintaining some competitive edge, but only after one was built at the Pittsburgh Works in 1937.

3. Figures are derived from Hogan, *Economic History of Iron and Steel Industry* 3:1255–61. The net income figure for 1940 was $10.3 million, reflecting the impact of the war in Europe. If only the figures for 1936, 1937, and 1939 are used, the average is just over $4 million.

4. Figures are from tables 10 and 15 in Schroeder, *The Growth of Major Steel Companies*, 175, 190–91.

5. Longenecker, "Jones & Laughlin Steel Corporation," 31. A listing of products in 1931 is given in *81 Years of Iron and Steel*, 10–12.

6. Hogan, *Economic History of Iron and Steel Industry* 3:1254–55.

7. Ibid. 3:1255–57. This 96-inch hot strip mill is highlighted in Charles Longenecker, "Jones & Laughlin Steel Corporation, 1850–1941," 24–30.

8. See, for example, Robert R. R. Brooks, *As Steel Goes, . . . : Unionism in a Basic Industry* (New Haven: Yale University Press, 1940), 115, for comments by two later union organizers.

9. A similar situation existed around the Pittsburgh Works, including dependence on company housing for some, but since neither South Side nor Hazelwood were developed by the company, the control was never as pervasive.

10. Quoted in T. R., Brooks, *Clint*, 128. He notes that ten thousand of the thirty thousand inhabitants were employed by J&L, which "owned the streetcar lines, the buses, the water supply and 774 houses."

11. Dennis C. Dickerson, *Out of the Crucible: Black Steelworkers in Western Pennsylvania, 1875–1980* (Albany: State University of New York Press, 1986), 52, 53, 57; Green, "Democracy Comes to 'Little Siberia,'" 8–10.

12. See copies of the employees representation plans and laws for both the Pittsburgh Works and the Aliquippa Works, Inman Collection. There are slight differences in verbiage in the Plans of the two Works, primarily in terms of how long a worker must be employed to be eligible to vote (initially ninety days for Aliquippa, but only the first day of the month of the election for Pittsburgh; later Aliquippa adopted the Pittsburgh model). In both cases nominees had to be American citizens, have been continuously employed by J&L for one year, and be at least twenty-one years old.

13. A nearly complete set of these is in the Inman Collection.

14. What follows is based on T. R. Brooks, *Clint*, 128–35; and R. Brooks, *As Steel Goes*, 111–14. Variations of the story still circulate in Aliquippa, sometimes garbled and without names.

15. R. Brooks, *As Steel Goes*, 114. The Greensburg barracks, which might otherwise have provided state troopers, was commanded by a brother of Captain Mauk of the J&L police.

16. Benjamin J. Taylor and Fred Witney, *U.S. Labor Relations Law: Historical Development* (Englewood Cliffs, N.J.: Prentice Hall, 1992), 153–63.

17. Ibid., 170.

18. Green, "Democracy Comes to 'Little Siberia,'" 12–13; Boyer and Morais, *Labor's Untold Story*, 290–93.

19. R. Brooks, *As Steel Goes*, 75–86; and for discussion of the "revolt of the company unions," see 75–109.

20. *The J&L Steel Employes Journal* 1, no. 3 (Nov. 8, 1935): 1; no. 11 (July 9, 1936): 1–2.

21. Ibid., 1, no. 10 (June 9, 1936): 1; 2, no. 7 (Mar. 25, 1937): 6.

22. Ibid., 1, no. 11 (July 9, 1936): 1.

23. For example, the J&L employees' male chorus figured prominently in its pages, as did reports of the bowling leagues. Much of the copy was celebratory in nature—weddings, births, studies, accomplishments of various individuals.

24. The ten were Domenic Brandy, Angelo Volpe, Harry Phillips, Martin Dunn, George Marrol, Royal Boyer, Martin Gerstner, Angelo Razzano, Ronald Cos, and Eli Bozich. Handwritten list found in miscellaneous papers on the Supreme Court case, Inman Collection.

25. Green, "Democracy Comes to 'Little Siberia,'" 13–16; T. R. Brooks, *Clint*, 144–46; R. Brooks, *As Steel Goes*, 114–15.

26. R. Brooks, *As Steel Goes*, 89–90; *Then & Now: The Road Between* (Pittsburgh: United Steelworkers of America, 1986), 40–41; T. R. Brooks, *Clint*, 157.

27. R. Brooks, *As Steel Goes*, 119.

28. Ibid., 119; Green, "Democracy Comes to 'Little Siberia,'" 18.

29. Quoted in R. Brooks, *As Steel Goes*, 118–19.

30. Green, "Democracy Comes to 'Little Siberia,'" 18. *The J&L Steel Employes Journal* 2, no. 6 (Feb. 25, 1937): 2, announced the recall by a petition signed by 70 percent of the membership of the division, but his later election as president of Local 1211 raises interesting questions.

31. Taylor and Witney, *U.S. Labor Relations Law*, 173–95.

32. One copy of the bylaws for the ERP at Aliquippa has typed amendments, dated April 29, 1937, which essentially remove management control of the plan. *The J&L Steel Employes Journal* continued for some months.

33. R. Brooks, *As Steel Goes*, 122.

34. Agnes Monahan, interview by James H. Sterrett, tape recording and transcript, July 17, 1997, BCIM.

35. R Brooks, *As Steel Goes*, 124–25, does not identify the writer, but Green identifies him as Meyer Bernstein in "Democracy Comes to 'Little Siberia,'" 20.

36. Bernstein's account as quoted by R. Brooks, *As Steel Goes*, 126.

37. Ibid., 125.

38. "An Agreement, dated May 25th, 1937, between Jones and Laughlin Steel Corporation . . . and the Steel Workers Organizing Committee," Inman Collection. On February 23, 1938, a second agreement continued the terms of the first with only a few procedural changes. A complete set of contracts between J&L and the SWOC/United Steel Workers of America (USWA) is in the Inman Collection.

39. *The J&L Steel Employes Journal* 2, no. 9 (May 26, 1937): 1.

40. Green, "Democracy Comes to 'Little Siberia,'" 23.

41. Ibid., 24.

42. Robert H. Ziegler, *American Workers, American Unions, 1920–1985* (Baltimore: Johns Hopkins University Press, 1986), 50, 56, 64–65; Hogan, *Economic History of Iron and Steel Industry* 3:1178–84.

7. Heady Wartime Expansion

1. Hogan, *Economic History of Iron and Steel Industry* 3:1259–61. However, Hogan points out that its profit in 1940 was still only half of what it had been in 1929.

2. Ibid. 3:1262–67.

3. See appendix table 16 in Schroeder, *Growth of the Major Steel Companies*, 232. In 1907 J&L had also purchased the Keystone Bridge Works adjoining the Soho Works, and this became the producer of J&L towboats and other transportation equipment.

4. J&L, *Annual Report to the Stockholders, 1941*, quoted in Schroeder, *Growth of the Major Steel Companies*, 134. Initial company histories, such as that by William T. Mossman, make essentially the same point: "With all its steel-making capacity located exclusively in the Pittsburgh district, J&L was at a considerable disadvantage with competitors having plants in two or more strategic locations." Mossman, "History of Jones & Laughlin Steel Corporation," 11.

5. "The Otis Steel Company-Pioneer, Cleveland, Ohio" (Privately printed, 1929), 1, Inman Collection.

6. "Jones & Laughlin Steel Corporation: Plants and Properties," 2; *The Otis Sheet* 8 (Feb. 1937); and ibid. 10 (Nov. 1939), all in Inman Collection. See Hogan, *Economic History of Iron and Steel Industry* 3:1262; and Schroeder, *Growth of Major Steel Companies*, appendix table 16 (p.232), for the purchase price.

7. Moreell, *"J&L,"* 27. This tonnage is for steel products; steel ingot capacity was given as 3,944,000 tons in 1940 and 1941, 4,433,000 tons in 1942, and 5,024,000 tons for

the remainder of the war. Schroeder, *Growth of Major Steel Companies*, appendix table 4 (p.219).

8. Mossman, "History of Jones & Laughlin Steel Corporation," 7. The tin plate plant was sold in 1948 to Kelsey-Hayes Wheel Company. Schroeder, *Growth of Major Steel Companies*, appendix table 16 (p.232) lists permanent acquisitions of J&L from 1928 to 1948.

9. Ibid., appendix table 4 (p.219).

10. "J&L Roll of Sacrifice," *Of Men and Steel* 11 (Nov. 1944): 8. Tony A. Mancini of the Aliquippa Works was listed as dead, while an Anthony Mancini of the Aliquippa Works was listed as missing in action; they may be the same person. Two Pinkoskys of Aliquippa were also listed, Michael as dead and John as missing.

11. Ibid. 10 (Oct. 1944): 6, 8.

12. Ibid., 6–8.

13. Ibid., 6.

14. Ibid. 9 (Sept. 1944): 3; 8 (Aug. 1944): 5–6. This was celebrated with a banquet and the awarding of lapel pins and a flag. The "E" flag that flew over the Aliquippa Works and other memorabilia associated with the award banquet are in the Inman Collection. The Liberty Bond flag that was granted for an outstanding performance in buying bonds is also there.

15. A complete set of *Of Men and Steel* is found in the Inman Collection. The last quotation is from the announcement that this was the final issue, *Of Men and Steel* 22 (Oct. 1945): 8.

16. Ibid. 11 (Nov. 1944): 7; 13 (Jan. 1945): 2–3, 5; Graham, *One Hundred Years*, 33,36.

17. *Of Men and Steel* 18 (June 1945): 5, 8. The Muncy plant had been put in operation only in 1938. The original wire rope, made by John A. Roebling, came from wire produced in Beaver Falls, Pennsylvania, at about the time B. F. Jones lived across the Beaver River in New Brighton.

18. Ibid. 19 (July 1945): 2. The J&L Steel Barrel Company was the amalgamation of a number of barrel fabricators, including the Bayonne Steel Barrel Company, the Gulf Coast Steel Barrel Company, the Wackman Welded Ware Company, and the Draper Manufacturing Company, with production facilities in Bayonne, New Jersey; Port Arthur, Texas; St. Louis; Kansas City; Lake Charles, Louisiana; New Orleans; Cleveland; and Philadelphia.

19. Ibid. 20 (Aug. 1945): 1–8.

20. Ibid. 16 (Apr. 1945): 1–7.

21. Longenecker, "Jones & Laughlin Steel Corporation, 1850–1941," 6–9.

22. Al Tilton, "No 'Ghost Town' Likely Here—Aliquippa's Future Bright Says Jones & Laughlin's President," drafts in Inman Collection. J&L had given two of Aliquippa's three swimming pools, and Mrs. Elizabeth Horne, daughter of B. F. Jones, had given a library in the 1920s.

23. Memorandum, W. T. Mossman to Mr. Lewis and Mr. Marshall, Mar. 5, 1940, Inman Collection. Old attitudes die hard, however; on a copy of the headline someone has written, presumably of Tilton, "Register Dem."

24. Hogan, *Economic History of Iron and Steel Industry* 4:1743–46. Dividends were resumed in 1941 at $1.35, rose to $2.00 from 1942 to 1948, rose again to $2.60 in 1949 and to $2.75 in 1950. Schroeder, *Growth of Major Steel Companies*, 191.

25. Ziegler, *American Workers, American Unions*, 64–74.

26. *Then & Now*, 54.

27. Ziegler, *American Workers, American Unions*, 74–92, 90 (quotation).

28. Ibid., 84–99.

29. *Then & Now*, 66; Ziegler, *American Workers, American Unions*, 100–108; T. R., Brooks, *Clint*, 226–33.

30. *Then & Now*, 67. The BCIM has a collection of these CWS manuals.

31. Ziegler, *American Workers, American Unions*, 108–14. It is interesting that the official USWA history, *Then & Now*, makes no mention of the Taft-Hartley Act or of Murray's actions about the affidavit. The pro-Communist side of the dispute can be found in Boyer and Morais, *Labor's Untold Story*, 340–65.

8. The Moreell Years

1. *Current Biography* (1946), s.v. "Ben Moreell."

2. Ibid. He is quoted as saying he "is prouder of being the 'King Bee of the Seabees' than of any other distinction" he attained.

3. Ibid.

4. He was known as Admiral Moreell throughout his years at J&L, and he would address memos to "All Hands" in the navy fashion. See, for example, *Men and Steel* 2, no. 1 (Nov. 1948): 15.

5. Inman Collection. The goal of "sufficient profit" was to pay "a good rate of cash dividends" to shareholders. The first quotation is in the foreword signed by Ben Moreell; the second is from the section labeled "Major Objectives."

6. Ibid., section entitled "Principles of Organization."

7. Ibid., no. 5 of "Plan of Organization" for first quotation and nos. 7 and 8 of "Basic Elements of Executive Responsibility" for the other two.

8. E. F. Jannuzi, interview by David H. Wollman, tape recording and transcript, June 23, 1997, BCIM. Gene Jannuzi worked in the advertising and public relations division from 1951 to 1966, where, as assistant director of public relations and advertising, he supervised *Men and Steel* and coordinated advertising with Ketchum, McLoud, and Grove. He left J&L in 1966 to become chairman and president of Moltrup Steel Company, his family firm.

9. *Men and Steel* 3, no. 11 (Nov. 1950): 9. The formation of committees seems to have been another management tool used extensively by Moreell, at least various committees are frequently referred to in the pages of *Men and Steel*.

10. Ibid. 1, no. 1 (Nov. 1947): foreword by Ben Moreell.

11. Ibid. 1, no. 3 (Jan. 1948): 2–3. The number grew to 46,000 by 1957. Ibid. 10, no. 3 (Mar.–Apr. 1957): 12.

12. The length of the inserts varied with the size of the part of the company covered. The inserts were for the General Office and District Sales Offices (4 pages), Pittsburgh Works (16 pages), Aliquippa Works (16 pages), Otis Works (16 pages), Benson Mines (4 pages), Blair Limestone Mines and River Transportation (4 pages), Coal Division (8 pages), Electricweld Tube (4 pages), J&L Wire Rope (4 pages), Jones & Laughlin Supply Company (4 pages), Inter-State Iron Company, both Minnesota and Michigan (8 pages), and Interstate Steamship, both Lake and Docks (4 pages).

13. *Men and Steel* 5, no. 4 (Apr. 1952): 3. Shortly after that Moreell's comments came under the label "The Admiral's Letter." During 1953 and 1954 the issues were again monthly, but in 1955 it was published more consistently as a bimonthly. Roman numerals were used for volumes until October 1952, when they shifted to Arabic numerals.

14. Ibid. 11, no. 5 (July–August 1958): inside front cover.

15. See, for example, *Fortune,* Jan. 1950, 10–11; *Time,* Sept. 2, 1946, 17; ibid., Jan. 18, 1952, 95; ibid., July 25, 1955, 79; and *Newsweek,* Aug. 11, 1958, 63, 66.

16. See, for instance, his "Let's Make the Draft Make Sense" in the *Saturday Evening Post,* Sept. 15, 1951, written during the Korean Conflict.

17. *Fortune,* Sept. 1952, 128, includes him, along with Lucius Clay and Douglas MacArthur as "military businessmen." Perhaps Eisenhower had him in mind, among others, in his famous warning about the "military-industrial complex." Paul A. Tiffany, *The Decline of American Steel: How Management, Labor, Government Went Wrong* (New York: Oxford University Press, 1988), provides a good summary of steel management views.

18. *Men and Steel* 1, no. 11 (Sept. 1948): 12, for institution of the award; 2, no. 4 (Feb. 1949): 2–3, and 3, no. 11 (Nov. 1950): 2–3, for Moreell's columns; 2, no. 6 (Apr. 1949): 10–11; and 2, no. 8 (June 1949): 8, for "Ray Minder."

19. Ibid. 1, no. 11 (Sept. 1948): 10–11.

20. Ibid. 2, no. 4 (Feb. 1949): 2–3.

21. Ibid. 3, no. 11 (Nov. 1950): ii–1, and 4, no. 1 (Jan. 1951): cover and 4–8, for pictures of recipients. The amount for 1950 was $68,775.00. Ibid. 4, no. 5 (May 1951): 1–2.

22. Ibid. 10, no. 4 (May–June 1957): 55, 58; Brody, *Steelworkers in America,* 167.

23. Jannuzi interview, June 23, 1997; *Men and Steel* 10, no. 4 (May–June 1957): 55, 58; Brody, *Steelworkers in America,* 167.

24. *Men and Steel* 2, no. 6 (Apr. 1949): 2.

25. Ibid. 2, no. 10 (Aug. 1949): 2–3.

26. Ibid. 1, no. 4 (Feb. 1948): ii–1. Total employees, including management, numbered about 42,000 at this time. Figures used early in 1949 were 16,000 consumers, 43,000 employees, and 25,000 shareholders. See ad reproduced in ibid. 2, no. 3 (Jan. 1949): 3.

27. Ibid. 1, no. 6 (Apr. 1948): 2–3.

28. Ibid. 3, no. 12 (Dec. 1950): 2–3; ibid. 4, no. 4 (Apr. 1951): 2; Moreell, *"J&L,"* 31; Hogan, *Economic History of Iron and Steel Industry* 4:1749.

29. *Men and Steel* 1, no. 7 (May 1948): 2, and 2, no. 4 (Feb. 1949): 3, where employees are called upon to "write your congressman" in support of Admiral Moreell's tax-change proposal.

30. Ibid. 2, no. 12 (Dec. 1949): 2–3; 3, no 2 (Feb. 1950): 2–3; 3, no. 10 (Oct. 1950): 2–3. His views in all this were typical of other steel executives at the time. See Tiffany, *Decline of American Steel,* 42–63, 83–102.

31. See Tiffany, *Decline of American Steel,* 143, for the figures.

32. *Men and Steel* 1, no. 8 (June 1948): 2–3.

33. Ibid. 6, no. 1 (Nov. 1952): 7. Moreell, Murray, Arthur Goldberg, and Austin lunched together after the strike in 1952 to "discuss ways and means of avoiding repetitions of that costly strike." See also *Time,* Feb. 18, 1952, 95.

34. John Hoerr, *And the Wolf Finally Came: The Decline of the American Steel Industry* (Pittsburgh: University of Pittsburgh Press, 1988), 287.

35. Ibid., 229–35, describes the beginnings of the practice and notes the role taken

by J&L, through John Kirkwood, in bringing about its end; see also 474–76.

36. These two were topics of columns in *Men and Steel* 7, no. 5 (Mar. 1954): 2–3, and 2, no. 5 (Mar. 1949): 2, respectively.

37. Ibid. 1, no. 5 (Mar. 1948): ii.

38. Ibid. 4, no. 9 (Sept. 1951): 2.

39. Ibid., 2–3, where he goes on to write: "The teachings of Christ invariably deal with the status of the individual. It is only the individual who can feel and live by religious faith. And it is only when individuals live by God's moral code that they can obtain and enjoy life's rich rewards!"

40. Ibid. 6, no. 4 (Feb. 1953): 3; see also 3, no. 9 (Sept. 1950): 2–3.

41. Ibid. 9, no. 5 (May–June 1956): 2–3.

42. Ibid. 9, no. 7 (Sept.–Oct. 1956): 2–3. The speech given to the California Chamber of Commerce in November 1956 is found in ibid. 10, no. 1 (Nov.–Dec. 1956): 18–19.

43. Jannuzi interview, June 23, 1997.

44. *Men and Steel* 5, no. 1 (Jan. 1952): 3. An article describing in positive terms the "Campaign for the 48 States" (supporting five constitutional amendments that would have required balanced federal budgets, restricted congressional taxing powers, reformed the electoral college, granted the states the power to amend the Constitution without congressional approval, and limited treaty powers) appeared in 1956. Ibid. 10, no. 1 (Nov.–Dec. 1956): 6–7.

45. Ibid. 4, no. 7 (July 1951): 5–6; 4, no. 10 (Oct. 1951): 10–12; 4, no. 12 (Dec. 1951): 12–13.

46. Ibid. 5, no. 3 (Mar. 1952): 2.

47. Ibid. 9, no. 7 (Sept.–Oct. 1956): 4–6. Gene Jannuzi was at the meeting where the study results were announced. Gene recounts from firsthand knowledge, and as an example of Austin's style, how Austin was known to call even at night to get information from subordinates. "You'd better have your notes at home and be ready to talk to him," Jannuzi claimed. He also attended one meeting that Austin chaired as vice chairman, at which it became evident he had no authority, "And that's the last meeting I ever remember his calling." Jannuzi interview, June 23, 1997.

48. *Men and Steel* 9, no. 7 (Sept.–Oct. 1956): 4–6. In the same issue an announcement was made that Moreell had received the 1957 John Fritz Medal, the top award in engineering, "for Service to Science, Industry, Nation, Church" (pp. 10–11).

49. Ibid. 9, no. 5 (May–June 1956): 5; 10, no. 2 (Jan.–Feb. 1957): 4; 10, no. 3 (Mar.–Apr. 1957): 6.

50. Hoerr, *And the Wolf Finally Came*, 97–99.

51. J&L Steel Corporation, *Jalmet Notes*, no. 203 (Aug. 1956) and no. 241 (Mar.–Apr. 1960), describe the basic oxygen process. See also Hogan, *Economic History of Iron and Steel Industry* 4:1543–63.

52. Hogan, *Economic History of Iron and Steel Industry* 4:1550, 1562–63; Hoerr, *And the Wolf Finally Came*, 136. When the PBS special on Andrew Carnegie was made, the producers had to film a Bessemer converter in operation in Russia because there were no converters still working in the West.

53. *Men and Steel* 11, no. 1 (Nov.–Dec. 1957): inside front cover, has a joint letter from Moreell and Adams expressing regret at having to impose layoffs, especially during the holiday season.

54. Ibid. 10, no. 3 (Mar.–Apr. 1957): 5, where it is said that a revolving bank credit of an additional $50 million had been recently arranged; ibid. 11, no. 3 (Mar.–Apr. 1958): 16–17.

55. Ibid. 3, no. 5 (May 1950): 14; 4, no. 1 (Jan. 1951): 13; 9, no. 5 (May–June 1956): 34.

56. Harold Geneen, with Alvin Moscow, *Managing* (Garden City, N.Y.: Doubleday, 1984), 71–72.

57. Ibid., 72–74.

58. On "J&L and the Presidential Steel Board," see *Men and Steel* 2, no. 11 (Sept. 1949): 2–3. The same theme appeared again in the following issue (no. 12 [Dec. 1949]), delayed two months by the strike. Ibid. 3, no. 1 (Jan. 1950): 2; *Then & Now*, 68–69; Tiffany, *Decline of American Steel*, 96–102.

59. *Time*, Jan. 18, 1952, 95.

60. *Men and Steel* 5, no. 4 (Apr. 1952): 2–3.

61. *Then & Now*, 72–73.

62. Tiffany, *Decline of American Steel*, 147; *Men and Steel* 8, no. 2 (Jan.–Feb. 1955): 4–7, for description of the tour; ibid. 8, no. 4 (May–June 1955): 2–3, for Moreell's comments on it.

63. *Then & Now*, 75, 79; Tiffany, *Decline of American Steel*, 148–52.

64. Admiral Moreell's speech at a dinner in July 1953 commemorating the hundredth anniversary of J&L was entitled *"J&L" The Growth of an American Business (1853–1953)* and was published privately by the corporation.

65. *Men and Steel* 9, no. 4 (Mar.–Apr. 1956): 14–15.

9. Rearguard Actions

1. Tiffany, *The Decline of American Steel*.

2. See especially his prologue and conclusion; ibid., 3–4, 185–90.

3. Ibid., 112–13.

4. Hoerr, *And the Wolf Finally Came*, 606–7.

5. Ibid., 121, 159–61, 211, 225, 228, 293, 419–22, 437, 471, 479.

6. Ibid., 90–93.

7. Stanley H. Brown, *Ling: The Rise, Fall, and Return of a Texas Titan* (New York: Athenaeum, 1972), 155–56.

8. Their practice of alternately writing opening columns in *Men and Steel* during the years of Adams's tenure and of making significant statements jointly reinforces this conclusion.

9. *Men and Steel* 13, no. 2 (May–June 1960): 12. Adams died of a heart attack on December 11, 1963. Obituary, *New York Times*, Dec. 12, 1963.

10. *Men and Steel* 21, no. 6 (Dec. 1968): 2; Brown, *Ling*, 150–52. Beeghly continued to serve as vice chairman of J&L's executive committee.

11. Roesch worked up through the ranks at J&L to become president in 1970 and chairman of the board in 1972. After four years at Kaiser Industries, in 1978 he moved on to U.S. Steel, eventually becoming president (the "first outsider to be named to such an important position" there). During his tenure as president he instituted austerity measures that resulted in 13,000 layoffs and the closing of 113 steel facilities—hard actions,

but they succeeded in keeping U.S. Steel viable. He retired in September 1983 as a result of the discovery of a brain tumor; he died December 2, 1983. See his obituary, written by Steven Greenhouse, *New York Times*, Dec. 4, 1983. The "callousness" of U.S. Steel in these 1981 layoffs was noted by Hoerr, *And the Wolf Finally Came*, 11–12, although he also commends the corporation on how much it spent in pension and medical benefits during the next three years. For Graham's later career at U.S. Steel, see ibid., 158–59, 428–37.

12. See accounts of this in Hoerr, *And the Wolf Finally Came*, and Tiffany, *The Decline of American Steel*.

13. *Men and Steel* 12, no. 2 (Jan.–Feb. 1959): inside front and back covers; no. 4 (May–June 1959): inside front and back covers.

14. Ibid. 12, no. 4 (May–June 1959): 16–21; 13, no. 1 (Jan.–Feb. 1960): inside front and back covers. This issue includes a summary of the contract signed January 4, 1960 (pp.16–17).

15. Ibid. 13, no. 4 (July–Aug. 1960): 16 (quotation), 16–19, 1; 14, no. 1 (Nov.–Dec. 1960): 4–8.

16. Ibid. 14, no. 1 (Nov.–Dec. 1960): 1–3.

17. J&L Steel Corporation, *1962 Annual Meeting of Shareholders*, 18, 21–25 (part of Beeghly's remarks to the shareholders, Apr. 26, 1962); Hogan, *Economic History of Iron and Steel Industry* 4:1515, 1755.

18. *Men and Steel* 15, no. 4 (July–Aug. 1962): 1–2; Hogan, *Economic History of Iron and Steel Industry* 5:2083–84.

19. J&L Steel Corporation, *1962 Annual Meeting of Shareholders*, 30 (references to the dispute are on 8–12, 28–32) The shareholders voted to send their resolution to President Kennedy, Senator Kefauver, Representative Emmanuel Celler, and Secretary of Commerce Luther Hodges. Adams closed his remarks with: "Have we reached the place where steel prices are to be determined by government rather than by judgment based upon economic facts?" (p.12). President Beeghly in his remarks noted that production and inventory were up both for the industry and J&L (p.16), which would seem to suggest, according the normal workings of the law of supply and demand, that prices ought to have fallen with the greater supply over demand. So perhaps "economic facts" were not always so straightforward.

20. J&L Steel Corporation, *1965 Report to Shareholders*, 6–10; Hogan, *Economic History of Iron and Steel Industry* 4:1755–56. The new facilities at Hennepin, Cleveland, Aliquippa, and Pittsburgh are highlighted in *Men and Steel* 18, no. 3 (May–June 1965): 9–12; 18, no. 6 (Dec. 1965): 4–5; 19, no. 2 (Apr.–May 1966): 10–12; 19, no. 4 (Sept.–Oct. 1966): 13–15; 19, no. 5 (Nov.–Dec. 1966): 11–15.

21. *Men and Steel* 17, no. 1 (Jan. 1964): 6–8; 19, no. 1 (Feb.–Mar. 1966): 16–17.

22. *Making Steel at J&L with Jake & Looey*, 24–25; Hogan, *Economic History of Iron and Steel Industry* 4:1564–76.

23. *Men and Steel* 20, no. 3 (June 1967): 6–8, 10.

24. Ibid., 16, no. 1 (July–Aug. 1963): 8–9; 18, no. 3 (May–June 1965): 1–3.

25. *Then & Now*, 106; Hoerr, *And the Wolf Finally Came*, 115–29. Gene Jannuzi suggested that the ENA was a major contributor to excessive costs. Jannuzi interview, July 9, 1997.

26. Brown, *Ling*, 41–149 passim.

27. Ibid., 147–53, for some of Ling's motivation. Greed for the pension funds has been expressed in the Aliquippa area, where James Ling is generally held in poor esteem.

Brown quotes Ling as saying "I won eight times and only lost once"; but as Brown points out, that once was at the end of the series (p.43).

28. *Tempo* 68 3 (May 1968). The complete issue of this "newsletter of management information," provided for J&L salaried employees, was devoted to the LTV offer. The voting trust would expire February 1, 1971. See also Brown, *Ling*, 151.

29. Hogan, *Economic History of Iron and Steel Industry* 4:1760.

30. *Tempo* 68 3 (May 1968): 2.

10. "Going Down for the Count"

1. *Men and Steel* 24, no. 3 (Dec. 1971): 24. This was in an article about William Stephens upon the announcement of his retirement.

2. Ibid. 21, no. 4 (Sept. 1968): 2–3.

3. Brown, *Ling*, 163, 166–67.

4. Ibid., 9–10, 151, 167–68.

5. For the announcement of the establishment of JLI, see *Tempo* 69 4 (Mar. 1969): 1, 4; for details of the relationship with LTV, see J&L Steel Corporation, *1969 Annual Report to Shareholders* (Mar. 11, 1970), 4

6. Brown, *Ling*, 181–82, 186–88, 195–97, 203, 215–16, 238. These pages are part of the book that reprints Ling's own diary; he also wrote, "what would bad managers do without 'start-up costs' to blame?" (239)

7. J&L Steel Corporation, *48th Annual Meeting of Shareholders*, 2–4. Chairman Stephen's remarks at the April 30, 1970, meeting blamed the unexpectedly poor results on sharp price increases for raw materials, technical difficulties with the rebuilt C-3 blast furnace at Cleveland, and a resulting inability to capitalize on the booming export market. The board announced a suspension of dividend three weeks later (p.15). Brown describes the LTV aspects in *Ling*, 241–90, 268 (quotation from Ling).

8. *Men and Steel* 24, no. 3 (Dec. 1971): 25, in an article praising him on his retirement the end of 1971. One member of the board was quoted as saying, "Bill Stephens proved to be the right man, in the right place and at the right time."

9. Ibid., 24, no. 1 (May 1971): 10, reported a first quarter income of over $10.7 million, the best earnings since the second quarter of 1968 (after a loss of nearly $1 million the previous first quarter).

10. Ibid., 24, no. 3 (Dec. 1971): 3 (the quotations are from Stephen's final chairman's letter), 15; ibid. 25, no. 1 (Apr. 1972): 3.

11. *Men and Steel* 25, no. 2 (Aug. 1972): 3.

12. In his letter of resignation Roesch said the Kaiser offer was "a challenge that could be accepted knowing that the management team at J&L represented strong, forward-looking leadership," and he also remarked that "My association with the board and the officers of LTV has been cordial." He praised both Graham and Haynie, who, while not a steelmaker, had "in the best tradition of the steel business, . . . worked his way up from the bottom in his chosen field" [at Wilson & Company] and had learned much about J&L as a director "and during part of the time as vice chairman of J&L" in 1971, before he became president of LTV. Roesch, in *Men and Steel* 26, no. 2 (Autumn 1973): 4.

13. Ibid.

14. An account of his career and an interview with him appeared in ibid., 4, 8–10.

15. *JALTeam Almanac* 28, no. 3 (Autumn 1975): 3. The effective date was September 1. Graham remained president and the position of chairman was vacated, with Graham assuming those responsibilities. Graham was also elected to the LTV board of directors and given the newly established post of LTV group vice president. Paul Thayer, chairman of LTV, made the announcement.

16. Jones & Laughlin Steel Corporation, *1974 Annual Report to Employees*, 3.

17. Hoerr, *And the Wolf Finally Came*, 297.

18. Ibid., 325. He adds quite rightly: "Such claims, of course, must be considered first in the context that it is common for the older generation to regard the younger as less able and less willing. Feelings run deep on this issue, and trying to sort half-formed notions from more objective observations is impossible, barring a full-scale study." The tensions during this period over the Vietnam War might also have exacerbated the intergenerational hostility.

19. Hoer provides much information as well as an evaluation of this; see, for example, chapter 5 on the no-strike agreement, or chapter 12 on section 2B.

20. *Men and Steel* 27, no. 1 (Winter [*sic*] 1974): 3, introduces Sokol. Ibid. 26, no. 2 (Autumn 1973): 13–16; 27, no. 1 (Winter [*sic*] 1974): 13–21; 27, no. 2 (Summer 1974): 11–24; and 27, no. 3 (Autumn 1974): 13–21 are all examples of the journals. Later, because of the popularity of his cartoons, Sokol was given his own page, beginning with 28, no. 1 (Spring 1975): 14. "Sokol's sketches" had appeared as early as the late 1950s. Ibid. 11, no.1 (Nov.–Dec. 1957): 7.

21. *JALTeam Almanac* 27, no. 4 (Winter 1974): 3. The editor added: "After much deliberation (and a few arguments) we came up with JALTeam Almanac, meaning a magazine for the J&L team, including the women."

22. Ibid., 27, no. 4 (Winter 1974): 4 (quotations are from Graham's column "Top O' The House"), 5–7; 28, no. 1 (Spring 1975): 9–12; and 29, no. 4 (July–Aug. 1976): 20–21. The name changes did not extend to the top, however, for Graham and his successors retained the title "chairman of the board."

23. *Men and Steel* 27, no. 1 (Winter [*sic*] 1974): 22–23. They were called "president's seminars."

24. Ibid. 27, no. 2 (Summer 1974): 8 (Graham's column "Top O' The House"), 27–29 (on "Pollard Shroud"); and 27, no. 3 (Autumn 1974): 8–11, 25.

25. *JALTeam Almanac* 29, no. 4 (July–Aug. 1976): 7.

26. Hoerr, *And the Wolf Finally Came*, 159. His assistant was Cole Tremain, who took over J&L's labor relations after Kirkwood left the company late in 1983. See ibid., 160–61, 480.

27. Ibid., 158–59.

28. The LTV Corporation, *Annual Report to Shareholders 1974*, 11–16; Jones & Laughlin Steel Corporation, *1974 Annual Report to Employees*, 4–6.

29. *Men and Steel* 27, no. 2 (Summer 1974): 3–4; ibid. 27, no. 3 (Autumn 1974): 3–11; The LTV Corporation, *Annual Report to Shareholders 1974*, 13–16; Jones & Laughlin Steel Corporation, *1974 Annual Report to Employees*, 9.

30. *JALTeam Almanac* 28, no. 3 (Autumn 1975): 7; ibid. 29, no. 3 (May–June 1976): 18; no. 4. (July–Aug. 1976): 3–5. Initially the intention was to modernize the BOF, but in 1976 management shifted to electric furnaces because it would use 100 percent scrap

charge, which was better during economic downturns. They are also superior environmentally, and over half of the $200 million was for environmental control systems. Completion was expected by May 1979.

31. *JALTeam Almanac* 28, no. 3 (Autumn 1975): 8–9. Cleveland and Pittsburgh were especially hard hit by layoffs, with the shutting down of electric furnaces at Cleveland and the open-hearth and blast furnaces at Pittsburgh.

32. The LTV Corporation, *Annual Report to Shareholders 1974*, 11; ibid., *Annual Report 1981*, 19.

33. *LTV: A New Company*, with accompanying letter of Dec. 5, 1978, from Thomas Graham to J&L employees; The LTV Corporation, *Annual Report 1981*, 17–21.

34. Hoerr, *And the Wolf Finally Came*, 95. Hoerr faults management, union leadership, and perverse governmental policies in his treatment of "The Decline of the American Steel Industry."

35. Ibid., 121, 233, 245–46.

36. Ibid., 419–22. The issue of whether early retirement benefits put an added burden on pensions was a source of dispute between J&L management and the parent LTV management. "Eventually the under funded [pension] plans helped push LTV into bankruptcy." Ibid., 422, 661n.6. Don Inman served on LMPTs at Aliquippa and made a presentation on them to LTV Steel executives in Detroit in 1988. Hoerr describes them as a major positive accomplishment of the 1980 contract and that "the very existence of LMPTs at Aliquippa put J&L light years ahead of most of the steel industry." Ibid., 155–59, 158 (quotation).

37. Ibid., 462, 437. Graham was rejoining his mentor. Hoerr also reported that "former associates" said that Graham "had been unhappy with LTV's treatment of its steel subsidiary." Ibid., 426.

38. The LTV Corporation, *Annual Report 1981*, 4–5. The figures are steel, $4,786,000,000; energy products and services, $2,08,000,000; aerospace/defense, $797,000,000; and ocean shipping, $457,000,000.

39. The LTV Corporation, *Annual Report 1983*, 2–4. The figures for 1983 were steel, $2,935,000,000; aerospace/defense, $1,142,000,000; energy products $501,000,000; for a total of $4,578,000,000 (less than steel alone had been two years before). They had sold the ocean shipping group in February 1983. Ibid., 9.

40. Ibid., 2. Management felt that the divestitures would not materially affect the efficiencies sought by the merger.

41. Hoerr, *And the Wolf Finally Came*, 480. With 15.7 percent of the American steel market, the new company was almost as large as U.S. Steel, but it had a large excess capacity in some weak-market products, and merging staffs and procedures of two old companies proved "more difficult than anticipated."

Epilogue

1. Hoerr, *And the Wolf Finally Came*, 415–538, passim, esp. chaps. 16–19.

2. *Business Week*, Mar. 4, 1991, 50–51. The announcement that Hoag would become CEO came on Jan. 4, 1991. Hay insisted he had initiated the idea but other sources suggested Hay was nudged out by LTV's creditors. Later in the year Hoag took over as chairman (*Forbes*, Sept. 2, 1991, 154, refers to him as chairman). He had been president and

chief executive of LTV Steel and executive vice president of the LTV Corporation at least since 1986. See The LTV Corporation, *1987 Annual Report*, listing of officers.

3. *Forbes*, Sept. 2, 1991, 154; *Business Week*, Mar. 16, 1992, 40.

4. Hoerr, *And the Wolf Finally Came*, 480.

5. Ibid., 480–85, 496–502.

6. Ibid., 479–80.

7. Ibid., 496–502.

8. Ibid., 421–22, 507–8. The three companies—J&L, Republic, and Youngstown Sheet & Tube—that made up LTV Steel in 1970 had 108,000 workers, 27,000 retirees, and 15.1 million tons of production. The contrast with 1986 was dramatic.

9. Ibid., 507–12, 523–29.

10. Personal recollection by David H. Wollman, director of BCIM. The steelworker quoted was George "Skinny" Suder. The speed pulpit was donated by Chaparral Steel Company, which had purchased the hot strip mill and moved it to Texas.

11. The LTV Corporation, *1990 Annual Report*, 3, notes that David Hoag assumed duties as president and CEO of the LTV Corporation in January 1991, with Peter Kelly succeeding him as president of LTV Steel. Hoag, however, remained CEO of LTV Steel until 1998, when he retired and was again succeeded by Peter Kelly.

12. The LTV Corporation, *Annual Report 1983*, 2; ibid., *1987 Annual Report*, 10; C. W. Beck, ed., *The Twentieth Century History of Beaver County Pennsylvania 1900–1988* (Beaver, Pa.: Beaver County Historical Research & Landmarks Foundation, 1989), 147.

13. The LTV Corporation, *LTV Steel Plants, Facilities & Technology* (ca. 1995), gives a survey of LTV Steel holdings.

Selected
Bibliography

Beaver County Industrial Museum
Geneva College, Beaver Falls, Pennsylvania

Inman Collection

"Brief History of Jones & Laughlin Steel Corporation." Typescript. 1949. [This appears to be a draft for the article "Pioneer in Steel Progress—A Brief History of J & L." *Men and Steel* 3, no. 5 (May 1950): 4–8.]

Bylaws of the employee representation plans of Jones & Laughlin Steel Corporation.

"Composition of the Son of Jacob Shook, Chief Engineer, Jones & Laughlins—1867 Re Trip Through Mills." Typescript.

Contracts between SWOC and USWA and Jones & Laughlin Steel Corporation, 1937–84.

Daschbach, Albert. "The Busy Southside." Typescript. 1898.

81 Years of Iron and Steel. Pittsburgh: Jones & Laughlin Steel Corporation, 1931.

Graham, H. W. *One Hundred Years.* Pittsburgh: Jones & Laughlin Steel Corporation, 1953.

John L. Haines Notebook.

"History of Jones & Laughlin Steel Corporation." With handwritten notation "Bill Harvey version."

"History of Pittsburgh: Development of the Iron and Steel Industry." Typescript.

Jones, B. F. Jr. "Jones & Laughlin Steel Corporation." Typescript. 1926.

Jones Family Bible. Facsimile.

"J&L—The Institution—The Men Who Made It." Typescript. ca. 1930.

King, Willis L. "On the History of the Jones & Laughlin Steel Corporation." Address before the Aliquippa Engineers' Institute. Nov. 19, 1930.

———. "On the History of Jones & Laughlin Steel Corporation before the Aliquippa Engineers' Institute." Typescript. Nov. 19, 1938.

Lloyd, Thomas E. "History of the Jones & Laughlin Steel Corporation." Typescript. Dec. 1, 1938.

Longenecker, Charles. "Jones & Laughlin Steel Corporation, 1850–1941." Reprint from *Blast Furnace and Steel Plant* (Aug. 1941).

LTV: A New Company. With accompanying letter from Thomas Graham to J&L employees. Dec. 5, 1978.

The LTV Corporation. Annual Reports for 1974, 1981, 1983, 1987, 1990.

———. *LTV Steel Plants, Facilities & Technology*. ca. 1995.

Making Steel at J&L with Jake & Looey. ca. 1965.

Moreell, Ben. *"J&L": The Growth of an American Business (1853–1953)*. Pittsburgh: Jones & Laughlin Steel Corporation, 1953.

Mossman, W. T. "History of Jones & Laughlin Steel Corporation." Typescript. N.d.

Organization and partnership records.

The Otis Company—Pioneer, Cleveland, Ohio. Privately printed, 1929.

"Otis Steel Has Colorful History." *The Otis Sheet* (Nov. 1939).

Plans of employee representation at the Pittsburgh Works and the Aliquippa Works.

Production Book 1910 (Aliquippa).

Tilton, Al. "No 'Ghost Town' Likely Here—Aliquippa's Future Bright Says Jones & Laughlin's President." Drafts. 1940.

White, William A. "From Canal Clerk to Steel Magnate." *Romances of Industry*. Reprint of pamphlet. N.d.

Jones & Laughlin Internal Publications

18th Annual Meeting of Shareholders. 1970.
Jalmet Notes.
JALTeam Almanac. 1974–84.
The J&L Steel Employes Journal. 1935–37.
Men and Steel. 1947–74.
Of Men and Steel. 1944–45.
1962 Annual Meeting of Shareholders.
1965 Report to Shareholders.
1969 Annual Report to Shareholders.
1974 Annual Report to Employees.
Tempo 68. 1968.
Tempo 69. 1969.

Jones & Laughlin Miscellanea, Archives for Industrial Society
Hillman Library, University of Pittsburgh

B. F. Jones Diary.
Jones & Laughlin family geneologies.

Published Sources

Beck, C. W., ed. *The Twentieth Century History of Beaver County Pennsylvania 1900–1988*. Beaver, Pa.: Beaver County Historical Research & Landmarks Foundation, 1989.

Boyer, Richard O., and Herbert M. Morais, *Labor's Untold Story*. 3d ed. New York United Electrical, Radio & Machine Workers of America, 1976.

Brody, David. *Steelworkers in America: The Nonunion Era*. Cambridge, Mass.: Harvard University Press, 1960.

Brooks, Robert R. R. *As Steel Goes, . . . : Unionism in a Basic Industry*. New Haven: Yale University Press, 1940.

Brooks, Thomas R. *Clint: A Biography of a Labor Intellectual, Clinton S. Golden*. New York: Athenaeum, 1978.

Brown, Stanley H. *Ling: The Rise, Fall, and Return of a Texan Titan*. New York: Atheneum, 1972.

Clowes, Walter F. com. *A Brief History of the Sons of Veterans U.S.A., Dealing Separately with the Commander-in-Chief and the Division of Pennsylvania*. Reading, Pa., 1895.

Cushing, Thomas, ed. *Genealogical and Biographical History of Allegheny County, Pennsylvania*. 1889. Reprint, Baltimore: Genealogical Publishing, 1975.

Dickerson, Dennis C. *Out of the Crucible: Black Steelworkers in Western Pennsylvania, 1875–1980*. Albany: State University of New York Press, 1986.

Eggert, Gerald G. *Steelmasters and Labor Reform, 1886–1923*. Pittsburgh: University of Pittsburgh Press, 1981.

Fitch, John. *The Steel Workers*. 1911. Reprint, Pittsburgh: University of Pittsburgh Press, 1989.

Geneen, Harold, with Alvin Moscow. *Managing*. Garden City, N.Y.: Doubleday, 1984.

Girdler, Tom M., with Boyden Sparkes. *Boot Straps: The Autobiography of Tom M. Girdler*. New York: Charles Scribner's Sons, 1943.

Green, James. "Democracy Comes to 'Little Siberia.'" *Labor's Heritage* 5 (Summer 1993): 4–27.

History of Allegheny County, Pennsylvania. 2 vols. Chicago: A. Warner, 1889.

Hoerr, John. *And the Wolf Finally Came: The Decline of the American Steel Industry*. Pittsburgh: University of Pittsburgh Press, 1988.

Hogan, William T. *Economic History of the Iron and Steel Industry in the United States*. 5 vols. Lexington, Mass.: Heath, 1971.

Ingham, John N. *Making Iron and Steel: Independent Mills in Pittsburgh, 1820–1920*. Columbus: Ohio State University Press, 1991.

Kaufmann, Dwight W. *Crucible: The Story of a Steel Company*. Privately printed, 1986.

Schroeder, Gertrude G. *The Growth of Major Steel Companies, 1900–1950*. Baltimore: Johns Hopkins Press, 1953.

Taylor, Benjamin J., and Fred Witney. *U.S. Labor Relations Law: Historical Development*. Englewood Cliffs, N.J.: Prentice Hall, 1992.

Then & Now: The Road Between. Pittsburgh: United Steelworkers of America, 1986.

Tiffany, Paul A. *The Decline of American Steel: How Management, Labor, Government Went Wrong*. New York: Oxford University Press, 1988.

Ziegler, Robert H. *American Workers, American Unions, 1920–1985*. Baltimore: Johns Hopkins University Press, 1986.

Index

Bar mills, 46, 61, 86, 124; at Pittsburgh, 82, 90

Basic oxygen furnaces (BOFs), 153–54, 166, 167, 317n.30

Bayonne Steel Barrel Company, 117

Beaver County Industrial Museum, 202–3

Beeghly, Charles, 162; and government regulations, 170–72, 315n.19; and LTV, 176–78, 182

Bennett, James I., 32

Bennett Chemical Works, 15

Benson Mines, 121, 130

Bernstein, Meyer, 108–12

Bessemer converters, 42, 303n.4, 313n.52; other furnaces compared to, 44, 153–54; at Pittsburgh Works, 90–91

Bethlehem Steel Corporation, 3, 92, 100, 115

Billet mills, 61

Bittner, Van, 131

Blair Limestone Division, 302n.16

Blank, E. F., 129

Blooming mills, 45, 90, 124

Bohne, Fred, 103

Boyle, Thomas, 14, 16, 19, 22

Brooks, R., 111

Brown, John, 15–16

Brown, Stanley H., 315n.27

Brownstown, Pa., 10, 14–15, 22

Calvary Episcopal Church, social gospel of, 55, 59–60

Campbell, Levin H., 122

Campbell Works, 195

Canal boats, 8–10

Carlock, J. B., 128

Carnegie, Andrew, 29, 302n.13; and Bessemer steel, 42–43; and labor, 48–49

CCSC. See Coordinating Committee Steel Companies

Centennial Exposition (1876), 39

Churches: in Brownstown, 14; Calvary Episcopal Church, 55, 59–60

CIO. See Congress of Industrial Organizations (CIO)

Civil War, 21–22

Cleveland, Ohio, J&L move to after merger with LTV, 201

Cleveland Works, 124, 203, 318n.31;

acquired as Otis Steel, 118, 203; expansion of, 153, 166–67; facilities of, 130, 326–28

Coke plants, 90, 130, 201–2

Cold rolling process, 39

Cold War, 147

Cold-finished steel, 90, 98

Colt's Midland Works, 195, 203

Communism/socialism: and labor movement, 85–86, 105, 133; Moreell's opposition to, 150–51

Congress of Industrial Organizations (CIO), 103, 105–7, 131. See also American Federation of Labor (AFL); Unions

Connellsville coal mines, 30

Continuous casting facilities, 167–70

Continuous strip mill, 98, 307n.2

"Cooperative Wage Study Job Description and Classification Manual," 133

Coordinating Committee Steel Companies (CCSC), 148, 164

Crawford, George G., 98

Crucible Steel Corporation, 60

Cunningham's Glass Factory, 15–16

Cuyahoga River, 167

Daschbach, Albert, 14, 22

The Decline of American Steel (Tiffany), 160–61

Democratic Social Club (DSC), 105, 115

Depression, effects on J&L, 97–100

Diversification, 156, 160

Draper Manufacturing Company, 120

Duplex process, 61–62

Duval, John, 16, 19

Earle, George H., 102, 111

Eaton, Cyrus, 92, 95, 97

Edgar Thompson Works, 42

Electric furnaces, 190, 317n.30

Electric Weld Tube, 120–21

Eliza furnaces: facilities of, 43, 60; production of, 20, 29–30

Elliot, W. R., 152

Employee Representation Plans (ERPs), 100, 103–4, 107–8, 308n.12, 309n.32

Evans, William, 95

Experimental negotiating agreement, 172

compared to son, 53–54; early life of, 7–10; and labor relations, 2, 30–36, 50, 52; ownership by, 28–29, 54; politics of, 15, 21, 36; and technology, 42–43, 46; wealth of, 10, 24

Jones, B. F., Jr., 1, 59, 83, 95; and father, 29, 53–54; and Girdler, 92–95; on J&L innovations, 86–87, 89–90; in management of J&L, 28, 52, 54, 84–85, 92

Jones, B. F., III ("Frank"), 85, 92, 94–96, 98–99

Jones, George, 7–8, 13, 16–18, 24–27, 53, 301n.9

Jones, Mary McMasters, 10

Jones, Thomas M., 7–8, 23, 24–27, 36; in partnerships, 13, 28, 53

Jones, Thomas O'Connor, 84

Jones, William L., Jr., 95–96

Jones, William Larimer, 54; death, 94; in J&L management, 28, 52, 53–54, 84–85, 92, 94; personality of, 54–59

Jones & Laughlin Industries (JLI), 180–81

Jones and Laughlin Steel Company, 53, 164, 305n.14, 306n.18, 315n.19; acquisitions of, 90, 117–21, 303n.8; advertising, 124–25, 204–57; antipathy toward unions, 76–79, 84, 85, 107–8; capacity of, 97–98, 190–91, 193, 303n.4, 309n.7; capitalization, 23, 62; centennial of, 1, 160, 314n.64; changes in products, 122–24, 190, 193; chronology of, 1–2, 273–85; in the Depression, 97–100; dividends from, 13–14, 23–24, 62, 98, 130, 144–47, 310n.24, 311n.5, 316n.7; expansion of, 23–24, 60–62, 81–82, 90, 117–21, 138, 153–55, 167; facilities of, 44, 86, 98, 129–30, 289–98, 309n.4, 315n.20; family management of, 53–54, 84–85; innovations in labor relations, 30–31, 194; integration of, 3, 20, 23, 30; labor relations at, 50, 52, 99–115, 103–4; layoffs, 152, 154, 172, 190, 313n.53, 318n.31; and LTV, 173–78, 179; management changes, 92–96, 152–53; management of, 98–99, 128, 133–36, 138–40, 162, 194, 317n.15; management under LTV, 180–86; modernization of, 147, 166–67; number of workers, 46, 98, 121, 312n.26; openness

to innovation, 3–5, 153–54, 161–61; politics of, 149–52; production by, 97–98, 116–17, 124, 166, 190–91; products of, 39, 42, 45, 62, 79–82, 88–90, 98; profitability of, 24, 190–91, 307n.3, 309n.1, 314n.11, 316n.7, 316n.9; reorganizations of, 27–28, 54, 62, 85, 91–94; standing of, 5, 84, 92, 135, 191, 200; technological innovations by, 3–5, 19, 61–63, 88–90, 122, 124–28; women at, 121–22, 187–89; workers' relation to, 103–4, 148, 185–87; in World War II, 116–33

Jones and Laughlin Steel Corporation: capitalization, 91; reorganization to public corporation, 91–94

Jones & Laughlins, 13

Jones & Laughlins, Ltd., 54

Jones, Lauth and Company, 10–12

Junior I-beams, 90, 128

Junior tees, 127

Kane, John, 103

Kefauver, Estes, 167

Kelly, Peter, 319n.11

Kennedy, John F., 167

Keystone Bridge Works, 309n.3

Kier, Samuel M., 8–10, 12

King, Willis L., 1, 28, 60, 99; on board of directors, 92, 96; in J&L management, 53–54, 54, 84

Kirkwood, John H., 162, 189–90, 194

Knights of Labor, 47–49

Korean War, 147, 157–58

Kossuth, Louis, 15

Labbitt, William, 33

Labor. See Unions; United Steel Workers Association; Workers

Labor relations, 172, 315n.11, 318n.36; effects of immigrants on, 3, 46, 50–52; effects of technology on, 46–47; under Graham, 189–90; at J&L, 99–115; J&L openness to innovations in, 30–31, 194; under Jones, 30–36; during Korean War, 157–60; under Moreell, 137–38, 147–48, 312n.33; in the steel industry, 161–65; and WWII, 131–33, 156

Labor-management participation teams
(LMPTs), 3, 194, 318n.36
Labor-Management (Taft-Hartley) Act, 133
Lakeside Works. *See* Cleveland Works;
Otis Steel
Landon, Alf, 105–6
Laughlin, George M., Jr., 128; on board of
directors, 92, 98; in J&L management,
84, 95–96
Laughlin, George McCully, 21–22, 52; in
J&L management, 24, 27, 53–54, 84;
ownership of J&L, 28–29, 54
Laughlin, Henry A., 13; in J&L, 24, 53;
ownership of J&L, 28–29, 54
Laughlin, Irwin, 13, 24, 27
Laughlin, Irwin B., 84
Laughlin, James B., 11–13; death of, 27–
28, 53; in management of J&L, 84,
301n.24
Laughlin, James, Jr., 24, 27–29, 54
Laughlin, Ledlie, 95–96, 306n.2
Laughlin and Company, 20, 30, 53;
reorganizations of, 1, 13–14, 27–28, 53
Lauth, Bernard ("Ben"), 10, 13, 15, 19,
300n.14
Lauth, John, 10–12, 15, 300n.14
Lauth, Johnny, 19
Laycock, John N., 127–28
Lewis, H. Edgar, 98, 114, 128, 133–34
Lewis, John L., 102–3, 105–6, 131, 142
Ling, James: financial style of, 315n.27,
316n.6; and J&L acquisition, 179–80,
181–86; and LTV conglomerate, 162,
172–78, 315n.27
Ling-Temco-Vought. *See* The LTV
Corporation
Little Steel. *See* Independent steel makers
Lockouts, 31, 34
The LTV Corporation, 1, 5, 162, 318n.36,
319n.11; chronology of, 172–78, 191,
286–88; finances of, 201–2, 318n.38,
318n.39; J&L in, 179, 200–203; role of
steel in, 195–99
LTV Steel Company, 1, 319n.13; creation
of, 197–99, 200–201; management of,
318n.2, 319n.11; standing of, 318n.41,
319n.8
Lykes Corporation, 191

MacDonald, David, 131
MacPherson, Orison, 124
Making Iron and Steel (Ingham), 47–48
Making Steel at J&L with Jake and Louie,
226–72
Malloy, Elmer, 103
Management, 1–2, 133; blame in decline
of steel industry, 160–62, 193; labor
working with, 133, 194; view of labor,
47–49, 84; workers' relation with, 2–3,
189–90. *See also under* Jones and
Laughlin Steel
Managing (Geneen), 155–56
Marketing: for American Iron Works, 23;
for J&L, 30, 117; use of *Men and Steel*
for, 124–25. *See also* Advertising
Marshall, S. S., Jr., 128
Mauk, Harry, 68–70, 76
Mauk, John, 99
McDonald, David J., 159–60
McGranahan, C. L., 128
McKeesport Tin Plate Company, 121–22
McLaren, Richard W., 180
Mechanics canal boats, 9–10, 15
Men and Steel, 164, 187, 311n.8, 311n.9,
314n.8; on acquisition by LTV, 179–80;
under Moreell, 140–44, 148–49, 152,
311n.12
Midland, Pa., 60
Midland Works, 195, 203
Mines, 30; Benson, 121, 130; Blair
Limestone, 30, 302n.16; Vesta, 30, 130
Mississippi River, 86–87
Mitchell, J. B., 152
Monongahela River: bringing raw
materials across, 29–30, 38, 50;
industrial congestion around, 62; using
for transportation, 87
Moreell, Ben, 1, 134–53, 312n.13, 312n.17,
313n.48; labor relations under, 312n.33,
313n.53; personality of, 140, 142–43,
149–52, 313n.39
Moreland, William C., 1, 85, 92, 96
Mossman, W. C., 106
Mossman, William T., 1, 129, 309n.4
Mullen, John, 103
Murray, J. C., 128
Murray, Philip, 105, 131, 142, 148, 158

Women: at J&L, 187–89; during WWII, 121–22, 131

Woodlawn Land Company, 63–64

Workers, 44, 50, 186; blame in decline of steel industry, 160–62, 186; employed by J&L, 46, 201; homes for, 59, 63–64, 73; layoffs, 313n.53, 318n.31; management's view of, 84; relation to J&L, 2–3, 133, 185–87, 189–90, 202–3; *vs.* shareholders, 140–41, 144–47, 158

World War I, 81

World War II, 116–33, 310n.10, 310n.14

Wysor, R. J., 94, 97

Youngstown Sheet and Tube, 92, 191, 203

Portraits in Steel

was designed and composed

by Will Underwood

in 11½/16½ Bodoni Book

with figures set in Berthold Bodoni Light

on an Apple Power Macintosh system

using Adobe PageMaker

at The Kent State University Press;

printed by sheet-fed offset lithography

on 140 gsm Japanese white A gloss enamel stock,

Smyth sewn and bound over binder's boards

in Brillianta cloth, and wrapped with dust jackets

printed in four color process on 157 gsm enamel

by Kings Time Printing Press Ltd., Hong Kong;

and published by

The Kent State University Press

KENT, OHIO 44242 USA

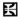